Authentically African

Arts and the Transnational Politics of Congolese Culture

⌒

Sarah Van Beurden

OHIO UNIVERSITY PRESS ⌒ ATHENS, OHIO

Ohio University Press, Athens, Ohio 45701
ohioswallow.com
© 2015 by Ohio University Press
All rights reserved

Printed in the United States of America
Ohio University Press books are printed on acid-free paper ∞ ™

25 24 23 22 21 20 19 18 17 16 15 5 4 3 2 1

Library of Congress Cataloging-in-Publication Data
Beurden, Sarah Van, author.
Authentically African : arts and the transnational politics of Congolese
culture / Sarah Van Beurden.
 pages cm. — (New African histories)
 ISBN 978-0-8214-2190-1 (hc : alk. paper) — ISBN 978-0-8214-2191-8 (pb : alk.
paper) — ISBN 978-0-8214-4545-7 (pdf)
1. Art, Congolese (Democratic Republic)—History. 2. Art, Congolese
(Democratic Republic)—Political aspects. 3. Art, Congolese (Democratic
Republic)—Appreciation—Belgium. 4. Institut des musées nationaux du
Zaïre—History. 5. Musée royal de l'Afrique centrale—History. I. Title. II.
Series: New African histories series.
 N7399.C6B48 2015
 709.6724—dc23
 2015034123

FOR MY PARENTS

Contents

Illustrations

PLATES

FOLLOWING PAGE 244

Acknowledgments

A great many people and institutions supported this project along the way.

There are simply no words for the thanks I owe the staff of the IMNC in Kinshasa and Lubumbashi, and the many people who helped me during my stays in Congo. Désiré Kapata, and especially Dr. Muya wa Bitanko of the IMNC in Lubumbashi, made my stay there very productive. I thank Nicole Sapato and Kiat Wandand for helping me get to know the city. Also in Lubumbashi, Léon Verbeek generously shared the transcripts of his interviews and his wealth of knowledge about modern Congolese art with me. At the IMNC in Kinshasa, André Kule, Françoise Toyeye, N'Kanza Lutayi, and especially museum director Prof. Joseph Ibongo greatly facilitated my research. Francklin Mubwabu helped with access to the newly digitized images of the museum. Dr. Henry Bundjoko was generous with his time and knowledge and helped me both at the museum in Lubumbashi and in Kinshasa after his move there. Vera Melotte, Marius Mihigo, the late Guy Efomi, Liesbeth Bernaerts, and Koen Vanden Driessche helped make my stays in Kinshasa possible. A special thanks goes to Chantal Tombu, for being such a generous host and friend. Most of all, I thank Augustin Bikale, whose support was crucial to my stays in Congo, and whose conversation helped shape this book. *Kinshasa mboka té!*

I have benefited tremendously from the expertise and support of the staff of the Royal Museum for Central Africa in Belgium. Nancy Vanderlinden, Julien Volper, Mathilde Leduc-Grimaldi, Mathieu Zana Aziza Etambala, Anne Welschen, Hein Vanhee, Maarten Couttenier, Viviane Baeke, and of course director Guido Gryseels, who supported this project from the very beginning, have all helped make this book possible. Raf Storme and Pierre Dandoy helped me navigate the African Archive at the Ministry of Foreign Affairs in Brussels, and Emmanuel Gerard helped me locate material in the archives of the

Royal Museum of the Armed Forces in Brussels. Darla Rushing and Trish Nugent gave me a very kind reception at the special collections of Loyola College in New Orleans, where I consulted the papers of Joseph Cornet.

Several institutions provided me with support and space to work on this project. At the Department of History of the University of Pennsylvania, Lynn Lees and Kathy Peiss provided me with insightful comments on numerous drafts. I cannot thank Lee Cassanelli and Bruce Kuklick enough for taking a chance on this project and for their continued and unfailing support of my work. This book would not have existed without them. Bruce and Tizzie's devotion to the Low Countries has also been much appreciated. The Ohio State University, the Institute for Historical Studies (IHS) at the University of Texas in Austin, and the Käte Hamburger Kolleg and Centre for Global Cooperation Research (GCR) at the University of Duisburg-Essen in Germany provided further support for the writing and research of this book, and the National Museum of African Art (NMAA) at the Smithsonian in Washington, DC, hosted me for four productive months. Janet Stanley of the Warren M. Robbins Library at the NMAA was always generous with her time and immense expertise, as were chief curator Christine Mullen Kreamer and Eliot Elisofon Photographic Archives archivist Amy Staples. I thank IHS director Julie Hardwick and IHS staff member Courtney Meador for making my stay in Austin possible, and Markus Böckenförde, Tobias Debiel, Alexandra Przyrembel, Volker Heins, and the GCR staff for welcoming me to Duisburg. The staff and my colleagues at the Department of African American and African Studies at the Ohio State University, particularly Anthonia Kalu, Ike Newsum and Franco Barchiesi, have been very supportive. A grant-in-aid for manuscript preparation from the College of Arts and Humanities at the Ohio State University helped defray the costs of the many images in this book.

Several museums provided me with images and archival materials for this study. These include the RMCA, the IMNC, KADOC, the Documentation and Research Centre for Religion, Culture and Society at the University of Leuven in Belgium, the Baltimore Museum of Art, the National Museum of African Art, the Milwaukee Art Museum, the National Gallery, the Dayton Art Institute, the Indianapolis Museum of Art, the Walker Art Center in Minneapolis, the Montreal Museum of Fine Art, the Los Angeles County Museum of Natural History,

and the Art Gallery of Ontario. The interlibrary loan staff at the Van Pelt Library at the University of Pennsylvania, the Perry-Castañeda Library at the University of Texas in Austin, and the Thompson Library at the Ohio State University, as well as Ohio State African Studies librarian Johanna Sellman, were incredibly helpful in my quest for published materials. A special thanks to the MAGNIN-A gallery and Chéri Samba for allowing me to use the beautiful Chéri Samba painting *Musée Royal de l'Afrique Centrale. Réorganisation* (2002) for the cover.

At different stages in this project, I have benefited from the advice, conversation, and help of David Binkley, Nancy Rose Hunt, Michel Verly, Jan Raymaekers, Louis Vos, Boris Wastiau, Louis de Strycker, Constantine Petridis, Idesbald Goddecris, and Renaat Devisch. I am grateful for the confidence Gillian Berchowitz of the Ohio University Press has had in this project, and the expertise with which Nancy Basmajian, Samara Rafert, and Rick Huard shepherded my manuscript through the publication process. The comments and feedback of series editors Jean Allman, Allen Isaacman, and Derek Peterson, as well as the two anonymous reviewers, considerably improved the manuscript. This manuscript has also benefited enormously from the comments of the many other people who read part or all of it. I thank Lee Cassanelli, Bogumil Jewsiewicki, Steve Conn, Jan Vansina, Steven Pierce, Franco Barchiesi, Allen F. Roberts, and Joanna Grabski for their feedback. Special thanks to Alice Conklin, who not only read several versions of the manuscript, but whose advice, friendship, and mentorship also helped me navigate my years as an assistant professor. Naturally, all remaining mistakes are my sole responsibility. Parts of chapter 1 and chapter 3 have previously appeared as articles in *History and Anthropology* (vol. 24, no. 4 [December 2013]: 472–92) and the *Journal of African History* (vol. 56, no. 1, March 2015) (reprinted with permission).

This book would not have existed without the willingness of so many people to talk to me about their personal histories with the museums in Belgium and Congo. A full list is included in the bibliography, but I particularly want to acknowledge the generosity and hospitality of Shaje'a A. Tshiluila, Eugénie Nzembele Safiri, and the late Célestin Badi-Banga ne Mwine.

My family and friends have encouraged and sustained me through a long and sometimes difficult process. Marilyn Sinkewicz, Naomi Greyser, and Susanne Sreedhar were an incredible support during the writing process. Although my career choices have taken me far away

from them, my family has always been supportive and encouraged me to keep going. My sister Liesje Van Beurden, her wife Els De Pessemier, and my friends in Belgium, the United States, and Congo have been patient and supportive. My love and gratitude go out to Brian, who has read every single word I wrote for this book, and who has cooked far more than his fair share of meals in the past years. I simply could not have done this without him. Most of all, I thank my parents for their unwavering support for me, always. This book is dedicated to them.

Abbreviations

AA BuZa	Afrikaans Archief Ministerie van Buitenlandse Zaken (African Archive, Belgian Ministry of Foreign Affairs)
AAI	Amis de l'Art Indigène (Friends of Indigenous Art)
AAI	African American Institute
ABA	Académie des Beaux Arts (Academy of Fine Arts)
AFA	American Federation of Arts
AIA	Association Internationale Africaine (International African Association)
AICA	Association Internationale des Critiques d'Art (International Art Critics Association)
ANC	Archives Nationales de la République Democratique du Congo (National Archives of the Democratic Republic of Congo)
ASAI	Ateliers Sociaux d'Art Indigène (Community Workshops for Indigenous Art)
COPAMI	Commission pour la Protection des Arts et Métiers Indigènes au Congo Belge (Commission for the Protection of Indigenous Arts and Crafts)
FIKIN	Foire Internationale de Kinshasa (International Fair at Kinshasa)
IMNZ/C	Institut des Musées Nationaux du Zaïre/du Congo (Institute of National Museums in Zaire/Congo)
IRSAC	Institut pour la Recherche Scientifique en Afrique Centrale (Institute for Scientific Research in Central Africa)
MNL	Musée National de Lubumbashi (National Museum of Lubumbashi)
MPR	Mouvement Populaire de la Révolution (People's Revolutionary Movement)

MVI	Musée de la Vie Indigène (Museum of Indigenous Life)
NMAA	National Museum of African Art
RMCA	Royal Museum for Central Africa
SIA	Smithsonian Institution Archives

A Note on Names and Translations

The spelling of the names of Congolese cultures varies. Local cultures such as the Luba and Kuba, for example, are sometimes referred to as BaLuba and BaKuba, particularly in older scholarship. The prefix "Ba" in these instances indicates the plural, but I have chosen to drop it, following the trend in more recent scholarship.

Whenever they are available, I use English names (so Leopoldville instead of Léopoldville).

All translations are mine, unless otherwise noted.

Many regions and cities were renamed under Mobutu. Some of the most important colonial and postcolonial names:

Coquilhatville	Mbandaka
Costermansville	Bukavu
Elisabethville	Lubumbashi
Katanga	Shaba
Leopoldville	Kinshasa
Luluabourg	Kananga
Mont Stanley	Mont Ngaliema
Paulis	Isiro
Stanley Pool	Pool Malembo
Stanleyville	Kisangani

INTRODUCTION

Congolese History and the Politics of Culture

IN OCTOBER of 1973, donning his trademark leopard-skin hat, Zairian leader Mobutu Sese Seko appeared before the UN in New York and in a booming voice deplored the "systematic pillage" of his country's valuable cultural heritage by Western powers. Just as he had led a campaign to nationalize the recently independent country's mineral resources, Mobutu imagined Zaire's cultural heritage as a resource to be protected and "nationalized" in its own right. His demand for the restitution of "authentic" and valuable museum objects laid bare not only the cultural, but also the economic and political value of art objects to the Mobutu regime.

How did these specific objects and collections become defined as cultural and national heritage for Zaire? The answers to these questions do not lie only in changing ideas about the nature and value of African art. We may also find them in the construction of cultural authenticity and heritage as well as in the institutional and organizational politics of the cultural economies of both colonial and postcolonial Congo.

Authentically African traces a transnational process of cultural reinvention from the colonial into the postcolonial era and demonstrates its role in the construction first of Congo's and later of Zaire's cultural and political economies.[1] In pursuing this project I have identified a common set of strategies that legitimate political power through the stewardship of cultural heritage. Collectively I will refer to these as *cultural guardianship*. I argue that cultural guardianship, particularly in the late colonial era, became a justification for Belgium's colonial presence in Congo, a development that had an impact on ideas about

1

political legitimacy far beyond the colonial era. We may trace the development of this theory of cultural guardianship through the definition, representation, collection, and possession of Congolese art and ethnographic material. Visible also in debates over cultural restitution and the creation of a postcolonial museum institute in Zaire, it complicates our understanding of the extensive process of decolonization. More broadly, the book analyzes the reinvention of traditional cultures as national heritage, as well as world heritage, in order to explore the cultural politics of the Mobutu regime and its claim on cultural guardianship in the construction of hegemony—nationally, but also internationally.

As Benedict Anderson has theorized, the creation of national identities required both forgetting and remembering; and in the creation of collections, the direction of research agendas, and the construction of displays, museums do quite a lot of both.[2] As this book shows, museums were a primary battleground for different and competing epistemic discourses regarding authenticity, and they were active participants in the decolonization process and the formation of the postcolonial nation of Zaire. Their collections were sites of debate over the nature of the colonial past and the definition of the postcolonial future as well as important pawns in the struggle over cultural guardianship. In this book, I use museums, the people connected to them, the politics that surround them, and the messages they shaped, as a "prism upon the field of cultural production," as well as on the broader field of cultural politics.[3] They are simultaneously symbolic representations of the state and microcosms that are at times the location of contradiction and contestation. They are an avenue through which we can explore the construction of ideas about cultural authenticity, as well as the political life of these ideas. Two museums in particular will be central to the history in this book. The first is the former Museum of the Belgian Congo, now named the Royal Museum for Central Africa (RMCA), but often called "Tervuren," after its location in a Brussels suburb.[4] The second is the Institute of National Museums in Congo, founded between 1969 and 1971 through a collaboration between the RMCA and the presidential office in Zaire.

This book is not "merely" about culture but, more broadly, about power. I concur with Fernando Coronil's observation that "power today cannot be analyzed exclusively within the boundaries of the nation-state."[5] It is in a broader, transnational context that we need to analyze

the construction, the circulation, and the affirmation of ideas about both cultural heritage and national identity—first, because of the transnational circulation of the objects, and second, because of the international nature of the creation of knowledge about these objects.[6] Transnational history is often understood as the study of movements, people, ideas, and processes that bypass or envelope the nation-state, but I believe it can also be very effective in informing the study of the very nation-state it is so often assumed to circumvent.[7] Particularly in the case of a newly independent African state, legitimation happened not merely among its own population but also in the arena of international politics and transnational organizations. In the case of the Mobutu regime, I would argue that the manipulation of perceptions of Zaire in a global public sphere became more important than their national construction.

But it is also at this point that the weaknesses of past treatments of transnationalism become clear.[8] All too often, the West still plays the role of center, while the rest of the world is relegated to the periphery of transnational processes and histories. The account of Zaire's postcolonial cultural and museum politics in this book offers a recalibration of transnational approaches by placing Africa in the center, and not at the periphery, of the analysis.

A COUNTRY WITH MANY HISTORIES

Central to this book is the circulation of objects, and their appropriation and reinvention, often for political purposes. The appropriation of the material cultures and objects from other cultures was not a process exclusive to Western collecting and display however, nor was it unique to the colonial and postcolonial eras. Although it is impossible to do the topic full justice here, this section serves as a short introduction to the diversity of cultures and histories in the Congo basin, while also drawing attention to the genealogies of what later becomes defined as Congolese art through a number of examples.[9]

Most of the Central African societies the Belgians encountered during their conquest in the late nineteenth and early twentieth centuries did not live in isolation. Trade routes crisscrossed the Congo basin and were engines of cultural exchange and change, connecting to the Indian Ocean world in the East and the Atlantic Ocean world in the West. Central African contact with Europeans started with the arrival of the Portuguese on the Atlantic coast in 1483. The trade that initially drove this contact was in the form of ivory and other goods,

although soon the transatlantic slave trade dominated. The contact effected great cultural changes, both locally and globally. Initially driven by the desire of the Kongo king for a spiritual and political transformation that would strengthen his position of power (locally as well as in the realm of Christian kings), Kongo cultures incorporated elements of Portuguese Christianity into Kongo cosmology and political economy, a "tradition of renewal" that started in the Kongo kingdom of the fifteenth century but continued in the many smaller kingdoms, polities, and communities in the region until the nineteenth century.[10] This cultural evolution became embedded in the material and artistic cultures of the region. Objects that served as markers of political power, such as swords, were both inspired by European examples and embedded within local cosmologies through the use of iron and the presence of the cross, for example.[11] The latter was a common theme in Kongo Christian art because of its dual origins: as the Christian cross, but also as the Kongo cross (or the corresponding diamond), a symbol of the cycle of life and representative of regeneration. It occurred not only in explicitly Christian Kongo art such as crucifixes, but also in healing objects, textiles, and pottery, among other things.[12]

Joseph Miller has suggested that western Central Africans had "an unquenchable thirst for foreign imports," which stimulated and reflected their integration into a global, Atlantic economy.[13] Imports included textiles, weapons, alcohol, and glass products such as beads and mirrors. Much of the wealth to buy these things was inextricably tied to the slave trade. That same slave trade was also the foundation for the global impact of Kongo (and other African) cultures, as they lived on and were reinvented in the diaspora.[14] It also signaled the beginning of European collecting of African-made objects. A market emerged in ivory objects, such as spoons, salt cellars, and decorated horns, made specifically for Europeans. Objects used within Kongo cultures, however, also started making their way to European collections. Regarded as "curios" and representatives of a world considered profoundly different from the European one, they set the stage for a centuries-long European process of representation and reinvention of African cultures and societies through objects.[15]

While immediate contact with Europeans was limited to the coastal regions, the impact of this contact reverberated far inside the continent, most conspicuously in the form of ever-expanding slave raids, but also in the new material things and foodstuffs traded along well-established

trading routes that had stimulated change and exchange in the region for centuries. By 1300 these routes already carried iron, copper, and salt, in return for beads and cowrie shells, linking equatorial Africa to southeastern Africa and eventually to the Indian Ocean world.[16] The Atlantic trade added various textiles, weapons, alcohol, and New World foods such as maize and manioc.

This growing economic sphere created and fed upon political and cultural change. The expansion of two of the most important polities of the area, the Luba and, later, Lunda spheres of influence, were tied to the exchanges that took place along these routes.[17] Objects, particularly those with a certain prestige, often embodied this "cosmopolitanism" and served the political economy of the power structures in the region. For example, the spread and use of royal Luba insignia, such as carved staffs, stools, ceremonial axes, and bowl figures, demonstrated not only the expansion of Luba power but also the appeal of the objects that physically represented this power. During the height of Luba power (ca. 1700–1860, sometimes referred to as the "age of kings") neighboring peoples (or "client polities") readily adapted these insignia as a sign of their incorporation into the Luba "empire," sometimes receiving them as a form of payment, sometimes copying or emulating them, or commissioning them from Luba artists. Their popularity illustrates the close association that existed between their possession and political legitimacy. Mary Nooter Roberts has demonstrated that these objects' power rested on their invocation of the interconnection between rulership and cosmology, effectively tying their possessors to supernatural realms of sovereignty.[18] Their popularity did not necessarily imply however, that they were on display for all to see. On the contrary, secrecy and limited access enhanced their value.

The eastern edges of the Atlantic world touched the western edge of the Indian Ocean world in what today is eastern Congo. By the nineteenth century, the impact of the Atlantic slave trade and the European presence on the western Central African coast were felt throughout the northern reaches of the Congo basin and as far east as the edge of today's Katanga region.[19] At the same time, communities in the eastern part of the Congo river basin were drawn into connections with Swahili ivory and slave traders from coastal East Africa and the Indian Ocean world. The trade with East Africa mirrored the Atlantic trade in its influence on political, cultural, and economic structures in the region, bringing for example the Swahili language as well as Islam to the region.[20]

By the time the Belgian king Leopold II set his sights on the area, the Kongo kingdom had long since fragmented and Luba, as well as Lunda, political influence had started to wane. The political landscape that explorers and colonial agents encountered in the east included polities established by Swahili-Arabs or East Africans like Tippu Tip and Msiri. The latter, in particular, straddled both the east- and westward trading routes, allowing Portuguese traders to raid for slaves and ivory in southeastern Congo, while also maintaining ties to the East African coastal economies.[21]

With Western imperialism came not only territorial conquest and economic exploitation, but also a top-down process of cultural interpretation and reinvention in which the extraction of material cultures, and particularly "art" objects by Europeans, played an important role. This extraction took place during the exploration and conquest of the Congo region in the latter half of the nineteenth century, was institutionalized during the Congo Free State (1885–1908), and expanded under Belgian colonial rule (1908–1960). Chapter 1 will investigate how the desire to control through collection, description, and classification gave shape to the collection of the Museum of the Belgian Congo, and how the latter represented and reinvented Congo for a Belgian audience. The book will then explore the implications and consequences of these representations and reinventions for the Congolese, particularly during the late colonial and postcolonial eras.

The process of the colonial conquest, and later the implementation of colonial rule in Central Africa, profoundly influenced the way in which the "precolonial" has been shaped as a historical category. For example, the belief in the existence of a historical "Luba empire," reflected "a fundamental misunderstanding of African political economy" based upon a literal interpretation of myths of kingship (which were themselves a tool for the promotion of political power) combined with "a prevailing sense that kingdoms *must* have existed."[22] A similar process has shaped views of the past of the Kuba of the Kasai region. Impressed by their artistic abilities and the perceived political centralization around the figure of the Kuba king, early visitors as well as later colonial administrators were convinced of the Kuba's superiority with regard to their neighbors. This reputation contributed to the Kuba king's survival in a system of indirect rule—although it certainly did not protect the Kuba from brutal exploitation during the colonial regime.[23]

Any admiration by missionaries, colonial administrators or travelers was usually projected upon the past of these societies, and ethnographic and descriptive accounts of cultural traditions were permeated with narratives of decline that underwrote the colonial logic of cultural guardianship. This decline was often attributed to either the impact of the East African slave trade in the Congo basin (which aligned with the Leopoldian justification of colonialism as an antislavery measure) or to the impact of Western modernity (or rather, the inability of Africans to deal with it in the "right" way and hence their need for colonial guidance). Any romanticized impressions of precolonial kingdoms and empires were thus rendered politically harmless and led at most to proposals for indirect rule.[24]

Instead of a perspective on the past that recognized long-term processes of cultural change and regional, transcontinental, and global connections, the precolonial African past became a category that locked Africans into an ahistorical and "authentic" past.[25] While this process created "authentic cultural traditions" as a defining category for the identity (and identification) of Congolese cultures, it simultaneously closed that category off to contemporary Congolese people by viewing the present through the prism of cultural decline—inventing a present, as much as a past.[26] This view legitimized "collecting" by Europeans, as the "salvaging" and safeguarding of Congolese cultures.

V. Y. Mudimbe has located the invention of a static and prehistoric tradition in the "*episteme* of the nineteenth and early twentieth centuries," and Johannes Fabian has also implicated more recent anthropological discourses and practices in the construction of "the other" as a "temporal, historical, and political act."[27] This book will demonstrate the late colonial and postcolonial life of these constructions, as well as their continued political relevance.[28] In particular, this book investigates the historical construction of the categories of "art" and "authenticity" and demonstrates their use as political tools, both within and outside the museum, first in the context of Belgian colonial rule and later in the context of the postcolonial Mobutist state.

MUSEUMS AND AFRICA, MUSEUMS IN AFRICA

The movement and possession of ethnographic and art objects and collections are historically part of larger political, cultural, and economic projects. A large and growing body of scholarship has demonstrated the connection between the creation of museum collections of

non-Western objects, the development of anthropology, and European colonialism.[29] We know far less, however, about the creation, development, and politics of museums on the African continent, particularly their postcolonial existence.

The museum landscape in Africa today bears the clear imprint of colonialism. A large majority of the museum institutions on the continent were founded during the colonial era. In French West Africa, the Institut Français d'Afrique Noire (IFAN), based in Dakar and founded in 1936, stood at the head of a system of satellite museums and scientific institutions across the region.[30] Many of the museums in former French West Africa today are the survivors of this institutional colonialism. Although the process was less centralized, most of the museums in the former British empire in Africa also have colonial histories. A number of small museums were created at elite schools before World War II, but a wave of "proto-national" museum openings followed between 1948 and 1959, not as a result of a centralized cultural policy, but because of the converging interests of local colonial organizations and administrators with those of African elites.[31] The case of the Belgian Congo more closely resembles the process in British West Africa. Despite lobbying for a centralized colonial *"politique esthétique"* (a "politics of aesthetics") after World War II, the network of small museums in Congo was the result of initiatives by local colonials, who often came into conflict with the central authority of the Museum of the Belgian Congo near Brussels.

Despite their colonial roots, museum institutions in Africa were not rejected after independence. Their role as nation-building tools suited postcolonial agendas and was often recast in the context of "development" policies.[32] However, it comes as no surprise that prominent postcolonial concerns included decolonizing these institutions, and seeking out or creating an African audience. Museum professionals struggled with identifying audiences, seeking out financing, and with the legacy of colonial structures of knowledge in their displays.[33] Regional and international organizations like UNESCO, WAMP (West African Museums Programme), AFRICOM (the International Council of African Museums), and ICOM (International Council of Museums) have all played an important role in the supporting the intellectual, institutional, and practical challenges of museum life in postcolonial Africa.[34]

Scholarship on museums and their histories in sub-Saharan Africa has been shaped by the many practical concerns of museum professionals and generally lacks analytical depth.[35] When this scholarship

is concerned with the past, it is often—and understandably—with the goal of making a clear break with said past. As a result, there are lots of short explorations of the history of individual museums in sub-Saharan Africa, but no sustained efforts to place them in a broader context.[36] This also applies to the history of the museums in Congo, where the little scholarship that exists is concentrated on the museum in Lubumbashi.[37]

An exception to this lack of critical literature is the cluster of publications of the past decade and a half focused on museums in South Africa. The political changes of the 1990s in South Africa, along with the existence of a significant network of heritage sites and museums, have created the conditions—and the urgent need—for critical investigations of the past, as well as a confrontation of the challenges the present holds.[38] The political role of public historical spaces like museums and heritage sites in the construction of national pasts and public memory in South Africa has been laid out, as well as the effort to decolonize these spaces.[39] This body of scholarship makes clear that museums in Africa have the potential for being relevant—although certainly not uncontested—participants in the public sphere. While authors challenge current museum institutions in South Africa to critically investigate their role in creating national pasts that supported the hegemony of the Apartheid regime, their scholarship also demonstrates a continued faith in the ability of heritage politics and museums to help effect social change via cultural identity formation.[40]

While the South African example is partially a result of specific political circumstances, it is also a reflection of a larger shift in the landscape of museum studies. Western museum professionals have become increasingly concerned with the complicity of cultural institutions in colonial structures of knowledge and the legacy of these structures in the shaping of inequalities of today's globalizing world. They also seek to redeem the museum by making it into a tool for social transformation that reflects postcolonialism.[41]

The scholarship on South Africa also nicely demonstrates the place of museums in what Tony Bennett calls the "culture complex," which comprises "a range of sites in which distinctive forms of expertise are deployed in "making culture" as a set of resources for acting on society." These sites, which include libraries, museums, heritage sites, schools, and so on, but also a range of knowledge practices and disciplines (such as ethnography and art history), are aimed at bringing

about "calculated changes in conduct by transforming beliefs, customs, habits, perceptions, etc." Most of these institutions and disciplines are connected to particular "rationalities of government."[42] In the case of South Africa, this was the Apartheid regime and its racial theories. In the case of the Belgian Congo, ideas about culture, formed in ethnographic and art historical practices and projected to a broader audience in the displays of Tervuren, underwrote and shaped colonial practices.

The work of Bruno Latour, who urged attention to the contexts in which culture is "made," looms large in the theorizing of the culture complex. Working with a broad interpretation of the laboratory, which includes locations such as the archive, as well as collections, Latour allows us to theorize the museum as a "centre of calculation"—a setting in which new entities are made that are inserted into fields of knowledge.[43] *Authentically African* starts off by tracing how colonial structures of knowledge, developed in and around the museum, intersected with and shaped the nature of Belgian colonial policies, but it departs from Latour and Bennett in its insistence on the "messiness" of the implementation and practice of these bodies of governmental theory. In the political use of the reinvention of cultures we can read the multidimensional and often contradictory nature of historical processes. Neither the creation of knowledge nor the translation of culture "made" in the context of the museum into cultural and social policy are clear-cut processes, proven by both the struggles of the Belgian colonial regime in implementing cultural policies, as well as the limited effect of the Mobutu regime's almost cynical use of the museum as a political nation-building tool.

The basis for the development of ethnographic scientific information about art and culture in the Museum of the Belgian Congo—its collection—was deeply unscientific in its own creation. The amount of objects acquired via scientific exploration was negligible in comparison with the donations from explorers, colonials, and missionaries and the acquisitions from art dealers and art collectors. The individual motivations to collect material and the knowledge that informed the decision-making process about the selection of objects varied tremendously. Their presence at Tervuren, however, fused this motley group of materials into a unit—"a" collection—and a basis for the creation of knowledge about the objects' cultures of origin. By contrast, the practices that informed the creation of the collection of the IMNZ in Kinshasa were more systematic and involved far fewer people. It was in

the process of knowledge creation and distribution, however, that the latter faltered, hampered by political co-optation and economic realities. The "crowd-sourced" nature of the Tervuren collection worked to its advantage when it came to the public role of the latter, while very few Zairians felt a similar affinity with the museums in their country.

The connection between museums as "critical switchpoints across different networks . . . [which] . . . in ordering the materials they accumulated from diverse points of collection, produced new entities that they then relayed back out to the world as resources" and particular (authoritarian) rationalities of government becomes even more salient in the second part of this book, in which the Zairian government moves to create a museum with the explicit purpose of decolonizing the country's cultural representation.[44] Can such a postcolonial application of the museum as a "technology of power" in central Africa be effective, however, given the deeply compromised nature of the museum as a colonial creation? In order to answer this question, I investigate whether and how the powerful categories of art and authenticity were constructed and used in the postcolonial Zairian context, and how they operated within the museum institute, as well as in the broader context of Zaire's postcolonial cultural politics.

ARTIFACT/ART AND THE CREATION OF VALUE

The scramble for Africa was accompanied by a "scramble for African art," as Enid Schildkrout and Curtis Keim have so succinctly put it.[45] Large numbers of ethnographic artifacts flowed into Europe, finding a home in several newly established museums and feeding the development of anthropology as a science. Taking the "concrete and palpable presence of a thing to attest to the reality which we have made it signify" was a fundamental aspect of Western imperialism.[46] Having started out as mere curios, these objects became artifacts of science, players in the construction of narratives about the "civilizing mission," and eventually art and the embodiment of wealth—both financial and cultural.

This shift from artifact to art, chronicled in this book, was reflected in museums displays. The curatorial approaches to displays vacillated between what I describe as "aesthetic" and "ethnographic" (or "anthropological") approaches. In an aesthetic approach the objects are presented as works of art, exemplified by their physical isolation and an emphasis on their formal qualities.[47] Ethnographic or anthropological

displays, on the other hand, use objects to teach museum visitors about a culture, so the objects are usually displayed in a way that attempts to tell the visitor something about the relationship between various objects, their function, and their use or symbolism. In reality, however, museum displays are rarely as clear-cut as these theoretical points of reference might lead us to believe: art displays are sometimes accompanied by photos of the objects in situ, for example, or ethnographic exhibitions might highlight the aesthetic qualities of objects.[48]

The art/artifact binary is by no means stable. Museum objects are canvases upon which many values were projected: financial or economic, cultural, and political. These different interpretations and values are not necessarily stable, nor did they exist in isolation from one another. On the contrary, they function as "regimes of value."[49] Throughout the book, I use "cultural value" to refer to the capacity of an object to represent "high culture" or "civilization." Central to the cultural value of an object is its "authenticity," in addition to its (Western) aesthetic value. These objects, whether they are interpreted as art objects (constructed as aesthetically appealing to the [Western] eye and consequently possessing a high "cultural value") or as ethnographic artifacts (with less importance as representatives of "high" culture, yet relevant as the representatives of a society and as objects in the scientific study of a society), also have an economic or financial value—that is, a value as commodities that can be traded.[50]

The twentieth century witnessed a progressive broadening of the category of African art. Aided by the primitivist modernists' interest in African art, Central and West African sculptural objects in particular were increasingly collected and displayed as art objects.[51] From the very first colonial exhibitions in Belgium, there were individual objects that were described as "art" rather than as ethnographic elements. A systematic scientific approach to these objects grew only slowly, however, and remained fragmented until Frans Olbrechts, who went on to become director of the Tervuren museum, developed a complete system of classification that canonized Congolese art and embedded it in the bodies of art historical and anthropological knowledge. The implementation of this classification in the displays at Tervuren in the 1950s—particularly in the form of a new art room—represented the culmination of this trend but was also symbolic of the increased attention accorded to culture among colonial organizations and in colonial policies. The cultural capital created through the institutionalization

of the reinvention of certain Congolese artifacts as art in Tervuren became fuel for both colonial and postcolonial constructions of political legitimacy. It was this ontological shift, and the epistemological changes that followed in its wake, that led to the reimagination of colonialism as a form of cultural guardianship motivated by the protection and preservation of native cultures, a political construction that reemerged in the cultural politics of the Mobutu regime.

THE INVENTION OF AUTHENTICITY AND THE CULTURAL LEGITIMATION OF THE COLONIAL STATE

A recurring topic in this book is the political nature of the invention and use of "cultural authenticity." Its varying application to objects and people reveal how and why museum employees—but also government officials, politicians, and audiences at large—valued culture. As Sidney Kasfir explains, ideas about the authenticity of African art are based on a series of flawed assumptions about "traditional society" as precolonial, isolated, and homogenous, and about the artist as "bound by tradition" and "controlled by larger forces than himself."[52] By investigating the processes through which authenticity was constructed and how, along with the category of "art," it was deployed, I seek to demonstrate the role of cultural (re)invention in the political projects of colonialism and postcolonialism.

"Indigenous" cultural authenticity became a useful concept in early colonial collecting of African material culture. In the process of removing material from its context, the projection of authenticity onto the objects served to legitimize the removal of an object as an act of salvaging. Crucial to the construction of cultural authenticity was the anxiety regarding "dying" traditional cultures that accompanied modernity's changes. The belief in their impending disappearance—essentially their existence as a past—was a prerequisite for their authenticity.[53]

The curators at the Museum of the Belgian Congo made the salvaging of authentic culture into a scientific undertaking, whereby the creation of expert knowledge and the development of a canon of Congolese art became key elements for the recognition of authenticity. The gradual emergence of a comprehensive system of classification accorded objects value and located authenticity, depending on how objects compared to, and fit in with, other objects in the collection. Becoming even further removed from their original context, authenticity and value were now also defined in the way objects were displayed.

The museum, and the art historical canon generated by scholars such as Frans Olbrechts, became authenticity-generating "machines," constructed as worlds of reference and classification that trumped the cultural context of Congolese societies. They also promoted the subsequent constructions of "traditional" Congolese cultures, and their need for protection, to a broader audience.

Another context in which authenticity played a crucial role was the art market. African art dealers—quite often collectors themselves—contributed significantly to the projection of authenticity upon Congolese cultures. African art trader Henri Kamer described it as follows: "An authentic African piece is by definition a sculpture executed by an artist of a primitive tribe and destined for the use of this tribe in a ritual or functional way. Never lucrative."[54] Art dealers and collectors often establish authenticity on the basis of the physical appearance of an object, looking for evidence of use in the patina, and by locating it in the classifications and canons constructed by scholars. Gradually the (Western) provenance—in the form of a genealogy of Western ownership—of an object became equally important in establishing value and authenticity, a trend also noticeable in the ways in which museums valued their collections. The growing importance of this kind of genealogy denied postcolonial Zairian collecting, like that of the IMNZ, access to a significant repository of authenticity, now located in the West. Through this process of identification, dealers and collectors constructed themselves as experts and connoisseurs, members of an elite with access to an exclusive knowledge—a knowledge that helped develop the canon as a scientific framework.[55] An object's authenticity also increased its commercial value and, ultimately, its commodification—a process clearly demonstrated in the growing market for African art in Europe and the United States. European colonialism, its networks enabling the movement of these objects from (in this case) Africa to the West, formed a crucial part of the story.[56]

The importance of cultural authenticity lies not merely in how it was defined but in the political implications of that definition. Parallel with the construction of an endangered Congolese cultural authenticity emerged the construction of the explorer, collector, museum director, and by extension the colonial state they represented, as the saviors and protectors of said Congolese culture. The political ramifications of these cultural constructions go beyond the museum and the art market: they legitimized colonial organizations and the colonial state

as creators of policies to save "traditional" Congolese cultures. Until World War II these were based upon an interpretation of colonialism as a "civilizing mission," but by the postwar period, a broader interpretation of Belgian colonialism as "welfare colonialism" intersected with the maturation of a scientific discourse about Congolese art that emphasized the value of the latter as a resource—one that not only could generate financial value but that could also serve to reinvigorate Congolese cultures.

Of course, "the categories of the beautiful, the cultural and the authentic have changed and are changing," as James Clifford points out.[57] The category of Congolese art (and "Primitive" art more broadly) evolved toward a canon and was framed increasingly with reference to objects in Western collections, while authenticity proved a malleable category that existed in the eye of the (Western) beholder. Not only did these categories evolve, they were also open to manipulation and co-optation. Christopher Steiner has illustrated how "authenticity" was captured by art traders in the Ivory Coast who reproduced the physical markers of "authentic" traditional art in order to create objects with significant market value.[58] The creation of "authentic" art objects for sale to a Western audience was not uncommon in Congo either. In some cases, the canon—in the shape of art books—helped shape the "authenticity" of "fake" pieces.[59]

The constructed nature of categories such as "art" and "authenticity" illustrates how disparate categories of value projected upon traditional African art objects operate in concert with one another. An object's economic value rises with its cultural value, but economic value can also create an aura of cultural value.[60] In their economic and cultural values resides another dimension as well, of course: the political. In their re-creation as art, and in their embodiment of authentic Congolese culture, Congolese objects became a resource to be protected and an element in the construction of colonial justifications for the presence of the Belgian colonial state as a cultural guardian of an "authentic" Congo.

The role accorded to material culture and art in the representation of cultural authenticity in the colonial era transformed the collections of the Museum of the Belgian Congo into subjects of political negotiation. Acquiring cultural guardianship—not only in terms of the possession of cultural heritage but also in terms of cultural practices—was understood as a way of acquiring authenticity, and hence legitimacy,

by the Mobutu regime. This book traces three of the avenues through which this process took place: the demand for cultural restitution in the process of decolonization; the creation of a museum institute in Zaire in order to generate a national repository of precolonial traditional culture; and the broader authenticity politics of the Mobutu regime.

CULTURAL HERITAGE AND THE POLITICS OF DECOLONIZATION

The Congolese struggle for independence and its immediate aftermath have the dubious honor of being one of the most famous moments in the African struggle for independence. From Lumumba's speech on independence day in June of 1960, in which he painted a picture of Belgian colonialism as one of abuse and exploitation, to the violence of the postindependence conflicts and secessions, the murder of Lumumba, and the involvement of the United Nations, the struggles around Congolese independence came to stand for the history of African decolonization at large. The contours of this well-known history have limited our understanding of the process of decolonization in Congo, however. Using the history of Congolese demands for postcolonial cultural restitution, this book investigates the process of decolonization as a "drama of competing visions" and proposes two major shifts in the approach to the history of Congo's decolonization: a thematic and periodization shift away from the history of the political and military events of the late 1950s and early 1960s, in favor of studying the debates over cultural sovereignty that took place from the late colonial era until the 1980s.[61]

The dominant construction of the category of decolonization emerged in the West in the face of anticolonial struggles and was organized around Western governmental frameworks, shaping not only the processes of decolonization but also the historical view of that process.[62] Consequently, the scholarship emerging from the former colonizer as well as later nationalist histories define decolonization as a moment of rupture, in which new and sovereign nation-states were (or should have been) created.[63] Far too often, the moment of political independence is portrayed as the end of a process. This approach set up the "failed states" narrative which emerged in the 1990s and which condemned many of these "new" African states as weak, incoherent, and failing in comparison with their Western counterparts.

In the case of Congo, the scholarship is dominated by a focus on political and military events taking place between roughly 1955 and

1965.[64] The first Congo Crisis, associated with the Katangese Secession and the regional conflicts of the early 1960s, is generally described as part of the process of decolonization. This means that Mobutu's second coup in 1965 is often seen as the end of the era of decolonization and the beginning of the postcolonial state in Congo.[65] This book questions that periodization, argues that independence was more a beginning than an end for the process of decolonization, and advocates for an examination of the history of the Mobutist state through the lens of decolonization.[66]

Since colonialism consisted of far more than political and economic dominance, so did African interpretations and expectations of decolonization. Often overlooked in the histories of decolonization in Africa are the ways in which cultural sovereignty was imagined and demanded. As this book argues, cultural guardianship came to play an important role in the justification for (late) colonialism, a point made clear in Belgium's defense of its possession of large museum collections of Congolese art and artifacts, even after Congo's political independence. As a consequence, Congolese expectations of independence were also shaped by the desire to reclaim the resources necessary to give shape to cultural sovereignty.

As Ngũgĩ wa Thiong'o writes, "To control a people's culture is to control their tools of self-definition in relationship to others."[67] An important part of this cultural identity relies on the past, which in the case of Congo was created as "authentic traditional culture" by the modernist imagination of Belgian colonial rule, a cultural category from which change and modernity itself were scrubbed. In the Belgian Congo, the preservation of this "tradition" was also conceived as part of the colonial project, particularly by the 1950s. This was implemented via initiatives for the protection and preservation of the production of "traditional" arts and crafts (the "present" past) in the colony, but also in the ownership and preservation of the collection of the Tervuren museum in Belgium. In this process, "traditional" cultures, and particularly the objects that had been recast as art, were reinvented as heritage.

A product of "ways of valuing the past that arose in Renaissance and Enlightenment Europe and [. . .] bolstered by nationalism and populism" as well as by Western obsession with identity (both collective and individual), heritage was projected upon non-Western cultures within the context of colonialism and shaped by colonial collecting and displaying practices.[68] This had practical consequences: in the European

context, the museum, as a place of preservation, had become an important tool in the "activation" of heritage into instruments of nation formation and solidification. Zoe Strother recently observed that if "heritage is culture conceived as property, it is also property obtained through legally determined rights of succession."[69] As such, it should come as no surprise that the ownership of these collections became the subject of debate in the process of decolonization; after all, Belgian rhetoric about Congo was rife with references to the colony as its "maturing child."

With the European nation-state as a model, the newly independent country sought to create itself as the guardian of its own cultural heritage. Possession of cultural heritage would enable the postcolonial state to construct a cultural legitimacy that underwrote its political legitimacy.[70] The historical role of cultural heritage in the African process of decolonization has received little attention to date: most studies of demands for restitution focus on more recent examples, the protection of the heritage of indigenous peoples in the west, or the development of international regulations.[71] Recently, African art historians have carefully started exploring heritage as a reflexive, historical concept, open to African interpretations.[72] As the embodiment of (imagined) identities and cultures, as well as their pasts, heritage ties the immaterial to the material, a (usable) past to a present, and "having culture" to the possession of cultural artifacts (or "cultural property"), often in the form of monuments, historical sites, landscapes, and museum collections.[73] In this book, I am concerned with how the reinvention of "traditional" art as national heritage was used as a political tool, and how preservation was imagined as a necessary road toward the creation of a new national heritage in the form of modern art.

An important role in the world of heritage is reserved for international regulations and conventions, and for UNESCO in particular. International regulations for dealing with the return and protection of cultural property took shape in the aftermath of World War II. These regulations soon became problematic in the face of intensifying decolonization struggles around the world. In combination with the increased tendency to regard African museum collections in the West as heritage, the demands from newly independent or decolonizing countries for the return of what was now by definition their national heritage created considerable pressure on Western cultural institutions.

By the 1970s there was a veritable international conservation regime for the protection of national heritage rights. Walking a tightrope

between acknowledging the importance of national heritage and a commitment to preservation, the 1970 UNESCO Convention on the Means of Prohibiting and Preventing the Illicit Import, Export and Transfer of Ownership of Cultural Property helped nation-states protect the cultural heritage within their borders against illegal removal but refrained from applying the regulations retroactively, sidestepping the matter of material removed during colonial occupations.[74]

Decolonization may have pushed the reinvention of museum collections like the ones at Tervuren as national heritage, but a competing heritage discourse with universalizing tendencies also emerged. This cast the material as the world's or mankind's heritage.[75] Not unlike the reinvention of African artifacts as art, the invention of world heritage provided Western museums faced with restitution claims with arguments to keep their collections.[76] Usually, preservation claims trumped (and trump) restitution claims. Thus, the international conservation regime, although ostensibly concerned with restitution claims, often worked to the disadvantage of newly independent countries.

"RECOURS À L'AUTHENTICITÉ": THE CULTURAL POLITICS OF THE MOBUTU REGIME

The campaign for the restitution of the collections of the Museum of the Belgian Congo cast the postcolonial Zairian state as the appropriate guardian for the country's cultural heritage. This fit in with a broader cultural campaign undertaken by the Mobutu regime. The *"Recours à l'authenticité"* ("recourse" or "resort" to authenticity) campaign, which reached its height in the early 1970s, was ostensibly aimed at a reinvigoration of Zairian culture, inspired by precolonial, "traditional" culture. It incorporated the antimodernism of colonial interpretations of Congolese traditional cultural authenticity into the construction of an African cultural modernity—in the guise of tradition. Composed of a wide range of initiatives—from the "Zairization" of people's names, to the renaming of the country, its river, and its cities, to the staging of elaborate cultural manifestations, and the creation of national ethnographic and art collections at the museum institute in Kinshasa—it was set up in opposition to the "inauthentic" nature of the colonial era. Paradoxically, this campaign for cultural authenticity relied heavily on the colonial construction of Congolese authenticity but couched the latter in anticolonial terms by promoting it as a part of a process of decolonization.

As the colonial history of the invention of Congolese cultural authenticity demonstrates, the concept had a political use: it legitimized intervention and "protection" by an authoritarian state. Yet despite its cynical application to legitimize an authoritarian postcolonial state, it also had an intellectual appeal that connected it to a pan-African tradition. It is in part this ambiguous nature of Mobutu's authenticity politics that make it an interesting historical phenomenon.[77]

While some of the broader traits of the authenticity campaign are explored in this book, the focus is on the way in which it shaped Congolese postcolonial museum politics and the ways in which the latter were a reflection of (often failed) attempts to decolonize the categories of art and cultural authenticity via collecting practices and the creation of displays and knowledge. This investigation reveals the internal tensions of the authenticity campaign: how its justifications of authoritarianism and the increasing emphasis on the figure of Mobutu as the political and cultural center of the nation eventually trumped the intellectual attraction of its cultural nationalism.

In the *Idea of Africa*, the Congolese philosopher and writer V. Y. Mudimbe characterized the Mobutist doctrines as "a discursive drama [that] claims to be the sign of a social reality" which instead muzzled reality.[78] The history of the Zairian Institute for National Museums and the Zairian demands for cultural restitution in this book confirm that "looking like a state," which in this case meant projecting the appearance of cultural guardianship, ultimately was more important to the Mobutu regime than the creation of a real cultural infrastructure for the country's citizens.[79] This is clear from the decline in funding and support for the IMNZ by the mid-1970s. Despite these circumstances, however, the museum institute did continue to function successfully as a representative of the Zairian state on an international level.

It is in the international dimension, in fact, that we have to look for the most effective political use of Zaire's traditional arts and postcolonial museum politics—and of the authenticity politics in general. Buoyed by a booming market in traditional African art, the Zairian museum institute managed to, if not replace, at least match the Belgian Royal Museum for Central Africa as an organizer of international exhibitions in the late 1970s and early 1980s. The most important and effective of those took place in North America and promoted an image of the Zairian state—and by extension the Mobutu regime—as the representative and guardian of the country's cultural heritage.

The book follows the colonial creation of cultural guardianship of Congo and the postcolonial struggle over the cultural sovereignty this guardianship represented. Chapter 1 tells the story of the creation of the collection of the Museum of the Belgian Congo and the adaptation of its displays to the reinvention of certain Congolese objects as art objects. It explains how this development was part and parcel of a changing interpretation of colonial guardianship, which now incorporated the protection of "authentic" Congolese heritage into the justification for its colonial presence. Chapter 2 juxtaposes the transformation of ethnographic objects into art, described in the first chapter, with the shifting definitions of "indigenous art" and cultural authenticity that were at work in the colonial environment. Policy agendas for the protection and preservation of artistic and artisanal cultures reveal the close association between economic, political, and cultural motivations for the controlled reinvigoration of a Congolese arts and crafts scene. These motivations also demonstrate how a colonial state envisioned engineering social conformity through cultural control, a trend that continued during the Mobutu regime.

The third chapter uses the story of the eventual return of a number of objects from the former Museum of the Belgian Congo to Zaire to provide a new narrative of the history of Congo's decolonization as a struggle over cultural heritage that took place in both a national and an international setting. The reinvention of Congolese traditional art as national heritage and the adaptation of colonial notions of cultural authenticity in the national cultural ideology of *authenticité* by the Mobutu regime, served as tools for the creation of Zaire as a postcolonial geopolitical space. In the process, cultural authenticity emerged as the currency of an international conservation regime that fueled Zaire's discourse on national cultural sovereignty and as a fundamental aspect of the legitimation of postcolonial political power.

The two following chapters turn to the cultural and political roles of the IMNZ within Zaire and to its efforts to reclaim the representation and the creation of knowledge about traditional cultures through a decolonization of institutional practices and collection and research activities, as well as exhibition practices. The chapters explain why the IMNZ largely failed in creating a domestic role or audience and how its struggles and decline can be located in the ultimate inability of the Mobutu regime to control the creation of a cultural narrative for the postcolonial nation.

The final chapter lays out the transnational context in which these processes of cultural reinvention took place. Through the history of four exhibitions of Congolese art and culture that traveled the United States, I argue that it was on an international level that Zaire most successfully came to project a reclaimed cultural guardianship. By analyzing how heritage and African authenticity were displayed and interpreted abroad, this chapter demonstrates that the remaking of postcolonial cultural representations was not a process limited to national actors and audiences.

Finally, a word on sources. The research for this book was conducted mostly in Belgium and Congo, with one long term and another short term stay in the DRC (and more specifically in Kinshasa and Lubumbashi) in 2006 and again in 2011. Very little of the current scholarship on Congolese colonial history incorporates Flemish language sources, which represents a serious blind spot this study aims to correct by using both primary sources and a relevant body of secondary literature written in Dutch.

Although the Belgian participation in this history is fairly well documented in terms of archival material, the side of this story that mattered most to me, the Congolese perspective, was much harder to research. Colonial propensities for classification and the resulting archives that are "cultural agents for 'fact' production" have made their mark on the production of the colonial past, but these structures of knowledge have also had repercussions for the way in which postcolonial histories are constructed.[80] The zeal with which the former colonial power continued to document its interactions with the former colony outweighs the extent to which the Mobutu regime was concerned with doing the same. In recent decades, Congo has also justifiably had other priorities than safeguarding archival material. The result is the fragmentation of the archival material relating to the colonial period and the Mobutu years. The national archives in Kinshasa do not have much material that was useful to the topic of this book, while the archives of the museums in Kinshasa and Lubumbashi have both suffered from plundering and neglect. In Lubumbashi, UN soldiers occupied the museum building during the Katanga Secession in the early 1960s, while the museum offices in Kinshasa suffered during the unrest of the 1990s. After much searching, I was able to collect some archival and photographic material, mostly from cupboards and filing cabinets around the museum offices in Kinshasa, but gaps persist. Interviews,

conducted both in Congo and Belgium, were an important source of information for me, although I have been attentive to the impact of nostalgia and current-day conflicts and problems in the museums, as well as the impact of people's political reinvention since the Mobutu years, upon their memories.

1 ⸾ The Value of Culture
Congolese Art and Belgian Colonialism

FOR MOST of the colonial period, the Museum of the Belgian Congo was the most visible presence of the empire in Belgium and one of the a major avenues through which Belgian citizens got to know their colony. Its neoclassical and marble halls filled with its zoological, mineralogical, and man-made "wonders" represented the colony. During the 1950s, the museum received between 141,800 and 197,859 visitors a year, the equivalent of up to 2.3 percent of the Belgian population. This made it one of the most visited museums in Belgium.[1]

This chapter lays out how representations of Congolese cultures were produced and projected at the museum, and the ways in which these intersected with and helped shape colonial ideologies. The process whereby Belgium became the custodian of a large museum collection of Congolese material is explored, and the chapter explains how a fragmented and varied process of collection was translated into seemingly coherent images of Congolese culture and bodies of knowledge.

I argue that the very guardianship of the museum's collections became integrated into late colonial justifications for Belgium's colonial presence in the Congo. This relied on two processes: the production of new values and meanings for African objects as art and the accompanying construction of Congolese cultural authenticity as endangered. This meant that Congolese art, eventually transformed into an exceptional resource with cultural and economic value, came to have its place in the *mise en valeur* narrative about the colony presented to the museum audience.[2] The "endangered authenticity" projected upon the communities that originally produced these objects also provided

an extra justification for Belgium's continued presence in the Congo: the protection and guardianship of "traditional" cultures.

THE MAKING OF A COLONIAL MUSEUM AND THE CHANGING FACE OF COLONIALISM

Scientific exploration and the origins of the Belgian Congo are inextricably connected. Masking his imperial ambitions as scientific interests, Leopold II in 1876 organized the International Geographic Conference, where the Association Internationale Africaine (International African Association—AIA) was created, ostensibly to promote the exploration of the African continent. Simultaneously, Leopold II hired Henry Morton Stanley, a Polish-American newspaper reporter turned explorer, to explore the Congo River basin and secure allegiance from local leaders in order to thwart other European interests in the region. Having deftly manipulated those interests, Leopold II succeeded in securing recognition as the sovereign of the Congo Free State at the Berlin Conference of 1884–85. From then on, the area was essentially the private property of Leopold II, although representatives of the Congo Free State would not bring the entire area under their control until early in the twentieth century.[3]

Although Leopold II firmly believed in the area's economic promise, he was not able to tap Congo's resources until the allocation of exploitation rights to a number of regional concessionary companies, as well as to the "Royal Domain," which remained directly under Leopold's control. The representatives of these companies (which included the Anglo-Belgian Rubber Company and the Société Anversoise) and state agents in the Royal Domain received commissions on the amount of product (initially ivory, but eventually mostly rubber) they extracted.[4] With no state regulatory controls, this arrangement led to widespread abuses at the expense of the local population while generating great wealth for the Congo Free State and its monarch.[5]

The creation of the Museum of the Belgian Congo was deeply intertwined with the colonial project of Leopold II. As early as the 1880s, the Belgian king seized on the potential of colonial exhibitions for the promotion of empire. These exhibitions served two purposes. On the one hand, they were intended to stimulate Belgian (and international) interest in the commercial opportunities of the area.[6] To that end, extractive products such as ivory, tropical woods, and rubber as well as agricultural products such as cotton, coffee, and cacao were most

Congolese Art and Belgian Colonialism — 35

prominently displayed. Displays on the natural sciences emphasized the diversity of fauna and flora, while geological maps and displays emphasized potential mineral resources. Aside from attracting investors and businesses to Congo, the other goal of these exhibitions was to convince the general Belgian population of the value of having a colony. While economic potential was certainly important in this respect, the organizers of these colonial exhibitions also emphasized the civilizing work there was to be done in the colony, organizing and displaying ethnographic material to this purpose.

For the international exhibition of 1897 Leopold II opened a "Palais des Colonies" in the royal park in Tervuren, near Brussels.[7] The success of the exposition (1.2 million visitors in six months) led to its becoming a permanent exhibition in 1898, and soon plans were drawn up to construct a real museum building. Leopold II envisioned a park, or a "small Versailles," with a museum, spaces for the exhibition of Asian art (another region on which he had set his imperial ambitions), extensive gardens, and an international school. The design of the new museum was entrusted to the Parisian architect Charles Girauld, and construction began in 1906, although the elaborate scale of the project was reduced to the building of a museum.[8]

From the beginning, the museum's mission was "to ensure the promotion of the colony, to spread knowledge about all its aspects and to encourage vocations for colonial careers."[9] The Belgian population had historically been apprehensive with regard to its king's colonial undertakings and worried about "their sons and their cents."[10] Whatever the degree of nationalism among Belgians, in most cases it did not extend to a willingness to travel to Central Africa or even to contribute financially to that adventure.

Tervuren's founding between 1897 and 1910 came late when compared to the first generation of ethnographic museums, founded beginning in the 1840s, but it coincided with the wave of new and renewed museums of ethnography opening across Europe in the late nineteenth and first part of the twentieth centuries. The creation of these museums was often driven by anthropologists' desire to elevate their discipline and to create spaces with both an academic and a broader educational purpose.[11] Tervuren, however, was not intended as a museum of anthropology or ethnography but rather as a museum for the promotion of colonialism. Empires and museums shared close ties throughout

Europe, but this founding purpose and oversight by the Ministry of Colonies set the museum of Tervuren apart.

While Leopold II promoted the idea of empire to the Belgian population, growing international critiques of the abusive system of rubber exploitation threatened Leopoldian rule in Central Africa. Spurred by protests from some of the Protestant missionaries, British accusations regarding the abuses began circulating widely in 1904. The widespread attention and international hostility generated by E. D. Morel's Congo Reform Association and the damning Congo report of British consul Roger Casement made the existing arrangement untenable for the monarch. As a result, the Belgian government—although not without internal debate—took over the colony, and its museum, in 1908.[12]

By the time the newly designed museum building opened in 1910, the colony—and its promotion—had become a matter for the Belgian state.[13] Little had changed, however, in the Belgian population's lack of interest in the colony, and the Museum of the Belgian Congo would become one of the most important tools in combating this indifference. A visitor to the museum in 1910 would first circulate through natural science displays before entering the halls housing the ethnographic material, followed by an area devoted to history that included a section on "political and moral sciences," documenting the influence of the West, and Belgium in particular, in the Congo. The visit finished with a tour of displays emphasizing the colony's potential to generate income for its colonizer. A visit was intended to induce wonder at the riches of the colony, and pride at the role of Belgium as a "civilizer."

Meanwhile, the Belgian state attempted to create a new kind of colonial system in Congo that would distance it from Leopoldian absolutism in the eyes of the international community, but even with an expanded colonial administration and colonial reforms, forced labor practices and violent suppression of African resistance persisted. The numbers of (Catholic) missionaries, civil servants, and entrepreneurs grew steadily, particularly after World War I.[14] The Belgian colonial system rested on three "pillars": the colonial companies; the (Catholic) missionary congregations, responsible for the "civilization" of the Congolese population, which in practice meant a monopoly on the religious, educational, and health systems in the colony; and the colonial administration, backed up by the Force Publique, or colonial army. The economic sector expanded and diversified after 1908—a

cash crop economy developed, but the exploitation of the colony's mineral resources, including gold, copper, and diamonds, was central, and it relied on large-scale regional migration for its labor force. [15]

The colonial state's indigenous politics were characterized by "prescriptive, administrative and judicial regulation of conduct [of the Congolese population] developed along with other forms of social engineering" that targeted things like hygiene, housing, and infrastructure development. The territory was divided into administrative territories and districts with civil servants assigned to each, but there were also efforts to integrate some of the local power structures into the colonial system. For example, local "chiefs" (known as *chefs médaillés*) amenable to the colonial power system were appointed by the colonial regime. Given their role as facilitators of colonial power, they did not always enjoy the respect of the population.[16]

The need for reform of the colonial system, overly reliant on large corporations and missionary groups, was apparent by the late 1930s, but World War II was the real catalyst for change. Not only was Congo the only "free" Belgian territory during the war, it also made considerable contributions to the Allied effort in the form of raw materials, especially uranium (most famously including the uranium used in the American atomic bombs dropped on Japan). Increased awareness of the great economic value of the colony's resources invigorated the Belgian state's desire to "modernize" the colonial system and increase its hegemony in relation to the powerful companies and missions.

The Belgian state also hoped that a "different" kind of colonial regime, which, in theory, applied some of the principles of the Belgian welfare state, would undermine any nascent independence movements. Belgian belief in its "welfare colonialism" remained strong, which explains why many Belgians were caught completely off guard by events in the colony in 1959.[17] Of course, postwar modifications to colonial regimes were not unique to Belgium. Both France and Great Britain attempted to sustain their empires in Africa by implementing limited reforms with the goal of placating the colonies' increasing demands for participation in the political, social, and economic life.[18] The impact of Belgium's "welfare colonialism" was limited and did not alter the political structures in the colony. Instead, the colonial government believed that social reforms aimed at diminishing the racial segregation between the colonizers and their subjects in daily life and promoting a class of *évolués* ("evolved" colonial subjects) would

be sufficient to ensure the allegiance of the Congolese population.[19] Additionally, increased construction of urban and transportation infrastructure and the limited introduction of social welfare benefits for the small class of Congolese wage earners sought to develop the loyalties of urban populations.[20] These efforts, however, ignored the rural underdevelopment that defined the communities in which most Congolese people lived.[21]

Crucial to selling this renewed colonial vigor to the Belgian population was the idea of *mise en valeur,* or the value the colony's exploitation could generate for the mother country.[22] As it had before, the Museum of the Belgian Congo played a prominent role in the promotion of the promise of the colony to Belgians. As I will argue next, in the postwar era and particularly in the 1950s, the changing status of Congolese art, expressed in the museum's promotion and display, moved it closer to the status of resource. The museum promoted the exceptional nature and value of Congolese material culture, converting artifacts of ethnography into art historical treasures. Belgium came to see itself as the guardian not only of the colony's mineral resources but also of the cultural authenticity of its "traditional" cultures, the protection of which was embodied by the museum.

COLONIAL COLLECTING AND THE ORIGINS OF THE TERVUREN ETHNOGRAPHIC COLLECTION

"Any collection promises totality," Susan Steward has written. This totality is achieved by the "temporal diremption," or the erasure of temporal dimensions, and the "imposition of a frame" or narrative.[23] Museums often present their ethnographic collections as comprehensive units, obscuring not only the diverse origins of the objects but also the diversity of the collection process. While its ownership is singular—the museum owns the collection—its composition was multiauthored and contained a variety of processes. This diversity is muted in the museum life of the objects. In the case of the Museum of the Belgian Congo's collection, a great number of people, most of whom were not affiliated with the museum, contributed to its collection. Not only were their motivations for gathering material very diverse, so were the practices and contexts of collecting and the pathways by which their objects arrived at the museum. As Anthony Shelton writes: "Collections are built on individual histories; histories that mediate the self and its specific historical and cultural milieu." These individual histories were shaped

into a unified collection that came to represent the culture(s) of the colony to a significant part of the Belgian population.[24]

The term *collecting* carries a deceptive innocence that can obfuscate a variety of ways of obtaining material. In a colonial context, some of this "collecting" was part and parcel of the violence of the early conquest, even when it came in the guise of scientific interest, while other forms of collecting were much closer to existing patterns of trade and exchange of commodities. This chaos around collecting and documenting runs counter to the museum's (theoretical) Enlightenment roots as a place for systematic organization and classification and lays bare the haphazard origins of colonial ethnography as a discipline. With regard to Tervuren, these circumstances created the selective and fragmented nature of the collection that would form the basis for representations of the colony's cultures to the metropolitan audience.[25]

Currently, the ethnographic collection of Tervuren holds about 125,000 objects, about 85 percent of which come from Central Africa. Between its founding after the colonial exhibition of 1897 and the opening of the museum building in 1910, it had gathered a collection of about 30,000 pieces.[26] It is difficult to be more precise about the rate of growth of the collection because, to this day, the museum does not possess an exact breakdown of the origins of its ethnographic collection.[27] It is, however, possible to give an overview of the origins of a sample of 250 of the museum's "treasures." This snapshot is based on the 1995 exhibition *Treasures from the Africa Museum Tervuren* and can serve as a window onto the collection as a whole.[28] I analyzed the available data on these 250 objects to discover how the objects were obtained by the museum, by whom they were originally collected, and when they were collected or registered. Of the 250 objects, 99 were gifts, 96 were bought, and 11 were collected by the museum staff in Congo.[29] Ninety-one of the "treasures" were originally collected by colonials and 13 by missionaries. It is also interesting to note here that at least 45 of the objects were at some point part of a well-known collector's collection.

Based upon the available but incomplete information, 29 of the objects were collected before the twentieth century, while no collection dates were mentioned after independence. For the objects that only had a date of registration connected to them, the numbers are pretty steady for the first half of the twentieth century with about 10 to 15 per decade. Not many of the objects (20) were registered after independence.[30]

The people involved with providing the museum with ethnographic materials can be roughly divided into four (overlapping) groups: colonials, explorers and scientists, missionaries, and last, art collectors and art dealers. From the earliest contact between Portuguese sailors and the Kongo peoples in the fifteenth century, the collection and appropriation of African objects (and vice versa) had been part of the relationship between both parties. The advent of late nineteenth-century European colonialism in Africa, however, greatly accelerated Western acquisition of African material culture and considerably broadened the area from which these objects were removed to include the interior of the continent. It is difficult to do justice to people's diverse motivations for collecting objects in Congo, whether they were doing so for personal, professional, political, economic, or religious purposes. What we can do, however, is follow these varied motivations as they became subsumed into increasingly comprehensive systems of knowledge that organized the collection and its displays.

The group that was among the first to start collecting ethnographic material in Congo were the colonial officers and soldiers in service of the AIA and, later, of Leopold II's Congo Free State. As Maarten Couttenier has noted, in the exploration and later conquest of Congo, "military conflicts and the acquisition of material culture went hand in hand."[31] These acquisitions were not merely the result of the private initiative of these men, however. They also gathered material upon the request of King Leopold II, who tasked them with the collection of material that could be used in various colonial expositions in Belgium.[32] So while the objects (which also included human remains, particularly skulls) were sometimes the spoils of war or the trophies of conquest, and other times the result of an exchange of goods and gifts, they were also, from the very beginning, promotional material for the empire.

One colonial officer who collected for colonial exhibitions, but whose personal collection also eventually ended up at Tervuren, was Émile Storms. Storms was a commander of the AIA, set up by Leopold II ostensibly to promote scientific knowledge about Central Africa. The very nature of the AIA as a scientific organization involved with colonial conquest illustrates how closely the gathering of knowledge (and things) was related to the imperial project.[33] Storms spent the years between 1882 and 1885 near the eastern shores of Lake Tanganyika, where he created a colonial post and collected, measured, mapped, and documented the fauna, flora, geography, and culture of the region,

but also where he defeated local Tabwa leader Lusinga, an event that ended the latter's life. Storms traveled home with a collection of ethnographic material for the colonial section of the 1885 world exhibition in Antwerp, but also with Lusinga's skull and several objects he obtained from the Tabwa and other Luba peoples for his personal collection. Allen Roberts has told the story of Storms and Lusinga's confrontation and illustrated how the objects Storms removed after his victory were de- and recontextualized multiple times.[34]

Initially, they were installed in Storms's house as war trophies and curios, elements in Storms's self-representation as an explorer and his quest for social relevance in Brussels society. After Storms's death in 1918, his widow held on to the objects, which had become relics of her husband's "brief moment of glory in the Congo," but eventually she donated them, along with personal memorabilia of Storms's years in Central Africa.[35] From illustrations of his personal history, the objects now evolved into the building blocks for the representation of a larger imperial project. Storms's personal memorabilia found their place in the museum's displays on the history of the Belgian colony, and the Tabwa and Luba objects long on display in Storms's living room now became part of the ethnographic and art displays at Tervuren. While Storms's role was memorialized in the historical displays of the museum, his collection also helped shape the image of Congolese cultures presented to the museum-going audience.

Overall, the material collected by colonials, particularly in the late nineteenth and early twentieth century, was badly documented; information about use and exact origin were rarely recorded. To remedy this situation, guidelines for the collection of material started appearing in manuals for colonials and visitors to Congo. The Tervuren museum, in collaboration with the Congo Free State, also distributed questionnaires to colonial officials, though few responded.[36] Eventually, an introduction to African ethnography, often taught by Tervuren staff, was included in the course load at the colonial university in Antwerp, greatly improving Tervuren's ability to create a network among the newer generations of colonial officials.[37]

Gradually, with the expansion of the colonial state, and particularly after the Belgian state took over the Congo Free State, a wider array of colonials became involved in the collection of ethnographic (and other) material in Congo. This group included colonial administrators and officers in the colonial army, but also engineers, doctors, teachers, and

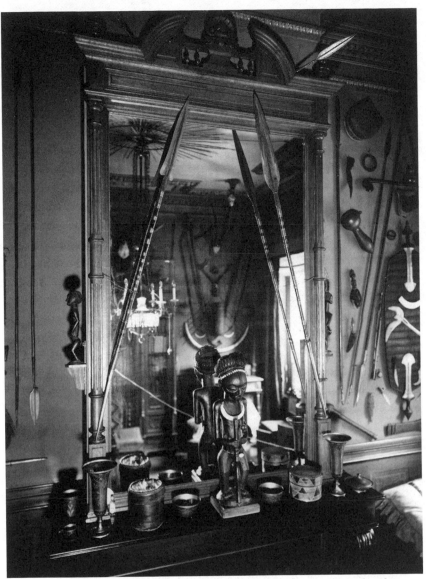

FIGURE 1.1. In Émile Storms's home, with Lusinga's statue centrally displayed, 1929. HP.1931.653.1, collection RMCA Tervuren; photo G. Hotz.

plantation and business owners.[38] Not only was this group very diverse, the kind of material they acquired varied greatly according to their reasons for collecting and the conditions in which they obtained material. For example, some of the objects were the result of a commercial exchange or of a gift exchange, while others were the result of judicial requisitions by the colonial government. With the exception of the latter,

many of these objects were "souvenirs of contact," ranging from objects produced explicitly for sale to colonials and travelers to "authentic" artifacts created for local use.[39] The trophies of conquest, typical of the earlier stages of exploration and conquest, were replaced by trophies of hunting, including tusks, animal skins, and local weapons. In all of these cases, collecting was a form of practical memory creation.[40] The personal collections of these men (and occasionally women) would years or decades later often end up in the Tervuren storerooms and displays, donated either by the former colonials themselves or by their families. This practice illustrates how much Belgian colonials and their families thought of the Museum of the Belgian Congo as "their" museum: it held the material traces of many personal histories, but re-created these as part of a larger, national patrimony.

Missionary congregations were not far behind the explorers and representatives of the AIA. Émile Storms, in fact, was recalled from Congo and replaced by Catholic missionaries after the Berlin conference.[41] In the long run, missionary congregations became one of the core pillars of Leopold's, and later Belgium's, colonial empire. Given their widespread presence, it should come as no surprise that some missionaries became important collectors, often in the context of a broader engagement with and sometimes admiration for African cultures. (Chapter 2 demonstrates that missionary engagement with Congolese material cultures was not limited to collecting but extended to the production of arts and crafts in the colony, particularly through art schools and artisanal craft programs.)

Although it is difficult to generalize, Boris Wastiau has concluded that collecting by missionaries was initially more focused on African religious and spiritual life, leading to the collection of a substantial amount of masks and statues.[42] Sometimes this material was removed in an attempt to eradicate "barbarous" local practices, but many missionaries also collected for personal purposes—simply out of admiration for the material or out of a scientific interest in the societies they were living among. Large amounts of the material ultimately ended up in missionary collections: some of it still belongs to the same congregations today. In comparison with how much material was collected by missionaries, little ended up at Tervuren. Our sample of the 250 "masterpieces" of the RMCA confirms this suspicion: only 13 of the 250 objects were collected by missionaries.

One missionary who became an ethnographer as well as a collector was Father Leo Bittremieux, a missionary of Scheut who lived

among the Mayombe in the Lower Congo region from 1907 until his death in 1946. He set out to collect almost immediately after his arrival, sending thirteen crates of "fetishes" to the Catholic University of Leuven, encouraged to do so by the young ethnology professor Eduard de Jonghe.[43] Bittremieux published widely on the language and culture of the Mayombe in the decades that followed, and he continued to gather material. Some of his collection he sent to his family, some to the congregation's small Musée des Fétiches in Kangu, but some of it ended up in Tervuren as well. From 1911 on, the colonial administration sent the missionary station in Kangu where Bittremieux lived an annual budget to collect and buy ethnographic material for the Congo museum in Tervuren. The collecting was not necessarily done by the missionaries themselves. Archival material reveals the role of one of the congregation's Congolese employees, Aloïs Tembo, in the production of information about Yombe culture and about the objects gathered at the missionary station.[44]

Minkisi were a particular target for the missionaries. Referred to as *fétiches* in the early twentieth century, minkisi were vessels for a substance that could be activated for healing or in the case of a conflict. Their most common form in museums and collections was as statues

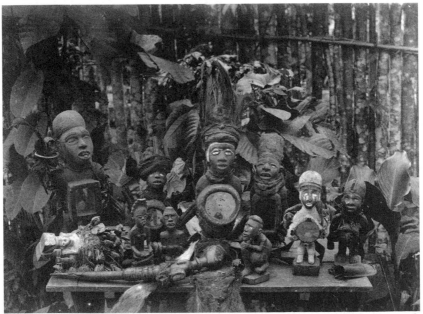

FIGURE 1.2. A collection of *minkisi* brought to the Kangu mission post by the surrounding population, 1902. Photo Book Scheut. Courtesy of repro KADOC-KULeuven.

with the substance embedded within them, although they took many different shapes, including simple containers.[45] Their association with a different system of beliefs meant missionaries preferred to have the custom of the minkisi eradicated. Sometimes the Congolese participated in the destruction or discarding of these objects. Several of the minkisi collected by the Kangu mission post were brought there by the population either after conversion or after local changes in political leadership prompted the removal of a certain type of minkisi.[46]

Missionaries like Bittremieux were important to Tervuren not only because they collected but for the wealth of knowledge they gathered about the people among whom they lived, feeding the development of ethnography and anthropology.[47] The museum began to recruit and educate missionaries in order to have a network of collaborators in the field, so although they might be underrepresented as donors of objects, they made important contributions in information gathering and knowledge production for the museum.[48]

Like missionaries and other colonials, those involved with museum-organized scientific missions were a heterogeneous and international group, and their scientific frame of reference changed dramatically over the years. Early scientific missions are almost impossible to distinguish from the conquest of the area. Many of the early military expeditions were in fact accompanied by scientists. This intertwined relationship of conquest and early scientific exploration only underlines the inseparable nature of the scientific and colonial projects.[49] In the same vein, many of the men that are now considered as the earliest ethnographers, like Emil Torday, were intimately tied to the economic exploitation of the area. Torday, a Hungarian collecting for the British Museum, was working for the Belgian Compagnie du Kasai, which organized the infamous rubber collection. Conquest, control, exploitation, and classification went hand in hand.[50] There was also a keen sense of competition with the scientific expeditions set up by other countries as they rushed to collect as much material as possible, fueled by the belief that collecting salvaged a dying form of cultural authenticity.[51]

From the outset, the colonial museum in Tervuren also positioned itself as the center of scientific activity connected to the colony, and ethnographic collecting was added to the responsibilities of the museum's staff. Despite this mandate, ethnographic expeditions by the staff were rare. Joseph Maes, who led the ethnography department from 1910 until 1946 only traveled to Congo once, in 1913–14. Convinced

he was in a race with time to salvage the remnants of a precolonial Congo, Maes prioritized collecting over the gathering of ethnographic information and the careful recording of contextual information about the objects he took. In roughly a year he visited 120 locations and collected 1,293 objects![52] Maes's successor, Albert Maesen, also made only one collection trip, from 1952–55, although he made sure collaborators of the museum (Jan Vansina and Daniel Biebuyck among them) also collected for the ethnographic department. In theory, ethnographers were more concerned with documenting pieces and selecting objects that were "authentic" or in use by the communities they visited. In practice, this was not always the case. For example, one of the Luba masks collected by Maesen in Congo in 1953, which became one of the museum's "masterpieces," was bought at a colonial fair, not collected in situ.[53] The influence of the museum's staff on the shape of the collection did go beyond their own collecting efforts, however. Their contacts with colonials and missionaries in the field was extensive, and they actively directed some of the collecting performed by these collaborators.

The museum's collection was also shaped by material that passed through the commercial market in African art or was sold by private collectors. Of our sample of 250 objects, 96 were bought by the museum, and at least 45 of the total number of objects were at one point part of the collection of a well-known collector. These objects were already valuable commodities before they reached the storerooms and displays of the museum, although the participation of the museum in the art market and its display of the objects stimulated their commodification. Another factor that explains the disproportionate number of "masterpieces" that passed through the hands of collectors or art dealers is that collectors, especially those of early generations, were mostly interested in undamaged figurative objects that displayed symmetry and showed no trace of Western influence.[54] This preference helped shape the body of objects available in the West and consequently impacted the way the canon of Congolese art was theorized.

The market for African art in Belgium coalesced somewhat later than in other European countries, but it quickly became an important European center. Although African objects had circulated in Belgium since the late nineteenth century, their introduction as art began in the 1920s.[55] The interest in these objects grew steadily in the 1930s, stimulated by a community of collectors and dealers of African art. Initially the circle of collectors was composed mostly of members of the upper

classes, some of whom had business interests in Congo, while others (like Émile Storms) had participated in the early conquest. Although the exorbitant prices for "primitive" art were still a thing of the future, a commercial space took shape in which collectors and dealers, both foreign and Belgian, circulated. Belgium's growing importance as a

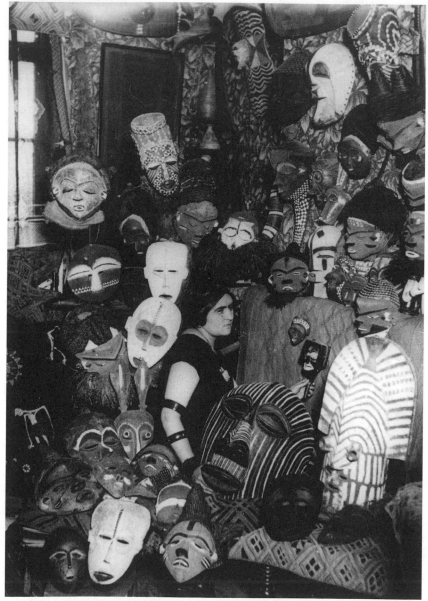

FIGURE 1.3. Art collector Jeanne Walschot, ca. 1940. HP.2014.3.1, collection RMCA Tervuren.

center for the trade in African art proceeded on the strength of objects brought back by returning colonials.[56] In the next decades, the circles of the collectors would widen and include many collectors who had never set foot in Congo, blurring the line between collectors and dealers. The names of well-known collectors and dealers—Jeanne Walschot, Henry Pareyn, and the painter Willy Mestach, to name a few—have since become connected to the objects formerly in their possession, creating a new history and provenance for the objects, reinventing them as Western commodities and as symbols of both cultural capital and wealth.

Frans Olbrechts, who took up the reins of Tervuren in 1946, made the museum an active participant in the art market. He tried to compensate for the limitations of the museum's own collecting by searching for material in Europe, spending many hours consulting retired missionaries, old colonial officials, and antique and art traders in Brussels, Antwerp, and Paris. This "extraordinary activity displayed by the Director of the Museum in the tracing of material" was responsible for the "steady growth of our collections," ethnography curator Albert Maesen commented in 1956.[57] But the relationship between the museum and private dealers and collectors was complicated. On the one hand, collectors and dealers were often competitors in the acquisition of desirable pieces. On the other hand, they also donated many pieces to the museum's collection. Museums can also have a tremendous impact on the value of privately owned objects by including them in temporary exhibitions, strengthening their status as authentic and valuable pieces. This ambiguous relationship made contacts with dealers and collectors an intricate balancing act.[58]

As this overview of the origins of Tervuren's ethnographic collection demonstrates, it was composed of objects selected for very different reasons, by different people, and at different times. Their collection reinvented these objects as trophies of war, souvenirs, and artifacts of science and created around them classes of consumption, connoisseurship, and science. What united almost all acts of collection was their interpretation as actions of salvage.[59] From collecting explorers in the late nineteenth century to connoisseurs buying objects from art dealers in the 1950s, a sense of urgency was shared. The objects were seen as the remnants of older, vaguely precolonial African cultures that were in decline, partly as a result of the impact of Western modernity. This story of decline not only justified the acts of collection and Western

guardianship of the objects but also framed the vision of the colonial state as the cultural guardian of the "authentic" cultures of colony.[60] There was a deep ambiguity at the heart of these acts of salvage. Colonial modernity was both the threat from which collectors sought to safeguard these "authentic" cultures and the source of their authority to rescue and properly value the objects that represented this cultural authenticity. As we shall see in the next chapter, this ambiguity was resolved by blaming Congolese subjects for their inability to handle the impact of modernity correctly.

FROM ARTIFACT TO ART: CHANGING PARADIGMS OF INTERPRETATION

If objects are the raw material for the creation of collections, collections are the raw materials for the creation of museum displays. The latter are given meaning through changing paradigms of interpretation, some more coherent than others. The result, in the case of African material culture, has been an increasing divide between ethnography and art classifications, including a growing construction of canonicity. Although this was not an entirely linear development, a trend is detectable toward a comprehensive system of classification in which the category of art objects expanded and the objects themselves increased in value.

Sharon Macdonald has aptly described the position of the museum as the "nexus between cultural production and consumption."[61] The employees of the Museum of the Belgian Congo created an image of Congo for consumption by Belgian citizens and international visitors, staging the empire through the display of objects from Congolese cultures. The meaning attributed to these objects shifted over time, and the overall message of the narrative also underwent subtle, but significant, shifts. The place of art as a valuable resource grew significantly, and an integrated interpretive framework evolved in which Congo was created as a unit. This transformation of certain objects from artifact to art, a process that reached completion toward the 1950s, reconciled and aligned the political and economic narratives about *mise en valeur* with cultural narratives of justification for the Belgian colonial presence.

A decontextualization of the objects started with their removal from their cultures of origin, followed by a journey of recontextualization and interpretation.[62] Although personal sympathies and tastes always played a role in this process, competing structures of knowledge

and classification profoundly impacted the way in which objects were regarded and the way in which they were represented and displayed to the public at the Museum of the Belgian Congo. These knowledge systems—from evolutionism, to diffusionism, to the development of an art historical canon—changed significantly over the years. So while collectors helped author the museum by providing it with objects, curators played an important role in the orchestration of the material. The meaning they created was derived in large part from the way the material was ordered, the relationship suggested between objects, and how different displays related to each other.

Ideas about evolution made a strong impact upon the museum's employees in the early years. African culture was interpreted as an early phase in human development, which aligned with the promotion of the "civilizing" mission of colonialism. Maarten Couttenier has argued that in Belgium, theories of physical anthropology gradually evolved into an interest in a colonial ethnography with a focus on material culture. This shift toward colonial ethnography helped establish the importance of scientific research at the Museum of the Belgian Congo, where objects were organized and classified to serve as a basis for research that facilitated the emergence of a cultural evolutionism dissociated from the methods and aims of early physical anthropology.[63]

The first iterations of the displays at Tervuren were at the 1897 colonial exhibition in the Palais des Colonies. The emphasis of the exhibition was on the economic potential of the colony and on the need for a civilizing mission. Weapons were a prominent part of the displays, arranged according to type and fanned out on the walls. The seeds of more scientific classification schemes were present, though, in the combination of a geographic approach with a thematic one. The result for the visitor was a "journey" through Congo.[64] The Congolese were present outside in an "African village," while inside their presence was embodied by large sculptures depicting Africans made by European artists.[65] A separate room, the Salle d'Honneur, functioned as an art room, but mostly displayed work created by Western artists inspired by materials and cultures of the colony. Congolese material—Kuba textiles from the Kasai, knives and other weapons, objects made out of ivory, and a smattering of statues that included a Kuba royal *ndop* statue and other "fetiches"—served mostly to emphasize the lack of civilizational development in Congo versus the artistic achievements of Western artists.[66]

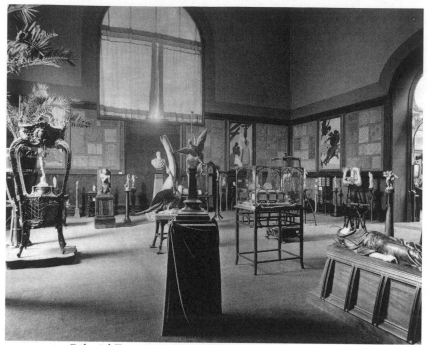

FIGURE 1.4. Colonial Exposition 1897, *salle d'honneur.* HP.1971.28.1–12, collection RMCA Tervuren; photo Alexandre.

The museum born out of this colonial exhibition that opened in the same space a year later kept many of the displays and was divided into four sections: botany, zoology, geology and mineralogy, and anthropology and ethnography. In 1910 these were rearranged into political economy, natural sciences, ethnography, "moral and political sciences" (with the history of colonization and civilizational projects), and photography and "vulgarization." The space devoted to the promotion of economic resources continued to dominate, although the ethnography displays were also expanded.

Joseph Maes, the museum's first curator of ethnography from 1910 until 1946, was deeply influenced by the then new theory of diffusionism, which posited that cultures, rather than all following the same linear evolution, developed through the adaptation of practices or material culture from others. He attributed anything he understood as an innovation or superior development to influence from outside Congo, even going so far as suggesting influence from Egyptian cultures.[67] In the 1920s Maes reinstalled and extended the ethnographic displays, organizing them thematically in a taxonomy that ranged from "native

crafts," musical instruments, burial and death rites, "fetishes" and sculptures, food and agriculture, to hygiene and beautifying products. This choice to organize the displays thematically instead of regionally or ethnically was a critical step in creating the impression that Congo consisted of one overarching "native" culture.[68]

The transition of select "primitive" artifacts into art at Tervuren followed a somewhat twisted path. A group of avant-garde artists and intellectuals began, as elsewhere, taking an interest in so-called "primitive art" because of the sculptural and aesthetic qualities of the objects. Compared to other European countries, in Belgium this phase started rather late and was limited to a small group of people. This trend was thus not immediately reflected in the displays of the Tervuren museum. As we've seen, the 1897 colonial exhibition included a number of Congolese objects in its art room, but they were not necessarily accorded the same respect European art works were. The first director of the museum, de Hauleville, spoke of the "repugnant and obscene character" of the nudity of the Congolese statues and did not regard them as art. Although Maes did not agree with his director's opinion that the statues needed covering up, his motivation for displaying them as they were came from his desire to demonstrate the "immense extent of the civilizatory task that awaited the colonizer."[69]

However, by 1936 the museum did possess a room of "indigenous art."[70] Its displays were densely packed with objects, and we know from the 1936 guidebook to the museum that the arrangement of objects in the indigenous art room was rather haphazard: the objects were partially grouped by type (weapons, decorated ceramics, wooden stools, musical instruments, etc.) and partially by region or group (sometimes by geographic area, other times by "tribal" names). Most prominent were objects from the Luba and the Kuba communities. Minimal identification was presented in the displays themselves, and the guidebook offered little more, adding descriptions such as "decorated baton," "wooden chairs," "shields." In the more elaborate descriptions of the centrally displayed Luba and Kuba objects, the guidebook mustered more enthusiasm, pointing out the "beautiful collection of seats and dignitary objects" and the "exceptionally beautiful wooden Balubamask."[71] These descriptions indicate an aesthetic appreciation of several of the objects on display but lacked a scholarly, systematic approach.

The only object displayed in isolation, emphasizing its singularity, is the Kuba royal statue (or *ndop*). From the first moments of contact

between Westerners and the Kuba of the Kasai, foreigners were impressed with the political centralization of the Kuba and with their decorative and artistic traditions. In combination with ideas about the possible racial superiority of the Kuba, ethnographers, missionaries, and later museum curators and colonial agents went in search of Kuba "art." This explains why the ndop was so centrally displayed in Tervuren in the 1930s; it was one of the most desired objects (there were only a limited number of "authentic" ndops) and had made the transition to "art object" much earlier than objects from other cultures in the Congo.[72]

The development of anthropology as a science, scholarship on Congolese art, and the displays at Tervuren underwent significant changes under the leadership of Frans Olbrechts. One of the central figures in the twentieth-century history of ideas regarding Congolese culture, Olbrechts was director of the Museum of the Belgian Congo from 1947 until his death in 1958. His art historical work on African material cultures placed aesthetic appreciation in a scientific frame, demarcating styles and, by extension cultures, while moving away from a strictly ethnographic approach. Originally a student of Flemish folklore, Olbrechts's scholarship underwent a significant transformation under the influence of Franz Boas when he obtained a postdoctoral position in the anthropology department at Columbia University in

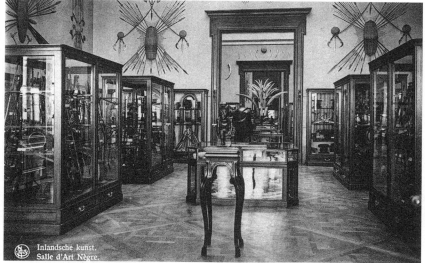

Inlandsche kunst.
Salle d'Art Nègre.

FIGURE 1.5. Indigenous art room, ca. 1937. Note the centrally displayed Kuba royal statue, or *ndop*. HP.2002.1.18, collection RMCA Tervuren; ed. Thill-Nels.

1925. Boas's belief in racial equality, his use of a concept of culture that was inclusive and democratic, and his openness to reading objects in terms of the criteria of their producers all marked his sharp divergence from the evolutionism still dominating ethnography at the time, as did his attention to the role of the individual artist and the creative process in non-Western societies. His student Melville Herskovits applied a Boasian approach to the study of Africa, and Olbrechts brought it to bear on the study of Congolese culture and, in particular, art.[73]

Upon his return to Belgium, Olbrechts made a definitive turn toward the study of Congolese cultures when he curated a large Congolese art exhibit for the city of Antwerp in 1937–38.[74] Adriaan Claerhout, later a curator of the ethnological museum in Antwerp, described the exhibition as a "laboratory experiment [in which] Olbrechts reduced the spectacle to the advantage of the main goal, namely testing the stylistic method [he was developing]."[75] Despite Olbrechts's attention to the role that the objects had in their societies of origin—or their "social function"—the main focus was on the presentation of the pieces as objects of art that could be classified, through an analysis of their characteristics, into geographically circumscribed stylistic zones inspired by Boas's culture zones.[76]

Plastiek van Kongo (*Congolese Sculpture*), Olbrechts's book based upon the work he did for the Antwerp exhibition, helped open the field of art history to the study of pieces of African material culture as art. Contrary to the scholarly production of previous scholars of Congolese ethnography, whose work was more fragmentary, the book presented a sweeping objective: a complete system of classification for Congolese art.[77] Olbrechts identified four large "culture areas" (with substyles) in Congo: the Lower Congo region, the Kuba region, the Luba region, and the Northern region.[78] Subsequent scholars have corrected, deepened, and elaborated upon Olbrechts's stylistic classification, but it continues to serve as a point of reference for students of Congolese art.[79]

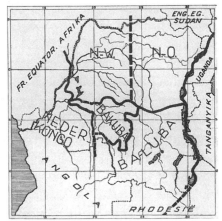

FIGURE 1.6. Map of style areas, 1946. Olbrechts, *Plastiek van Kongo*, 38.

Although Olbrechts's experience with Boasian anthropology shaped *Congolese Sculpture*, he was also profoundly influenced by the methodology of Western art history. His system of classification was inspired by the method developed by Giovanni Morelli, a nineteenth-century scholar of Renaissance art. Based on a meticulous dissection of the form of the artwork—today mostly referred to as the practice of connoisseurship—pieces of art could be inserted in a larger developmental scheme.[80] Olbrechts used this method to undermine the traditional classification that placed African cultures at the bottom of an evolutionary scale of civilizations. The application of a method developed and reserved for Western art to African sculpture elevated the stature of these pieces as art, but it also carried implications for the image of the producing cultures. While certain African artifacts had long been regarded as art, Olbrechts redefined that status as one grounded in the development and refinement of the cultures that produced them. The combination of Boas's influence and an art historical methodology also led Olbrechts to pay special attention to the individual artist within African culture, identifying a specific workshop responsible for a series of Luba sculptures, specifically stools, known as the "Long Face Style of Buli."[81]

Olbrechts's approach was certainly not without problems, as several generations of scholars have pointed out. For example, *Congolese Sculpture* was not based on fieldwork, which helps to explain why the stylistic analysis was much more profound than the anthropological analysis of the sculptures' function.[82] The choice to include only sculptures, and to leave aside any two-dimensional art, also severely restricted his analysis, as did his limited use of masks.[83]

Olbrechts constructed the Western museum professional and academic as the savior of the remnants of a culture in decline. He distinguished two phases in the production of African art: the "classic" (or precolonial) and modern eras.[84] He attributed the bulk of the material from the "classic" period to the creative genius of the African communities that produced the objects, explicitly arguing against those Westerners who attributed African art forms to foreign influences because they "consider[ed] these indigenous people primitives without art."[85] He argued that colonialism brought an influx of style elements, techniques, and tools that led to such profound changes in the production of art that it effectively stopped being African. The implication was that through the recognition and valuation of academics, the "classic" material could be identified and protected in places like Tervuren.

Congolese Sculpture displayed a clear connection between the organization of knowledge and the organization of the colonial space and its subjects. Olbrechts's project was shaped by the geopolitical space of the colony, a space he also helped solidify and naturalize. Projecting style areas on a map of Congo created the impression of delineated identities that fell within the boundaries of the state of Congo. Olbrechts of course acknowledged that some of the stylistic areas he described crossed the borders of Congo, but he understood those to lie outside the boundaries of his work. Congo, delineated by colonial boundaries, emerged as an unquestioned cultural unit in this presentation.

The areas delineated and defined by their artistic styles often paralleled the areas of the major ethnic groups, as they were identified by the Belgians, making the scholar complicit in the colonial tradition of invented and imposed identities.[86] That the major ethnic groups (Luba, Kuba, and the Mangbetu of the Northeast, for example) were exactly those that were popular with early collectors and thus strongly represented in the collections in Belgium only strengthened these categories. In relying heavily on private collections for his research, Olbrechts transferred these collectors' preferences into delineations of Congolese cultural communities, reducing groups who varied according to language, customs, and political organization to a taxonomy based on isolated elements of material culture production.[87]

Olbrechts's 1930s scholarship was part of a slow global evolution that redefined certain objects in African museum collections from artifact to art. By changing the methodology and giving a scientific foundation to the aesthetic impulse to redefine these objects as art, Olbrechts opened space for a discourse in which certain Africans could be seen as having "culture," although he located its production mainly in the past. This reemphasized the older, conflicted, image of African societies as both the site of decline and the reflection of an authentic African culture rooted in the past. Although individual African cultures, through their art, were worthy of admiration and not merely underdeveloped backwaters, their worth, as Olbrechts defined it, was locked into their "traditional" lifestyles.[88] The promotion of the idea of Congo as a "world populated with endangered authenticities," to use James Clifford's words, diverted attention from Congolese claims for political identity and presence.[89]

CONGOLESE MASTERPIECES AT TERVUREN, 1946–60

In 1946 Olbrechts accepted the position of director of the Museum of the Belgian Congo, which he occupied until his death in 1958. How did the changing image of Congolese cultures, as constructed by Olbrechts in his scholarship, translate onto the theater of the museum in a period of, at least discursively, colonial reform? How and where did colonial propaganda meet scientific innovation? How did visions of the past translate into a message for the present and the future?

A renovation of the ethnographic displays took place between 1952 and spring 1958 (officially opened in 1959). Unfortunately, there is limited information available about the changes. An updated series of guidebooks was published in 1959, but they did not include the ethnography section, and photographic evidence from this time period is very sparse.[90] In 1960 *Congo-Tervuren*, the museum's periodical, reported that the displays were now "more rationally organized. The two main galleries are filled with objects: the first one in an ideological and functional order, the second by ethnic group, and a third gallery called "hall of art" holds certain chosen pieces."[91]

By indicating the need for a "rationalization" of the displays, the museum clearly sought to reject Joseph Maes's organization of the exhibits as outmoded and disassociate the department from his legacy. (Maes lost his position in 1946, accused of collaboration with the Germans. He was replaced by Obrechts's student Albert Maesen.)[92] In reality, however, it is likely that the setup of the two first rooms—in "ideological and functional order," focusing on the ways in which objects were used—was not that different from Maes's thematic organization. Significantly, Olbrechts's "style areas" were already being interpreted as "ethnic groups" in the museum displays.[93]

The third room, the "hall of art," was developed by Olbrechts not long after his arrival at the museum.[94] Despite his resistance to a mere "aesthetic approach" in *Congolese Sculpture*, he clearly advocated a view of African culture that elevated a portion of its their material culture to the category of art—objects that could be universally appreciated because of their intrinsic beauty. This did not mean, however, that these objects should be completely removed from their cultural contexts. The combination of the three different display taxonomies—by function, ethnicity, and aesthetic criteria—affirmed this belief in proper contextualization. At the same time, however, Olbrechts

developed the selection and promotion of a number of objects as the museum's "masterpieces."

In 1952 Olbrechts put together a small book, *Quelques chefs-d'oeuvre de l'art africain des collections du Musée Royal du Congo Belge, Tervuren* (*Some masterpieces of African Art from the Collections of the Royal Museum of Belgian Congo, Tervuren*) comprising twenty-four pictures that were also sold separately as postcards in the museum's store.[95] He created the booklet in response to ever-increasing demands from visitors, artists, students, and collectors for images of the museum's most beautiful pieces, affirming the wider acceptance of the aesthetic approach. The booklet demonstrates the increasingly important role of the museum's "art" objects in the overall image of the colony presented in the museum, and hence in the promotion of the colonial empire.

Olbrechts's selection of pieces revealed his biases: they were almost all figurative wooden sculptures, all from the southern part of the country, with a heavy emphasis on Kuba and Luba art. In contrast to the extensive background information provided in *Congolese Sculpture*, the explanations accompanying the pictures in this booklet were kept to a minimum, with only a brief identification of the object (such as "chief's seat" or "statue of woman") and the "tribe" of origin. In some cases Olbrechts added an extra line about the style (such as the "Buli style") or the person depicted (in the case of the royal Kuba statues).

The decision to focus on a limited number of objects, stripped of their context, represented a culmination of the trend whereby certain pieces of African material culture migrated from the status of artifact to the status of art. This "art-culture system," "a system of thinking in which a binary opposition—in this case "art" and "artifact"—generates a field of meanings," as James Clifford described it, reinvented African objects as singular, universally beautiful, and "authentic."[96] Olbrechts's use of the concept of "masterpiece" shows his ambitions for the status and place of African art objects in the museum. Traditionally used in Western art to refer to the most skillful and beautiful pieces, the term implies a creation that rises above the general level of production of art. In the context of African art, and in particular at Tervuren, the concept of the masterpiece functioned in a number of ways. While elevating the culture of origin to the level of an art-producing civilization, it simultaneously removed the objects from that cultural background and made them symbolic of the collection itself—in this case, the museum of Tervuren.[97] Their recognition as masterpieces was situated entirely

in the West and appropriated them for Western collectors and museums. Locating masterpieces among the African objects stimulated the cultural, but also the financial, value of both these objects and of others like them, benefiting mostly collectors and dealers of African art and stimulating their continued circulation.

Arjun Appadurai has described this process as the "aesthetics of decontexualization," a process of "diversion" of the regular flow of commodities whereby the value of things increases by placing them in an unlikely context.[98] The heightened profile of certain sculptural objects, raised by scholarship and display, increased their economic value. This commodification contributed to the objects' redefinition as another exceptional resource for the colony, in turn supporting the idea of Congo as an exceptional place and justifying the welfare colonialism of the Belgian state. As with many other colonial resources, the financial value generated by the exchange of similar pieces by art dealers remained in Western hands.

The term "masterpiece" refers explicitly to the creator of a piece, the artist. While acknowledging the (unconscious) creative genius within African culture, applying the term to an African object accentuated the absence of information about the creator of the object. So while the singularity of the object increases, and with it the potential respect for its culture of origin, the individuality of the African artist remains a void. Sally Price characterized this approach: "Any work outside the 'Great Traditions' must have been produced by an unnamed figure who represents community and whose craftsmanship represents the dictates of its age-old traditions."[99] Arguably, the void is filled either by the scholar or the collector responsible for "discovering" the piece, or by the museum institution functioning as the "guardian" of the object. Removed from their original context and only vaguely identified, the masterpieces become "signs" for the museum that possesses them, muting them as signifiers of another culture. Any reassessment of the "primitivism" of African cultures in a favorable light is redirected to the role of the museum—and, by extension, the colonial state—as a guardian of the material.

Along with the promotion of certain choice pieces from the museum's collection as "masterpieces," the museum also reinstalled the art room. The idea of an art room was not in itself a new concept for the museum, as we've seen above. There were significant differences,

however, between the older displays of Congolese art and the new art room. The new "Congo art room" contained a much smaller selection of objects in a modernist setting with a much more spacious arrangement against a white backdrop.[100] Most ceramics and series of weapons and shields had disappeared. Instead, a careful selection of objects, each occupying a place in Olbrechts's stylistic classification, was presented in a spacious, well-lit, simple setting designed to bring out the aesthetic qualities of the objects themselves, although some contextual information was provided.[101] The display was organized by style area and substyles, as delineated by Olbrechts's scholarship. Each style area was accompanied by a short introduction of the characteristics of each style. In figure 1.7 we see part of the display on the Luba on the left and in the second and third cases from the right. Also visible are a large Kongo statue, one vitrine of Kuba objects, and one vitrine devoted to the less-defined northern styles (to the far right). The functional descriptions of the objects were reduced to a bare minimum. In the case of the Luba, for example, the two cases to the left are accompanied by the description "Chief's insignia; seats, arrow holder, scepters and ax." By minimizing references to the objects' function, elaborated upon in the ethnographic displays, Olbrechts created room for the visitor to focus on the appearance of the objects in a setting that encouraged admiration. This technique represented a change from the 1936 art room, where references to function were omitted entirely and display cases were crowded.

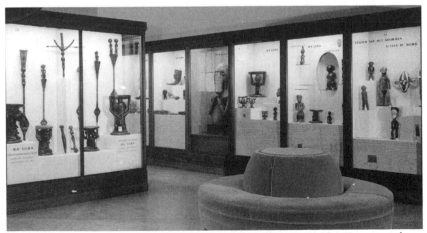

FIGURE 1.7. Congo art room, 1963. HP.1963.1.205, collection RMCA Tervuren; photo J. Loddewijck, RMCA Tervuren ©.

There was a noticeable difference between Olbrechts's scholarship, however, and the installation of the Congo art room. In the museum display, the contextualization of the pieces has to take a back seat to their display as art objects, illustrating the different demands placed upon the scholar versus the museum professional. The latter, while also respecting the museum's scientific identity and ensuring that the displays reflect the current state of scholarship, is forced to make decisions about the amount of contextualizing information that can be included in a display and to decide how to integrate the displays into the overall narrative of the museum.

Most of the visitors to the museum probably had very limited knowledge of the various cultures in Congo. The lack of a printed guide to the ethnographic and art room before 1967 meant that, despite the presence of a large ethnographic map above the door, the diversity of cultures might have blended together into a more homogenized image (after all, the art room was named the *Congo* Art room).[102] Nonetheless, the message, both visual and written, about the ability of Congolese people to produce true "Art" was likely to make an impression. An audience used to visiting Western art museums would have interpreted the limited availability of information and labels as an expression of the value of the pieces. The presentation of the pieces also affirmed their autonomy and singularity.[103]

An essential requirement for objects to make the transition to art was their "authenticity." Olbrechts used the term to refer to their origin in a rural and traditional precolonial past, untainted by the influence of Western modernism—and thus unattainable for the current African cultures in decline. He believed it was revealed in the sculptural and aesthetic qualities of objects, which, conveniently, also heightened their exhibition value.[104] Authenticity was thus not only present in the object but was also projected upon its community of origin and proceeded from "assumptions about temporality, wholeness, and continuity."[105]

By giving certain African objects access to the universal and timeless category of art, Western art lovers changed the values attributed to these objects and to their cultures of origin. However, as Sally Price has noted in her exploration of the "universality principle," the "'equality' accorded to non-Westerners (and their art), the implication goes, is not a natural reflection of human equivalence, but rather the result of western benevolence."[106] While the visitors to the art room at Tervuren affirmed their modernity by viewing African material culture

as art—an aesthetic experience—Congolese people were denied that same modernity on the basis of their assumed inability to experience that same aesthetic experience.

In France, anxiety about the impact of Western modernity on the colonies had reached its height earlier, during the 1930s, as did a broader acceptance of certain African objects as art. The belief that the *déracinement* or uprooting of colonized peoples from their lives and values led to problems played into a "new project of recognizing and fostering cultural difference," visible in the creation of the Musée des Colonies in 1931 and the reshaping of the Musée d'Ethnographie du Trocadéro as the Musée de l'Homme by Paul Rivet.[107] These developments were accompanied by a form of "colonial humanism" in which Leftist thinkers and administrators sought to reform France's colonial policies.[108] Similarly, the gradual integration of Congolese art into the promotion of Belgian colonialism as a valuable resource that needed protecting occurred simultaneously with the discussion about the possibilities of "welfare colonialism."

ORGANIZED WALKING AS EVOLUTIONARY PRACTICE

Last, we should also take into account the place of the art room in the overall narrative the museum presented to its visitors.[109] A visitor touring the museum in the 1950s would first pass through the halls devoted to the natural sciences. By then these included displays on zoology, primatology, entomology, birds, fish, reptiles, nonvertebrates, geology, and mineralogy. Next came the hall devoted to prehistory and (physical) anthropology, from which the visitor "progressed" to ethnography, and then moved on to the new art room. After the Congolese art room, visitors entered the history section and Memorial Hall, both devoted to Belgian colonialism and the first introduction to a historical dimension in the displays about culture. A visit was capped off with the halls devoted to the economic resources of the colony, with displays on mining, wood, and agriculture. These emphasized to the visitor the *value* of the colony. Obviously embedded in this trajectory was a clear and deep-seated evolutionary hierarchy in which Congolese people were the transition between the natural world and that of civilization and history with the Congo art room as the threshold. The museum scholar Tony Bennett aptly described this spatial organization as "organized walking as evolutionary practice."[110]

Throughout the museum, but particularly in and around the ethnographic section, yet another if different throwback to the late

nineteenth and early twentieth centuries was present in the form of a series of sculptures representing various Congolese "ethnic groups" by Belgian artists such as Isidore De Rudder, Julien Dillens, and Charles Samuel. Additionally, sculptures around the rotunda depicted themes such as *Belgium Bringing Security to Congo, Belgium Bringing Civilization to Congo,* and *Slavery* (by Arsène Matton) and *The Colony*

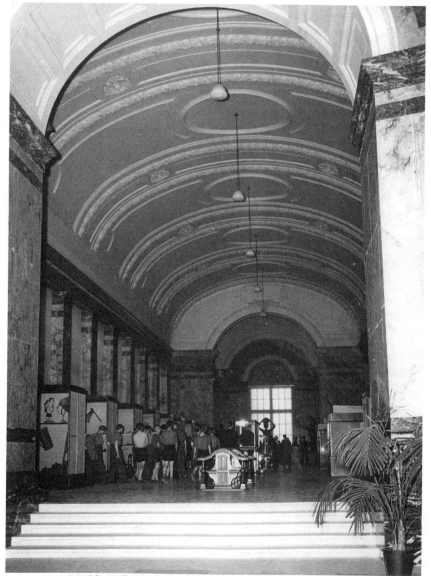

FIGURE 1.8. Marble Hall. Congolese ethnography, 1954. CNEPOM 1954.10.20, collection RMCA Tervuren, RMCA Tervuren ©.

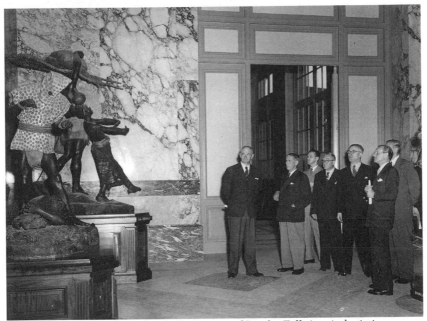

FIGURE 1.9. (*Left*) Paul Wissaert's *The Aniota of Stanley Falls* (1913), depicting a leopard man threatening a victim, on the far left; and (*right*) Julien Dillens's *De Dragers* (The carriers) (1897), 1953. HP.1955.96.1061, collection RMCA Tervuren; photo Inforcongo, RMCA Tervuren ©.

Awakes in Civilization (by Frans Huygelen). The sculptures, several of which dated back to the 1897 colonial exhibition, portrayed Belgium's role as the savior and civilizer of Congo, spatially disrupting the ethnography section and negating the more nuanced image of Congo constructed there in the 1950's.[111]

Another competing narrative about the value of African cultures and societies was presented in the museum's section on prehistory and physical anthropology, which included displays on archaeology.[112] Despite the ostensible postwar discrediting of so-called "racial science" and hierarchical classification of races, the Tervuren museum was still using skin color, hair, and physical characteristics, particularly of the face and head (such as the form of the lips and skull), as the main characteristics in determining race. The most prominent artifacts in the room were skulls from Congo, lined up to illustrate the "natural difference" of the "melano-African race."[113] The field of physical anthropology was alive with debates over the concept of race in the 1950s and '60s, but Tervuren's identification of races through a typology that relied on ideas about racial purity was a leftover from the late nineteenth

and early twentieth centuries that was becoming fast outdated in a scientific environment moving toward dynamic evolutionism. Until the late 1950s, the room also contained a series of bronze body casts of the bodies of Congolese people, created in 1929 by the artist Arsène Matton from plaster casts he made in 1911 on a trip to Congo. These body casts functioned both as scientific specimens and as pieces of art, serving as a prime example of the exoticizing of the black body in service of the "scientific" mission of the museum. When the room was renovated in the late 1950s, the casts disappeared into storage.[114]

The room was set up so that the visitor was first introduced to the idea of evolution and the science and techniques of archaeology. Then, and before an overview of prehistoric cultures of the region, came a wall panel illustrating the usefulness of ethnographic research to the archaeologist. This panel created a clear line from the ancient past of Africa to the present. The visitor advanced toward biological anthropology, passing, on the left, a chronological arrangement of the different cultures in the Belgian Congo. Set apart on the right side of the room were a case on Neolithic cultures and another on the progression to the "Bantu iron age." Thanks to this setup, the panel introducing the science of (biological) anthropology and the "races" of Congo was located right next to the display on Mesolithic cultures in Congo. Although the curators refrained from associating races with civilizations, the spatial proximity of the prehistoric and physical anthropology displays was suggestive. The grouping of the displays on prehistory and physical anthropology, and their positioning as a bridge between the halls on nature and those on culture, framing the ethnographic and art displays, encouraged a racialized understanding of cultural difference.

Determining what the museum defined as history and what shaped the historical narrative presented to the museum audience is crucial for our understanding of how the Belgian audience related to their country's colonial endeavor. How was Belgian colonialism presented in an era emphasizing modern reform, what place did colonialism have in the Belgian national identity, and what role did it play in the larger narrative the museum presented? The department active in creating historical displays for the museum was that of Political, Moral and Historical Sciences, a somewhat odd description that covered Belgian activities in the colony. The curator, Marcel Luwel, like his colleagues in ethnography, believed his role was to assist in the modernization of the museum and to provide museum goers with

more scientifically and historically founded information on the displays in the history halls.[115]

The focus of many of the historical exhibitions was on the explorers of Central Africa, Stanley in particular, and the early generation of Belgian military officials. This was clearly visible in the way the Memorial Hall was organized. The space was named after a monumental plaque engraved with the names of Belgians who had died on African soil before 1908. The hall was adorned with a series of military flags commemorating the military conquest and organization of the colony, covering both the period of the Congo Free State under Leopold II and the post-1908 period, when Congo became a colony of the Belgian state. Both the name of the space—Memorial Hall—and the exhibits themselves show the importance of remembrance in the way history was conceptualized. The museum goer was invited to participate by visiting the room, effectively sharing in a ritual that defined their citizenship as imperial.

"History" in Congo started with the arrival of the Portuguese in 1483, the visitor was told. In the middle of the central history hall was a reproduction of the *padrão*, or commemorative pillar, erected by

FIGURE 1.10. Memorial Hall, 1955. HP.1955.96.357, Collection RMCA Tervuren; photo Inforcongo, RMCA Tervuren ©.

Diogo Cão to commemorate his arrival on the Congolese coast. The surrounding display cases told a chronological story of the European presence in Congo. Starting with the relations between Portugal and the kingdom of Kongo, the bulk of the material referred to the political, administrative, and military reign of Leopold II and, later, the Belgian state in central Africa. The only artifacts produced by African people in the history displays were the metal crucifixes attributed to the Kongo kingdom. Central to this colonial story were the military victories against the so-called Arabized slave traders, the abuse of which Leopold II claimed to be freeing the Congolese from. Museum goers could thus admire the heroic efforts and humanistic intentions of Leopold II and his colonizing efforts.[116]

In 1958 the fifty-year anniversary of the takeover of the colony by the Belgian state was commemorated with a special exhibition. The political significance of this exhibit at this moment in time is not to be underestimated, since rumblings about Congolese independence had started to surface both in Congo and in Belgium. Tervuren proceeded with an exhibition that celebrated not only the fifty years the Belgian state had been responsible for the colony but also the earlier

FIGURE 1.11. Visit of the Yaka king to the Tervuren museum, 1959. HP.1959.28.860, collection RMCA Tervuren; photo R. Stalin (Inforcongo), RMCA Tervuren ©.

reign by Leopold II. The official opening speech by the minister of colonies did not mention the current situation in the colony but focused instead on the heroics of Leopold II and his collaborators. The exhibition closed on January 4 1959, the very day political violence broke out in Congo's capital.[117]

⟳

JUSTIFICATION OF the continued presence of Belgium in Africa depended not only on economic, but also on cultural politics that created an image of the colony as exceptional and valuable, a process in which the museum played a central role. In the 1950s Tervuren's message about the *mise en valeur* of Congo suggested not only exceptional natural and economic resources but also exceptional and rich cultural resources in the form of art. The history of the ethnography and art displays at the museum shows very clearly how the meaning attributed to the objects on display changed over time, as did the image of Congolese cultures. Olbrechts's administration was marked by the definitive shift of certain objects from the realm of ethnography to the realm of art. The Congo art room in the museum gave shape to the contours of what came to be considered valuable Congolese cultural heritage. These pieces became the prime carriers of cultural authenticity, defined as untouched, of the past, and traditional.

While a Congolese heritage was given shape in the halls of Tervuren, a Belgian heritage was also created. In the history displays, the struggle for Central Africa was presented as part of the past of the Belgian people, while their present and future were suggested in the displays of the many resources and riches, now including art, of the colony.[118] The museum and its collections came to stand for the colony, were an essential part of Belgian heritage, and eventually served as a monument to Belgian colonialism itself.[119] The rebirth of certain objects as art allowed for a shift in the interpretation of the "civilizing mission," in which African material culture previously was used to underwrite the necessity of European colonialism to lift African societies out of primitiveness. Although they were still used to justify the colonial project, it was their preservation that now required the role of the Belgian state as a protector of "traditional" African cultures, and hence, as a cultural guardian.

One wonders about the — admittedly very few — Congolese visitors to the museum. On a number of occasions during the 1950s, mostly

during the World Exposition of 1958, Congolese *évolués* visited the museum in Tervuren. What were their thoughts as they were guided through the halls of the monumental and rather pompous building promoting Congo as a natural unit and praising its riches, but undermining any regard for the lives of its subjects? The following chapter will explore how the contradictions between the colonial regime's desire to advance and "civilize" on the one hand, and to protect and save African cultures on the other hand, played out in the cultural politics of the colony itself.

2 ⤳ Guardians of Heritage

A Politique Esthétique *and the Museum as a*
"Laboratory of Native Policy"

IN A 1955 article on the modest Museum of Indigenous Life in the Congolese capital Leopoldville, the museum's director, Jean Vanden Bossche, enthusiastically described the museum as "a laboratory of native policy."[1] On the one hand, he hoped its displays might inspire and educate Congolese artisans, remedying the perceived decline in authentic traditional arts and crafts. On the other hand, perhaps museum visits could serve as a "civilizing ritual" and shape a modern Congolese subject.[2] Through exposure to the sciences of ethnography and art history, a growing urban population would learn to value indigenous cultures as their country's heritage and would develop a "pure gaze," becoming modern subjects in the process.[3]

This chapter investigates how the changing ideas about African art impacted ideas about cultural policies in the colony, and how Belgian cultural guardianship was exercised in the colony.[4] More specifically, it traces the activities of a set of metropolitan and Congo-based organizations active in the promotion of Congolese arts and crafts as well as the organization of workshops, art schools, and museums in the colony.[5] What role did developing ideas about African art, heritage, the role of museums, sustainable and traditional artisanal production, and the growing influence of Western art education play in attempts to reinvent and control Congolese "traditional" cultures in the colony? Was cultural authenticity interpreted differently with regard to artistic life in the colony than it was in the halls of Tervuren? How was Congolese material culture collected and displayed in the museums in the colony,

and how did they differ from metropolitan museums? By analyzing Belgian interpretations of Congolese cultures as a political project, I trace changes in the Belgian colonial regime during the 1950s and rising tensions between the colonial government in Belgium and cultural organizations and Catholic congregations involved with the organization of "indigenous" education in the colony. Although the archival material has been profoundly shaped by the colonial project, I attempt to trace how Congolese leaders, artisans, and artists responded to the various colonial initiatives aimed at the organization of artistic life. This exploration of the introduction of ideas about cultural authenticity and heritage to the colonial scene will shed light on the nature and content of postcolonial culture explored in the following chapters.

The chapter first sketches the creation of a framework for cultural politics with regard to art and crafts in the colony during the 1930s, but it focuses mostly on the most active period, from 1945 until 1959. It was during these years that artistic (associated with the creation of art) and artisanal (associated with the creation of crafts) life in Congo was most actively subject to interference and control by the colonial government and a number of colonial organizations. By exploring the cultural, political, social, and economic motivations for the formulation of colonial cultural politics, as well as the attempts to translate these into practice, this chapter establishes the connections between the worlds of politics and culture. The opposing views on the potential function of art schools, artisanal workshops, and museum spaces and collections that arose — including attempts to steer cultural initiatives from the metropole and debates around the definition and value of art versus *artisanat* or crafts — reveal the complex impulses at work in concerns over the conservation of traditional cultures in the colony.

The art/artifact binary at play in the reinvention of the displays in Tervuren was more unstable in the context of the cultural politics in the colony because of the close proximity between contexts in which artisanal production took place, and the contexts in which objects were put on display. The art/artifact binary masked objects' identities as commodities — a result, in part, of the ontological fallacies of the categories of "authenticity" and "art" employed by colonial representatives.[6] These reflect the contradictory nature of imperialist modernity itself, which relied heavily on the construction of the antimodern. The latter could be read into discourses about the "primitive other," but also into the "authenticity" of that other which "functioned as the critical opposite to modernity's

fragmented world."[7] By appropriating the material culture of the "other" into the discourse about colonial modernism—but also into the colony's cultural economy—the colonizer created the circumstances necessary to sustain the colonial system This process, I will argue, was particularly important to the construction of cultural guardianship that marked Belgian late-colonial politics.

The category of "crafts" or *artisanat* was much more often invoked than "art" was by those interested and involved in artistic life in the colony. As a concept, "crafts" fits neither the art nor the ethnographic artifact category. Although they were commodities, crafts could be aesthetically valued and their production was associated with the artistic sphere. Although threatened by commercialization, they were connected to pre-modern, "authentic" life.[8] Interestingly, it was not uncommon for the Belgians in this chapter to believe that the re-emergence of a "true art" could be coaxed out of the artisanal scene, under the proper Western supervision.

THE EMERGENCE OF COLONIAL CULTURAL POLITICS IN THE 1930s

In the 1930s, institutional frameworks and organizations emerged that dealt specifically with arts and crafts in the colony. One of the most important of these was the Commission for the Protection of Indigenous Arts and Crafts (Commission pour la Protection des Arts et Métiers Indigènes, COPAMI), created by the colonial ministry. Its official task was "to study and research all matters related to the protection, re-creation and advancement of indigenous arts and crafts [and] make suggestions on the subject to the minister of Colonies."[9] The commission resided in Belgium, and its members were a mix of former high-level colonial administrators, artists, academics (mostly museum curators and art historians), former missionaries to the Congo, and staff from the colonial office in Brussels. COPAMI's role was only advisory, and it tended to function as a lobby. Its unofficial influence was at times considerable because of its members' social positions and backgrounds. It was the hope and ambition of the founding members of COPAMI that, eventually, a department of arts and crafts, or even a department of fine arts, could be institutionalized within the colonial government.[10] The driving force behind COPAMI was Gaston-Denys Périer (1895–1962), an employee of the Ministry of Colonies in Brussels with a great admiration for avant-garde artists such as Apollinaire and Picasso, who stirred

his interest in African art, in which he discovered the "irresistible draw" of Africa, the "soul of a faraway and unrecognized humanity."[11] Despite his progressive opinions on the artistic culture of Congolese subjects, his views were firmly entrenched, as he was himself, in the colonial project; he believed in the value of the protection and development of cultural life in the Congo as a part of Belgium's mission.[12]

By the mid-1930s such ideas were increasingly popular. A more inclusive and long-term understanding of the responsibilities of the Belgian state as a colonial power was gaining ground. The interest in these matters also grew among the colonials, the number of which increased slowly with the growth of the colonial system in the colony. A number of the new arrivals had become increasingly concerned with the state of local traditional cultures and their perceived decline with exposure to the West.[13] By founding the Friends of Indigenous Art (Amis de l'Art Indigène, or AAI), a group of these colonials aspired to create museums in the colony in the interest of preserving traditions and inspiring Congolese artisans to produce "authentic" material. Organized into regional committees, of which the Leopoldville and Katanga branches were the most active, AAI was less centralized than COPAMI, but as opposed to the latter, it was based in the colony itself, far from Brussels, the center of power in colonial politics.

Despite overlapping interests, COPAMI and AAI had a tense relationship that was an expression of the general tension that existed between the colonial government in Brussels and its representatives in Congo. The members of COPAMI thought many AAI members were loose cannons who lacked an academic understanding of the situations in which they worked. This deeply offended many AAI members, who felt their hands-on knowledge was far more relevant than COPAMI members allowed. Another significant difference between the two organizations was that AAI included some Congolese members while COPAMI had none, since its members deemed "few Congolese qualified owing to a lack of education in 'artistic life.'"[14]

In the first few years of its existence, COPAMI focused on lobbying the government for new legislation to protect the "sites, monuments and indigenous arts" of the colony. Signed into law in 1939, the legislation provided the legal framework for the selection and protection of an official heritage that included archaeological sites, buildings and monuments, and, theoretically, museum collections.[15] Although the legislation was largely aimed at protecting sites and monuments from

the early colonial era, COPAMI used it as a starting point, creating an ambitious agenda that included initiatives to protect the remnants of past artistic traditions in the colony, the centralization of the sale of artisanal crafts, the organization of artisans into workshops and cooperatives, and the protection of environments conducive to high-quality artisanal production. In addition, it aspired to evaluate all existing art education in the colony.[16]

AAI branches around the colony created small museums with mostly ethnographic and some archeological collections. One of those was the Musée de la Vie Indigène (MVI) or Museum of Indigenous Life, in Leopoldville, which first opened its doors on March 14, 1936. The product of the efforts of the artist and author Jeanne Maquet-Tombu and Adrien Vanden Bossche, with the support of the local government and UTexLéo (one of the largest textile companies in Leopoldville), the MVI included an exhibition space, a library, a museum shop, and a workshop for educating artisans.[17] The seven thousand objects that filled the museum's storerooms and displays were largely collected by the handful of individuals associated with its creation, although donations from colonial administrators returning to the capital from their posts in the interior soon formed an important contribution.[18]

Governor-General Pierre Ryckmans expected the Congolese to be "deeply grateful for our conservation of the vestiges of their past life."[19] "The talented Negro will be guided to the museum in order to look for inspiration," the AAI hoped.[20] Clearly, the AAI not only envisioned educating both Belgians and Congolese in the value of traditional culture but also hoped the Congolese population would one day thank them for their conservation efforts.

The various rooms were organized according to colonial administrative units with some level of ethnic divisions. Shelves were brimming with ranks of statues and more utilitarian material such as pots, knives, and weapons. The only objects that were more or less consistently grouped together were of Kuba origin. No distinction was made between material of an ethnographic, archaeological, or artistic nature, nor was there any indication of the materials' function or elaboration on the items' historical or ethnic background.[21]

The Museum of Indigenous Life was not the only museum in the colony by the 1930s. In addition to a number of missionary collections on display and small, often short-lived museum initiatives by regional AAI branches, there was also the Leopold II museum in Elisabethville,

the capital of the Katanga mining region.[22] The museum had its origin in the personal collection of archeological material of Francis Cabu, an employee of the National Institute for Agronomical Studies and Research, in Katanga. At first he opened up his living room as an exposition space, but soon the collection began a long journey through a variety of locales and gradually included more than prehistoric and archaeological artifacts.[23] Colonial officials brought the museum artifacts from their respective administrative units. The legal authorities in Elisabethville also donated the "fetishes and medicinal objects" they confiscated during raids on "sects" prohibited by the colonial government.[24] Although it amassed a decent collection of ethnographic material, the museum's strengths remained its archaeological and geological collections. As such, it was not the center of activism for the preservation of indigenous art that the MVI in Leopoldville was.

A *POLITIQUE ESTHÉTIQUE*: AN AGENDA FOR CULTURAL POLITICS IN THE COLONY

While World War II froze the incipient activities of COPAMI and the AAI, it accelerated the Belgian government's desire for change and modernization in the colony, a trend that was accompanied by an increased concern about the state of Congolese traditional cultures, their artistic heritage, and their artisanal production. Pierre Ryckmans, governor-general of the Belgian Congo since 1934, stressed the importance of separating the government system from the interests of the big colonial companies. In 1946 he openly opposed those companies' practice of exporting their profits. The 1949 ten-year plan for economic and social development in Congo proposed the use of government funds to modernize the economy, which translated into an increased presence of the state at all levels of life. In reality most of the attention went to economic development, but the growing presence of the state translated into increased control over various aspects of the lives of colonial subjects, felt not only in social policies but in the cultural domain as well.[25] Some colonial administrators became convinced that knowledge of "traditional societies" could be seen as "applicable knowledge" in the service of modernization and development.[26]

While the colonial state expanded its presence, anxieties about the impact of modernization and Western society and culture on "traditional" African societies increased. The expanding expatriate population, which reached 109,457 people in 1958, 86,736 (or 79.2 percent) of

whom were Belgians, observing the growing migration toward colonial cities, became increasingly worried about the disappearance of "authentic" rural communities and their traditions. This resonated with the metropolitan community's growing intellectual and aesthetic interest in African art.[27]

While the goal of expanding the colonial system was an increased *mise en valeur* of the colony, Belgian nostalgia for an imagined Congolese past with "authentic" traditional communities grew in tandem with the colonial state. In her interviews with former Belgian colonials, Marie-Bénédicte Dembour noticed their preference for "the bush," which they saw as the real Congo. While they downplayed the destructiveness of the colonial system, they lamented the changes occurring in rural societies. Dembour notes that many of her interviewees displayed a striking lack of awareness about the origin of these changes.[28] Defined as "imperialist nostalgia" by Renato Rosaldo, this admiration for a traditional way of life was not new. Admiration for the "noble savage" went back centuries, going hand in hand with the image of the "primitive savage."[29] The romanticization of rural and preindustrial life translated into a desire for local, handmade, and "authentic" objects, in which these qualities were supposedly embedded. This perspective was compounded with a view of colonized peoples as part of a previous stage in the evolution of human development. Ultimately, the goal of the "civilizing" process was to lift such peoples out of the past and into a future in which they would be manufacturers and consumers. But by placing such emphasis on cultural authenticity, colonialism denied colonized Africans a place in a political, cultural and social modernity.[30]

The activities of COPAMI and AAI reveal how these growing anxieties about modernity in the colony focused on the demise of artisanal and artistic production in the colony, and how the solution to these was located in the creation of an institutional complex that included workshops, art schools, and museums. COPAMI members decided that the right course of action was to draw up a *politique esthéthique* ("politics of aesthetics"), a central manifesto for cultural action by the colonial state. The commission members all envisioned a clear split between a past, when the masterpieces of Tervuren were produced, and the present, which was their sole area of concern. The possibility that contemporary Congolese societies were capable of producing pieces equal in quality to those in Tervuren was largely dismissed. What was

understood to be under discussion may be more accurately described as artisanal production: arts and crafts or *artisanat*, the "minor" arts.

While the *mise en valeur* of the art collection at Tervuren revolved around the exceptional nature of the pieces and the artistic value that translated itself into economic and financial value, like other resources of the colony, the valorization of artistic traditions in the colony itself lay with artisanal production, which represented the connection between the rich artistic past and a modern future with a crafts industry rooted in tradition. "Authentic" arts and crafts, however, were considered to be in decline, a consequence of the disappearance of traditional identities and ways of life and a sign of a changing, destabilizing society. As Adrien Vanden Bossche, the first director of the MVI, wrote, "The works of indigenous artists are no longer supported by the complex ideology that generated them in the past. The suppression of certain customs and superstitions inherent in primitive life results in a certain disinterest in the making of artistic oeuvres."[31] While, in an earlier phase of the colonizing process, local art and crafts had been seen as inferior to Western products and representative of the savagery of the Africans, many of these same objects (particularly sculptures and textiles) were now viewed as a potential source for disciplined and industrious craftsmanship, as part of the civilizing process.[32]

On the face of things, colonial modernization was the culprit for the decline. However, the Belgians reasoned, it was rather the inability of the Congolese to deal with modern developments, allowing themselves to be seduced by the money offered by Western art dealers both for their "ancestral" art and for artisanal production, that caused the problem. From this perspective, it was the financial incentive that impaired the ability of communities to hold onto their older and more beautiful objects. Attracted to the tools and materials of modernity, artisans also lost the ability to work with traditional techniques, thereby undermining their ability to produce authentic work. The Belgians believed the loss of these traditional techniques reflected a loss of traditional identity, which was the real issue and was feared to have political consequences.

The increased commercialization of the arts and crafts market also worried the members of COPAMI and AAI. They feared that artisans overly concerned with earning money—in order to participate in the modern colonial economy—were susceptible to Europeanization, and therefore deterioration, either because they would adapt their products

to the wishes and tastes of the foreign buyers or because they would ne-
glect quality in favor of quantity in order to maximize profits. Clearly,
however, it was not the rising popularity of Congolese crafts as consump-
tion products (or "colonial kitsch," as Jean-Luc Vellut has called it) that
was the problem for COPAMI and AAI, but the fact that they believed
a growing market in crafts needed to be controlled by the colonial state
and its representatives in order to maintain the "authentic" character of
artisanal production.[33] This authenticity rested with "traditional" modes
of production and "traditional" materials, assumed to lead to a more sus-
tained development of artisanal production and of a rural artisanal class.

COPAMI and AAI's view of rural life ignored the pressures and dif-
ficulties faced by large parts of the Congolese population in the 1950s.
There was considerable pressure from forced cultivation and crop rota-
tion systems, an insistence on restructuring rural communities around
nuclear families, and an increased dependence on a monetary econ-
omy.[34] The extension of systems of compulsory cultivation left little
room for subsistence farming and had dire effects on the quality of
rural life in the colony, destabilizing communities and encouraging
migration to cities. As the social structures of rural communities disap-
peared, the colonial state attempted to stabilize rural life and produc-
tion with a series of economic initiatives. Among them was the attempt
to create a peasant class (or *paysannat*) through a system of land divi-
sion by family as well as crop requirements. These initiatives reflected
the colonial administration's desire for social and population control.[35]
The reinvigoration of craftsmanship and an artisanal class was seen as a
way to promote indigenous peasantry and family and village life, allow-
ing for a productive rural class without the social instability that came
with migration and urbanization.

Another source of concern for COPAMI was the role of Western-
style art education in the colony. It was feared it would lead not only
to "inauthentic" and inferior crafts but also to inauthentic modern art,
diverting Congolese students' attention from their "true" heritage and
identity. By the early to mid-1950s, however, a number of COPAMI
and AAI members, such as museum director Jean Vanden Bossche
(who succeeded his father Adrien as director of the MVI) and artist
and scholar Jeanne Maquet-Tombu, became more open to the devel-
opment of a modern or "living" art.[36]

The majority of the works considered modern were the products
of students in one or more of the emerging art schools in the colony.[37]

These included the Academy of St. Luc in Leopoldville, led by Marc Wallenda, a brother of the congregation of Christian Schools, and the Academy of Popular Arts in Elisabethville, led by Pierre Romain-Desfossés. Wallenda encouraged the development of traditional craftsmanship, but many of his students ended up adopting an idealized realism.[38] Romain-Desfossés, a French painter, was opposed to the teaching of Western art history and techniques to Congolese students, worried that it would impede their creativity and jeopardize the authenticity of their work.[39] He founded his Workshop for Indigenous Arts, commonly referred to as "Le Hangar" (The Warehouse), as a space for crafts and more decorative arts. However, his students were not limited to the more traditional, artisanal sculptural work, and he ended up renaming the workshop the Academy of Popular Arts. This change in nomenclature reflected his widening understanding of traditional crafts, while demonstrating that he had not abandoned his interpretation of Congolese cultural authenticity.[40]

Upon Romain-Desfossés's death, his workshop merged with the Academy of Fine Arts and Crafts in Elisabethville, founded by Laurent Moonens in 1951, an institution that admitted both black and white students.[41] Moonens acknowledged the possibility of a contemporary art production but thought it useless and even damaging to teach Western art history to young Congolese students. His fear was that such instruction would be akin to "giving them a heavy artistic past that is not theirs and would distance them from their own inspiration." Instead, they should "find an African style."[42] Moonens believed that the survival of artistic traditions depended on a rational organization of production under the guidance of colonial representatives or missionary congregations. This supervision would ensure that sales would not drive the "immediate needs" of producers and would thus prevent a deterioration of quality. For Moonens, these immediate needs were not rational economic needs, but a lack of impulse control and an irrational desire to obtain quick money on the part of the Congolese. As he put it, "We cannot lose sight of the fact that the black is a large child and needs help in order to make a decent living of his artistic production"[43]

Despite the hesitant acceptance of newer artistic forms of expression, most advocates for these developments argued that they must be guided by Western teachers and artists. Those same teachers, however, should refrain from teaching Western art history or techniques in order to prevent that knowledge from contaminating Congolese art. (Wallenda was

regularly under fire for introducing his students to Western traditions and techniques.) This argument merely transferred the desire for authenticity in traditional artisanal techniques to a desire for a similar authenticity in modern works—untainted by the West and grounded in some form of "Africanness" inspired by "traditional" life and art. In short, the kind of modernity that was tolerated in art production combined Western stewardship with roots in African techniques, forms, and content.

On the other side of this debate was a sizable group of COPAMI members who steered clear of promoting anything but traditional artisanal production, convinced that it alone could reconnect the Congolese to their ancestral art. They emphasized restoring "traditional" cultural patronage—interpreted to be the village chiefs—although the latter were also succumbing to "cars instead of art."[44] The COPAMI member and painter Robert Verly believed that "reinstating, in the measure to which the colonial politics permits, the authority of traditional chiefs" would be the best way to preserve traditional art production. Verly argued it was in the regions where traditional authority persisted that a royal art still thrived.[45] This remark—a clear reference to the Kuba region, where the Kuba king had been incorporated into the colonial system as an indirect ruler—highlights Verly's belief in the power of the Congolese themselves, albeit only those communities under centralized rule, to reinvigorate and protect their cultures.

The longing for "traditional"—and, therefore, rural—societies in the face of the destabilizing forces of urbanization and change brought on by colonial modernities led to a deeply conservative and antimodern reaction from a considerable part of the colonial establishment. The attachment to the idea of "family" or "home" industries was one that projected on the colony the nostalgia in many European societies for preindustrial and rural life.[46] To describe the fear of decline as mere nostalgia, however, would be to miss an important political motivator behind colonial cultural politics. A rerooting of Congolese population in a traditional form of rural life was seen as an antidote against Westernization and its supposed fellow traveler, political awakening.[47] Many COPAMI and AAI members, however, saw themselves as a progressive response against the iconoclasm perpetrated against native cultures by missionaries in their zeal for conversion and the destructive side effects of colonial modernization.

After years of discussion, in 1954 COPAMI finally approved the *politique esthétique*. The document sidestepped the problem of defining indigenous art, since despite years of exhaustive discussions commission

members could not arrive at a uniform definition. Although the document consistently used the term *art*, the practical guidelines reinforce the impression from the debates that the commission's actual concern was artisanal production, or the minor arts.

The document acknowledged that forms of expression could change when inspiration changed, but it stipulated that guidance was necessary to ensure that traditional sources of inspiration were replaced by the right alternatives and that the "social and collective character of its production was maintained as much as possible." This meant that artistic education should start with "negro-African classicism," and that Western art history should be introduced only under teachers' careful guidance. Conversely, it was important for the Western art teacher to immerse himself in the study of traditional indigenous art in order to "penetrate the black soul and aim to let it bloom freely." With unique exceptions, pushing artists to create "great art" would prove unsuccessful. The commission, as a result, recommended a focus on a lower level of education, mirroring the educational policies of the colonial state at large.[48]

Jackson Lears, in his study of antimodernism in American culture, argued that it was more than mere nostalgia or escapism and often "coexisted with enthusiasm for material progress."[49] The same can be said of the conservationist agenda of COPAMI and AAI. The professed goal of Belgian colonialism was the modernization and civilization of the colony, but many in the colonial apparatus became uneasy about the impact of colonial modernity on the social and political fabric of traditional, rural life. The ambivalence inherent in this mission is clear in the political and social undertones of the conservationist agenda of COPAMI and AAI and the attempts by their members in the 1940s and '50s to come to terms with change while containing it within a framework of "Africanness." The tension between the identities of artisanal objects as commodities and as repositories of authentic traditions could only be resolved in the creation of an artisanal industry under the guidance of the colonial power, guarding the authenticity of the environment, artisans, and objects. This would not only create the industriousness desired for "civilizing" the Congolese people but also guard them against the potential social and political effects of modernity.

PRODUCING ARTISANAL AUTHENTICITY

Having published the manifesto, COPAMI moved on to the "renovation and the promotions of progress" of Congolese arts and crafts. This

entailed the study and organization of the situation "on the ground," in particular with reference to the already existing art schools, workshops, artisan's cooperatives, and museums. Although COPAMI would have preferred to create a new structure for the cultural sector in the colony, this was beyond its power. Its politique esthétique, after all, carried no legal weight. The Belgian government had no interest in investing that amount of effort and money into Congolese artistic and artisanal life, so COPAMI worked on a smaller scale, and its members lobbied individual government officials relentlessly.

Even before the final version of the politique esthétique was approved by the Belgian government, COPAMI members started preparing for its practical application. Their plan included four major elements: (1) extending the application of the 1939 legislation for the protection of Congolese patrimony to the protection and classification of Congolese indigenous arts in the colony; (2) a reorganization of the existing museums in the colony into a centralized system; (3) the organization and control of artistic education in a way that promoted "the artistic sensibility of the race"; and (4) the creation of artisanal workshops, cooperatives, and sales venues in order to create a modern artisanal class that was rooted in rural traditions.[50] Since these latter institutions already existed in Congo, COPAMI was in reality concerned with their centralization and control.

Both AAI and COPAMI advocated the organization of artisanal cooperatives and workshops, led by Belgians, where artisans could refine their techniques, obtain materials at advantageous prices, and sell their products. Cooperatives had first appeared in the agricultural sector in the 1920s, when producers of commodities such as milk, palm oil, and coffee began to organize to process, transport, and sell their produce collectively. Eventually, a 1949 government decree established such cooperatives as legal entities under the supervision of the colonial administration, but the government was simply regulating a preexisting phenomenon.[51] Although government support for and organization of the cooperatives were motivated by a desire to create a rural Congolese middle class, the cooperatives remained a marginal phenomenon when compared with the large-scale compulsory cultivation and European plantations.[52]

The proposed artisanal cooperatives and workshops would not only centralize and organize the sale of production in a way that allowed the artisan to earn a living, they would also allow the colonizer to exert

"quality control." By giving space to artisans to develop as a viable economic class, they would counteract the perceived disappearance of artistic customs and traditions, especially since the preferred setting for these workshops would be in areas away from the larger colonial centers.

In 1952–53 former AAI and current COPAMI member Jeanne Maquet-Tombu toured the Leopoldville and Kikwit areas in search of existing initiatives that could either serve as models for the workshops or else be incorporated into a centralized system. Among the sites she visited were a ceramics workshop run by Jacques Laloux in Leopoldville; a weaving and basket-making operation run by the Apostolic Annunciade sisters of Heverlee in Totshi, southeast of Kikwit in the Bandundu region; a sculpture workshop at the mission of Kahemba, south of Kikwit near the border with Angola, that had sent material to both Belgium and the United States; and a workshop of raffia textiles, also known as Kuba cloth or Kasai "velours" or velvets, in the mission of the Annunciade Sisters near Nsheng. Maquet-Tombu found some of these initiatives useful. Almost all of the missionaries reported encouraging the use of traditional techniques in craft production, although the sisters in Nsheng complained that "their girls" were more interested in trying out new things. The fact that missionary congregations had created most of these initiatives was no coincidence. The Catholic Church was a tremendously powerful participant in Belgian colonialism and had a de facto monopoly on education in the colony. For COPAMI, however, the creation of workshops independent of missionary congregations and connected directly to the colonial administration was preferable.[53]

The information collected by Maquet-Tombu, in line with the guidelines laid down in the politique esthétique, led to the formulation of concrete plans. COPAMI, in collaboration and consultation with the Ministry of Colonies, created a blueprint for Ateliers Sociaux d'Art Indigène (ASAI), Community Workshops for Indigenous Art. Gathering artisans into these workshops would allow them to make money and work in their "original environments," thus providing an educational and social service while stimulating the "regeneration of communities." These workshops—created primarily in environments that were "rich in tradition," contradicting the commission's professed interest in reinvigorating artisanal traditions in the entire colony—could also connect to trading posts and sales venues created and run by the colonial government or by museums in the colony and even abroad.[54]

The crafts produced in the ASAI would receive a stamp that certified their authenticity in terms of quality and origin.[55] The curator of the MVI was a strong advocate of recording the name and biography of the artist as well.[56]

In possessing the stamp that would authenticate objects, the colonial state would be the arbiter and proprietor of authenticity, allowing the colony to capitalize on the growing market for artisanal crafts production. Unfortunately, as Viviane Baeke has pointed out, the obsession with authentic artistic traditions had the ironic side effect of creating artisanal environments that undermined precisely those aspects of craft production that interested those concerned with authenticity.[57]

COPAMI's interest in containing and controlling the sale of crafts indicates the extent to which the sale of souvenirs and crafts had become a significant business. The popularity of these objects was the result of the confluence of two developments. On one hand, the growing colonial community and the increase in tourism in the 1950s generated a market for the sale of arts and crafts. On the other hand, the booming African art market encouraged craftsmen and artists to produce pieces that they hoped would meet the standards of "authentic" art. Desiring to emulate art collectors, people wanted to obtain similar representatives of African "authenticity," but at a lower price. Not only did the yearning for local and handmade objects reflect the buyer's desire for "cultural capital," it was also a symptom of the commodification, romanticization, and fetishization of preindustrial, traditional societies by modern Westerners.[58] The case of the Kuba is a well-documented example. Active art and craft traders since the very beginning of colonial contact in Central Africa, by the 1950s it was a well-developed part of the local economy. Both Kuba and Luba people sold to traders, but also directly to visitors along the railroad that ran to the south of Kuba land.[59]

The growing Western consumption of African crafts gave rise to the category of "tourist art."[60] The ambivalence at the heart of this trade was the desire of the buyer to acquire an authentic representative of "native" culture, while the production of these objects was suspected of devaluing artistic traditions because of their commercial power, thus undermining the desirable "authenticity." Most of the work on African tourist or "airport" art focuses on the postcolonial era, but the attempts of COPAMI and the colonial administration to regulate commercial crafts production in the 1950s demonstrate the viability of the category of "tourist art" during the colonial era as well. Attempts at producing

and controlling its authenticity demonstrate both its economic and cultural power and the social and political anxieties wrapped up in a potential loss of authenticity.

While Bennetta Jules-Rosette's research on tourist art in the late 1970s and early 1980s led her to the conclusion that "ethnicity is a cultural particular that is generally disguised or muted . . . [or employed] in order to reference a cultural whole that stands for the idyllic past," John and Jean Comaroff have expanded upon the post-colonial commodification of African objects on the *strength* of an (admittedly abstracted) ethnic association.[61] The history of Congo's cultural economy shows us, however, that the process of ethno-commodification the Comaroffs describe in the context of the neo-liberal political economy of the late twentieth and early twenty-first centuries was predated by the homogenization and commercial use of "indigenous" cultural traditions in service of a growing cultural economy in the late colonial era. Ethnic references, especially Luba, Kuba, or Mangbetu, were present in that cultural economy, but the overall impression that COPAMI and AAI members cultivated was an abstract "traditional" identity in which regional differences were acknowledged but not much engaged. Regional identities were desirable as a basis for marketability and authentication, but the cultural identity of the category of products overall was imagined as "Bantou," "Black," or "Congolese."

In 1956 the Ministry of Colonies followed COPAMI's recommendations and created two workshops: one in Tshikapa, under the leadership of Robert Verly, and the other in Paulis, led by Lina Praet. This time, the language used by both the commission members and the government indicated a consensus with regard to the art versus artisanship question by defining the target as the *artisanat d'art*, or art craftsmanship, elevating it above the mere production of souvenirs, but still grounding it in craftsmanship. The workshops were to allow artisans to affirm their work's "active cultural and social value." The ministry emphasized that the workshops should be, above all, in service of the traditional community and the "prestige of the old cultures."[62] It is likely that Tshikapa was chosen because it was within reach of several traditional cultures rich in artistic traditions, such as Chokwe, Pende, Luba, and Lulua. It was also the location of the Forminière company, which exploited the rich diamond fields in the area.[63] The Paulis (today named Isiro) area was probably chosen because of its proximity to the

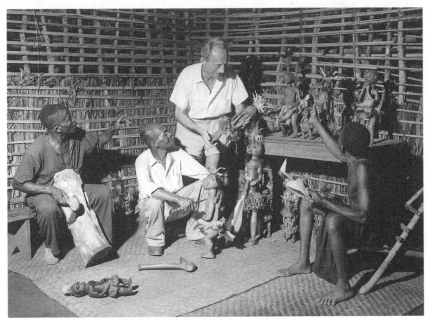

FIGURE 2.1. Robert Verly in one of the Tshikapa workshops, 1957. HP.1957.1.747, collection RMCA Tervuren; photo C. Lamote (Inforcongo), RMCA Tervuren ©.

Mangbetu people, another group famous for its art and considered one of the "classic" Congolese cultures. Clearly the workshops were established in places where it would be easy to capitalize on existing traditions. This strategy demonstrated the preference for the *mise en valeur* of artisanship over an activation or regeneration of cultural production in underdeveloped regions.

In 1957 a delegation of COPAMI members toured the colony for six weeks to get an overview of existing art and artisanal initiatives. While Maquet-Tombu, during her journey of the early 1950s, had reported on the art production organized by Congolese communities themselves, the 1957 delegation chose instead to visit workshops, museums, art schools, and other initiatives organized by Westerners (mostly Belgians). They devoted special attention to the Ateliers Sociaux d'Art Indigène, created the previous year. By that time Verly had set up a network of twelve workshops in and around Tshikapa. His efforts garnered praise from the delegation for stimulating the "creative spirit" and instigating the "return to a purity of forms" among "his" artisans. Praet had only been working for six months, but she had succeeded in establishing a series of workshops around Paulis, some of which already possessed commissions to send material to the 1958 world exposition in Brussels.

Both she and Verly recruited artisans and artists, gave them a space in which to work, provided them with basic materials, and attracted young Congolese apprentices. Praet's approach was somewhat different from Verly's: she attracted the artisans to local centers under the assumption that they would provide the strongest presence of traditional leadership, while Verly maintained his workshops in more rural areas.[64]

COPAMI did not succeed in allying all the artisanal workshops scattered around the colony—far from it. The majority of workshops and schools remained unaffiliated with the colonial administration. Some of these unaffiliated groups had to adhere to a certain set of standards because they received subsidies from the government, but many others were independent. Among the subsidized were the Sisters of Charity in Kikombo and the artisanal school at the mission in Gandajika in the eastern Kasai region. Among the independent workshops that drew the commission's attention was the one created in Leopoldville by the businessman Maurice Alhadeff.[65] Of Greek origin but an American citizen, Alhadeff contracted with artisan and artists, provided them with materials and a wage, and took whatever they produced in return, hoping for a financial reward for his investment. He sponsored the work of painters, potters, and ivory sculptors. Leopoldville's AAI and the visiting COPAMI members were not very happy with his approach, which they considered to be too intrusive in the artistic process and too heavily dependent on his own personal taste.[66]

A particular source of frustration for COPAMI was its inability to establish control over art and artisanal production among the Kuba. As one of the most, if not the most, admired form of Congolese art in the West, its "protection" was of prime importance. Mweka, a regional center in the Kuba region, possessed a cooperative for arts and crafts in which the local administration was involved. It had been created at the request of both the Kuba king and the many sculptors who produced pieces for sale at the railroad that passed just south of Kuba country. The sheer number of objects had a negative effect on the sales price, and the creation of the cooperative allowed a minimum price to be established. COPAMI and the AAI, however, felt that the quality of the work being sold by the Mweka cooperative was too low.

Also in the area was the artisanal school of the Josephite congregation in Nseng, which received subsidies from the colonial government.[67] Fathers Antonin D'Haenens and Cyprianus focused on traditional Kuba motifs in wood and ivory carving. COPAMI felt that

the fathers' influence was "too modernizing" and encouraged too much serial copying. The supposed copying was a particular problem for the commission, since it was rumored to be done straight from the illustrations in Emil Torday's and T. A. Joyce's works on Kuba art.[68] Elizabeth Cameron confirms that "the arrival of the Flemish priests imbued with European ideas of preserving heritage . . . forced the Kuba themselves to move to new production and profoundly changed the meaning of the *ndop*, making it export art."[69]

COPAMI was worried that the school might develop a separate trading post through which they would be able to dominate the artisanal sales of the region.[70] The Kuba king, who was allied with the school, pressured it to hire a Kuba sculptor, Jules Lyeen (son of the former king), in order to have more influence over production. The school, as a result, became something of a "joint venture," as the Kuba historian Jan Vansina put it, effectively locking out COPAMI interference.[71] Clearly, the struggle to gain control over the landscape of workshops, sales initiatives, and art schools was an uphill battle.[72] COPAMI repeatedly ran up against the strong and powerful presence of missionary congregations and schools. Although the commission's relationship with these was not always negative, COPAMI preferred to see stronger state control of the artistic landscape.[73]

The Catholic monopoly on education in the colony wasn't broken until 1958, and little was accomplished in the two years before independence in 1960. In the end, COPAMI never achieved the creation of a fully implemented system of regulation and control and had to satisfy itself with a few directly controlled workshops and constant negotiations with local colonials—be they administrators, company officials, or missionaries—who often resented the meddling from the metropole. Artisanal workshops and art schools, however, were not the only focus of concern for COPAMI and AAI members. Museums devoted to Congolese life and cultures were also accorded place in both organizations' plans for the protection and revival of artistic and artisanal life in the colony.

MUSEUMS IN THE COLONY: A "LABORATORY OF NATIVE POLICY" OR THE DREAM OF A CONGOLESE TERVUREN?

As mentioned at the beginning of this chapter, a number of museums popped up in the colony during the 1930s. They were all the result

of either private initiatives, the collection of artifacts by missionaries, or efforts by AAI branches. In addition to the Museum of Indigenous Life, created by the AAI in Leopoldville, the capital also had a museum of prehistory and a museum of geology. There were two ethnographic museums run by missionary congregations in the Mayombe region, one in Lunda territory and one intermittently under colonial administration in Mweka; geology museums in Jadotville and Bukavu; and of course the Leopold II Museum in Elisabethville, which focused on prehistory and geology.[74] Other ethnographic museums existed, at some point, in Stanleyville, Coquilhatville, Lwiro, and Mushenge.[75] Of all of these ventures, the MVI was the one that drew the most attention from Brussels, and was the most active in the promotion of Congolese cultures.

The colonial administration's increased attention to the artistic life of the colony after World War II created difficulties for local cultural institutions. While Brussels was pushing for centralization and for more control over existing museums, the colonials were torn between maintaining their independence in the face of pressure from Brussels and securing enough funding from the colonial administration to continue operations. These divided interests bred tense relationships, especially between the AAI in Leopoldville and COPAMI in Brussels, and between COPAMI and the Leopold II Museum in Elisabethville.

A closer look at museum politics can offer a window into the wider cultural politics in the colony. How did a museum function in a colonial environment? Were its views on Congolese cultures different from those in the metropole? Was there such a thing as a local (Congolese) audience? Were the views promoted by museums in the colony at odds with the views on culture and authenticity promoted by the metropole? In other words, was value assigned differently in the colony?

During the immediate postwar period, the Museum of Indigenous Life was located in the former Stanley Hotel in downtown Leopoldville, one of the many locations it occupied during its existence. The installation of the material and its contextualization had become both more elaborate and more professionalized since the 1930s. At the entrance to the museum was a map of the colony displaying regions represented by aspects of the material culture. Portraits of the Belgian king Leopold III and the governor-general of the colony, Pierre Ryckmans, flanked the map. The map highlighted art from the western

FIGURE 2.2. Musée de la Vie Indigène, 1946. HP.1955.106.241, collection RMCA Tervuren; photo J. Costa (Inforcongo), RMCA Tervuren ©.

part of the country, largely ignoring the Katanga and the east-central region. A journalist reviewing the museum in 1946 assumed that "industrial development has obviously not been favorable to the progress of indigenous art" in the Katanga region. More likely, the map's emphasis was in part the result of more intense collecting in regions closer to the museum. The division in territorial coverage between the museums in Leopoldville and Elisabethville also mirrored the political distance between the administrative capital of the colony and the economic capital.

The MVI maintained its early division of rooms into administrative provinces and territories, but by the postwar period the displays had become more professionalized, with more enclosed glass cases and clearer labeling. Within the regional divisions, most of the material was classified according to type, such as weapons, masks, and so on. The first room was devoted to the Lusambo province, where the Kuba community lived, although it also included objects from neighboring Luba communities. A Kuba mask took up a central position in the room; other masks lined the walls, along with seats, cups, and musical instruments. One visiting reporter wrote admiringly that one was clearly witnessing the "evolution of an entire dynasty" here.[76]

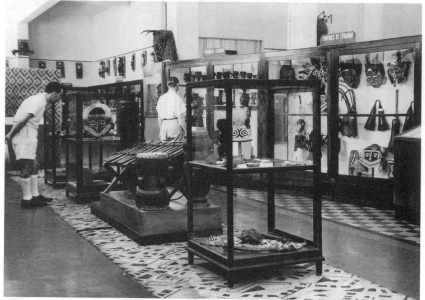

FIGURE 2.3. Musée de la Vie Indigène, Salle Province de Lusambo, 1946.
HP.1955.106.242, collection RMCA Tervuren; photo J. Costa (Inforcongo), RMCA
Tervuren ©.

The following room was filled with material from the provinces of
Leopoldville and Coquilhatville, mostly displays of older ceramics next
to more modern examples. According to the museum's director, Adrien
Vanden Bossche, the examples of older pottery were to help regener-
ate artisanal pottery production. The AAI helped create these displays
so that Africans could be inspired by the work of their forefathers. Ex-
amples of this reinspired work were sold in the museum shop.

In 1946 the museum also included various dioramas: one showed a
Kuba village scene in which the production of crafts was shown. Another
represented a scene of the famous royal Batutsi dancers of Ruanda-Urundi
(also a Belgian colony). Another room was reserved for the provinces
of Stanleyville and Elisabethville and contained a variety of ironworks,
cups, and weapons, with some sculptures mixed in. During a 1953 visit
to the museum that she helped to create in the 1930s, Jeanne Maquet-
Tombu noted with disappointment that the displays failed to emphasize
the aesthetic beauty of the objects and that many of the museum's most
beautiful pieces were not even on display.[77] The presence of dioramas,
reconstructions, maps, notes on the use of objects, and photographs
made for a more anthropological approach to the material.[78]

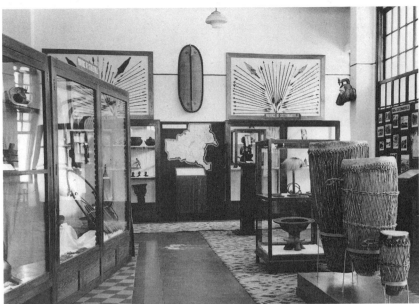

FIGURE 2.4. Musée de la Vie Indigène, corner representing the provinces Stanleyville, Elisabethville, and Costermansville, 1946. HP.1955.106.248, collection RMCA Tervuren; photo J. Costa (Inforcongo), RMCA Tervuren ©.

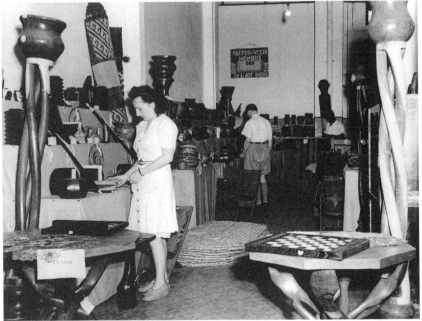

FIGURE 2.5. Musée de la Vie Indigène, crafts shop, 1946.HP.1955.106.249, collection RMCA Tervuren; photo J. Costa (Inforcongo), RMCA Tervuren ©.

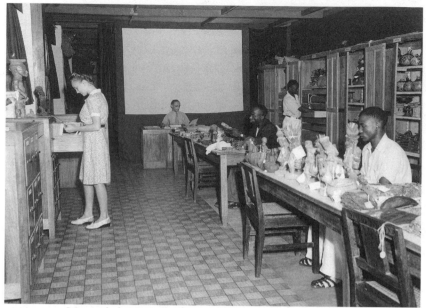

FIGURE 2.6. Musée de la Vie Indigène, 1946.HP.1955.106.249, collection RMCA Tervuren; photo J. Costa (Inforcongo), RMCA Tervuren ©.

Jean Vanden Bossche, son of the first museum director Adrien, started as a curator at the museum in 1951 and took over as director in 1953.[79] He made an explicit distinction between the role of European museums and the educational function of his own museum. In Africa, he argued, "an ethnographic museum must be a laboratory of native policy," a contained setting in which the native population of the colony can be reacquainted with its cultural traditions, which would lead to a reinvigoration of traditional life, and especially artisanal production. If this proved successful on a small scale, it could be a model for the *politique indigène* ("indigenous politics") of the colonial administration as a whole. In addition, the museum was a place for the "collecting, selecting, classifying and studying of material so that the administrative services can use the knowledge when dealing with the local inhabitants." In short, both groups could benefit from the museum: one to rule and the other to value traditional cultural identity and translate it into economic productivity.[80]

Jean Vanden Bossche, who had received formal training in African art history at Ghent University, made a serious effort to draw Congolese visitors to the museum. He organized courses on ethnography reserved for a Congolese audience and group visits especially for Congolese

artisans. Like most COPAMI and AAI members, he believed that access to the rich artistic traditions of the past would reinvigorate a deteriorated artisanal production. To this end, the museum also had a workshop in which Congolese sculptors were welcome to come practice their craft and a sales counter where their works could be sold. The museum, together with AAI, also organized exhibitions and competitions for artisans during the postwar years.[81]

Museum records confirm that a significant number of Congolese visitors came to the museum over the years, although there were always more European visitors.[82] These were not only tourists but also colonial officials on their way through Leopoldville to their assigned stations in the *"brousse"* ("bush"). New recruits to the colony could familiarize themselves with the cultures of their assigned regions by coming to see "how the Black dresses, eats, hunts, fishes, cultivates."[83] For the Western visitor, the image of the Congolese native that emerged from the museum's displays was one that emphasized difference. If any group stuck out, it was the Kuba, whose masks, statues, textiles, and other objects received more space than any other group.

Despite the similarities between the agendas of Vanden Bossche and COPAMI, they had a tense relationship. The commission was frustrated because it had no direct control over AAI or the museum. In addition, over time the museum also considerably expanded its activities as a place for the collection, conservation, and study of Congolese culture, steadily growing beyond the confines of its original identity as a regional museum. COPAMI, and also Vanden Bossche's former professor Frans Olbrechts, were worried that the MVI would become a competitor to Tervuren. Olbrechts, although convinced of the educational value of museums in the colony, did not think they ought to serve as centers for preservation and study but should leave the collection, conservation, and care of Congolese art and ethnography to the metropole, that is, to Tervuren.

The tension between COPAMI and AAI needs to be seen in the broader context of tensions between the colonial government in Brussels and the colonial community in the colony. The concentration of political power in Brussels bred resentment among the political establishment in the colony. This discord was not new: in the 1920s the colony's governor already insisted on more autonomy for his administration. In the aftermath of WW2, the desire to obtain more independence from Brussels in political matters only grew. This was partially

due to the freedom of political decision-making the colonials in Congo had experienced during the war, but also because of the steady growth of the colonial community in Congo. This community was developing its own identity, and it desired more autonomy in the shaping of a "Belgian-Congolese community."[84] A clear expression of this tension was the struggle of people such as Vanden Bossche to carve out a cultural space in the colony that was determined and governed by the colonial community, and where the latter could implement its own ideas about the role and importance of Congolese cultures.

While relations between Belgium and the MVI were tense, those between Belgium and the Leopold II Museum in Elisabethville were even worse. Nor was there much contact between the MVI and the museum in Elisabethville, a result of the tension between the colonial government in Leopoldville and the regional government in Katanga. As the economic pillar of the colonial economy, the Katanga region and the colonial companies that dominated it were less dependent on the colonial government in Leopoldville. The museum in Elisabethville also enjoyed the financial support of these companies, so it had to rely less on COPAMI to advocate on its behalf in Brussels. Nonetheless, the Leopold II Museum and the MVI shared an important interest: their disagreements with Tervuren about the right to collect and preserve Congolese artifacts.

The strained relations between the museums in the colony resulted not just from their different political situations but also from their different curatorial priorities. The Leopold II Museum's origin was in a collection of archaeological artifacts, a category of material in which the MVI was less interested.[85] The Leopold II's collection reflected the region's orientation to what was located in the ground: its most important collections were in mineralogy, prehistory, and geology and were made up of the original Cabu collection and a series of gifts from the mining companies Union Minière de Haut-Katanga and the Comité Special du Katanga. Its ethnographic collections were added later. Founding COPAMI member Gaston-Dénys Périer, during a visit to Elisabethville in 1950, was not impressed with the museum's neglect of ethnography and art, its lack of engagement with the local art scene, or its failure to "intervene and teach the contemporary interpretation of the arts of the past."[86] Périer gave the museum short shrift, since it did have a prehistoric display and an ethnographic collection arranged in chronological order. In contrast to the displays at the MVI, which

at this point were still organized by administrative territories, Burkhart Waldecker, the curator in Elisabethville, choose to organize his collections by ethnic group, combined with displays of objects according to function or custom, an organization Vanden Bossche did not implement until 1954.[87]

In preparation for the fiftieth birthday of the company, the Union Minière and the city of Elisabethville cooperated in the construction of a new cultural quarter in town. Situated in the European (hence white) quarter, it had a theater building and included a music school, a radio station, a stadium, and a building for the Leopold II museum.[88] The striking, modernist museum building, completed right before independence, was by far the best museum building in the colony and the envy of Leopoldville's MVI.

In order to gain control over the museum sector in the colony, COPAMI proposed the creation of a new office, the Office of Museums of Indigenous Life. This office would centralize and streamline the decision-making process with regard to museum politics in the colony and gain control over existing museums. It was to guard against the deterioration of artistic heritage in the colony. Périer in particular counseled haste because the activities of private collectors—especially Americans—meant that heritage would be "lost to us" and to

FIGURE 2.7. Back view of the museum in Lubumbashi, 1971. Ro48–22, Photo Archives IMNC. Courtesy of IMNC.

the "education of the Congolese people."[89] The proposed office would coordinate all collection and conservation of objects of a prehistoric, historic, or ethnographic nature, in addition to representative artisanal material.[90] It would also aim to create an extended network of local museums. The main office would be located in Leopoldville, a decision that would help draw the museum in Elisabethville further into the orbit of the colonial administration and away from the colonial companies' sphere of influence. The proposed structure of the museum office sought a balance between the powers of the colonial government and the representatives of that government in the colony, a situation certain to exacerbate tensions between the colony and the metropole.

Resistance against this plan came not only from the colony but also from Tervuren and, eventually, from the minister of colonies. The MVI director Vanden Bossche was worried about losing independence and being absorbed into a slow and restrictive administrative body.[91] He also worried that Tervuren would swoop in and take the most valuable objects of his museum under the pretense of providing better conservation in Belgium.[92] Tervuren director and COPAMI member Olbrechts, however, also opposed the plan. He argued that such an office, and its museums, would not be able to adequately protect the objects from theft, which he claimed was already a problem, saying that "the Americans are pillaging the Congo and agents of transportations companies are trafficking art." Nor did he think the museums should fall under the control of "a group of friends," a clear stab at the AAI's current control. The best solution would be simply to place the museums under direct state control and to limit their charge to a merely educational one.[93] Clearly, Olbrechts represented the perspective of Tervuren. He felt that all valuable objects should go straight to Tervuren, where they could be properly protected, preserved, and studied. Reproductions of the best pieces in the Tervuren collection, along with less valuable objects of an ethnographic nature, would be sufficient to guarantee the local population access to material that could inspire their artisanal production.

COPAMI member Robert Verly, supervisor of the Tshikapa workshops, was not a fan of the proposal either. In direct opposition to Olbrechts's position, however, he wanted a system in which the emphasis would be on local museums centered around ethnic groups. These "racial museums," as he called them, would be administered by a combination of representatives from the colonial administration and the local traditional elite. Most importantly, he believed that these museums

should get first choice of all artistic material located in their regions, and be able to block objects from leaving the colony.[94] Although he did not mention Tervuren by name, this restriction would prevent the Belgian museum from removing valuable heritage from communities. In addition, Verly argued, once the trust of local chiefs was gained, they would present "their museum" with the objects they had hidden away.[95]

Despite the objections of Verly and Olbrechts, the majority of COPAMI members voted in favor of the proposal, which was then sent to the Ministry of Colonies. Probably because of the many differences of opinion, and in particular the opposition of Olbrechts and Verly, the proposal for an Office of Museums of Indigenous Life got bogged down in administrative procedures. Auguste Buisseret, the minister of colonies, did not lend any real support to the plan. (It was rumored Verly had his ear.)[96]As a result, COPAMI continued to operate in much the same mode as it had before and tried to find different ways of gaining some oversight and control over the cultural landscape in the colony. COPAMI's interest in smaller museums increased, especially in the Kuba region, with suggestions for creating a museum in either Mweka (a colonial center in the region) or Nsheng, the Kuba capital.[97]

Aware of the public relations value of the royal Kuba art—not to mention the revenue generated by the sale of objects based on the Kuba tradition and copies of the most valuable pieces—the Kuba king (also known as the Nyimi) was invested in retaining control of Kuba heritage. One way of doing so was to create a museum. In the early 1950s the Nyimi, together with the colonial territorial agent Charles Schillings, attempted to collect enough funds to build a museum in Mweka and hire a curator. But despite their collaboration, the interest of COPAMI, and the availability of material to put on display, the plans had not advanced beyond the planning stage by the time the unrest accompanying decolonization reached the Kasai region.[98]

COPAMI approvingly noted the "desire manifested by certain leaders of the indigenous world and by several 'évolués,' "to preserve in Africa those objects whose value our administration has revealed to them."[99] Not just the Nyimi but also the ruler of the Lunda people, the Mwata Yamvo, had understood that the presence of a museum increased the economic and financial value of the objects housed in it and could shape people's respect for their culture. The Mwata Yamvo had organized a small museum in Musamba in the Katanga province.[100] COPAMI members appreciated that the influence of the

Kuba and Lunda leaders over a wider territory enabled them to gather objects of value at a regional center, no doubt only enhancing the impression that traditional leadership and artistic preservation went hand in hand, although they were reluctant to release full control over such museum projects.

In Tshikapa, Verly obtained subsidies from the Forminière company and mobilized the local Congolese leadership in support of a local museum. As they wrote to COPAMI, these leaders supported Verly's proposal for a museum "with a resounding 'yes,' like the French people replied to the referendum of General de Gaulle—'yes' to museum 'Tshivulukilu Tshietu'—here in Tshikapa, so that our own children can visit it and so that no collections will leave the territory." The local support for Verly's proposal was based in part on a desire to maintain a form of ownership over their heritage. In referring to the 1958 French referendum—in which the French colonies in Africa voted for continued affliation with France and its new Republic versus immediate independence—the letter emphasized the importance of local consent, but it also accepted a continued colonial relationship. The letter was a clear sign of the times in Congo, where the country's colonial status was starting to be questioned more publicly and cultural politics were an avenue by which this could be done more safely.[101]

The Nyimi, the Mwata Yamvo, and the local leadership in Tshikapa all realized the potential of a local museum. For one thing, it would give them partial control over their communities' cultural production and heritage. Secondly, the letter from Tshikapa also indicated a link between the presence of a museum and political representation. Examples like these underline the political potential of the cooptation of structures of cultural hegemony.[102]

Verly held regular expositions in Tshikapa. These included both pieces he had collected in the surrounding villages and material produced by the workshop's artisans. Both categories of material were displayed alongside one another, blurring the boundaries of the categories of art and craft. There is mention of a small museum in Tshikapa in 1960, but the absence of references to it later on seems to indicate that it was not long lived.[103] The workshops, however, continued to exist well into the postcolonial era. Rik Ceyssens, an employee of Belgian Technical Support, the developmental aid agency of the Belgian state, noted in the 1970s that the workshops still produced pieces "that appeared authentic and fooled many a collector and art dealer."[104]

CONGOLESE ART ON THE EVE OF INDEPENDENCE

By the late 1950s COPAMI, and the colonial government in general, realized that some changes were necessary to diffuse the tensions with the colonial organizations. The law for the protection of cultural heritage was finally applied to Congolese art in the 1950s. Reluctantly, they also came to acknowledge that "European museums had to develop and enrich [their collections] but not at the cost of local museums."[105] Simultaneously, museum life in Congo became increasingly active and diversified.

Because of health problems, Robert Verly was unable to remain in Congo in 1959. The supervision of the activities in Tshikapa was taken over by Paul Timmermans, a Belgian teacher who had arrived in the region in 1956. On the eve of Congolese independence he created the Museum of Art and Folklore in Luluabourg, the regional capital, instead of Tshikapa. The initiative was supported by the governor and the departments of education, public works, and Affaires Indigènes et Main d'oeuvre (the service for indigenous affairs and labor). This was the last museum to be created during the colonial era.[106]

The museum's rooms were organized regionally and included displays of Lulua, Chokwe, Kuba, Pende, and Songye material. Timmermans aimed to show both "objects of artistic value and of interest

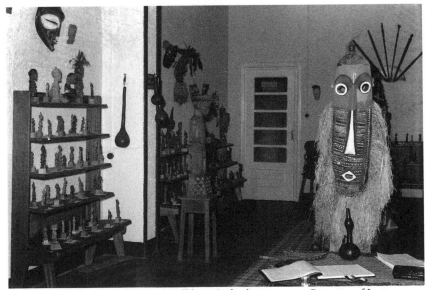

FIGURE 2.8. Museum of Art and Folklore, Luluabourg, 1959. Courtesy of Jan Raymaekers.

from the point of view of folk-lore."[107] Tempering the antimodernism of earlier years, Timmermans saw the acquisition and enjoyment of knowledge of the past as part of modern life: "It is our duty to demonstrate and reveal the beauty and educative value of the cultural life of the past. Every African tribe has the right to its own museum." Although the burden to instruct still lay with the Belgians, it became more important to "show [the Congolese] that the fact that we exhibit these objects is evidence of the interest we take in any artistic or folk-art production."[108] While the museum's exhibitions and educational program (Timmermans traveled to schools and workshops with small collections of objects) were geared more toward a Congolese audience than in any previous colonial museum, the distinction between education for the Congolese and research and documentation for the Western audience remained firmly in place.

By this time, the goals for the MVI had also shifted. The impact of the younger Vanden Bossche's vision increased with the 1954 reopening of the museum in the old Hôtel des Postes. Although Vanden Bossche continued to devote attention to the educational value of the displays, he modernized them along the lines of a more art historical, or aesthetic, approach. He reduced the number of objects per case and "endeavored to adopt for each showcase an arrangement striking to the eye." In terms of the overall arrangement, he chose a combination of "ethnological and ideological" approaches, which in general meant that some objects were grouped according to ethnicity and others arranged to afford "a general impression of how a given object was used."[109] The dioramas, considered outdated, disappeared. This new approach represented a middle road between the ethnographic and the art displays at Tervuren; the director did not abandon the ethnographic displays, which he deemed necessary for educational purposes, but he desired to give the museum a more "modern" appeal by also including objects that had become recognized as aesthetically pleasing, highlighting their appearance over their educational value. Vanden Bossche's ambition to challenge Tervuren's monopoly also grew consistently. He wanted the MVI to be taken seriously as a museum with a scientific mission where research went hand in hand with the possession and conservation of valuable pieces. It is possible that these modifications also reflected the changing tastes of the museum's Western audience and their desire to see the growing urban "sophistication" of Leopoldville reflected in its museum's modernization. As has been

clear throughout this story, the colonials in Congo gradually emerged as a community with different opinions about the colonial project from those of the colonial government in Brussels, and they attempted to carve out a space for themselves politically, but also culturally.

Possibly the most important cultural development of the 1950s was the rise, particularly in Leopoldville and Elisabethville, of a modern art scene. Biennales, or "Artisanal Expositions," were a common feature of colonial life and took place in several regional centers. The earlier versions of these exhibitions displayed artisanal production and offered prizes for the best submissions. The 1952 Artisanal Exposition in Leopoldville, for example, looked for objects that displayed the "persistence of traditional Bantou art." (The dubiousness of that category is clear from the winning object: a chess set.)[110] Slowly but surely, however, the art created by art school students and by a few independent artists, such as the painters Mongita and Bela, began to appear in these expositions. Vanden Bossche, in particular, made an effort to include material that did not come from the traditional artisanal workshops.

Symptomatic of the changing attitude of the colonial elite was the 1956 biennale in Leopoldville, envisioned as a new approach to the "Congolese artistic problem," that is, the decline in quality—and hence "authenticity"—of the artisanal production. As we've seen, COPAMI's attempt to "revive" Congolese art by trying to organize artisanal production under colonial or Western supervision was unsuccessful. Eventually, certain colonials started looking elsewhere for a true "Congolese" art: one that represented the contemporary identity of the colony. It was in the art schools that answers to this desire were found.

The 1956 exposition was divided into two parts. The first part of the exposition, "Primitive Art from the Traditional World," was displayed at the Academy of St. Luc. Objects were vaguely described as "statue," "bust," "drum," "carving," and so on, and few of the 105 objects were attributed to a specific artist. Rather, they were identified according to the ethnicity of their makers and their administrative unit (either a *territoire* or a village). The use of the word "art" instead of "artisanal" in the section's title, however, indicated the organizers' desire to associate the objects with the by now renowned concept of primitive art.

The second part of the exposition, entitled "Art Schools and Workshops," was on display at the Museum of Indigenous Life and consisted of work produced under European supervision in the Alhadeff workshop and at the Academy of St. Luc. This section was divided

into three groups: the Alhadeff "school," the Shamusenge workshop (in Kahemba), and the St. Luc academy. The location of this section of the biennale in the museum created a different context for the material than the artisanal displays in the classrooms of St. Luc. The exhibition at the museum was presented in a sleek and modern style, with very little accompanying text, inviting visitors to solemn reflection on the aesthetic qualities of the pieces. The displays were arranged according to type, divided into sculpture, ceramics, and painting. Although the sculptural and ceramic pieces were labeled with the same vague designations as in the traditional section of the biennale, they all bore the names of the individual artists. Clearly, the organizers assumed that ethnic identities only existed in the context of "traditional" work and were of no consequence in the context of artistic modernity. Instead, a national designation introduced the paintings in the modern section.

It was the painting section in particular that excited Vanden Bossche, who saw it as "an art with a European character but in which the young artist is nonetheless left free in the choice of colors, the play of composition and the spirit of its themes." He argued that in urban, nontraditional environments it would be wrong to subject artistic development to "those who wanted to conserve its purely traditional character." Further, it was "unreasonable to want to introduce European customs and material values in the colonies and refuse all association with the local creative and spiritual values." Instead, a new Congolese art could "enrich the artistic patrimony." By characterizing this new art as Congolese, instead of the usual terms *native, indigenous,* or *traditional,* and by embracing its urban character, Vanden Bossche moved beyond the careful acceptance of cultural and artistic change expressed in COPAMI's politique esthétique. In fact, he criticized that document, writing that a clear overview of the art scene in the colony was necessary before launching a politics of aesthetics.[111] The Congolese author Jean-François Iyeki wrote about the exhibition in the same terms as Vanden Bossche: painting was emerging as a new Congolese art, representing the new Congo, which was a mix between European influences and Congolese adaptations, yet expressing the same "Bantou soul" that had permeated traditional art.[112] Despite this enthusiasm for painting as the new Congolese art, however, no independent artists—of which there were a few in Leopoldville, including Mongita—were allowed to participate in the biennale.[113] This affirmed the importance of the workshops and art schools.

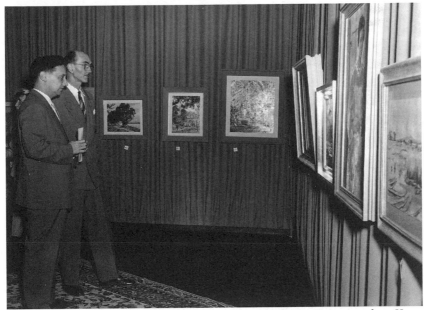

FIGURE 2.9. 1956 Biennale. HP.1956.32.677, collection RMCA Tervuren; photo H. Goldstein, Sofam ©.

Authenticity, as the defining characteristic of Congolese artisanal traditions, was tied to certain conditions of production and origin. The same desire for authenticity was present in the gradual acceptance of a modern Congolese art. This time, authentic inspiration was connected less to traditional production techniques and modes of expression than to the inspiration and themes of the work. What remained constant was the need to maintain Western oversight and protection of the process of creation and the aversion to any depiction of Western modernity. In the acceptance of the "new" Congolese art on display at the MVI, we can see the acknowledgment of a certain Congolese modernity. This modernity, however, was required to be "authentically" African in its inspiration.

⤷

MUSEUMS IN the colony were not merely viewed as places for the protection of Congolese heritage. They were also considered as spaces where contemporary Congo, and its cultures, could be shaped. Jean Vanden Bossche, who described his museum as a "laboratory for native policy," clearly believed the MVI could help construct a new reality for the world outside of the museum.[114]

Jean Vanden Bossche's description of his museum as a laboratory is a remarkable illustration of Tony Bennett's theorizing of museums

as "civic laboratories"—spaces that are simultaneously civic and epistemological.[115] Colonial museums presented an epistemological universe, in which different Congolese cultures were ordered. This varied from an order that reflected the administrative divisions of the colony (as the MVI did early on), to those that presented a hierarchization of objects and defined which ones occupied the status of "art" (like the MVI did in later years), to those that gathered regional objects, thereby defining and delineating local cultures (like Verly and Timmermans did).

These spaces were also civic, however. They tried to educate colonials on the cultures of the colony, with the belief that they could fulfill their duties better if they had knowledge of the cultures of the colonial subjects. But most of these museums also aimed to educate colonial subjects about the value of their "authentic" cultures. Even more so, men like Vanden Bossche, Verly, and Timmermans believed that they could renew the relation between Congolese artisans and their traditional art, which would lead to a reinvigoration of artisanal crafts, and even of "traditional" society. In the case of Jean Vanden Bossche and the MVI, this went a step further. In his embrace of a new and modern Congolese art, he defined the museum as a location in which the contours of a new and modern Congo, and possibly a new Belgian-Congolese community, took shape. This new Congo was one shepherded by colonials like himself, and not by the metropolitan powers such as COPAMI or the Tervuren museum.

What did the Congolese population think of all of this? As we have seen, a number of Congolese leaders were drawn to the idea of having a local museum in the hopes it would both safeguard their heritage and promote local artistic traditions and, therefore, the economy, but also because of the connection between the ownership of heritage and the legitimation of political power, exemplified by the rhetoric of cultural guardianship deployed by Tervuren but also by the museums in the colony.

Congolese artists were also involved with workshops and schools as teachers. The Kuba sculptor Jules Lyeen, for example, taught at the Josephite school in Mushenge. In the Alhadeff workshop in Leopoldville, more experienced members often guided younger members, and at Tshikapa, Robert Verly relied on older craftsmen and artists in the region to teach in the workshops.

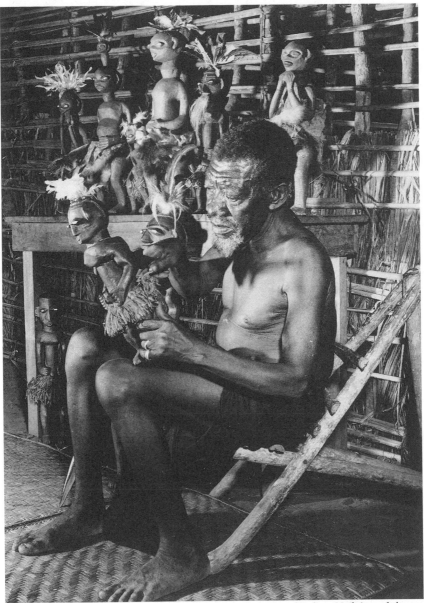

FIGURE 2.10. The sculptor Kaluesha, who worked in one of Robert Verly's workshops, 1957. HP.1957.1.743, collection RMCA Tervuren; photo C. Lamote (Inforcongo), RMCA Tervuren ©.

COPAMI, however, operated in complete isolation from the Congolese population. When Antoine-Roger Bolamba, vice president of AAI, editor-in-chief of the colonial adminstration's newspaper *La Voix du Congolais*, and noted poet, visited Brussels as a member of a delegation of évolués in 1953, the COPAMI leadership neglected to invite him to a meeting.[116] Bolamba, who also wrote for *Brousse*, the AAI journal, was one of only two Congolese members of AAI in Leopoldville, along with Maurice Kasongo.[117] Toward the end of the 1950s, Bolamba and Kasongo became significantly less active in AAI, around the same time when political organizations were starting to appear on the Congolese scene. These organizations offered the Congolese a more significant opportunity for participation in the political life of the colonial state than cultural organizations did.[118] In the case of Bolamba, his advocacy and praise for the cultural heritage of his community, the Mongo, was due to the influence of the Mongo unification movement and translated into his commitment to Mongo unification as a political goal.[119]

Not until the eve of independence did COPAMI consider the possibility of Congolese members, and it did so only in a bid for continued relevance after Congolese independence. COPAMI suggested to the Ministry of Colonies that it should continue its work after independence, with a few changes. Half of the commission members should be Congolese, and the name of the commission needed to be changed: "To avoid certain reproaches from [the Congolese], the removal of the terms *protection* and *indigenous* from the name of our commission [is recommended,] the first because it represents a certain paternalist tendency in the eyes of some Congolese [and] the second because it is pejorative and limits us to traditional [art]."[120]

In addition to these mostly cosmetic changes, COPAMI hinted at the role cultural politics might play in the process of decolonization: "In certain African and even European and Belgian milieus there exists the question of a return to Congolese artists of the educative documentation that constitutes the artistic collections at Tervuren."[121] This was not a new sentiment. In 1957 COPAMI members noted that "the irritation has been easy to see with our African visitors to the museum in Tervuren, and in the face of the expatriation of the riches they are starting to regard as a cultural patrimony."[122]

Several decades of changing views on the nature and value of Congolese art were translated into a cultural agenda for the independent

state that included taking possession of these collections, which had been defined as authentic heritage. As the next chapter will explore, Congo's demand for the return of its artistic heritage formed the start of a long period of negotiations about restitution that were deeply revealing of competing interpretations of Congo as a postcolonial nation.

3 ⌐ The Art of (Re)possession

Heritage and the Cultural Politics of Congo's Decolonization

In April 1960, only months before Congo's official independence on June 30, *Notre Kongo*, the periodical of the Association of the BaKongo, a leading political party in Congo, questioned Belgian ownership of the collections of the Royal Museum of the Belgian Congo near Brussels.[1] If Congo was becoming an independent nation, did it not have the natural right to possess its own national heritage? Were the objects in the museum's collections not a resource of the country, like its mineral wealth? These challenges, and the support they received across the political spectrum in Congo, led to long-term, continuing conflict between Congo and Belgium over ownership of museum collections. Initially, these debates played a role in the nations' bilateral relations, but gradually their impact extended into the national cultural politics of the Mobutist state and international world heritage politics.

Congo's road to independence was a short one, and its aftermath was marked by violence and international intervention. Many Belgians—politicians, colonials, and the general population as well—were rudely awakened by the violence that broke out in Leopoldville in 1959. It was a shock to a colonial regime that had prided itself on being exceptional and thus immune to the unrest that was spreading through other colonies in Africa. Political decolonization followed less than two years after the first outbreak of violence in Leopoldville. The subsequent Congo Crisis, marked by Belgian and international intervention in the newly independent country and the murder of Patrice Lumumba, the county's first democratically elected prime minister, attracted worldwide

attention. This version of the history of country's decolonization is dominated by political and military events. But there is another story to be told about Congo's decolonization that reflects a struggle over cultural guardianship. We can trace this aspect of the decolonization process in the ongoing debate between Belgium and Congo about the rightful possession of the collections at Tervuren.

Between 1976 and 1982, 1,042 ethnographic and art objects were shipped from the Royal Museum for Central Africa (RMCA) to the Institute of National Museums in Zaire (IMNZ).[2] On the surface, this looked like a victory for Zaire's ruler, Joseph-Desiré Mobutu; a response to his forceful demand for restitution of a cultural heritage that had been subjected to "systematic pillage."[3] This public version of the events, however, ignores a far more complicated history of negotiations, one that is deeply revealing of competing interpretations of the process of decolonization.

The history of the demands for restitution and the eventual return of some objects to Zaire is also used here to explore the postcolonial imagination of the country's cultural sovereignty. Two historical events that were particularly important—the creation of the Institute for National Museums in Kinshasa and the launching of the campaign for cultural authenticity (*authenticité*) by the Mobutu regime—provide the starting point for a discussion about the nature of Zairian postcolonialism that is continued in the following two chapters. In this chapter, I focus on the relationship between the process of cultural decolonization and the creation of a postcolonial state, and more particularly on how the Mobutu regime retooled colonial ideas about cultural authenticity into an ideology of national and postcolonial authenticity and appropriated the process of decolonization for the construction of an autocratic state. This account will confirm what Bogumil Jewsiewicki has written: the historical basis of the political logic of the Zairian second republic, created after Mobutu's 1965 coup, needs to be traced to the Belgian colonial regime.[4] This chapter reveals how Belgian's creation of the cloak of cultural guardianship as a legitimation of its colonial rule impacted the postcolonial *imaginaire politique* both in terms of the creation of political legitimacy, as well as in its totalitarian nature.[5]

LES CONTENTIEUX: NEGOTIATING DECOLONIZATION AFTER INDEPENDENCE

The previous chapter revealed Congolese attempts to create locally controlled museums by local leaders such as the Kuba king and the Lunda

ruler, as well as a growing dissatisfaction with the Tervuren museum's possessions on the eve of independence. Both signaled the rising political role of traditional arts as heritage, a role that would become even stronger in negotiations for independence. With Congolese independence on the horizon, Congolese political organizations and the media picked up on the earlier references to Belgium's possession of large collections of Congolese ethnographic and art objects, and reformulated them as elements in the quest for decolonization.[6] What made these collections so important was both the financial value they had garnered at this point, which cast them as economic resources, and their symbolic value as representatives of an African precolonial heritage.

The appropriation of economic resources, a fundamental aspect of Belgian colonialism, took center stage in the Belgian-Congolese negotiations in preparation of independence. Roundtable meetings addressed the political structure and economic processes of separation. Ownership of several large colonial companies (such as the Union Minière du Haut-Katanga, the largest mining company) was shared by private and state interests, and although Congolese negotiators expected the state holdings to be transferred to the independent Congo, this plan was far less appealing to Belgium, since it would make the newly independent republic a large stockholder in various Belgian companies in Congo. The failure of the transfer of these holdings resulted in demands for their restitution by the newly independent Congolese government. These disputes, referred to as the *contentieux*, dragged out for several decades.[7]

Accounts of the history of the contentieux neglect to inform that in the early to late 1960s the demands for the restitution of the Tervuren collections became attached to the demands listed as contentieux. Initially, these included all the collections of the museum and the ownership of the buildings, but gradually the demands focused on the collections of ethnographic objects, particularly on those now categorized as art. It was clear that possession of these particular collections played an important role in how sovereignty was imagined in Congo by both the media and the political world.

The Congolese demands caused a stir at the museum in Tervuren. It did not help that Belgian government officials in the early 1960s initially acknowledged that Congo's demands had a "legal base."[8] Although they were kept off the table during the roundtable negotiations, the Belgian government realized that the issue would eventually

surface, making it crucial for them to control negotiations and thus avoid the depletion of what was now considered Belgian patrimony and to make sure the debate would not become a trial on the legitimacy of Belgian colonialism.

The RMCA's response to the Congolese demands highlighted the fact that the Belgians had a far more limited view of decolonization than the Congolese, in part because of their different views of the colonial past. Lucien Cahen, who had become director of the RMCA in 1958, constructed a defense of his institution's possessions. First, he pointed out the universal scientific value of the collections as they existed.[9] Second, he argued that none of the museum's collections had been acquired in an improper or illegal manner. Third, Cahen questioned Congo's focus on Tervuren's collections instead of other collections of Congolese art abroad. Last, he cast doubt on the newly independent country's ability to safeguard the valuable collections of art, as evidenced by deterioration of the colonial museums and the presence of objects "of direct (fraudulent) Congolese provenance" for sale on the New York art market.[10] In portraying Congo as an immature state unable to protect the heritage still in place, Cahen reaffirmed Belgium's role as cultural guardian, and Tervuren as a safe haven for Congolese art.

He admitted that "it is true that public Belgian and Congolese funds have contributed to [the museum's] maintenance, but the museum of Tervuren is not . . . 'exclusive' property of the Congolese state . . . a division of the collections in accordance with the funds received from each source would encounter numerous practical problems and would above all obliterate the scientific effort, *unique in the world*, that has been accomplished here."[11] Cahen's response to Congo's claims was not entirely negative, however. In the early 1960s, he employed a dual strategy and suggested an alternative by which the RMCA "would assist in the creation of a large national museum in Leopoldville" and perhaps provide it with a "gift . . . in the context of exchange and in an atmosphere of understanding and mutual respect," provided it would "not be *accountable for filling* a national museum."[12]

The chaotic situation following Congo's independence delayed official negotiations about the contentieux, although a partial resolution emerged in 1965 whereby the holdings of the former colonial companies were transferred to the new nation and an arrangement was reached about the colony's debt.[13] Congolese claims on Tervuren's

art collections remained unresolved, however, only to reemerge later, both in the context of the national cultural politics of Mobutu's regime and as elements in its international aspirations.

PERSONAL POLITICS AND THE FOUNDING OF THE INSTITUTE OF NATIONAL MUSEUMS IN ZAIRE

Asked about the founding of the Institut des Musées Nationaux, current and former employees speak of Léopold Senghor's visit to Congo in the late 1960s. The Senegalese president is said to have asked Mobutu to visit a museum to admire the world-renowned Congolese traditional art. Realizing that Kinshasa had no museum to showcase its national art, Mobutu decided to create the institute. Whether this exchange between Senghor and Mobutu actually occurred is secondary to the exemplary founding myth it provides for the IMNZ. It depicts Mobutu as the keeper of his nation's artistic heritage and places him alongside Senghor, one of the great symbols of African independence and cultural identity, setting the museum's founding firmly in the tradition of African cultural independence and Pan-African unity. The real history behind the museum's founding, however, takes us back to the contentieux and the construction of Congo's cultural sovereignty by Mobutu's regime.[14]

Mobutu's rise to power in 1965 initiated a period of relative stability. Belgium's early enthusiasm for his reign was quickly tempered, and relations between the two countries fluctuated, which the Belgians blamed on Mobutu's "unreliability." While Mobutu could be irascible, Belgium's discomfort also had to do with his effort to construct economic and cultural sovereignty for Congo by pursuing the ownership of economic and cultural resources in a renewed commitment to an extended process of decolonization. These processes, however, served an increasingly authoritarian system of power.

After unsatisfactory negotiations with Belgium in 1966 about the ownership of the Union Minière du Haut-Katanga, one of the most valuable economic resources in the country, Mobutu decided to nationalize the mining company. Founded during the era of Leopold II, it was the largest mining company in the country, mining copper, cobalt, tin, zinc, and uranium.[15] Since the Union Minière was largely owned by a Belgian holding company, this takeover brought relations between the two countries to a standstill.

In a system parallel to regular diplomatic contacts, the personal diplomacy of the rotating cast of Belgian advisers to the Congolese

president often achieved resolutions to these difficult situations.[16] One of these advisers was Colonel J. Powis de Tenbossche (1924–99). The Belgian nobleman arrived in Congo in 1949 as a military official and started working with Mobutu around 1963.[17] For many years, he was a crucial liaison between Belgium—particularly the royal court—and Mobutu's camp.[18] After the nationalization of Union Minière he played a pivotal role in the resolution of the tension this created between Belgium and Congo by acting as intermediary between the Congolese presidential office and the Belgian government.[19] It is not surprising that he took on the same role when the issue of cultural restitution resurfaced, especially since the collection and preservation of Congolese traditional art was high on his personal agenda.

What brought the Congolese demand for cultural restitution back to the foreground was the controversy over the traveling exhibition *Art of the Congo*, co-organized by the RMCA and the Walker Art Center in Minneapolis. Made from select pieces of Tervuren's collections, *Art of the Congo* relied on the prestigious place of traditional Congolese arts in the realm of "primitive" arts and served to advance the position of the RMCA in Belgium as the proper place for the protection and appreciation of Congolese cultural heritage. That exhibit, which toured prestigious American museums in 1967–69, provoked the ire of Mobutu, who saw it as the ultimate illustration of Congo's lack of control over its resources, its inability to represent itself through its own cultural heritage, and a continuation of colonial structures of representation and possession in a postcolonial setting.[20]

The parallel diplomacy of Powis, which had proved useful during the Union Minière talks, also created a breakthrough in the case of Congolese traditional art. Colonel Powis and Tervuren director Lucien Cahen met in person during a visit to the Royal Palace. Powis's direct access to Mobutu and Cahen's position as director of the RMCA allowed them to discuss the matter directly, circumventing numerous layers of government officials. Belgium was more responsive to Congolese demands this time but paid careful attention to the framing of the negotiations. It wanted the term *restitution* avoided at all costs because its use acknowledged the legitimacy of Congo's interpretation of decolonization as a compensation for previous exploitation. Also, Cahen wanted the talks to "start from the principle that there are no more Congolese claims on all or part of the 'museum of Tervuren.'" Congo was to drop all references to the other contentieux in the talks because

they tied negotiations over Tervuren's collections to debates about the Belgian colonial regime. There were also practical requirements: Congo had to have a museum to house the objects and needed to develop legislation against exportation of traditional art from Congo. By pointing out these deficiencies, and ascribing them to the postcolonial government instead of the colonial past, the Belgian government again undermined the idea of Congo as a legitimate, or "adult," state—implying instead that it needed guidance and development—and erased the failings of the colonial state. If these demands were met, Cahen suggested, he would be able to convince the Belgian government to donate to Congo the two hundred pieces of the *Art of the Congo* exhibition.[21] Additionally, in his correspondence with Powis, Cahen suggested Congo and Belgium could collaborate in creating the necessary cultural infrastructure in the form of a museum institute in Congo. That proposal allowed the RMCA to play a significant role in shaping the cultural contours of postcolonial Congo. Furthermore, it allowed Tervuren's staff to do field research again: since the advent of Congolese independence, the museum's scientists had not had ready access to the country, which in the long run could negatively affect Tervuren's reputation as an epicenter for the study of Congo.

In his communications with Mobutu, Cahen was careful to frame the museum project in terms of its benefits for the Republic of Congo by emphasizing that the museum would be unique in Africa and comparable to what Leopold II had created in Tervuren: "The spirit in which the exhibitions will be created will be motivated by a concern to show the similarities in the regional diversity of traditional Congolese styles [and] the similarities in the Negro-African arts and cultures [in general]," he wrote to "mon Général."[22] But in his communications with the Belgian government, Cahen held back. He emphasized the need for care in choosing the terms to describe the possible transfer of objects as a "long-term (or permanent) deposit, thus without an official transfer of the property title."[23] During the late sixties and early seventies, Congo was riding the wave of the copper boom, with money flowing into the country. The state benefited from these revenues, and Mobutu had money to spend on nation-building projects. A museum, unequaled on the continent of Africa and showcasing the famous (and valuable) "traditional" art of the region, was exactly the kind of project he envisioned.

The agreement for the creation of the Institute of National Museums was signed on April 30, 1971.[24] Officially, the Belgian contribution

was limited to a five-year period of technical help supplied by the experts of Tervuren, the planning of mutual field missions (during which the new museum institute would benefit from Tervuren's logistical aid), and internships for the institute's staff at Tervuren.[25] In practice, however, the cooperation was very close, especially because Lucien Cahen, director of the Belgian museum, was also named general director of the museum institute in Kinshasa.[26]

Aside from gaining opportunities for field research for the RMCA, Cahen succeeded in (temporarily) avoiding the issue of real restitution. And whereas the negotiations began with the idea that a "gift" of objects would be forthcoming, this clause did not make it to the final agreement, leaving the option of a gift up to the good will of Belgium. The agreement made Belgium look like a benevolent former colonial power, graciously willing to assist in the development of a struggling third-world nation.

The Mobutu regime, on the other hand, obtained from the Belgians the know-how and educational resources to create a national museum, which Mobutu hoped would become a symbol of cultural sovereignty and a valuable tool to promote nationhood and create citizenship.[27] The presidential office wanted the IMNZ to create a national collection of traditional art to use in national and international exhibitions. It also saw the IMNZ as a place where the creation of scholarly knowledge about Congo's traditional cultures could be reclaimed from foreign scientific institutions. Lastly, the IMNZ could serve as a place for the formation of a Zairian intellectual upper class.[28] This Zairian vision of the IMNZ was underwritten by the International Council of Museums, which was enthusiastic about the opportunities presented in Kinshasa, believing that the creation of a "truly African museology," removed from European traditions and adapted to "building a new culture combining traditions and progress," was central to decolonization.[29] With a fully staffed museum and a university in the same city, Kinshasa would be a good candidate to succeed Jos, Nigeria, as the center for training museum personnel.[30] Whether or not the IMNZ lived up to these expectations, and whether it represented a truly African museology, will be the subject of the next two chapters.

THE POLITICS OF NATIONAL AUTHENTICITY AND ZAIRIAN CULTURAL SOVEREIGNTY

Creating a museum institute in Zaire did not end the discussion about cultural restitution. Cultural politics came to the forefront of Mobutu's

national politics in the 1970s under the new ideology of authenticité. The cultural and political agenda of this new phase in cultural politics couched the issue of restitution in a broader struggle for cultural identity and sovereignty.

In 1971, the Mobutu regime made the politics of authenticité the state's official ideology. Reorienting the country's cultural identity to "authentic" indigenous African values, it intended to end the cultural alienation attributed to the colonial experience. The goal of this new ideology was a veritable "cultural revolution," in which a new national, authentic Zairian nation would be born out of the values and traditions of precolonial Zairian cultures.[31] The discussion about the contentieux was now recast in a much wider context, where the literal reclaiming of objects of cultural heritage from Tervuren in the name of the nation came to stand for a symbolic reclaiming of the entire heritage. Despite its guise as cultural politics aimed at erasing the impact of colonialism, in reality authenticité entailed an appropriation of colonial epistemes for the construction and justification of postcolonial systems of power.[32]

The most visible practices associated with authenticité were marches and public spectacles that included dancing and singing and were known as *animation culturelle et politique* (cultural and political entertainment), and new rules, such as the adaptation of new "Africanized" names and clothing replacing Western naming and dress. Western dress was discouraged in favor of the "abacost" (a name derived from the French *à bas le costume*, "down with the suit") for men and the pagne (wrapper) for women. Colonial monuments were removed from the cityscape, and Christian names abandoned in favor of Bantu names. Joseph-Desiré Mobutu himself became Mobutu Sese Seko Nkuku Ngbendu wa Za Banga. The country, its famous river, and the country's monetary unit were renamed Zaire. Terms such as *monsieur* and *madame* were replaced with the bourgeois-free *citoyen* and *citoyenne*.[33] The new policies were also felt in an increased promotion of traditional cultures.[34] The fabled traditional art was considered one of the "natural" resources for this cultural "revolution"; its continued presence in the showcases of Tervuren, therefore, was all the more heinous in the eyes of the Mobutu regime.

The legitimacy of the state of Zaire, and the "narrative of the past," were of unique concern to Mobutu's regime.[35] As the space where the embodiment of cultural authenticity was preserved, the museum was (theoretically) able to transfer this authenticity back to a nation and its

population through its exhibitions and educational activities, radically altering the position of the museum objects in the narrative of progress. Instead of being mere representatives of a culturally "pure" past, they now played a role in the making of the modern future of Zaire as a nation. The precolonial past that was central to the imagination of authenticité, however, was rarely defined in the affirmative, merely as the absence or erasure of colonialism. The undemocratic start of Mobutu's regime in a coup, and its structural origin in the colony, needed to be erased, making this exercise in history construction through the erasure of the colonial era doubly important. The museum was one of several elements of the "culture complex" that emerged.[36] A variety of cultural institutions were either created or reinvented. These also included a national ballet, a national library and archives, a national cultural festival, and plans for a national theater.

Central to the ideology was the belief Zairians suffered from cultural alienation, which manifested itself as "an inferiority complex and a negative self-image" and which led them to "copying and conforming to colonization and a foreign model," but which could be combated by a cultural struggle for "the re-personalization, the rehabilitation, and the promotion of national creations and values."[37] The animation culturelle et politique was a clear example of a state-sponsored initiative to counter this perceived cultural alienation of the population. These organized events of singing, dancing, and theatrical performances, extensively broadcasted by the state-controlled Zairian television, drew upon a mix of traditional and urban music and dance but always included great praise for the leadership and person of Mobutu.[38]

The ideological inspiration for authenticité is easily traceable. Pan-African thinking and Léopold Senghor's concept of *Négritude* hover near the surface. The writings and speeches of the commissioner of national guidance, Sakombi Inongo, and the commissioner of culture and arts, Bokonga Ekanga Botembele, bear the mark of Cheikh Anta Diop's reclamation of the history of the African continent for Africans, the Pan-African nationalism of Edward Wilmot Blyden, and the writings of W. E. B. Du Bois.[39] Authenticité, however, was not focused on race but on culture, which made it much more locally adaptable. Like Négritude and Pan-Africanism, its purpose was to unite. In this case, that meant creating a sense of nationhood and citizenship for Zairians.[40] A sense of national unity was of central importance to the Mobutu regime, which came to power in a country heavily splintered

by local and ethnic allegiances. Authenticité had the potential—or at least the goal—of creating an overarching, generalized "native" cultural identity tied to the Mobutist state. Like Senghor's Négritude, it was a tool used to advance "cultural, political and economic development plans."[41] However, attributing authenticité to the influence of *Négritude* alone obscures the intellectual and ideological roots of authenticité in European modernist traditions (deeply formative of Négritude as well.)

Initially termed the *retour à l'authenticité* (return to authenticity), the campaign was soon adapted into *recours* (recourse) *à l'authenticité* in order to emphasize that the ideology was not about moving backward but about creating a new nation that was authentically African. Although this new nationhood was supposed to be inspired by "pure" African traditions and values, it was in itself a modern concept designed to modernize the way Zairians experienced allegiance to the state. The cultural authenticity bestowed upon African art objects by primitivist modernism became a cultural authenticity upon which an African modernism could be built. Creating a distance from Western and colonial influence through a decolonization of culture was a process that reproduced the deep paradox of primitivist modernism and colonial humanism, in which an admiration for and inclusion of otherness was wrapped into the civilizing project.

It appears that the architects of authenticité and Zairian cultural politics (which included Kalande Mabika, Sakombi Inongo, and Bokonga Ekanga Botembele) drew inspiration from *Bantou Philosophy* (1948), the work of the Belgian missionary Placide Tempels on African cosmology, and from the scholarship on Congolese cultures of the historian Jan Vansina, in order to build an image of a unified Congolese culture.[42] Also undeniably present were colonial ideas about the value of rural, traditional life, as well as the simultaneous acknowledgment of ethnic diversity and the erasure of its particulars in favor of a vague "indigenous" identity that had also characterized the presentation and promotion of arts and crafts in the colonial era.

Although not officialy enacted until 1971, authenticité bore the stamp of the political atmosphere of the late 1960s, when nationalism became the central organizing principle for the Mobutu regime as a way of creating political legitimacy for itself. The 1967 N'Sele Manifesto established a process of political centralization with the establishment of a one-party system around the state party Mouvement Populaire de

la Révolution (People's Revolutionary Movement; MPR).[43] Relying on what is now called "the myth of the chief," Mobutu argued that this model of centralized and one-party rule was more suited to the history of the African peoples, who were used to being ruled by a chief who consulted with his advisers but whose decisions were entirely his own.[44] Mobutu declared: "All the meaning of our search, all the meaning of our effort, all the meaning of pilgrimage on this African earth, is that we are seeking our authenticity, and that we will find it because we want, in all the fibers of our profound being, to discover it, each and every day. We want, in one word, we all other Congolese, to be authentic Congolese."[45] With the MPR in place, the political system also included a unified union and youth organization.

The process of cultural decolonization that authenticité was designed to advance was similar to political and economic processes of decolonization aimed at nationalization of the country's economic resources. The nationalization of the Union Minière was followed by a "Zairization" of foreign-owned businesses in 1973, driven by a desire to keep their profits in Zairian hands. Although the effects were disastrous and attempts were made to reverse some of these policies years later, they were similar to the process of cultural decolonization attempted with authenticité: the goal was the nationalization of resources, whether cultural or economic, thereby reversing the effects of colonialism.[46]

The vagueness of authenticité was also what made it, in Bob White's words, "one of the most powerful rhetorical tools of the regime."[47] It was simultaneously a "new aesthetic vision" and a tool for political action, for the forging of a national culture, and for promoting centralized state authority over ethnic divisions.[48] There are noticeable similarities to the politique esthétique established by representatives of the colonial state (see chapter 2), although it had a much stronger presence in people's lives than the latter, a testament to Mobutu's political power. The public dance and singing spectacles were a real part of many people's lives, as were the folkloric "ballets"; and authenticité had an impact on the music industry as well.[49] In addition, it was an excellent tool for the international promotion of Zaire, on both a Pan-African and a global level. Mobutu had witnessed the impact of Senghor's Négritude across African and in the West, and was eager to claim a leadership role in Africa and to use the admiration for Congolese art to his regime's advantage.

Not surprisingly, the politics of authenticité and increasing claims on the country's resources led to reinvigorated attention to the issue of

cultural restitution, with Mobutu strategically relaunching the debate during an international meeting of art critics in Kinshasa. Addressing the opening session of the conference, he broached the subject of restitution in language directed at a larger, international battle in which Zaire was taking the lead:

> Our artistic patrimony has been subjected to systematic pillage. And we, who address you and attempt to reconstruct this rich patrimony, we are often reduced to powerlessness. As a consequence, the art objects, often unique, are located outside Africa. [This conference should] draw the world's attention [to this subject] so that the rich countries, which possess the artworks of the poor countries, can return part of them.[50]

More confrontational than before, Mobutu evoked an image of colonialism as "systematic pillage." With the international press present, he was speaking not only to art critics but to a wider audience of formerly colonized nations and colonizers, thereby casting himself as an international leader of formerly colonized nations.

These cultural politics demonstrate that the art-culture system that James Clifford so aptly named "a machine for making authenticity" had ramifications far beyond the mere recategorization of artifacts as art.[51] These ideas affected the realm of politics, as, in the colonial context, authentic traditional culture came to be regarded as the antidote for the side effects of modernization, or as the antidote to political ramifications of the implementation of Western economic modernization without political representation. Despite the rhetoric, in the case of authenticité this relationship between tradition and modernity was reversed. "Authentic" cultural traditions and the country's heritage were the very road to a modernity in the shape of a unified nation-state. Mobutu also used authenticité to strengthen the undemocratic political system that succeeded the authoritarian colonial state. It is important to note that in the case of authenticité the postcolonial *state*, and not the people of Zaire, was presented as the legitimizing body for cultural authenticity, in an attempt to divert attention away from ethnic identity politics. In the case of traditional art, its possession by a Zairian state institution (the IMNZ) was desired, not its return to its communities of origin.

To dismiss it as mere "clouds of smoke," as Thomas Turner does, subordinate the cultural aspect to the political goals, as Jean-François

Bayart does, or to see it merely as the "dramatization of postcolonial *commandment*," or a grotesque mask for power, as Achille Mbembe does, disregards authenticité's initial appeal to Zairians and foreigners alike.[52] The dubious origin of the politics did not take away from their genuine reception by at least parts of the Zairian population in the early 1970s, or from the belief of both government officials and intellectuals in the validity and role of cultural legitimacy in creating sovereignty for the postcolonial nation and state. As Michael G. Schatzberg has pointed out: "While seeing the authenticity campaign as a cynical mechanism of political control and domination [it can also be] understood as a manifestation of cultural nationalism, or of nation-building."[53] Although by the middle of the decade, the corrupt, authoritarian nature of Mobutu's regime was apparent, the opportunity to create a "new" cultural identity in a post- and anticolonial context had at one point appeared liberating and invigorating.[54]

The reality of the popular reception of authenticity politics is understudied and complicated, and requires separating out the various aspects of the politics; particularly the mass activities such as the animation culturelle from authenticité as an intellectual project. As the latter it had a clear impact, visible for example in debates in the media, albeit one that had varied interpretations. The most sustained and long-term discussions about authenticité took place in the circles of writers and artists, who attempted to move the ideology beyond the sloganesque. The "recourse" to traditional societies and cultures was interpreted, for example, as an increased attention to local languages, the need for a new kind of literature that respected oral traditions (both in form and in content), the search for a philosophy that broke away from Western traditions, the creation of a modern art that was true to traditional artistic traditions, and, generally speaking, the development of a truly African science that encompassed all these different branches.[55] Part of the reason authenticité had a moment of success as an intellectual project was because it connected to preexisting interests in the potential role of traditional cultures in the invention of a modern Zairian culture. In theater circles, for examples, there was already an interest in a "return to the sources," particularly a call for a revaluation of oral traditions.[56]

Although the opposition media—much of it located in Brussels—denounced the authenticity politics as "a masquerade," the underlying idea of taking inspiration from the values of traditional society was not

denied but instead incorporated into suggestions for the stimulation of, for example, "national arts."[57] The search for cultural authenticity per se was not attacked, but the Mobutu regime's approach to it was. For example, *Le Libérateur* critiqued the new name of the country, Zaire, by explaining that it did not entail a return to traditional names but was the adaptation of an "ancient colonial invention."[58]

AUTHENTICITÉ AND THE IMNZ

The campaign for cultural authenticity naturally affected the IMNZ. It raised the museum institute's status as a keeper of the nation's true identity and made the issue of the restitution of collections from Tervuren more pressing, but the regime also became anxious about the involvement of so many Belgians in what should be a national operation and pressed for the "Zairization" of the IMNZ's operations. This resulted in an increased role for the young Zairian researchers in collecting and research expeditions, although the leadership of the institute remained in Belgian hands.

A look at the microcosm of the museum (expanded upon in the next two chapters) confirms how, in practice, the concept of authenticité was interpreted quite broadly. The vagueness of the concept made it a powerful canvas for the projection of the ambitions and dreams of a generation of Zairians that had come of age in the era of independence. Several of the young Zairians working at the museum in the early 1970s professed their initial excitement about authenticité. It appeared to legitimize the scientific and public missions of the museum and reconnected Zaire to a broader Pan-African body of thought that encouraged pride, both in an African cultural identity and in a black racial identity (a connection it had lost with the demise of Lumumba a more than a decade earlier). Two of the young women who were working at the IMNZ while completing their PhDs in anthropology, Eugénie Nzembele Safiri and Shaje A. Tshiluila, were encouraged in their desire to venture beyond their own ethnic communities in their research. For both women, building a national museum and emancipating the creation of knowledge about Zairian cultures, meant engaging scientifically with the diversity of the nation.[59] For government officials like Kama Funzi Mudindambi—the liaison between the presidential office and the museum—authenticité meant the decolonization of the IMNZ's operations via a Zairization of its leadership (see chapter 4.)[60]

Authenticité's appeal existed mostly in the first half of the 1970s, however. By the middle of the decade the corrupt and authoritarian nature of the Mobutu regime was apparent, and the marginalization of the Department of Culture and Arts led to a lack of resources for cultural institutions like the museum. The Mobutu regime launched "Mobutism," which largely supplanted the earlier focus on culture with a focus on the figure of Mobutu, although certain elements of authenticité, like the animation culturelle et politique even expanded, becoming an avenue to "demonstrate one's support of the Founder-President."[61] These performative aspects of authenticity became increasingly oppressive and resented by the population, but the authoritarian nature of the regime made it difficult to express such critiques, particularly in the media, which became closely controlled by the regime.[62] This narrowing of the ideological spectrum of authenticité was accompanied by a rising anti-intellectualism, which criticized artists, writers, and academics for lacking the "right" kind of revolutionary action.[63]

THE INTERNATIONALIZATION OF DEBATES OVER CULTURAL HERITAGE

Developments in the world of heritage preservation and international cooperation also confirmed the emphasis on cultural heritage as a legitimizer of cultural sovereignty and gave rise to an international conservation regime in which the protection, movement, and possession of cultural property was increasingly monitored. Mobutu's regime profited from this international context, since it provided both a forum and a semilegislative framework for the campaign for restitution. Despite promoting the regime's international, and particularly Pan-African profile, the results of the strategy were mixed.

After World War II, heritage became increasingly important in national and international political agendas. The 1954 Convention for the Protection of Cultural Property in the Event of Armed Conflict (commonly referred to as *The Hague 1954*) expressed the need to protect cultural property, particularly in the context of wartime destruction. Its reasoning rested on a belief in the collective ownership of cultural heritage and a shared responsibility for protecting that heritage as the property of humankind. This "cultural internationalism," as legal scholar John Merryman has characterized it, made way for a "cultural nationalism" by the 1970s.[64] The 1970 UNESCO Convention on the Means of Prohibiting and Preventing the Illicit Import, Export and

Transfer of Ownership of Cultural Property showed how international opinion on heritage had changed since the postwar years. Created to help nation-states protect the cultural heritage within their borders against illegal removal, it emphasized that nations had a natural right to a cultural heritage. Yet this new regulation held an important caveat: the regulations were nonretroactive.[65] While recognizing the nation-state as the custodian of cultural heritage, the 1970 UNESCO convention disavowed the possibility of international discussion of the status of objects removed during colonization. While suggesting the possibility of bilateral negotiations for disputed objects, as Ana Filipa Vrdoljak notes, the document indicated "the need to maintain the integrity of [these] collections for 'scientific purposes.'"[66]

By the 1970s there was an international conservation regime for the protection of national heritage rights. Unlike Merryman, I argue that the cultural internationalism of the 1950s was not replaced by a cultural nationalism, but that those schools of thought provided competing interpretations of the importance of a nation's heritage. Just as art became a universal category that included "primitive" arts, so did heritage. Casting art objects from formerly colonized countries as "world heritage" weakened claims for repatriation and restitution from former colonies in the light of Western museums' continued claims in the name of the protection of world heritage. As David Lowenthal has remarked, "Universalism endows the haves at others' expense."[67] With the successful World Heritage Convention in 1972, nationalist claims on cultural heritage were considerably undermined to the advantage of Western museums. Mobutu's appeal was a challenge to the cultural internationalism of this conservation regime on the basis of nation-based claims to heritage.

A closer look at the Belgian-Zairian debates reveals these competing interpretations of heritage and their political effects. They became another avenue for the expression of competing interpretations of the colonial past, particularly when considered alongside the ideology of authenticité. Zaire's demands for cultural restitution and the history of international discussion and legislation on cultural heritage became intertwined at this point. In October 1973 Mobutu addressed the UN in New York, repeating his message about colonial pillage and the need for postcolonial cultural restitution. Zaire requested that cultural restitution be placed on the agenda for the twenty-eighth meeting of the UN General Assembly, arguing that "these works represent the hand

and heart of the forefathers. . . . It is natural and just to restitute to un-derdeveloped countries their beacons of light, their authentic images of a continued future."[68] Zaire proposed a resolution stipulating that "the cultural heritage of a people conditions in the present and in the future the growth of their artistic values and [their] general develop-ment." By using the language of nationalism and heritage to contest the nonretroactive nature of UNESCO 1970, Zaire underlined that this great transfer of art from poor to rich countries had often been a consequence of colonial occupation.[69] The proposed resolution was immediately backed by nine other African countries.

During the debate over the proposed resolution, European coun-tries contested the language indicating that colonialism alone was re-sponsible for scattering poor countries' cultural heritage. Instead, they also put blame on "unscrupulous traffickers and the ignorance, com-placency and even at times the collusion of locals who out of greed, avarice or naiveté contributed to the clandestine expropriation of artis-tic and cultural treasures that are truly irreplaceable."[70] The resulting adaptation of the resolution was significant because it pushed it back in the direction of UNESCO 1970, which had singled out the illegal art trade as the culprit for the depletion of cultural heritage in former colonies.[71] The final draft was adopted by a vote of 113 to 0, with 17 ab-stentions. Not surprisingly, most European countries abstained, as did the United States.

The resolution that passed was watered down and difficult to en-force internationally. Nonetheless, Zaire's maneuvering had a clear impact on Zairian-Belgian relations and provoked frantic responses in Tervuren. Mere weeks after Mobutu's speech to the UN, Belgian minister of foreign affairs Renaat Van Elslande attempted to influence media reports on this issue by holding a press conference in Kinshasa where he mentioned the existing collaboration between the museums in Kinshasa and Tervuren and Belgium's financial help to the IMNZ. He emphasized that the latter was well on its way to creating a na-tional collection by collecting objects in Zaire. He also mentioned that "it was envisioned that Belgium would transfer a certain number of pieces, meant to complete the collections created [in Kinshasa]. . . . The idea was not to empty the halls of Tervuren, but to select in service of the blank spots in the Zairian collections."[72] That message created dis-may in Belgium, where it seemed too defensive, too much like an ad-mission of guilt or disavowal of the Belgian colonial regime in Congo.

Cahen, who had so diligently negotiated the agreement with Zaire over the creation of the National Institute for Museums, was deeply frustrated. Now, any return of objects from Tervuren to Zaire would look like the result of pressure exerted by Zaire through the UN and the media.[73] Cahen tried to regain control of the situation by also giving a press conference in Kinshasa, but that plan was blocked by the Zairian presidency. Increasingly, the ability to define "the true character of the Belgian gesture" became more important than the actual content of a transfer.[74] For Belgium, and particularly Tervuren, the ability to define the repatriation of objects as a "gift" was a central motivation for offering objects from their collections. Calling it a restitution implied a different interpretation of the process whereby the objects were obtained, and therefore of the nature of the Belgian colonial regime. Zaire's attempt to change the parameters of the debate by way of the UN was an attempt to reengage with a process of decolonization through the political construction of a symbolic example of cultural sovereignty.

The strength of an ideology like authenticité was that it functioned on two different levels: the national and the international. On a national level, it promoted a Zairian cultural exceptionalism that encouraged Zairians to take pride in their cultural heritage. Hence, it promoted an allegiance to the state that constructed itself as the guardian of that heritage. Mobutu's UN speech reverberated through the Zairian media landscape for several years, and reporting on cultural heritage matters occurred frequently, and usually in a manner that emphasized the importance of taking ownership—not merely literally, but also figuratively, in the protection of traditional arts, and in their importance as a source of value (financially and culturally) for contemporary society. Both national and international expositions of African art were keenly reported on and evaluated.[75]

Authenticity politics simultaneously created the international opportunity for Mobutu to take the lead in the discussion about the rights of postcolonial counties to possess their cultural heritage, and consequently also the discussion about the rights of non-Western and formerly colonized countries as nations. Although the 1973 UN resolution lacked enforceability, the institutional framework the UN and UNESCO offered in the form of an international conservation regime, along with the discourse for framing claims in nationalist terms that aligned with the goals of authenticité, enabled Mobutu's regime to demand the return of the embodiment of its past.

THE OBJECTS OF CONTENTION

Despite years of argument, by the start of 1976 no transfer of art objects had taken place. In part, this was because economic nationalization in Zaire soured the relation between the two countries. On the other hand, Tervuren's hesitations—which it justified by invoking the lack of a proper museum building in Kinshasa and the failure of the government to gain control over the illegal art trade—also played a role. Both parties ignored the reality that the IMNZ already had a real museum building in Lubumbashi. The centralization politics of Mobutu's regime would not tolerate yet another of the country's resources to be in the hands of Katanga, the mining region. Several plans for museum buildings in Kinshasa (the IMNZ was housed in temporary barracks) were developed over the years, but financial concerns and power struggles within Mobutu's regime prevented their realization.[76]

In 1976, the agreement between Belgium and Zaire that established the cooperation between the IMNZ and Tervuren was coming to an end. The museum institute had amassed a considerable collection by organizing collecting trips throughout Zaire and by buying from art traders in the capital. Its scientific activities were underway, as was the education of its young Zairian staff at Tervuren and at Belgian universities. But this all had come to a halt by 1975. Due to the economic crisis (caused by the nationalization process and the end of the copper boom), money for the museum evaporated, along with any serious plans for a real museum building. A continuing cooperation with Tervuren was necessary for its survival.

In order to debunk rumors about Belgium's "special interest" in Zaire, the Belgian government was now trying to couch its relations with the colony within the larger context of foreign and developmental aid, theoretically diminishing the special relationship between the two countries.[77] Zaire, on the other hand, accused the Belgians of neo-colonial motives, and the presidential office became suspicious of the Belgian staff at the IMNZ and the institute's close ties to Tervuren.

Like the IMNZ, Tervuren had a stake in continuing cooperation. Although the Belgian museum attempted to broaden its collections and research beyond the scope of the former colony, it was still heavily oriented toward Zaire. Continued cooperation between these institutions would be mutually beneficial. Luckily, relations between the two governments improved somewhat between November 1975 and September 1976, because of a partial compensation of foreign business

owners affected by the nationalization of the country's economic resources. Additionally, Zaire made an important gesture toward Belgium. During a UNESCO colloquium in Venice, Eugénie Nzembele Safiri, a young employee of the IMNZ, publicly sided with the Belgian interpretation of a transfer of art: "There has been . . . a "gentleman's agreement" on the subject of a gift of pieces of ethnographic art that will be complementary to the collections gathered by Zaire itself."[78] This statement endorsed the interpretation of the transfer as a "gift" and "support" for the IMNZ's collection, not as restitution.

But what would be the content of the gift? Initially, the Zairian demand had been driven by Mobutu's desire for the objects in the 1967 *Art of the Congo* exhibit in the United States. In response, in the early 1970s Cahen drew up a list of pieces that took as its starting point the two hundred objects of the exhibit but forty of these, including some of the most prestigious, were replaced by "similar" items.[79] However, only one of the objects on this revised list (a ndop, a royal Kuba statue) eventually made it to the IMNZ.

The physical return of objects took place on four separate occasions. Minister Van Elslande made the first transfer in person in March 1976 by handing over the valuable ndop.[80] Only a limited number of ndop—representing former rulers of the Kuba—exist. The oldest were made in the mid to late eighteenth century, and three of those (collected by Emil Torday) are now in the collections of the British Museum, Tervuren, and the Brooklyn Museum. Another generation of these statues, stylistically somewhat different, is from the late nineteenth and early twentieth centuries, likely created in response to the interest of collectors. The ndop returned to Zaire was one of the second-generation statues and had been collected by the colonial administrator M. Blondeau between 1924 and 1930.[81] Since Tervuren possessed another example of these later statues, in addition to one of the original ones, the Belgian sacrifice was limited.

The symbolic value of the ndop statue should not be underestimated, however. The Kuba king had been recognized by the colonial regime as an influential figure and was subsequently assimilated into a system of indirect rule exceptional for Belgian colonialism. The Kuba were also regarded by the West to be superior to other cultures. By spearheading the return of materials to Zaire with a royal Kuba statue, Tervuren affirmed the connection between a certain version

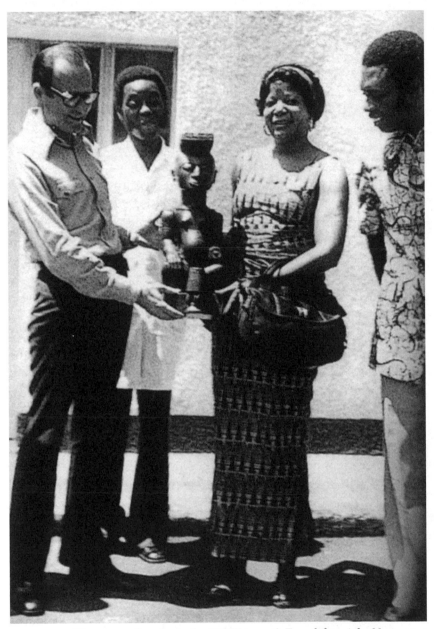

FIGURE 3.1. The return of a *ndop* to the IMNZ in 1976. *From left to right:* Nestor Seeuws (IMNZ); Kieto (IMNZ), Zairian commissioner of arts and culture; Mbemba Yowa; and Zola (IMNZ). Collection RMCA, HP.2011.76.1, RMCA Tervuren ©.

of the country's precolonial past, organized around a centralized form of political power, and the current nation. The ndop was a symbol of "indigenous power," but it represented the only form of indigenous power recognized by the colonial power, and it stood for a centralized, undemocratic system of rule. Considering Mobutu's reliance on the "chief of chiefs" image to justify the centralization of power in the presidential office, it certainly was an apt choice of object.[82]

Two larger shipments of material were sent off in 1977, following a disagreement between Tervuren and the IMNZ regarding responsibilities for the transportation cost. (The Belgian museum grudgingly ended up paying.) Thirty-two of the sixty objects had been the property of the colonial Museum of Indigenous Life (MVI) in Leopoldville, which had become the victim of the chaotic 1960s. Jean Vanden Bossche, director of that museum, had originally shipped material for use at the World Exposition of 1958 in Brussels. After the exposition closed, these objects went on tour in Germany and Austria. By the time the tour ended in 1960, the situation in Congo had changed drastically. Instead of sending the objects back to Leopoldville, Vanden Bossche decided to deposit them at Tervuren until the situation in Congo stabilized.[83] Since the MVI seems to have become property of Congo, there is a legal argument to be made that these objects already belonged to Zaire.[84]

Staff at Tervuren were aware that the shipments, with a mere twenty-eight objects from the museum's own collection, could scarcely be perceived as a genuine gesture of cooperation. Cahen admitted that "the current shipment, which just contains objects originally from the Museum of Indigenous Life, could pose a diplomatic problem" and confirmed that "there needs to be a real *contribution* aside from the four boxes of the Museum of Indigenous Life, which are nothing but a return to Zaire of what belongs to it."[85] Nonetheless, the next shipment followed the same pattern. The bulk of the material had been part of the collection of the Institute for Scientific Research in Central Africa (Institut pour la Recherche Scientifique en Afrique Centrale — IRSAC) and was sent to Tervuren around the time of independence.[86] The institute's material had little artistic or financial value, having been collected mostly for ethnographic research purposes.

After 1977 there was scant political will at Tervuren to send more shipments. Cahen had retired, and his successors were not as invested in the IMNZ.[87] Further shipments would also have to come from Tervuren's own collections. Another temporary rapprochement between

Belgium and Congo in 1981 led to political pressure on Tervuren and a last shipment of fifty-four objects, all from its own collections.

In total, 1,042 objects left Tervuren for the museum institute in Kinshasa, of which 869 originally came from the IRSAC. Thirty-two had belonged to the collections of the former Museum of Indigenous Life in Leopoldville, and only 114 came from the reserves of Tervuren.[88] These 114 were selected to compensate for the lacunae in the collection the IMNZ had amassed but without damaging Tervuren's collection.[89] The curators thought them interesting or attractive enough to be used in museum displays, but, with the exception of the ndop, they were certainly not among what Tervuren thought of as its "masterpieces." For IMNZ employees, the shipments were a great disappointment. The former collections of IRSAC had little value for a museum institute whose primary purpose was to create a collection on par with prestigious Western museums.[90] Far from being the restitution of Tervuren's collections demanded by Congo, the true meaning of the transfers lay in their symbolic value. Mobutu's regime could still use the transfers as propaganda, as a symbol of Zaire's cultural sovereignty and an affirmation of its ability to stand up to the former colonial power.

〜

WHAT CONNECTS the discourse on the economic value of the museum collections of Tervuren with the politics of authenticité and the international claims to cultural heritage is the usefulness of cultural heritage as a (multifaceted) resource for the process of decolonization. There is a clear evolution visible, however, in the manner in which museum objects and collections were approached. As contentieux, their economic value was central. The latter faded into the background in favor of their role as cultural representatives of a vague but politically useful precolonial past, as well as their political value as props for the ideology authenticité and for Mobutu's international political maneuvering. In each of these incarnations however, cultural heritage could be deployed for the construction of postcolonial sovereignty.

Saloni Mathur has characterized the restitution debates between India and the United Kingdom as "replaying the history of power relations between West and non-West, and positioning the museum as a neocolonial institution."[91] In this case, although the debates over restitution were deeply affected by the history of power relations between Belgium and Congo, "neocolonialism" is not the appropriate description. That

term suggests a *new* or re-created stage in the countries' relationship. Instead, these events were directly connected to negotiations about Congolese independence and must be seen as part of a continuing process of *de*colonization, taking place over several decades.

The debates described in this chapter are not merely about the literal return of objects from Tervuren to Zaire; they are also about the right to define the meaning of the transfers, which by extension meant defining the character of colonialism and decolonization. Tervuren triumphed in this debate. The initial demands from Congo were formulated in terms of restitution, but Tervuren and the Belgian government consistently and relentlessly directed the discussion away from the concept and language of restitution.

The term *restitution* was inextricably bound up with a view of Belgian colonialism as a system of exploitation. Defining a transfer as "gift" or "support," however, affirmed Belgium's self-image as a benevolent (former) colonizer. Not only did Tervuren retain almost its entire collection, its involvement with the IMNZ lent it an air of generosity, leaving its cultural guardianship largely untouched. In a 1979 article for the UNESCO publication *Museum*, Huguette Van Geluwe, one of Tervuren's curators, even referred to the return of the objects as "Belgium's contribution to the Zairian cultural heritage."[92] Ultimately, Belgium's ability to define the transfer, content, and timing made it more an act of domination than an exchange between equals. This does not detract, however, from the effectiveness of the Mobutu regime's use of the IMNZ in the context of authenticité, and of the demands for restitution, to project a cultural sovereignty to an international audience.

Despite providing a forum for debates about cultural property, the organizations (like UNESCO) behind the international conservation regime failed to provide a sufficiently powerful framework to support the demands of former colonies like Zaire. Instead, they sanctified the continued existence of deep structural inequality between the West and its former colonies by facilitating "symbolic" acts like the transfers between Belgium and Zaire.

Today, some at Tervuren argue that since no transfer of titles of the objects ever took place, Tervuren can still legally claim ownership of the objects. Due to unrest in Congo, objects from the IMNZ collection emerged on the international art market during the late 1990s and early 2000s. Among them were a number of the pieces from the transfers; so Tervuren had some legitimate concerns about the safety of

the collections in Kinshasa. The Belgian museum attempted to recover some of the stolen pieces, but the efforts met with limited success.[93]

Debates about cultural restitution continue to take place. In a recent publication, Kwame Anthony Appiah argued against what he calls "the logic of cultural patrimony," or the idea that all cultural objects should be shipped back to their location of origin. He argues that if cultural patrimony " belongs to the culture that gives it significance, most art doesn't belong to a national culture."[94] Older arguments, about the scientific value of the collections and the universal role of art, also still play a role. The 2002 "Declaration on the Importance and Value of Universal Museums," signed by nineteen internationally well-known museums suggested that "objects acquired in earlier times must be viewed in the light of different sensitivities and values" and have now become part of the heritage of the museums that house them but also serve "citizens of all nations."[95] This in turn has elicited accusations of "imperialist museology," particularly from the African continent.[96]

Homi Bhabha, inspired by Frantz Fanon, speaks of the "problem of how, in signifying the present, something comes to be repeated, relocated and translated in the name of tradition, in the guise of a pastness that is not necessarily a faithful sign of historical memory but a strategy of representing authority in terms of the artifice of the archaic."[97] Central to the history in this chapter is the capacity of objects to act as signs and repositories of an imagined precolonial past and to serve as both symbol and embodiment of the country's national resources and cultural sovereignty. Ironically, it was their location at Tervuren that legitimized them as "authentic" art objects, lent them their allure and legitimacy as heritage in the eyes of the postcolonial Congolese regime, and gave them the ability to fortify the authenticity of the postcolonial nation.

This chapter establishes the cultural politics of decolonization as an avenue through which authoritarian power structures of the colonial state, which relied on narratives of guardianship, were reproduced in the postcolonial cultural narratives used to construct legitimacy for the state. The politics of authenticité were rooted in the very knowledge structures produced by the colonial system it attempted to erase. Both the objects themselves (through the meanings projected upon them) and the importance attached to the act of restitution demonstrate the belief in the capacity of art objects—and culture at large—to legitimize a collective Zairian identity, and hence a nation. In what Bayart has

called the "process of cultural extraversion," control and possession of the museum objects provided a basis for such a legitimation and for the emergence of a "true" postcolony. The state would not only "have" culture, it would also be able to construct an "authentic" nation on the basis of an extraversion of the cultural authenticity accorded to these objects.[98] Mobutu's regime could construct a new history that attempted to erase the impact of the colonial era, all the while building upon colonial regimes of value and categories of art, sovereignty, and guardianship. In addition, the demands for restitution conveniently served as a vehicle to raise the regime's international profile.

4 ⌒ Mobutu's Museum

Authenticity and Guardianship

BORN OUT of the negotiations that followed Congo's demand for the return of the art and ethnographic collections of the Tervuren museum, the IMNZ was a space upon which both Belgium and Zaire had pinned their hopes. Belgium expected the institute to facilitate Tervuren's scientific activities in the former colony, as well as to safeguard, at least temporarily, the Belgian museum's collections from demands for restitution. Zaire, on the other hand, hoped that the IMNZ would provide both the basis for grounding the country's new national identity in traditions of a precolonial past and tools with which to dominate its representation and image, both nationally and internationally.

One of the legitimizing narratives put forth by the late colonial regime was that traditional cultures required the care and protection provided by colonial modernity. If it was to create a sense of maturity as a nation, Zaire needed to reclaim this role of cultural guardianship. By building its own collection of the material cultures, archaeological traces, and musical traditions of the past, an "illusion of cognitive control" over that past could be wrestled from Belgium.[1] This chapter argues that while the cultural authenticity of an imagined, usable past had functioned during the colonial era as an antidote or critical opposite to modernity and as a justification for colonial guardianship, it had now been transformed into a tool for the creation of a postcolonial modernity—presented here as a sovereign nation-state with citizens. The continued impact of colonial ideas about the need for cultural guardianship also reproduced the authoritarian nature of colonial justifications for Western power in Africa, an element that contributed to the authoritarian nature of the Mobutu regime.

The state's claims on museum objects were not motivated solely by their prestige as a cultural resource. Their financial value also made them an economic resource that could be reclaimed and nationalized along with the other economic resources of the country. This was visible in the parallels between the quests for economic and cultural restitution, discussed previously, but also in the similarities between the nationalization (Zairization) campaigns of foreign-owned businesses and of the museum institute, as well as in the ways ideas about cultural authenticity and guardianship were translated into practice at the museum. While the museum institute functioned as a tool for the promotion of an increasingly authoritarian state, this chapter also explores another side to its history. The enthusiasm of the young Zairian IMNZ employees for the museum project and for the politics of authenticité illustrates a small window of optimism about the broader cultural project of Zaire in the early 1970s.

This chapter looks at the organizational structure, the research and collecting practices, and the institutional politics of the IMNZ. The institute was a place both of cultural production and of political struggle — one of the trenches in which the battle for decolonization continued to be fought, reflected in a constant tug-of-war between Tervuren's influence and that of the presidential office. Caught between these two were the employees, both Belgian and Zairian. The IMNZ itself was embedded in the macropolitics of a postcolonial world, while also being the scene of its own micropolitics. The IMNZ was a place of work, friendship, mentorship, conflicts, aspirations, and disappointments. Personal narratives of the people who worked there, woven into these chapters, provide us with a bottom-up perspective that complements, and at times drives, the larger narrative.

This chapter also needs to be read in the context of a growing literature on the sociology of science in Africa that considers questions about the role of African scientists in the creation of knowledge about Africa and investigates processes of epistemic decolonization. Work by Lyn Schumaker, and Helen Tilley, for example, has shown how the contributions and work of African research assistants and scientists animated the colonial development of sciences and European research agendas.[2] This chapter considers the role of Zairian museum professionals (which, as opposed to Schumaker and Tilley's examples, included several women) in the postcolonial struggle to decolonize the production of knowledge about Zairian cultures, essentially attempting

to "provincialize" Europe by recentering the creation of knowledge in Zaire.[3] These ambitions, however, eventually ran up against the increasingly autocratic tendencies of the Mobutu regime, which largely abandoned its earlier cultural politics in favor of an increased focus on the leader himself.

MORE THAN A "NDAKO YA BIKEKO" (HOUSE OF STATUES): THE FOUNDING OF THE IMNC

In the early years after Congo's independence, the colonial cultural infrastructure continued to exist.[4] Few of the smaller, local museums survived the chaos of the 1960s, but the museums in Leopoldville, Elisabethville, and Luluabourg continued their operations.[5] The MVI in Kinshasa hung on until 1965, although its curator, Jean Vanden Bossche, left the country in 1961.[6] Rumors about the demise of the MVI were abundant, and varied according to which political point of view they might support. The Belgians, with Tervuren at the helm, were inclined to emphasize the Congolese government's lack of ability to protect the collection from being sold. Many years later, Mobutu told Western journalists that the last mayor of Leopoldville before the Mobutu era sold the collection for his own benefit.[7] Although it is true that a large part of the MVI's collection disappeared during the 1960s, not all of it did. The IMNC today still possesses fragments of the card catalog and some of the photographic material of the MVI. At a time when most of the government's attention was still directed elsewhere, colonel Powis, who later brokered the deal for the creation of the IMNZ, had started collecting as much of the material belonging to the MVI as he could find. That material was transferred to the IMNZ upon its creation.[8]

The museums in Elisabethville and Luluabourg were both forced to deal with visits from UN soldiers.[9] This was particularly dramatic in the case of the museum in Elisabethville, since UN troops chose it as the headquarters for their mission to contravene Katanga's secession.[10] The collection was put into bags used "to fortify the construction against enemy gunfire. Other objects ended their days as firewood!"[11] Retired museum employee Isak Kisimba Mwaba recalls how he and curator Roger de Poerck negotiated with the UN leadership to release the collection to them. Kisimba safeguarded the collection outside the city until the end of the war in 1963.[12] A lack of funds then postponed the much-needed renovation of the building, which was closed to the public until 1967.

The IMNZ, the successor to the colonial museums, began operations in 1970. The structure and workings of the IMNZ reflected its identity as a postcolonial institution caught in an extended process of decolonization in which former colonizer and colonized grappled to find a new balance of power. On the one hand, the Tervuren museum needed access to the former colony in order to maintain its identity as one of the premier places in the world to study Central Africa. On the other hand, the Mobutu regime needed the know-how of Tervuren to build a similar institution. As a result, the role of the Tervuren museum in the IMNZ's operation was substantial. Lucien Cahen, the director of Tervuren, also became the director of the IMNZ and agreed to spend three months a year at the institute. Four other Belgians were recruited in addition to Cahen, including the adjunct director Joseph-Aurélien Cornet, a member of the congregation of Christian Schools. He was recruited in Kinshasa, where he taught at the Academy of Fine Arts.[13] The great advantage of Cornet was that he was not associated with the Belgian colonial regime, since he did not arrive in Congo until 1964. In addition, since he already lived in Zaire, his appointment reduced the appearance of a neocolonial move on behalf of Tervuren. Albert Maesen, the ethnography curator at Tervuren, was distrustful of Cornet's knowledge of Congolese art, and the relation between Tervuren and Cornet deteriorated over the years.

The Belgian Cooperation and Development Agency (Agence de la Coopération et Développement, or Belgische Technische Bijstand) agreed to pay the wages of two Belgian "technical advisers," Nestor Seeuws and Benoît Quersin. Seeuws, the only Flemish Belgian at the IMNZ, was also the only employee who had a colonial career.[14] Repatriated to Belgium after Congolese independence, he became interested in working as a curator through his sister, who was employed as a restorer in a Brussels museum. He was trained at Tervuren with the intention of being sent to work at the new museum in Kinshasa. He was in charge of much of the IMNZ's administration and often served as the main contact person between Tervuren and the IMNZ.

Benoît Quersin, a former jazz musician, was hired in 1973 to lead an ethnomusicology department.[15] The salary of a fourth Belgian staff member, Charlie Hénault, was paid by Zaire. Also a musician, he first came to Congo in 1960 after being recruited as a drummer by the Congolese band African Jazz on their European tour and was working at a photographer's shop in Kinshasa when he was recruited to work at

the IMNZ.[16] Quersin and Hénault had no real academic background. Their lack of academic credentials combined with their positions of leadership would cause conflict with some of the younger Zairian staff over the years, especially once those staff members started obtaining degrees in higher education. With the exception of Seeuws, none of the Belgian employees had any association with the Belgian colonial regime, likely an important factor in their hiring.

Official power at the IMNZ rested in the hands of Mobutu—or practically speaking, in the hands of the presidential office—and during the early years Mobutu took a personal interest in the institute, though he never visited. Two figures in the president's circle played key roles in the conception and operation of the IMNZ: Colonel Powis, and the presidential adviser Kama Funzi Mudindambi.[17] Powis's role diminished in July 1973 because of a conflict with the head of the presidential office, Barthélémy Bisengimana, although his involvement with IMNZ continued intermittently.[18] Kama worked as an adviser in education, culture, and arts in the 1960s and ascended to the position of adviser to the presidential office on arts and culture in the 1970s. He was the one who obtained permits for collecting or research trips, gave permission to hire and fire, and discussed budget issues. Although he became disillusioned with the Mobutu regime's cultural policies toward the end of the 1970s, Kama is representative of an educated postcolonial generation of intellectuals influenced by the early promise of the Mobutu regime and the opportunity to be active and influential in the state.[19]

A group of young and promising Zairian university students were hired to be trained as scientific staff so that they might eventually take over the Belgians' positions.[20] While undergraduate courses in anthropology and archeology were available at the university in Kinshasa and Lubumbashi, students had to pursue doctoral degrees at Belgian universities. Lema Gwete, who studied anthropology, was considered to be the most promising assistant and was designated early on to become the institute's first Zairian leader. In 1986 he succeeded Cornet, but the change of regime in 1997 forced him to leave his job.[21] Two of the students hired were women. Eugénie Nzembele Safiri, who had gone to boarding school in Belgium, was working as a press secretary in the presidential office when she was hired. Shaje A. Tshiluila became an anthropologist and was deputy director of the institute under Lema Gwete. She served as a director from the late 1990s to 2005, when she

took a position with the Inter-African University Council in Dakar, Senegal.[22] Kanimba Misago and Muya wa Bitanko started PhDs in archaeology, with Tervuren's help.[23] Zola Kwandi Mpungu Mayala, hired in 1973 after an internship, was grudgingly given a spot because of his family's political connections. Seeuws and Cornet were not impressed with him, and even Kama had only taken him on because of the political pressure.[24] Aside from the scientific staff, the IMNZ also hired technical assistants. Among them were Charles Kalema, Marcel Bétu, and N'Kanza Lutayi. They assisted on missions and archaeological digs and were trained to maintain the museum's storerooms, restore objects, and so on.[25] Many other Zairian staff members worked at the IMNZ for varying periods of time.

The relationship between the Zairian and Belgian staff did not always proceed smoothly, but conflicts also erupted among the Belgians. Seeuws had his eye out for financial irregularities and complained that Cornet was too lenient in his treatment of the personnel. In one case, Seeuws found out that an employee had purchased one roll of film but tried to get reimbursed for two by reusing an old receipt. When Seeuws and Cornet clashed on the subject, Cahen intervened on Seeuws's side and made it clear to Cornet that his "indulgence of such excesses" would not be tolerated.[26]

In a sense, the Institute for National Museums was an application of the COPAMI blueprint for an office of colonial museums (see chapter 2), with the main seat in the capital and several regional museums spread around the country. Although during the colonial era Tervuren and its director Olbrechts had been opposed to the promotion of museum life in the colony out of fear of competition, the postcolonial context had radically altered Tervuren's access to the former colony. The creation of a centralized museum institute in Zaire over which the Belgian museum would have influence meant there was significant advantage to Tervuren in promoting the cause of postcolonial Zairian museums.

The 1950s plan for an office of museums in Congo included the integration of existing smaller museums and the creation of more regional museums, a feature transferred to the IMNZ. The museums in Lubumbashi (formerly Elisabethville) and Kananga (Luluabourg) were incorporated into the structure of the IMNZ, and the museum in Mbandaka (formerly Coquilhatville) was revived. While colonial museums had tended to collect and display regional material, the IMNZ's

provincial museums were to be local representatives of the new nation but also promoters of the idea of a Zairian entity. Ideally their displays should include objects from around the country. This followed the recommendations of the International Council of Museums, which suggested that newly independent nations would benefit from the establishment of regional museums. These institutions were to reflect the local history but also fit that history into a larger national context and that of humanity at large.[27] In practice, however, they continued to be mostly local museums.[28]

The situation was different in Lubumbashi. With the integration of Lubumbashi's museum into the IMNZ in 1970 came advantages and disadvantages. While money was now available for the restoration of the building and for research expeditions, the museum was relegated to the status of a provincial institute, with its research agenda determined by the IMNZ in Kinshasa. Roger de Poerck, the curator, opted to take a position in a high school in Kolwezi rather than be dependent upon the Zairian government for an income.[29] Guy De Plaen, a Belgian professor of anthropology at the University in Lubumbashi became the museum's director and was, like Seeuws and Quersin, paid by the Belgian Cooperation and Development Agency. When he returned to Belgium in 1986, the archaeologist Muya wa Bitanko replaced him.

The actions of the presidential office were informed by the belief that it was important to reclaim the country's past for reasons beyond the simple promotion of tourism. As a regime in the midst of imagining and creating a future for itself and its country, it saw in its growing museum complex an opportunity to control the shaping of future national identity by regaining control over the representation of its past. This would entail taking in hand not only the processes of collection and display but also the creation of anthropological and art historical knowledge. The Zairian media generally echoed this vision of museums. A new African museology would be one in which museums were more than a mere *ndako ya bikeko* ("house of statues") but places of education and science, in service of the Zairian community.[30] Museums were considered representatives of a new and modern Zairian life, since African art "has finished her glorious career in the active life of our modern cities. Except in museums and collections." It presented a past that could merely be relevant as inspiration for a new future, with museum collections as sources of inspiration and consciousness-forming experiences for modern artists.[31]

THE PRICE OF CULTURE:
TRADING ART AND GENERATING VALUE

As we have seen in previous chapters, the process by which African artifacts were reinvented as art was deeply intertwined with the growth of the African art trade. By the 1950s art dealers and collectors no longer relied solely on a supply of objects brought to Europe by former colonials but actively undertook collecting trips in Africa.[32] In colonial Congo, regulations existed for the protection of heritage, but these generally failed to prevent an outflow of material to the West. However flimsy these legal protections had been, they disappeared entirely with the advent of independence. The unstable political situation during most of the 1960s meant there was very little attention to, or control over, art exportation by the Congolese government. A testament to this was the liberty with which UN soldiers helped themselves to souvenirs in the museums of Elisabethville and Luluabourg.[33] At the same time, many regions with desirable artistic traditions, such as the Kasai, remained difficult to access for European collectors, creating a space for Congolese middlemen to increase their role in the market by bringing material to the major cities or even to European and American locations to be sold to Western art dealers.[34]

By the late 1960s, once Mobutu had settled into power and negotiations about the creation of a museum institute for Congo were under way, a legal framework was reinstated. As a prerequisite for the establishment of the museum institute, Belgium demanded that Congo create the necessary legislation to regulate the growing art trade. In this demand, Belgium reaffirmed its identity as the savior and protector of Congolese heritage. In contrast to the colonial era, Belgium was in the comfortable position of no longer carrying the legal burden for this protection, which had shifted to the Congolese government.

Although the legislation was swiftly put in place by Zaire, its enforcement was quite another matter. On March 15, 1971, the state of Zaire imposed law 71-016 for the protection of cultural goods, including monuments, sites, and art production. It decreed it illegal to export any object considered to be part of that cultural heritage without the proper authorization. The task of deciding which objects fell under the definition of cultural heritage was left to the directors of the IMNZ and the Ministry of Culture. The state demanded the right to buy art objects before they were offered to anybody else, and the director and adjunct director of the IMNZ were authorized as "judicial officers of

the police," which in theory legally enabled them to investigate infractions against the legislation. In 1975 a special condition was added to export permits in the form of a payment to the Zairian state of 10 percent of the value of the object. As a result, buying and selling were not necessarily prohibited, but uncontrolled exportation was, and on paper the IMNZ controlled the process.[35]

At the same time, the market in African art continued to boom. Certain styles, popularized by scholars and by their display in museums like Tervuren, were becoming hard to find, which only increased their desirability.[36] The participation of increasing numbers of—especially American—collectors and museums also accelerated the market's growth. A new generation of dealers habitually went to the field themselves, usually accompanied by local African guides and dealers. More than mere salesmen, these young Western art dealers tended to present themselves as collectors and adventurous scholars, and they went in search of "new" and "undiscovered" artistic traditions. In the case of Zaire, these included objects from the Hemba and Tabwa communities, for example, in addition to several of the communities surrounding the Lega.[37]

During the late 1960s and 1970s, the combination of continuously rising prices, the influx of "newly discovered" art objects, and the more stabilized situation in Zaire created ideal circumstances for the expansion of the international art market. The Mobutu regime was keen to capitalize on the cultural power accorded to art and ethnographic collections, but it also wanted to create a monopoly on the resource that art objects presented. A permission to export, or an export tax, created revenue from the trade, while the IMNZ's right of "first choice" would make sure that the best pieces became the possessions of the state.

Although publicly vilified by Belgian and Congolese officials, the (legal and illegal) art trade clearly played an important role in the creation of economic value and meaning (or cultural value) for Congolese artistic heritage. On the one hand, the trade contributed to the financial value of museum collections, as objects became increasingly desirable on the international art market and developed even more importance as a potential economic resource for the nation. On the other hand, this desirability created serious competition, which undermined the ability of the Museum Institute to collect. In other words, the African art trade created the conditions in which objects from "traditional" cultures could emerge as a valuable economic

resource, while also pushing the postcolonial state to attempt to regulate and control that resource and to increase its own prestige by creating a national collection.

Art dealers had a distinct role when it came to creating and shifting definitions of authenticity. While the cultural authenticity of the objects that Olbrechts had selected lay in their stylistic characteristics, the (perceived) lack of Western influence in materials and techniques, and the presumed age of the objects, the growing presence of Western traders and researchers in the field increased the emphasis on the contexts of use, the intended (African) audience, and the process of collection (or the known origins) in determining the authenticity of a piece.[38] Although the processes whereby the IMNZ acquired objects were varied, and included collecting missions, the institute also bought from local and foreign art dealers who passed through the city. The dealers brought material, usually to Cornet, who would select which objects the IMNZ wanted to acquire. The remaining objects could be sold elsewhere. Of course, there was no way to prevent the traders from offering the highest-quality objects to foreigners who could pay a higher price than the IMNZ. This was not a significant problem in the early years, when the IMNZ had a sizable budget for acquisition, but later, when its budget had shrunk, the museum had no real leverage to prevent objects from leaving the country, despite the legal restrictions.

This arrangement also meant that the IMNZ staff had a close personal relationship with some of the art traders in Kinshasa, and even employed some of the traders to collect for them. They would pay for the objects such collectors gathered and brought to Kinshasa. Of course, Cahen admitted, they had to be careful that these contacts did not build up their own collection with the money.[39] Marc Leo Felix, a Belgian art dealer and collector, remembers his own "gentleman's agreement" with the museum. He was allowed to collect in the countryside on the condition that he would present the objects to Cornet, who would choose a number of pieces for the museum while allowing Felix to take the rest.[40]

Interestingly, the most trusted sellers were foreign, not African, merchants because the information Africans provided about the objects was considered less reliable.[41] Foreign art dealers were deemed capable of a scientific and aesthetic gaze that could identify true authenticity, while African dealers were (and continue to be) seen as "runners," or mere movers of objects pending the assignment of value,

which could only legitimately be done by Westerners. African sellers were also more often suspected of trying to pass off "fakes."[42] In 1973 Kama asked Cahen to stop buying from dealers.[43] The practice of using foreign collectors as agents of the IMNZ also greatly diminished.[44]

The Belgian staff was also known to contact other foreigners in Kinshasa (often Americans) to buy objects that had been offered to the IMNZ but that the institute was unable to buy—effectively functioning as agents in an art market. They believed these objects would be better off in well-maintained collections, even if those were abroad. Although this practice clashed with the ideology of authenticité and the theoretical purpose behind the foundation of the IMNZ, it reflected older ideas about the importance of Western guardianship.[45]

There was also a constant fear of being sold "fakes," but suspicions were always higher of material offered to the museum by dealers and merchants in Kinshasa. Given the continuing existence of both a high- and low-end art market in Zaire (and the criminal elements within those), my interviewees were often reluctant to discuss this topic, but it is clear that often the production of "fakes" was guided by the tastes of high-end collectors and museums. Sometimes art historical books would be mined for information on the appearance and style of objects.[46] It is also necessary to put the concept of the "fake" into perspective, however.

The distinction between the production of "fakes" and the production of artisans and artists was nebulous at best. Objects made explicitly for sale to foreigners had been created since the very first contact between foreign visitors and the local population, a practice that continued and was accepted to a certain extent. For example, the IMNZ commissioned Pende sculptor Kaseya Tambwe Makumbi to create a mother and child sculpture for them (see figure 4.1). This sculpture, although intended to be a museum piece, was made by a sculptor who also provided his own community with sculptures. Strict definitions of "authenticity" would exclude an object like this, since it was never used by the Pende community, but it was certainly created in the same vein as objects for the Pende themselves were made.

Another interesting case is the material made in art schools and workshops established during the colonial era. As we saw in chapter 2, a network of workshops was established in the Tshikapa region with the intent of protecting and stimulating the local artisanal production, often with the collaboration or guidance of established local sculptors.

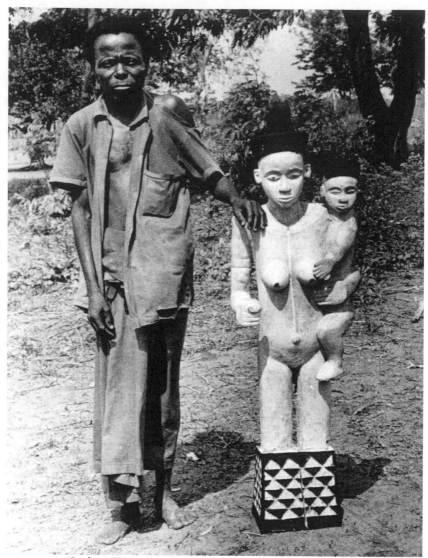

FIGURE 4.1. Sculptor Kaseya Tambwe Makumbi with a statue (*kibuadi kia muketo kia kwambata*) commissioned by the IMNZ,1974. Photo Archives IMNC, photo by Nestor Seeuws. Courtesy of IMNC.

Several of these workshops were still producing material in the 1970s, and it was often sold it to collectors and art dealers as authentic material, although, again, it was never used in local cultural practices.[47] A similar story can be told about Kuba art, the production, sale, and export of which formed a vibrant part of the Kuba economy, with a sales network that extended to the capital.[48] In other words, the line between

the production and sale of "fakes" and the existence of local economies of production, sometimes in collaboration with museums, art dealers, or art schools, was fluid.

The distance between the official restrictions and the reality of the art market was considerable, and a large "gray zone" operated in the middle. This had everything to do with the state of the Zairian economy at large, which was increasingly characterized by kleptocracy and the existence of a black market. The country's "second" economy, a result of political instability and economic insecurity, was a breeding ground for illegal trade. Especially by the mid-1970s, the economic crisis and disruption caused by dropping copper prices and Mobutu's Zairization of foreign-aid businesses gave a strong impetus to the second economy. State employees who controlled official avenues for the export of art objects provided exportation documents or opportunities to art dealers in return for bribes.[49] Both for African and foreign art dealers, personal ties to custom officers or the right contact at the Department of Culture and Arts or the presidential office could make the difference between arrest and an easy exit. In November 1973, for example, Cornet discovered that a regional head of the arts and culture section in Kabinda (in the eastern Kasai) was selling collecting permits.[50] The members of a Zairian "society of antiquarians" had established routes and contacts to get material out of the country, a service that foreign art dealers were happy to use. Despite the legal powers they were assigned under the new legislation, IMNZ officials usually lacked the necessary influence to control these situations.[51]

Several foreign art dealers that operated illegally were identified over the years by the IMNZ, and they included Africans, Europeans, and Americans, some quite well known. The African art traders were usually identified as "West African" and were especially active in the Katanga region. The only one of these known by name was Dembo Kanouté, an artist from Mali who was also associated with trafficking art in Nigeria. The IMNZ also watched a number of Europeans who created successful careers as African art dealers and scholars. The Frenchman Jacques Kerchache was in trouble in Cameroun and Gabon and was in theory banned from obtaining a visa for Zaire.[52] In 1971 he obtained permission for an expedition to Zaire from Powis, having promised that no collecting would take place. By the time the IMNZ director learned the truth, the objects Kerchache collected had already left the country, and Kerchache was expelled.[53] Christian Duponcheel of Belgium, a well-established art dealer, had encountered

problems with the Nigerian government for the exportation of objects and was not a welcome guest in Zaire.[54] Pierre Dartevelle, owner of the Dartevelle Gallery in Brussels, was accused of transporting Luba objects to Belgium in a private airplane in April 1973.[55]

The museum storerooms themselves were frequently the target of thieves. Sometimes certain objects were clearly targeted; other times the thefts were less organized. Some objects were stolen from inside the museum; others disappeared before they were registered. It is certain that the international demand for traditional African art objects fueled the rate of thefts. Huguette Van Geluwe, the curator responsible for art and material culture at the Tervuren museum, regularly alerted Cahen to rumors circulating in Brussels regarding the arrival of new material from Zaire and from the IMNZ's collections. Part of the problem was that the regular cataloging system used by the IMNZ—cards on which the provenance, identification, and collection date of objects were recorded—was not sufficiently flexible to allow the staff to determine quickly whether objects had disappeared.[56]

Like the state officials selling export permits for art, the reports on thefts need to be seen within the context of the increasingly kleptocratic nature of the Mobutist state, in which it became common practice for an elite with access to government and other resources to use these for their personal benefit.[57] In this sense, IMNZ employees who did become involved with theft or the art trade (although they were a minority) did not behave any different from other state officials, particularly after the mid-1970s, when the payment of salaries was often lacking. By their very presence in the museum's storerooms, objects were transformed into public goods, open to exploitation.

A number of Zairian staff were at some point accused of irregularities. In a particularly disruptive case in 1975–76, allegations tied Zola to the disappearance of objects from the diocese of Boma. This collection had been in the hands of the Scheut congregation in Kangu in Lower Zaire, and the IMNZ had undertaken negotiations to obtain it. Before they came to an agreement, however, the diocese in Boma claimed the collection. Zola, sent to Boma to investigate, warned of the risk that the collection could disappear into the hands of art dealers. One piece in particular, a nail sculpture of a dog with two heads, was worth acquiring for the museum.[58] When the money for the purchase finally came through, Seeuws headed to Boma, where he concluded, upon inspecting the collection, that the sculpture in question had been replaced by

a copy. Father Ntsumbu, who was in charge of the collection, claimed that Zola had sent somebody for the statue earlier. Zola, in return, alleged that Ntsumbu, having become aware of the piece's value, had sold it on the black market. Although it was clear that Seeuws was more than ready to believe that Zola had acquired the piece behind the IMNZ's back and sold it to an art dealer, in the end no disciplinary action was taken because Zola's involvement could not be proven. But the episode strained the already difficult relationship between the Belgian and Zairian staff members.[59]

This was not the first collection owned by the Catholic Church that the IMNZ had problems acquiring. Early on, in 1971, the Scheut congregation at the vicarage of Matadi was suspected of illegally shipping a valuable collection of early Portuguese-influenced crucifixes to Belgium, ignoring the newly installed laws against the unauthorized exportation of art. Powis had to use his contacts at the Belgian royal court to get a response from the Belgian branch of the congregation, which deflected requests for information and possible repatriation by claiming that the collection they had received in 1970 had been depleted of the best pieces, which must have remained in Zaire. Cahen and Cornet were convinced that the congregation's representative was hiding the truth. Cornet used his religious contacts in Zaire and found out that the collection had in fact been shipped out in March of 1971, the very month the legislation for the protection of heritage was passed. The IMNZ concluded that the collection was either still in the hands of the congregation in Belgium, or it had secretly been sold in the United States.[60]

Even more than at the IMNZ in Kinshasa, the Lubumbashi museum was plagued by theft, which made Kinshasa very suspicious of the Lubumbashi staff. In part, the thefts were due to the close proximity of Lubumbashi to the Zambian border, which was notoriously "leaky." The distance from Kinshasa and the unfamiliarity of the Kinshasa staff with the personnel in Lubumbashi also contributed to the IMNZ's desire for better control over the situation in Katanga. In May 1972 five large and valuable Songye statues were taken by somebody with keys to the museum. This prompted Kinshasa to fire all but two of the museum's Zairian employees.[61] The case of the stolen Songye statues had a curious ending. In November, Cornet wrote to Cahen that a visitor had seen them in the private collection of the collector Willy Mestach in Brussels and was told they had been sold by the museum

in Lubumbashi.[62] Cahen was able to recover four of the statues for free and sent them back to the IMNZ in Kinshasa, which refused to return them to Lubumbashi.[63]

The initiatives taken by the Lubumbashi museum to stem the tide of illegal exports met with little success. The museum director, Guy de Plaen, agreed to go to the border police every Sunday to help them check luggage—a mostly symbolic act unlikely to have real effect on the illegal art trade.[64] In March 1974 another robbery took place at the Lubumbashi museum, which illustrated the complicated relationship between law enforcement, foreign art dealers, museum employees, government officials, and representatives of Tervuren. The setup for the robbery was elaborate. A group of soldiers came to the museum when it was closed and arrested the guard who refused them entrance, after which they backed a truck up to the museum and proceeded to take pieces from the storerooms on the second floor. What the burglars did not know was that, at the time of their crime, a young American scholar was at work in the museum, two floors up from the exhibition rooms. Allen Roberts was immersed in his research and did not notice anything was amiss until the guard failed to send the elevator to him at the agreed-upon time. Roberts spent hours trying to attract the attention of passersby from a second-floor window. Someone finally alerted museum staff, who discovered the theft when they came to free him.[65]

De Plaen took the case to the local authorities, but became caught in a web of politics and intrigue, and was himself accused of trafficking art objects by one of the officers behind the robbery, Major Ikolo of the Centre Nationale de Documentation.[66] The latter claimed his actions simply constituted a confiscation of material De Plaen was planning to send out of the country. He even forced a local art trader to make false statements to this effect. Despite repeated demands from the curator at the museum, Ndoy, that Ikolo create an inventory of the goods he "seized," Ikolo refused to do so.[67] Cahen and Cornet suspected De Plaen's activities against local illegal art exportation were probably the reason he came under fire. Kama came to Lubumbashi to resolve the case in what became a test of strength between local Katangese and national officials. After difficult negotiations, during which the presidential adviser and museum staff were repeatedly threatened, Kama was eventually able to get the museum guard released and have disciplinary action taken against the officers involved.[68] This story demonstrates the vulnerability of Kinshasa's power in the Katanga region but also shows

the extent to which a corrupt political system and a powerful second economy drowned out good-faith efforts to protect the country's cultural heritage.

The art trade was also important in the creation and maintenance of different kinds of value for traditional art objects. When a certain type of object became popular and valuable in the African art market, they also became more important emblems of cultural heritage. Thus the tastes of Western art collectors, and their interpretation of the object's aesthetic beauty, contributed to the selection of certain objects or artistic traditions as *national* heritage. This, in turn, affected the art trade, since their enhanced status caused the Zairian state to see itself as their rightful owner. However, the art trade was protected by the fact that a complete state monopoly would undermine the system that was generating value for the pieces.

Even though art dealers were ultimately concerned with economic value and the museum staff with cultural value, the perceived authenticity of a piece was the key to both their aims. An added complication was that the economic value of an object could be understood as an expression of its aesthetic valuation in the West and was therefore also relevant to the museum. The groups, then, shared similar interests in the pursuit of different goals. While traders were ultimately concerned with the translation of economic value into tangible income, the museum's relationship to financial concerns was more ambivalent. While the economic value of the museum's collection certainly contributed to its prestige and to its visibility as a national resource, the collecting practices of the museum staff were not limited to economically valuable pieces.

It is clear that the trade in African art objects, be it legal or illegal, was important to the life of the museum institute. The trade presented more of a threat to it than to Western museums because, being in the process of forming a new collection, it was in direct competition with the traders on the open market. However, the most important source of material for the growing collection were the expeditions of the museum's own employees.

COLLECTING FOR A POSTCOLONIAL NATION

From 1970 to 1990 between 35,000 and 50,000 objects were acquired by the IMNZ. The majority of these were gathered on one of the 117 IMNZ expeditions.[69] In theory, the majority of the expeditions were

supposed to be ethnographic in nature (focused on fieldwork and collecting that would further the knowledge on the cultures and societies visited) in order to foreground the scientific task of the museum. In practice, however, many of them (especially during the first four years) were focused on finding "museum pieces" for the national collection. The musicology expeditions, of which there were about 20, were an important exception. Quersin, in collaboration with Tervuren, led a very productive ethnomusicology department devoted to recording as much "traditional" music as possible before it disappeared. Archaeology expeditions also left from Kinshasa, but mostly they were sent out by the museum in Lubumbashi, where this was a more active branch of research.[70]

Unfortunately, the sources allow us only a limited look inside the expeditions. Yearly reports offer enough information to form an idea of the number and nature of expeditions, but little more. Very few expedition reports or research journals survive.[71] A small amount of correspondence between Seeuws and Cornet still exists that allows us a glimpse of the methods that the staff used to acquire materials from the local population. There is also a haphazardly organized and incomplete photo archive at the IMNC, and the memories of some of the participants. What emerges is a pattern of active collecting in the early years diminishing to a standstill by the middle of the 1970s, for reasons that will be discussed below.

FIGURE 4.2. Second IMNZ mission, Kiadi and Charlie Hénault, near Mushenge, 1970. R053–36, Photo Archives IMNC. Courtesy of IMNC.

The expeditions were plagued by practical problems. Usually the team selected for a trip left from Kinshasa in one of the two Land Rovers owned by the museum. Bad roads and vehicle breakdowns were a staple on these trips, which lasted from a couple of days to several months. A solid third of the correspondence with the home base in Kinshasa concerned problems with the vehicles. For example, on a 1972 mission, about seventeen kilometers from Kikwit in the Bandundu area, there was a serious accident when the truck carrying the results of weeks of collecting broke down and ended up in the water. It took several days for the IMNZ staff, with the help of local laborers, to get the truck out of the water. By then, most of the material had suffered serious water damage. Making things worse was the fact that Jos Gansemans, an ethnomusicologist from Tervuren, had encountered the group during their mission and entrusted them with an entire case of recordings from his field research, all of which were destroyed.[72]

Another problem was the unknown condition of the roads in the interior. On multiple occasions expeditions had to turn back or adapt travel plans because roads turned out to be inaccessible. The expedition members tried to send material to Kinshasa via military and government channels (usually by airplane) or with foreigners on their way to the capital, but these attempts had a variable rate of success. Sometimes cases with material got stuck or were left behind along the way, requiring extended efforts to relocate them. The most trusted method

FIGURE 4.3. Kabongo-Kabalo route, Luba area, February 1974. R053–36, Photo Archives IMNC, photo by Charlie Hénault. Courtesy of IMNC.

was simply to load up the vehicles until there was no space left and then drive back to Kinshasa, or to put the vehicles on barges and float down the Zaire River back to Kinshasa.

The reactions of local people to the IMNZ staff varied greatly from place to place and were shaped by prior relations with art collectors. Many of the communities the IMNZ visited had seen ethnographers or collectors pass through since the late nineteenth century. Several had even started producing objects for foreign visitors.[73] While visiting the Pende in 1971, Seeuws reported that people spontaneously brought them objects and local leaders sometimes gave them information on where to obtain certain pieces. These responses were unusual, though. Normally researchers had to make an extended stay in a locale and to carefully develop relationships with local people before they could obtain information about objects. Ideally, it was "absolutely necessary to pass through the same place several times to find a good piece." Once a piece was located, it usually took time to obtain it.[74]

In some regions the collecting went more slowly because there was very little material to be found. This was certainly the case in several places in the Katanga region, for example, where Senegalese traders had passed through.[75] Seeuws and Hénault encountered a network of local scouts set into place by these traders. Despite his disapproval of the Senegalese traders' activities, Seeuws used their suppliers in hopes of finding something interesting.[76] In some cases, art dealers had left

FIGURE 4.4. IMNZ mission, location unknown, 1970. R053–37, Photo Archives IMNC. Courtesy of IMNC.

much resentment among the local population, who accused them of stealing objects.[77] Few people saw the difference between museum staff and other collectors or art merchants who came through their communities. Identifying themselves as representatives of a national institution created to safeguard the heritage of the nation was not always a viable strategy. Many Zairians had experienced the state as a tool of oppression, either during the colonial era or after, and "the nation" was still a somewhat abstract concept.[78]

Many decades of collecting by traders and colonials had shaped the expectations of the communities through which the IMNZ staff circulated. While in northeastern Zaire, collecting among the Mangbetu and the Zande, Seeuws found a well-made "fake" Zande statue. After talking to locals, he learned that a foreign collector passing through had asked for this type of sculpture, giving a local representative of the state the idea of having similar statues made by a local craftsman. Remarkably, to give the craftsman an example, the administrator had shown him an image published in Cornet's book *Art de l'Afrique noire au pays du fleuve Zaïre!*[79]

Local populations were not always keen on giving up the objects the museum desired. On one occasion, Seeuws was shown two seats (*Kihona*) of the Kifwa, a subgroup of the Hemba.[80] A local leader was interested in selling them to Seeuws, but his brother, sister, and other family members opposed the sale. Seeuws worked out a deal whereby he would pay for the seats but leave without them. They would be brought to him under cover of darkness, and he would make sure that a sculptor made two new ones to replace them. After several days, the seats had not arrived, and eventually the chief simply sent Seeuws back the money, declaring that he was unable to provide him with the chairs because opposition to the sale was spreading through the village.[81]

Collecting was done mostly by the Belgian employees in the early years, echoing the preference for European over African art dealers in the museum's acquisition politics in Kinshasa. The Zairian staff served as assistants to the Belgian staff on these missions. This arrangement continued a long-standing tradition in African research, in which African assistants or servants accompanied foreign collectors, researchers and explorers as guides and culture brokers. Their roles, however, in obtaining and shaping knowledge have been systematically erased.[82]

On some occasions, the Zairian assistants had more success collecting. This was usually the case in their regions of origin. Sometimes

family and local connections helped, as they did for Zola in the Zaire-Angola border area. Among the Zande in the north, however, he experienced the same level of hostility the foreign IMNZ employees did.[83] Although not her region of origin, Nzembele recalls being better able to approach the women of the Mbole when she accompanied Quersin, his wife, and the Belgian art historian Marie-Louise Bastin, on a trip to the Eastern province. She believes this was due to her status as a woman and fellow Zairian.[84]

During the first years of the IMNZ's existence, the Belgian staff members embarked on a survey of the country in order to create a long-term plan for collecting. Seeuws recommended that, ideally, the staff spend at least one month per *territoire* (a subdivision of a province) so that they would have time to build relations with the local population and gain the trust necessary to obtain the more valued objects associated with rituals and societies. Additionally, time was needed to come to agreement about prices.[85] Cornet and Hénault went to Lower Zaire, and the team of Cornet, Seeuws, and Hénault visited the Kasai, where a total of 1,200 objects were collected among the Pende, Kuba, and

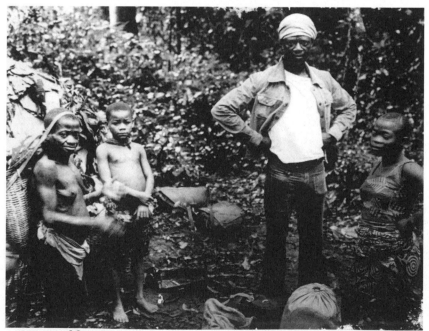

FIGURE 4.5. Museum employee Epulu among the Mbuti in northeastern Zaire, March 1973. R053–14, Photo Archives IMNC, photo by Charlie Hénault. Courtesy of IMNC.

Songye. Quersin and his wife, with the help of the Zairian assistant Boilo, explored the Equator region. A smaller ethnomusicological reconnaissance was also done among the Kwango of Lower Zaire, and Cornet went to the Kuba—his main area of interest—in the northern Kasai. Lastly, Seeuws and Hénault headed to the Shaba (Katanga) region.[86] They spent most of their time prospecting in the northern part, where other art dealers were most active. This trip was a clear example

FIGURE 4.6. Museum employee Ngamba and a Songye mask, fallen victim to a rat, May 19, 1974. R053–45, Photo Archives IMNC, photo by Charlie Hénault. Courtesy of IMNC.

of the IMNZ's prioritizing in order to compete with art dealers, thereby affirming trends in the preferences of the African art market.[87]

On the basis of the first year of trips, the Songye in the Kasai and the Zande and the Mangbetu in the north were targeted first for collecting. The interest in the Mangbetu was also a clear example of a collecting agenda being shaped by existing Western tastes and museum collections, since the motif of the elongated female Mangbetu heads had been popular since the early twentieth century.[88] In early 1973 Seeuws went on an expedition to collect among the Zande and Mangbetu. The results among the Mangbetu were disappointing. Seeuws found the region to be devoid of its material culture: "The region seems emptied out of sculpture and one would need really a lot of luck to find even one statue."[89] He even recommended resorting to the international art market in order to find representative pieces of the Mangbetu.[90]

The objects collected tended to be pieces that were understood to be rare and considered to be of high aesthetic quality, as well as having been in use by the local people, following prevailing Western interpretations of authenticity. The early searches focused on objects such as statues, ritual knives, special textiles, and masks. A stay among the Songye, for example, resulted in the acquisition of two boxes with geometric designs, ten masks, and a number of smaller statues.[91] Acquisition in situ was used as a mechanism to underwrite the authenticity of the objects.

The IMNZ strongly favored certain material cultures and areas over others. These preferences were shaped not only by the individual research interests of the staff but also by the tastes of the international art market and the contours of existing collections. The objects that were most desired and valuable in those circles were also often the ones the IMNZ was most eager to collect and prevent from leaving the country. Objects from Kuba, Songye, Lega, Yaka, Kongo, Pende, and the Kasai, Kivu, Bandundu, and lower Zaire regions were most strongly represented in the collection in Kinshasa.[92]

While selecting material from the objects offered by art dealers in the capital, Seeuws and Cornet looked for objects that were "exceptional": those of a new, unknown type, or one of a known type but noticeably bigger or smaller, and so on.[93] Collecting in the field happened more indiscriminately, since the staff was more trusting of the "authenticity" of objects collected. In addition, there was more opportunity to trace and record the provenance of objects.

FIGURE 4.7. Nzembele among the Mbole in zone Opala, April 1974. R067–86, Photo Archives IMNC, photo by Charlie Hénault. Courtesy of IMNC.

Triaged items from the collections of existing local museums supplemented the IMNZ's collecting process. While the museum in Lubumbashi was able to resist these incursions on its collections, in part because it was run by a Belgian but also because resistance from the local expat community would have been strong, the museum in Kananga was not so fortunate. On a visit to the Kasai in the early 1970s, IMNZ staff selected the best pieces from the local museum and sent them to Kinshasa, in effect centralizing the collection of exceptional and valuable pieces. The IMNZ's adjunct director, Cornet, also recruited Rik Ceyssens, a Belgian working for the local college with a background in ethnography, to collect in the region, which he did until the mid-1970s. In addition, Ceyssens was charged with paying the Zairian museum staff in Kananga their monthly wages.[94]

Tervuren monitored the collecting process. Albert Maesen, head of the ethnography department at Tervuren, came to Kinshasa a number of times to evaluate the quality of the material collected. During a first visit in 1971, he took a closer look at about eight thousand of the ten to twelve thousand pieces that had been collected so far. He decided that thirty were of an exceptional quality—meaning they had no equal in any other collection—and another hundred were of special quality.[95] These "quality control" visits had multiple goals. First, Maesen

genuinely had more know-how in terms of theoretical knowledge than the IMNZ employees, who had little to no training in art history or anthropology (yet.) Secondly, an assessment of the material collected helped create a future collecting agenda. But Maesen's contribution was also advantageous for Tervuren. It allowed the Belgian museum to keep tabs on the collecting and potential research possibilities in Zaire. Finally—and most important—a well-balanced and valuable collection in Kinshasa meant a reduced risk of renewed restitution demands.

Other factors shaped the collecting practices of the IMNZ. For example, the accessibility of areas played a large role. The southern part of the country was most accessible by jeep from Kinshasa and had a more developed colonial transportation network than the northern regions. The southeast was explored from Lubumbashi, where the IMNZ also had a base. Furthest removed were the north and east-central areas.

The existing knowledge about and desirability of certain artistic traditions also played a role. This was the case for the Mangbetu and Zande communities, despite being far north. Collecting motivated by already established, colonial, systems of meaning and value reaffirmed those systems and the hierarchies embedded in them. The disappointment of Seeuws upon finding the area "empty" of objects, followed by his subsequent push to buy Mangbetu material from art sellers in the capital, is an example of this. The presence of art dealers in certain areas sometimes also motivated the staff to go there, both because the presence of art sellers indicated there was probably something to be found, and because they wanted to prevent regions from being "emptied" before they had a chance to visit.

Relocating traditional objects to the storerooms of the museum institute was crucial to their "activation" as authentic national heritage. In the "field" (in other words, in their original context), they were useless to the national project.[96] Just as their cultural and economic value was created in their exhibition as art in the museum of Tervuren, their national character could only be affirmed in the context of a Zairian museum. The objects did not even need to be on display; they merely had to be in the museum's possession, having been subject to a process of selection and definition that inscribed them with their new status as representatives of the nation.

A comparison with the colonial era reveals similarities and important differences. The majority of the collecting was still being done by Belgians, especially in the early 1970s, with Zairian assistants in

a supporting role. It was not until a process of Zairization was set in motion that this changed (see below). Both colonial and postcolonial collecting was done for the benefit of state-run museums, and both of these museums—Tervuren and the IMNZ—had nation-building purposes. While Tervuren promoted Belgium as a colonial power, the IMNZ was created to give shape to a national culture that could underwrite a postcolonial power structure. Both aimed to mold Zairian society, but the Zairian state was invested in creating modern subjects, and the "possession of heritage . . . [was] an instrument of modernization and mark of modernity, particularly in the form of a museum."[97]

AUTHENTICITY IN ACTION:
THE "ZAIRIZATION" OF THE IMNZ

Within the ideology of authenticity, a systematic claim was made on traditional culture as a resource for the new nation. A reimmersion in "traditional" cultural elements was invested with the power to erase decades of colonial rule and promote the establishment of a national cultural identity, an important step on the road to modern citizenship and the formation of a nation to legitimize the Mobutu-led state.

Reclaiming the country's resources for the benefit of the independent state had been part of the political program from the moment of independence, when the debate about the contentieux took up a lot of attention in Belgian-Congolese relations (see chapter 3). Upon his establishment as the country's leader, not long after his second coup in 1965, Mobutu moved to nationalize the Union Minière, the nation's most important mining company. The next phase of the nationalization program came in 1973 with the "Zairization" of foreign-owned businesses.[98] The Zairization process was ostensibly driven by a desire to keep the profits generated by the economy in the country. However, the increasing patrimonialization of the Zairian state and the nepotism involved in the reassignment of resources spectacularly undermined revenues. Additionally, the Zairian economy had to contend with dropping copper prices and rising petroleum prices. The government tried to reverse the disastrous effects of Zairization, first by a process of "radicalization," whereby the government took over the bigger companies. When this failed because of the corruption of the government system, Mobutu moved to declare a "retrocession," in which the companies were returned to their previous owners with the mandatory requirement of taking Zairian partners. The result was an exceptionally

wealthy Zairian elite, a troubled economy, and an increasingly impoverished population suffering from a deeply corrupt and malfunctioning state system.[99]

Both the campaigns for cultural authenticity and the politics of Zairization underscored a process of increased centralization of political power in the hands of the Mobutu regime. What the literature on Zairization has not yet acknowledged is that it extended beyond the confines of economic life. The IMNZ, with its mixed Belgian-Zairian character, became subject to its own process of Zairization. There were some significant differences between the Zairization of the economy and that of the museum, however. The IMNZ and its collections were already the property of the Zairian state. It was the leadership, the creation of knowledge, and the image of the museum as a Zairian institute, and not a Belgian-Zairian cooperation, that were at stake. While the Zairization process in the economic sector served only to increase the wealth and dominance of a limited class of Zairians who already possessed the most political acumen and power in the country, the Zairization of the museum institute was intended to educate and create an intellectual elite. In addition, Belgians, and the museum of Tervuren, were dominant in the production of knowledge about Zairian art and cultures. The presidential office wanted the IMNZ to become the center for such research, and wanted Zairian students and scientists to take the lead there, too.

The presidential office charged one of its advisers, Kama Funzi Mudindambi, with the implementation of a process of Zairization of the IMNZ. Kama had replaced Colonel Powis as the main liaison between the presidential office and the museum. Kama, along with several of the young Zairian researchers, strongly believed in the national project and in the role of the museum in shaping the new Zaire. The discussions between Kama, the Belgian staff, Tervuren, and the young Zairians focused on a number of issues: participation and leadership in expeditions, educational opportunities, the leadership of the museum institute, and the representation of the museum to the outside world.

In signing the agreement for the creation of the IMNZ, Tervuren had acknowledged that it would assist in a transition and would turn over the leadership of the IMNZ to Zairians as soon as possible. Ideally, the IMNZ would contribute to the education and emergence of a Zairian cultural elite. In practice, however, the Zairization process and the promotion of the young Zairians were impeded by personal conflicts among the staff and a growing reluctance by Tervuren to hand over the reins.

The status of the Zairian personnel became an almost constant source of tension between the presidential office and the Belgian museum staff. Kama repeatedly complained they were not given enough opportunities to go on collecting missions, which were led by Seeuws, Cornet, or Hénault (or by visiting scholars in the early years).[100] It came to Kama's attention, for example, that Benoît Quersin had taken his family on a mission to the equatorial region, while none of the Zairian assistants were offered the opportunity to go along.[101] Cahen defended the situation by claiming that it was not abnormal for researchers to take their spouses to the field, citing as examples Jos Gansemans and Francis Van Noten of the museum in Tervuren. Kama insisted that in the future the Zairian personnel should receive priority over spouses on trips to the field. Another issue of contention involved Charlie Hénault, a Belgian staff member who lacked appropriate training and a PhD degree but was allowed to lead missions. Cahen and Cornet had argued that experience and education were necessary to lead missions, an argument that Kama noted did not seem to apply to Belgian staff. Cahen, however, refused to take Hénault out of rotation.[102]

Another issue was the level of involvement of the scientific staff of the Tervuren museum. The fear was that the IMNZ was being run as a branch of Tervuren instead of as a national Zairian institute. This fear was not entirely unfounded. For many at the Belgian museum, the IMNZ had been the gateway back to their site of field research.[103] Cahen argued that these researchers were needed to train the students at the IMNZ.[104] Kama, however, complained that "the expatriate researchers do not have to smother the Zairian assistants at every step. They have to be able to let them be. . . . This does not mean eliminating them, but to reserve the role of technical assistance for them."[105] Cahen replied that not including the expatriates in field missions would also be discrimination. "I understand well that the mixed missions can appear to have an offensive character to some sensitive types, and that the program that has been presented is full of these [mixed missions]," Cahen wrote, "but only considerations of efficiency and acquired experience have motivated the authors of the program."[106] As a result of these conflicts, a new policy was created in 1974 that stipulated that every mission include at least one Zairian staff member and prohibited "others" (wives, etc.) from participating.[107] As a consequence, Cornet's and Seeuws's participation in missions drastically diminished, with the exception of Cornet's research trips to the Kuba.

Archaeological expeditions too were a source of conflict, and for a number of years a complete stop was put to all archaeological expeditions involving Tervuren. Previously, Francis Van Noten and Pierre De Maret had taken excavated material to Tervuren for research and restoration. In an already tense atmosphere, the Zairian government (possibly on the instigation of the Lubumbashi curator Guy De Plaen) interpreted this as a breach of the law for the protection of national heritage. Cahen defended the young archaeologists, pointing out that the materials were only in Belgium for the duration of their research and would then be returned to Zaire. His efforts were to no avail, and archaeological expeditions from Tervuren came to a standstill in 1975.[108]

Education and the museum's leadership were also the subject of debate. There were internships available at the Tervuren museum for both the Zairian scholars and technicians in training. In addition, doctoral candidates, like Lema Gwete and Shaje A. Tshiluila, were educated at Belgian universities. Nonetheless, their education was not proceeding at the desired speed for the presidential office, which was not happy that the Belgians were still the work leaders.

By 1973 the tensions between Lema Gwete and the Belgian staff members reached a boiling point, exacerbating the relationship between Kama and Cahen as well. Again, the central issue had to do with the authority of the Belgian staff members over the local staff members. Lema was expected to take over as director once his education and training were completed, although when that would be was always uncertain. Serious tension emerged between him and the Belgian collaborators over what the Belgians called his attitude. They complained that he made other Zairian employees call him director and had terrible leadership skills. They preferred Nzembele, arguing that she had the necessary leadership skills as well as the intellectual capacity to lead.[109] In the long run, this plan seems to have been shelved, in all likelihood because Kama objected. In 1976 Lema was promoted to director of research, but he did not become full director until 1987.

A last issue in the debate around the Zairization of the IMNZ was the public face of the institute, particularly abroad. Around the time that the tensions over leadership and missions surfaced, the presidential office decided to send an exposition to Paris. Tempers flared when it came time to select staff members to accompany the exhibition. Cahen recommend Seeuws, which Kama accepted only on the condition that

two or three of the Zairian assistants be included and that Seeuws, "out of respect for the authenticity, not make himself seen."[110]

Despite Kama's attempts to place limitations on the Belgian staff, he was well liked by most of them. They felt that he was reliable and would do his best to solve any practical problem resulting from the unreliability of the Zairian state system.[111] At the IMNZ, he was not seen as the real source of pressure. "The principle [of Zairization] comes from Mr. Bisengimana," Cornet wrote. At the museum, "we do not yet feel any hostility in the group of assistants, although they talk a lot among themselves . . . and we have to be careful and discreet."[112] Kama's greater conflict over the identity and future of the institute was with Cahen, Tervuren's director. Increasingly, Tervuren held the Belgian staff of the IMNZ in suspicion. Cornet, in particular, was considered too close to the Mobutu regime and was therefore distrusted. Cornet reciprocated the lack of trust, as did Hénault and Quersin from time to time. All three sympathized with the desire of the Zairians for a true cultural decolonization, and they came to see Tervuren's behavior as heavy handed and even neocolonial. Only Seeuws, who had always been closer to the Belgian museum, felt different. Having trained there, he was the only one of the IMNZ's Belgian staff to have spent any considerable time at Tervuren, and he was responsible for most of the museum institute's correspondence with Belgium. Seeuws was also the only Flemish staff member of the IMNZ, and Cornet was rumored to be resentful of Flemish dominance at Tervuren.[113]

It is difficult to determine what the Zairian employees thought of the tensions between the various camps, since the archival material reflects only the interaction between Kama and the Belgians. Nor are interviews always a reliable source of insight into this problem. People's memories tend to be colored by their experience of the present, making it no surprise that both those on higher education tracks and those in technical positions remember the first half of the 1970s as an era of opportunities. Additionally, the interviewees only represent a selection of the museum's employees of the 1970s, some having moved on, or (like Lema) passed away. The two women, Shaje A. Tshiluila and Eugénie Nzembele Safiri, both recall Cornet's support for their careers and his sensitivity to the Zairian point of view in the conflicts with Tervuren. Nzembele also fondly recalls the support she received from Huguette Van Geluwe, the only woman on the Belgian side of this equation.[114] Clearly, none of the

parties in this story represent one-sided identities, a reminder of the fallacies of reproducing the monolithic images of colonizer and colonized so often projected upon the colonial history of the area.[115]

The tensions concerning Belgian authority were never completely resolved, in part because the IMNZ considered Tervuren's support too important to its future. Problems continued to surface until 1975, when the IMNZ was transferred from the authority of the presidential office to the Department of Culture and Arts. In terms of budget and opportunities, this move was disastrous for the IMNZ, but the commissioner of arts and culture was less concerned with internal staff tensions and the rate of promotion of the Zairian assistants than the presidential office had been.

The extension of the politics of Zairization to the museum institute show that the IMNZ was regarded as a resource for the nation: not merely in its capacity as a repository of cultural heritage—the raw material for the creation of a national cultural identity—but also as an institution in itself. As such, it was a vehicle for the creation and advancement of an intellectual segment of the Zairian upper middle class. The results of the attempted Zairization at the IMNZ were uneven, however. While Zairian assistants did get more opportunities to go out into the field to research and collect, it took many years for a Zairian to rise to the position of director. The Belgians remained at the IMNZ until the early 1990s, when they were forced out of the country during Mobutu's expulsion of all Belgians supplying technical aid.

NATIONALIZING THE CREATION OF KNOWLEDGE

Although the IMNZ made its collecting activities a priority during much of the 1970s, the museum institute had not been created only to collect and display Zaire's material cultures. It was also intended to become a new center for the study of Zairian cultures. Mobutu wanted the IMNZ's emulation of Tervuren to include competing with the Belgian museum as a center for scientific research. The IMNZ was not the only element in the regime's plan for the nationalization of the creation of knowledge. In the context of the authenticité campaign, the Catholic university of Lovanium (still affiliated with the Belgian University of Leuven) had been nationalized and reorganized, with two other university campuses, into the National University of Zaire, and it was suggested the colonial research institution IRSAC should be retooled in order to research the "political sociology of authenticity."[116]

The promotion of scientific research under the auspices of the Zairian state aligned with a larger intellectual project of the epistemic decolonization of the production of knowledge about Africa.[117] In the case of the IMNZ, this was focused not so much on the creation of a new approach to anthropological or art historical research, but a Zairization of the intellectual class producing this material, as well as an emphasis on the Zairian context in which they worked. The hope for the success of these activities lay with the young Zairian cohort of students employed at the IMNZ. Although their progress was much slower than expected, the first to obtain his doctorate was Lema Gwete in 1978. Nzembele failed to finish her doctorate, but several others of the generation hired in 1970 obtained their PhDs in Belgium, including Shaje A. Tshiluila and the two archaeologists, Muya wa Bitanko and Kanimba Misago.[118]

The IMNZ never developed a comprehensive research agenda, however. The bulk of the research activities in the region were associated with foreign researchers, many of whom were connected either to Tervuren or to IRSAC.[119] Of the Belgian employees at the IMNZ, only Cornet's research led to a body of published work; he was also (with the exception of Cahen) the only member of the Belgian staff who had an advanced degree. The government's support of scientific research also turned out to be driven more by a desire to use scholarship as promotional material than by an interest in research for its own sake. An analysis of the publications that received funding from the presidency provides insight into the administration's priorities. The first publication funded by the presidential office was Cornet's large and well-illustrated volume on art from Zaire. Mostly intended for a foreign audience, the book appeared in Dutch and English in 1971 and in French in 1972. Although the book deals solely with art from Zaire, its French and Dutch titles—*Art de l'Afrique noire au pays du fleuve Zaïre* and *Kunst van zwart Afrika in het land aan de Zaïre*, respectively—frame Zairian art as part of black Africa. The English title, *Art of Africa: Treasures from the Congo*, does not carry the same racial connotation.

The book resembles an "imagined museum," and the most famous sculptural traditions are represented. One could also call it a "Zairization" of the standard book on Congolese sculpture, written by Frans Olbrechts in 1946. It similarly opts to focus on sculpture and follows the division of styles set up by Olbrechts, although it incorporates new research that recognized more stylistic variation within regions. Cornet

did not question Olbrechts's basic geographical and stylistic divisions, and the organization of the material moves similarly from the southwest (the capital region) through the center and the south to the southeast and north.

Although he participated in writing several exhibition catalogs, the focus of Cornet's research activities continued to be the royal Kuba art traditions, culminating in the publication of *Art Royal Kuba* in 1982.[120] Strongly art historical in nature, the richly illustrated book is a detailed investigation of royal art, but Cornet construed this category broadly and included textiles, costumes, and architectural features.[121] The book makes historical and ethnographic information available but puts it in service of the objects. Although Cornet mentions early foreign visitors, such as Emil Torday and William Henry Sheppard, "history" takes place in a distant past, and he ignores the impact of Belgian colonialism on the Kuba and the commercialization of their artistic traditions. Instead, they are represented as a "pure" culture, stripped of all outside influence. This is also reflected in the many pictures of the royal court and several ceremonies, which contain no references to changes brought by modernity. Cornet also studied the art of the Kongo peoples of the Lower Zaire, particularly their stone funerary art, interest in which was relatively new. By the late 1970s the IMNZ possessed a large collection of 394 *ntadi*, stone funerary sculptures. Cornet's main interest here, as with the Kuba, was in the objects themselves—their meaning, their form—more than in the people or societies to whom these objects belonged.

Although the Zairians at the institute continued their role as support staff, by the mid-1970s this situation was changing.[122] In the push for Zairization of the IMNZ, Zairian trainees were increasingly doing their own research and collecting. However, Zairization policies were no guarantee against the exclusion of the Zairian staff's contributions from the archive. One clear example involves the work of Eugénie Nzembele Safiri, who accompanied Benoît Quersin and his wife, Christine, to the Mbole, where Quersin wanted to document female skin scarification. Because Nzembele, as a young Zairian woman, seemed better able to approach the Mbole women and take photos of their scarifications, Christine Quersin suggested that she switch her research topic from mat weaving among Mbole women (recommended to her by Huguette Van Geluwe at Tervuren). Taking up this suggestion, Nzembele returned to the Mbole in the company of Charlie

Hénault in order to take more photos.[123] The resulting collection of photos is still in the museum institute's photo archives, but Nzembele's name appears on none of them. Instead, they are registered under either Hénault's name or Quersin's, effectively erasing her contribution. This example illustrates not only the cooptation of Nzembele's work by the Belgian staff but also the role Zairian assistants continued to play as culture brokers.

More often during research trips, though, her identity as a young Zairian woman worked against Nzembele. Rural populations were familiar with European and American researchers and collectors passing through their communities, but she was often the first Zairian—let alone a Zairian woman!—they encountered in that role. Not only was her gender unusual (Western female researchers were not unheard of, but certainly uncommon), but since Zairian researchers were so rare, there was a lack of trust and perhaps even a degree of contempt in her reception.[124] This lack of trust was likely founded on the perceived transgression in the identity of the Zairian researchers, since they adopted a Western identity in their urban, educated manner and maintained a researcher-subject relationship in their contacts with locals.[125]

Local political and state authorities were not always welcoming either, in spite (or perhaps because) of the IMNZ's role in representing the national state. For example, Nzembele's collection of photographs was confiscated by the National Security. As a consequence, some of the more intimate photos the women had allowed her to take started circulating, eliciting complaints from the Mbole community against the IMNZ. The photographs were eventually returned to the IMNZ, but only after the intervention of the governor of the Upper Zaire region, the Belgian embassy, and eventually the presidential office.[126]

It was not only their female identity that set Nzembele and Tshiluila apart as researchers. They also chose to do research among communities of a different ethnic background than their own. In 1986 Tshiluila completed a PhD in anthropology on funerary traditions in Lower Zaire after fieldwork in Angola and the Lower Zaire region. Her choice of subject was motivated by the large collection of these objects the IMNZ possessed and by the wide-open research options given the relative newness of some of the discoveries in the area. While in Nzembele's case her gender played a role in determining her research because it gave het better access, both she and Tshiluila believed studying a culture different from their own affirmed their identities

as scientists, since objectivity required distance. Tshiluila's desire to venture beyond her own ethnic community was also motivated by her belief that it made her a true citizen of Zaire.[127] For both women, building a national museum, and emancipating the creation of knowledge about Zairian cultures, meant engaging scientifically with the diversity of the nation.

Access to the terrain and financing undoubtedly also played a role in research decisions among the Zairians. Much research took place in the environs of Kinshasa and Lower Zaire, particularly in later years, when there was less money available.[128] Archaeological research, originally a strong component of the institute's activities, tapered off. A conflict between Belgium and Zaire about the removal of archaeological material to the Tervuren museum played an important role in this decline, but steadily diminishing funds did not help.[129] The research that took place was enough to allow the museum to refer to a deeper historical dimension in the nation's history, but its decline represented the loss of an exciting and growing field of research.[130]

While museum catalogs for foreign exhibitions and Cornet's more general work promoting Zairian art resulted in glossy publications sponsored by the presidential office, most of the more thorough, scientific work was not met with the same enthusiasm. Ultimately, for the Mobutu regime, promotion and general attention trumped the creation of painstakingly researched knowledge, which worked to the disadvantage of the young Zairian researchers, who were being educated as academics. For them, scientific research and publishing were career requirements. Given the logistical and political impediments, the IMNZ never developed a culture of fieldwork or a coherent research agenda.

MOBUTISM AND THE DECLINE OF THE IMNZ

In the mid- to late 1970s the IMNZ's position weakened considerably, mainly because of a shift in the legitimating narratives of the Zairian state and leader away from authenticité and toward Mobutism.[131] The Zairization of foreign-owned companies, the subsequent government takeover of these companies during Radicalization, and the partial reversal of the nationalization between November 1975 and September 1976 seriously affected the country's economic and social fabric. The state, already well on its way to becoming an instrument of exploitation for a wealthy minority, was, as Catherine Newbury has remarked, "no longer so visible in performing the functions associated with the

post-industrial state in the West (such as health, education, transport, infrastructure, and court systems). But it was nonetheless very active in performing functions associated with a preindustrial state: the accumulation of resources and the creation of a dependent workforce."[132]

The ideology of authenticité was supplanted by the personality-driven cult of Mobutism. While maintaining the importance of cultural authenticity, Mobutism shifted the focus from precolonial, traditional culture to the figure of Mobutu himself. The teachings of the founder-president were to be the center of all ideological and political life. The doctrine even went so far as to declare that "the people and the chief constitute one same and sole person." As Crawford Young and Thomas Turner noted, it is hard to tell how seriously the population took Mobutism, trapped as they were by the economic crisis and the dictatorial tendencies of the regime.[133]

The legitimizing narrative of cultural guardianship was now reassigned, or conflated with, the very embodiment of power: the president. In the process, political legitimacy, despite being the object of Mobutism, increasingly became a hollow concept, and the sources for cultural legitimacy founded on traditional culture diminished in importance to the regime. One consequence was a reduced interest in a national collection and a national museum as legitimizing tools. While the museum's continued existence was important, since its expositions continued to serve as promotional tools for the regime, particularly abroad, the production of research declined. The IMNZ's desire to have complete collections in the interest of science was no longer something the government was interested in funding. The issue of restitution, however, because of its value as a political tool, did continue to receive considerable political support (see chapter 3).

Michael Schatzberg argues that the mechanisms through which political legitimacy and the growth of the state's absolute power were interpreted by the population increasingly invoked religion, spirits, or witchcraft as explanations for the concentration of power among a limited class. The Mobutu regime increasingly called on the father-chief image to invoke political legitimacy.[134] This affirms that cultural narratives of legitimation did not entirely lose their role, since Mobutu's invocation of the father-chief image was underpinned by the same vague and opportunistic invocation of culture that had previously supported the ideology of authenticité. But the scientific and more precise approach of the IMNZ could not avoid drawing attention to cultural

diversity and difference, despite the use of a national framework. Its materials did not easily lend themselves to the justification of Zaire's power structure, and the museum's role as a potential source for the creation of a unified cultural identity declined, along with the interest in the legitimizing possibilities of such a national culture. This does not mean, however, that authenticité failed across the board. It was a totalitarian project with roots in the colonial state, but that does not diminish its tangible effect on Zairian perceptions of cultural legitimacy and on the importance of a museum to a society's modernity, visible in, for example, the Zairian media's expectations of the IMNZ, as well as the critiques of its failures.[135] One could argue that authenticité—particularly its iteration as an intellectual project—escaped some of its totalitarian framing.

Economic circumstances challenged the continued existence of the IMNZ. The combination of declining copper prices, rising petroleum prices, the economic consequences of the civil war in Angola (which closed the Benguela railway, the easiest export route for the copper belt), the decline in tax income because of failing companies that had been "Zairized," and a long-term agrarian decline made the Zairian state far less economically viable. The now deep-seated corruption in political and economic life only exacerbated this adverse combination of economic factors. The result, for the IMNZ, was a decline in support and funds.

Once the presidential office's lost interest in directly sustaining the IMNZ, the institute became the responsibility of the cabinet of the commissioner of culture and arts. Although Kama and Powis kept tabs on the institute and occasionally tried to advocate on its behalf with the president, the IMNZ gradually lost its proximity to power. The financial consequences of the move were considerable. Although the budget of the IMNZ had risen steadily from 1971 to 1975, it began to decline in 1975. Rampant corruption in the Mobutu regime meant that there was a significant difference between the funds budgeted for the IMNZ and the actual amount the museum received. Now, with an added layer of bureaucracy to navigate in the Department of Culture and Arts, even less of the budgeted amount made it to the IMNZ.[136] Special budgets for projects such as the construction of a museum building seldom came through.

The IMNZ's financial decline understandably had disastrous consequences for its operations. Money for expeditions and collecting all but vanished. The salary payments from the Department of Culture and Arts

became irregular. Although the temporary structures on Mont Ngaliema (discussed in more detail in the next chapter) were becoming too small, plans for a real museum building were postponed. In 1976 a glimmer of hope emerged when a bank building opened up, but the government's Finance Department, which had more political pull than the Department of Culture and Arts, obtained the building.[137] By the late 1970s chances for a new building had all but disappeared completely.

Another problem was the expiration of the cooperation agreement concerning the IMNZ between Belgium and Zaire. Agreed upon in 1969 and enacted in 1970, this agreement had provided the IMNZ with Cahen's leadership and paid the salaries of Seeuws, Quersin, and De Plaen in Lubumbashi. It also facilitated cooperation with Tervuren, which had provided expertise, and gave the Zairian staff internships and access to higher education in Belgium. The Department of Culture and Arts, however, ignored the imminent expiration of the agreement. The fact that Belgium and Zaire were embroiled in discussions over the failure of the Zairian state to adequately compensate former Belgian business owners for the effects of the Zairization and Radicalization did not help. The Belgian government was not willing to open another discussion with the Zairian government, and it is likely that Mobutu did not want to be perceived as asking Belgium for developmental aid—as the Belgians now defined their support.

The Belgian staff of the IMNZ made several attempts to resolve the matter by appealing to Powis to use his influence at the presidential office.[138] Cornet also defended a continuation of the agreement with the commissioner of arts and culture, Mbemba Yowa Mabinda Kapinga, arguing that "one has to conclude that the national museums have not yet arrived at their optimal growth and especially the museum of Kinshasa, the most important one, only exists as a project. An immediate transfer into exclusively Zairian hands, even though this is the envisioned goal, to be achieved as soon as possible, still seems premature."[139]

By November 1975, however, the Zairian government had undertaken the first steps toward Retrocession, a reversal of some of the elements of Zairization and Radicalization. This development vastly improved the possibility of a renegotiation of the IMNZ agreement, although the Belgians insisted that Zaire approach them.[140] (The Belgians also had certain demands with regard to the issue of cultural restitution, as discussed in chapter 3.) Right before the agreement was to run out, on June 30, 1976, a visit by the Belgian foreign minister,

Van Elslande, to Kinshasa prompted the signing of a renewal. One of the stipulations made by Zaire was that a Zairian be appointed general director when Cahen retired at the end of 1976. When that moment arrived, however, Cornet was appointed general director, while Lema Gwete was promoted to director of research.

In the end the IMNZ in Kinshasa failed to create the flagship museum they desired and needed in order to build an international reputation. But while the IMNZ's role as a tool of nation-building was restricted after the turn away from authenticité, its role as a gateway for international researchers interested in anthropology and art history continued to grow, as did its role in the organization of international exhibitions, promoting the idea of Zairian nationhood in the West.

THE MUSEUM Institute was a battleground for the reclaiming of postcolonial cultural guardianship. The tension between Belgium's idea that Tervuren should guide the IMNZ's maturation as a museum and the Zairian view that Belgian participation was a neocolonial intrusion was not resolved. This tension was also reflected in Belgium's description of the cooperation agreement between both museums as developmental aid and Zaire's interpretation of the relationship as a privilege granted to Tervuren.

Despite their resistance to the proposed Zairization of the museum staff, the Belgian employees were increasingly distrusted by Tervuren. Instead of being considered allies in the Belgian museum's quest to maintain ownership of its extensive collections, and with that its position as cultural guardian, Cornet and the rest of the Belgian staff were suspected of being under Mobutu's spell. The Zairian government officials, on the other hand, also misread the situation and saw the Belgian staff members as neocolonial tentacles in their midst. Undoubtedly, the allegiance and trust of these employees varied over time, but it is notable that none of them seem to have considered leaving. Their careers at the IMNZ ended only with the rupture of relations between the two countries in the aftermath of the massacre of prodemocracy students at a rally at the university in Lubumbashi in 1990.

With the emergence of Mobutism, the IMNZ's national role diminished. Aside from the financial situation and the museum's political demotion, the IMNZ's ability to play its desired role as a supporting actor

in the cast of authenticité was simply too limited. With the reorientation of national ideology to the figure of Mobutu, the political value of museum objects as cultural resources diminished. Their political usefulness as props in the continuing power struggle between Belgium and Zaire continued, however, as the restitution debates demonstrate.

5 ⮑ Civilizing Citizens?

Museums as Brokers of Postcolonial Zairian Modernity

Leaving behind the political economy of the IMNZ, we turn to its role in displaying Zairian cultures and defining the country's heritage. Among all the activities of a museum, arguably the most important is displaying its collections to visitors. In displays, the potential of objects to represent the past is activated in service of the present and future and narratives about culture, identity, citizenship, and value are projected by museum professionals and consumed by visitors. Because these narratives also carry a broader relevance, we can examine them as discourses about political ideas.

How did the IMNZ present the objects it had acquired to the audience, and which audience did it have in mind? The collections contained both art objects and ethnographic or anthropological material, but which was preferred and why? Was the "regime of value" that dominated colonial evaluations of traditional African culture the same as the one that operated in the context of the postcolonial institute, particularly, as Ruth Phillips and Christopher Steiner write, since "in tying the definition of authenticity for non-Western arts to . . . art's putative pre-industrial quality, scholarly practice also denied art makers their place in modernity."[1] More broadly, this raises the question of whether or not the postcolonial Zairian reworking of the modern nation-state and its accompanying "imperializing and disciplinary autocracies" resulted in a tangibly new order.[2]

Mobutu's ideology of tradition was constructed and appropriated as a category of resistance against the legacy of colonialism. This was not how it functioned in the context of museum displays, however. Failing

to defeat the epistemological categories of the colonial system, it instead reified them, as was reflected in the cultural praxis of the IMNZ. In other words, it appears that the mark of the extremity of "otherness" was hard to shake.[3] But given that the colonial world was not one of simple binary oppositions, it would be a mistake to look for them in the postcolonial setting. Instead, I will underline the importance of recognizing the intricacies and contradictions of power dynamics, and the nuances indicated by the personal reflections of both Zairian and Belgian museum employees.

Four themes make up the chapter. First I discuss the spatial and exhibitionary politics of the museum institute. The geographic location of the museum institute in the city of Kinshasa is revealing of its symbolic place in the Zairian state, as is the cultural narrative that the politics of display and exhibition practices of the IMNZ presented. Both the spatial and display politics tell a story about the attempt to construct Zaire as a "cultural state," a political unit with a clear cultural narrative. The two following themes show the other side of the story, in which the limitations of the politics of heritage in Zaire come to light: first, in the failed attempts to come to terms with the development of modern art and, in particular, the emergence of the Popular painters, urban artists who challenged prevailing understandings of authenticity; and second, with the contestation of national heritage from within when the Kuba king applied the politics of heritage locally.

THE POLITICS OF PLACE AND SPACE

Arguably the biggest failure of the IMNZ, and a severe restriction on exhibition activities, was its inability to obtain a real museum building in Kinshasa. The story of the many failed attempts to build or renovate a museum building reads as a condensed history of the failures of the Mobutu regime: having begun with grand plans, it ended in murky political waters clouded with vanishing funds and government neglect.

Upon its creation in 1970, the institute was given temporary space on Mont Ngaliema. The latter, a hill overlooking the Zaire River and downtown Kinshasa, was the site of a large presidential park. During the colonial era, when it was known as Mont Stanley, it was the location of a monument to Stanley, administrative offices for the colonial state, a military camp, and a small cemetery with the graves of Western "pioneers" of the exploration and settlement of Congo. Upon independence, it became the location of the president's house.[4] After he

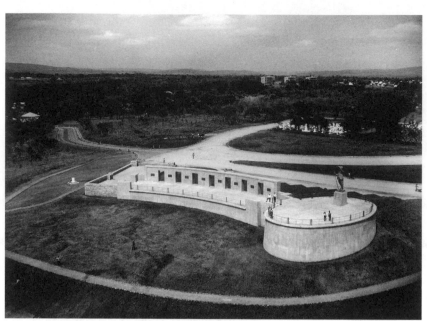

FIGURE 5.1. Mont Stanley, Leopoldville, 1957. HP.1957.2.12, collection RMCA Tervuren; photo H. Goldstein, Sofam ©.

came to power in 1965, Mobutu converted the hill into a presidential space. In addition to a presidential palace and the headquarters of the presidential office, the park contained a military camp, the Ministry of Defense, and three extensive gardens, in the English, French, and "Zairian" styles. While the first two followed a strict design, the latter was filled with indigenous plants and had a small zoo with cages of animals (lions, tigers, a mountain gorilla, okapis, and zebras among them). Wedged in between the animal cages and a small open-air theater were the quarters of the IMNZ. Meant to be temporary, they were hastily constructed barracks previously used by the technical service of the presidency.

Redesigned with the French royal complex of Versailles in mind, Mont Ngaliema became a reflection of Mobutu's vision for the new state. Emulating the sophistication of European centers of power in the shape of a museum and city parks, it also included a Zairian version of that sophistication in its display of the country's natural resources in its garden of indigenous flora, fauna, and wildlife—by far the most spectacular of the three gardens. The entire space was the property of the presidency, but the population was allowed to visit the parks on weekends and holidays.

The presence of an expanded military camp and the Ministry of Defense were equally revealing of Mobutu's vision of the new state, as was the newly built compound for the 1967 Organisation d'Unité Africaine meeting. The Cimitière des Pionniers (Cemetery of Pioneers), a very different kind of monument and a tangible reminder of the early colonial era, was moved closer to the IMNZ and renovated. The decision to renovate the cemetery was unusual, given the removal of all colonial statues from the city. Lastly, the concourse of the large monument for Stanley was "Zairianized." The statue of the explorer was replaced with a modern sculpture named *Le bouclier de la révolution* (The shield of the revolution) by the Zairian sculptor Liyolo (see figure 5.2). In all, the hill, having been a special representation of various forms of power and history during the colonial era, was reinvented as a nationalized and postcolonial space.

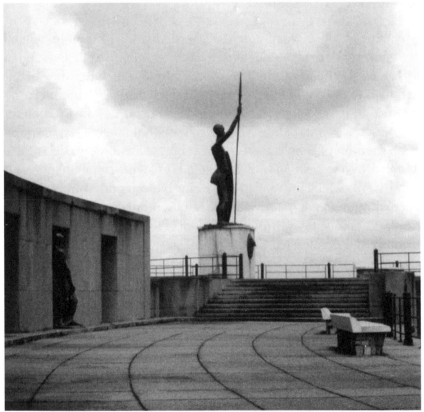

FIGURE 5.2. *Le Bouclier de la Révolution* (The shield of the revolution), by the Zairian sculptor Liyolo, the spot previously occupied by a statue of Stanley, Kinshasa, n.d.

FIGURE 5.3. IMNZ buildings on Mont Ngaliema, Kinshasa, 1970s. R028–2, Photo Archives IMNC. Courtesy of IMNC.

Although the buildings on Mont Ngaliema were meant to be temporary, the IMNZ still resides there today. Following the Belgian-Zairian agreement that created the IMNZ, the Mobutu regime expressed its commitment to building a real museum space. A Belgian architect was hired to design the plans, which were ready by 1971.[5] The location for the museum would be not Mont Ngaliema but another, larger presidential terrain in N'Sele, on the banks of the Zaire just outside the city. This location was part of Mobutu's grand urban development plans for Kinshasa, by which the road from the city to the airport would be developed in imitation of the Avenue de Tervuren in Brussels. The latter, a tree-lined avenue from Brussels to the site of the Tervuren museum, was planned and constructed by Leopold II in emulation of Haussmann's renovation of Paris and led through a number of beautiful and wealthy suburbs. Under this plan, the art museum would be part of the architectural and spatial embodiment of Kinshasa's modern development.

The plans for N'Sele had a late-nineteenth-century urban character and expressed what scholar Tony Bennett has called the "exhibitionary complex," in which the "space of representation was shaped by the relations between an array of . . . disciplines" and which encouraged civic self-fashioning.[6] The museum would encompass an area that included access roads, gardens, monuments, a museum for natural sciences, fountains, and possibly a zoo. Mobutu personally followed the

development of the plan and gave it his approval.[7] The museum plan included eight hundred square meters for the exposition of a permanent art collection, several halls for temporary exhibitions, five hundred square meters of dioramas, a large library, offices, a large entrance hall and reception area, a cafeteria, laboratories for the maintenance and restoration of material, and, of course, large storerooms for the collections. The ambitious purpose of the museum was to create a space to display not only the country's traditional art but also African art from other regions and Zairian contemporary art in order to "bring out the unity (in the diversity) of the negro-african vision."[8] In addition, the museum was to shape Zairian visitors' view of a collective past by creating a narrative of the country's national history through material culture. Although the audience that administrators envisioned included foreign visitors, their primary interest was the local population.

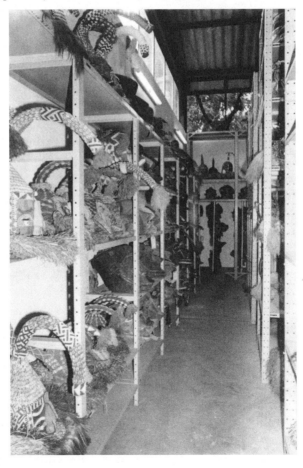

FIGURE 5.4. IMNZ storeroom with Kuba masks, 1976. R028–55, Photo Archives IMNC, photo by Nestor Seeuws. Courtesy of IMNC.

The project got bogged down in a swamp of practical and financial problems. Powis, who was in contact with Mobutu, Bisengimana, and the commissioner of culture and arts, Bokonga Botembele, about the project, assured a doubtful Cahen that "nobody here is thinking of slowing down [this project]."[9] In reality, architect Puyts had been worried about contradictory information regarding the funding for the project since 1971. In January 1973 even Powis confirmed the problems and began "a campaign against this pure and simple 'desertion' of the construction projects for the Museum in '73." He had a long conversation with Bisengimana, who "appeared to be surprised and promised me to clear up this situation."[10] Despite Powis's efforts, the financial situation did not improve. In 1974 Cahen expressed concerns about Zaire's attempts to involve Belgium in the financing of the museum building. Was there a real absence of funds, he wondered, or was this a ploy to get more Belgian development aid?[11] In all likelihood, the problem began as a simple delay because Mobutu or somebody in the presidential office decided to finance another project first, but by 1974, as the economic troubles began to grow, the state's budget declined drastically. Additionally, relations between Belgium and Zaire soured because of Mobutu's nationalization of the economy, so the regime was less likely to spend money on a project that benefited the IMNZ, because of the latter's association with Tervuren.

THE AICA AND *TRÉSORS DE L'ART TRADITIONNEL* (1973)

In order to draw attention to its cultural politics and to fortify its pan-African and international leadership, the Mobutu regime invited the International Art Critics Association (Association Internationale des Critiques d'Art; AICA) to hold its 1973 annual conference in Kinshasa.[12] The conference was not only the first AICA meeting held in Africa, it was also the first international cultural event organized by Mobutu, simultaneously creating an international audience in a Zairian locale and a national audience for Mobutu's international role.

From September 11 to 18, about 150 delegates from seventeen national branches of the AICA gathered at the presidential estate of N'Sele for the conference, the theme of which was "AICA Meets Africa."[13] The crowd was international, including delegations from all of Europe and the Americas, although Africa was represented only by delegations from Zaire and from the Organization of African Unity. The delegates, most of them unfamiliar with African art, heard lectures

by Joseph Cornet and Lema Gwete on topics ranging from traditional to modern Zairian art.

The conference was important to the IMNZ for several reasons. First, it was a platform from which Mobutu could draw public and global attention to his politics of authenticité and the issue of cultural restitution, testing the waters in advance of his UN visit (see chapter 3). Second, it was the occasion of the IMNZ's first public exhibition, which set the tone for their display practices for many years to come. Finally, the attention it drew to the contemporary art scene in Kinshasa raised important questions about the potential role of modern art as authentic, national art. How was modern authenticity defined, and did it have a place in the collection of a national museum?

Mobutu addressed the opening session of the conference, using the occasion to relaunch the public demand for cultural restitution and to impress the international audience with his campaign for authenticité. His rousing entrance to the conference deeply impressed the *New York Times* correspondent:

> Mr. Mobutu's entrance to the vast auditorium where the meetings were held—an auditorium jammed, for the occasion, with enthusiastic citizens of Kinshasa—was preceded by a 45-minute build-up that included chanting and dancing by about 150 jubilant and inexhaustible performers decked out in brand new costumes, made from fabric bearing the President's portrait, and apparently endowed with extra sets of pelvic joints and stomach muscles unknown to ordinary people, which they exercised in marvelous synchronization to the rhythms of a corps of tribal drummers. It was a celebration for a village chieftain enlarged and transformed into a theatrical extravaganza, at once emotionally arousing and technically impressive—an unassailably valid demonstration of the vitality of traditional arts in the service of a revolutionary nationalistic identity.[14]

It is difficult to determine whether the journalist was merely transmitting the stereotypical character of the performance, or whether the limitations of his own cultural register shaped his description. Clearly, though, he was impressed with the spectacle, and his enthusiasm for the use of traditional arts in service of the Zairian nation was undoubtedly the desired effect.

At the insistence of the commissioner of culture and arts, Bokonga Botembele, the IMNZ organized an exhibition of traditional art to accompany the conference. Cahen, in his capacity as director of the IMNZ, had not been in favor of the idea. He argued that while it certainly would be good publicity for the institute, it would overburden the staff. He also believed that an exposition was premature because the institute did yet not possess enough great pieces and should not risk the safety and condition of the few it had.[15]

The resulting exhibition, *Trésors de l'art traditionnel* (Treasures of traditional art), was the first occasion on which the IMNZ displayed some of its nascent collection. About 130 pieces were selected from the roughly 25,000 the institute had collected. They were "elegantly presented, under spotlights, in a grey ambience and a reverential atmosphere." The museum staff had chosen to follow the "masterpiece approach" and presented a selection of pieces "of great quality and beauty" instead of giving an overview of the diversity of traditional art in Zaire. They desired to provoke "aesthetic contemplation." "It speaks for itself," the catalog continued, "that this approach cannot but favor certain styles, such as those of the Kuba, the Kongo and a couple of peoples from Shaba." This format set the tone for practically every future exhibition by the IMNZ. The use of "treasures" in the title evoked not only the cultural value of the objects but also their financial or economic value. In conjunction with Mobutu's demand for cultural restitution, the exhibition, ironically, underlined the *absence* of the bulk of the nation's heritage, which would have included a much wider variety of cultures.[16]

By insisting on the status of the objects in the exhibit as "high art," the organizers also emphasized the universal value of Zairian culture. While Tervuren's emphasis on the universality of the category of art in its displays of African art was motivated in part by the ability to use that universal appeal in arguments against the demand for restitution, within Zaire the emphasis on the universal appeal of traditional art carried different connotations. It constituted a claim to status, prestige, and inclusion on a global level. It also legitimated the Zairian state as the representative of the country's many communities. The universal value of the pieces was reinforced in the catalog's introduction, which argued that "some of the objects on display have no equal in any museum or collection. Is this not a sign that the Institute of National Museums is from now on capable of contributing to a better

understanding of African arts?" The catalog also addressed the scientific work undertaken at the institute and emphasized—playing a bit loose with the truth—that this was done principally by "nationals."[17] Despite the explicit categorization of the objects on display as art, the catalog also situated the objects in an ethnographic context with ample descriptions of the role the objects played in their respective cultures. Later catalogs of IMNZ exhibitions would contain even less contextualization of the material, increasing the emphasis on objects as art.

In his preface to the catalog, commissioner Botembele emphasized the role of traditional art in the country's "recourse to authenticity." The value of a national museum for Zaire was crucial for the latter, especially since the objects were "rapidly disappearing." Therefore, he saw national museums as "conservatories of our authenticity; they are storerooms where the Zairians of today and tomorrow, will learn the dimensions of their history and renew their pride in their past."[18] Zaire could have its cake and eat it too, claiming both a traditional and a modern identity by espousing a cultural authenticity grounded in traditional culture while simultaneously being a modern society, demonstrated by the familiar lament about the decline of traditional societies and the "salvage" paradigm of classic anthropology.[19]

The exposition also included a significant amount of archaeological material, which was the result of three successful digs recently organized by the IMNZ and the Royal Museum for Central Africa (RMCA). The thirteenth- and fourteenth-century material from the Sanga excavations in the valley of the river Zaire and from a series of digs in Kinshasa offered a deep historical perspective that contrasted with the ahistorical presentation of the art objects and evoked the kind of deep past characteristic of nineteenth-century romantic nationalism.

DISPLAYING TRADITION, CREATING THE NATION

Since the plans for a museum building in Kinshasa were not moving along, the IMNZ worked out temporary solutions for exhibition space. At first, a small room in the IMNZ's offices on Mont Ngaliema was organized as an exposition space. Crammed with exhibition cases, the exhibit presented a "best of" series of sculptures collected by the IMNZ. The middle of the room was taken up by a large split drum from Northern Zaire that remained the centerpiece of many IMNZ exhibitions in Kinshasa.[20] Although the only surviving photos are of poor quality, they provide a general impression of the room. The objects were loosely

organized by region and ethnic group. When walking clockwise, the visitor would start at the case with material from the Lower Zaire, with a typical Kongo crucifix (dating back several centuries) and a stone funerary monument, or *ntadi*. (The latter was a relatively new discovery; see chapter 4.) The display moved northward across the Bandundu region to the southwestern Kasai with a Yaka and a Holo mask. These were followed by material from the Pende, Kuba, and Chokwe. The Luba were represented with a memory board, or *lukasa*, collected by Seeuws in 1971; and the Hemba, by a seat and an ancestor figure. The Kivu region was represented by a Lega mask, and the cases came full circle with objects from the Zande and a typical string instrument from the Mangbetu in the northeast. Since Lower Zaire and the Bandundu region were the two regions closest to the capital Kinshasa, the sequence of the displays reflected a vision of the country centered on the capital and the southern part of the country. Since there were no labels or other information posted (although visitors to this room would have been accompanied by an IMNZ staff member who could give some background about the material on display), the sequence of the objects—and hence the circumference of the country—provided the only context.

The room on Mont Ngaliema was not so much about the objects on display as it was about the IMNZ itself. The arrangement of the cases, with several single, isolated objects, is clearly inspired by an art historical, not an ethnographic, approach. Referred to as the "treasure room" by the staff, it displayed the most valuable and beautiful pieces, demonstrating to the visitor the IMNZ's ambitions to be a contender with the African art collections in the museums of the West.[21] The objects came to stand for the reputation of the institution more than they were promoting Zaire's cultures or peoples. A factor that left much to be desired was the limited accessibility of the exhibition. With no regular opening hours for the public and no promotion, the IMNZ in Kinshasa could not really be called a museum. The majority of the visitors were Zairian notables, expatriates, or foreign researchers. Without a wider audience, the museum could not fulfill its role in the broader community.

Once it became clear that the presidential office was wavering on the commitment to build a flagship museum, the staff looked for other solutions. In collaboration with the Academy of Fine Arts (Académie des Beaux Arts; ABA), they created a space on the campus for the display of part of the IMNZ's collection.[22] This building was (and is) known

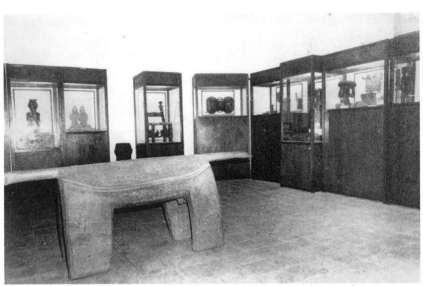

FIGURE 5.5. Early exhibition on Mont Ngaliema, IMNZ, Kinshasa, early 1970s. R028–49, Photo Archives IMNC. Courtesy of IMNC.

as the National Museum of Kinshasa. It was not seen as a flagship national museum for the entire nation, but as the provincial museum of the region, on a par with the museums in Kanaga, Lubumbashi, and Mbandaka. These museums were provincial in name because their audience was meant to be the population of a certain region, but in theory their collections were national in scope given their intended role in representing the state.[23]

Although several of the Zairian employees were in training to become anthropologists (so capable of situating the objects in a broader cultural context,) the displays were once again organized primarily as art displays, emphasizing aesthetic value and uniqueness. The first iteration of the permanent exhibition at the ABA was almost identical to the treasure room on Mont Ngaliema, but slowly other types of material were added. By 1977 an updated version of the space had been opened. Upon entering the building, the visitor saw a long counter to the left, where small crafts and some publications were for sale. In front of the visitor was an alcove that generally held some larger pieces (among them the Loi drum that was also used in the displays on Mont Ngaliema) along with a national flag and an "ethnic" map of Zaire that indicated the geographic locations of nine culture areas, each with subdivisions.[24] The combination of map, flag, and art objects suggested a symbolic and ideological relationship between Zaire's political entity, its geographic

entity, and a cultural heritage In combination, they constructed the totality of a nation—a territory with a past and culture that was whole in its cultural representation, its territory, and its political identity.[25]

Also facing the visitor upon entering the ABA exhibition hall was at least one picture of Mobutu, leaning on his carved cane. As the personality cult of Mobutu grew, this presidential presence developed into a more elaborate display, with a larger picture placed on a pedestal and decorated with the flag. The suggestion of a tie between the museum, the material on display, and the state via the symbolic presence of the state's leader and its "signs" (the map and the flag) was not uncommon for museums. The colonial Museum of Indigenous Life in Leopoldville had a picture of the governor of Congo and the Belgian king on display, and the Von Saksen–Coburg dynasty was well represented in Tervuren, both in the form of statues and as actors in the history displays.

The map identified the Lower Zaire, the Kinshasa-Bandundu area, the lower Kasai, the mid–Kasai, East Kasai, and northern Katanga (roughly centered on the Luba area), the middle and northern Kivu (stretching into the area around Kisangani), the northeast, and the northwest as cultural regions. The equatorial region and part of the north were not identified. The detailed information on the southern and western half of the country reflect the same regional bias as the maps of Olbrechts and those in Museum of Indigenous Life in colonial Leopoldville, although the coverage of the southern half of the country had become much more detailed and the map acknowledged that some of the southern culture areas crossed into neighboring Angola.

Both in the cartographic representation and the displays, we can see the presence of the "one tribe, one style" paradigm, in which cultural entities, or "tribes" (a concept borrowed from anthropology), were equated with a particular artistic style that generally did not reflect any change over time. Neither did it take into account things like population movement or cultural exchange.[26] The continuities between the older maps from the MVI, or those at Tervuren, and the IMNZ's map show the long-term development (and solidification) of the contours of these "tribes" and styles.

The exhibition room itself stretched out to the left and right of the entrance and contained roughly twenty display cases of material. The content and arrangement of these varied throughout the years, but the (undated) pictures show that the displays were always organized according to region or ethnic group. The right side of the hall

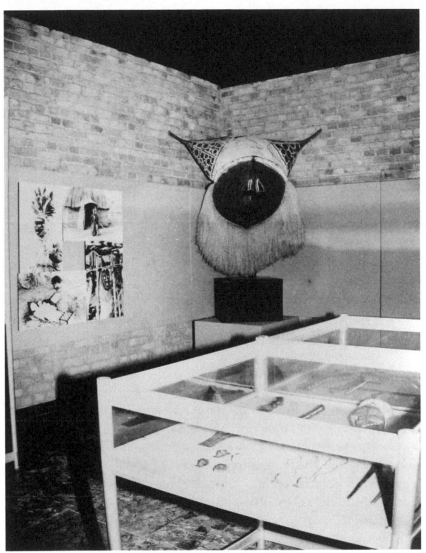

FIGURE 5.6. Yaka rattle mask, ABA exposition space, Kinshasa, n.d. Box Expo ABA, Photo Archives IMNC. Courtesy of IMNC.

was devoted to the Lower Zaire region and the Kuba, while the left had cases with Luba, Bemba, Yaka, and Suka material. Although the amount of material increased dramatically over the years, the regional diversity did not, paralleling patterns developed on collecting missions. The Lower Zaire, Kuba, and Luba areas remained the favorites. The privileged position of the Lower Zaire can be explained by the area's proximity to Kinshasa and the fact that it was one of the places where

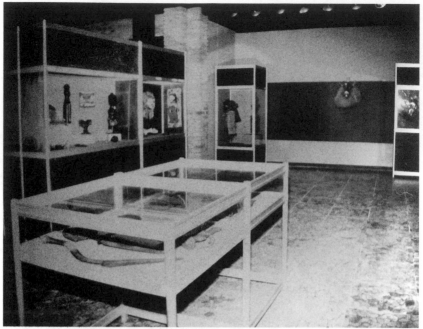

FIGURE 5.7. ABA exposition space, Kinshasa, n.d. Box Expo ABA, Photo Archives IMNC. Courtesy of IMNC.

the IMNC had "discovered" funerary objects previously little known to researchers. The steady increase of objects from the Kuba was, of course, due to Cornet's interest in their art.

Two categories of material were separated out from the display cases lining the walls. The archaeological material and the metal objects — regardless of cultural origin — were displayed in lower glass cases located in the middle of the space. As in the 1973 exhibition *Trésors de l'art traditionnel*, these materials from the Sango valley and the capital region came to stand for the prehistoric past of all the cultures in the country, reducing regional differences and projecting the Zairian nation into a deep past.[27] While the archaeological displays served to add historical depth to the idea of civilization in Zaire, the cases on metalworking also served as an answer to older stereotypes: nineteenth-century views on African cultures often advanced the belief that either African cultures were inferior because they did not practice advanced forms of metalworking or that the existence of metalworking was due to outside influences.[28]

One departure from earlier displays of the Mont Ngaliema collection was the use of photographs to show some of the collected material in its original context. This was mostly true for the masks, in order to

show that some of them were part of a larger costume. These photographs were one of the few traces of a more anthropological approach to the material, which otherwise was being presented without any information on the context and use of the objects.

The cases with Kuba objects grew the most significantly over time because of Cornet's research visits to the community, in itself a consequence of the reputation of Kuba art. They eventually became grouped by type of object, a more ethnographic approach that contrasted with the singularity attributed to the other exhibited objects. Kuba textiles were the first nonsculptural objects to appear, but these were relegated to a supporting role as the backdrop for the Kuba masks. At various times the display included drums, costumes, and more utilitarian but decorated objects, such as cups, pipes, and boxes. The inclusion of utilitarian objects in the displays was limited to the Kuba culture. The artistically superior reputation of the Kuba allowed for the blurring of the lines between art and ethnography.

This emphasis on "high" traditional art helps explain the Mobutu regime's lack of interest in current craft production. As we saw in chapter 2, in the colony the category of authenticity had been projected upon people in rural, "traditional" communities. The Mobutu regime, however, required that authenticity be projected upon the entire population, particularly on citizens living in urban settings and engaging with new political systems. The IMNZ, with the exception of its Kuba collection, carefully avoided displaying anything that could be considered tourist art or crafts so as not to foil its efforts to secure a "high" traditional art of equal reputation to European fine art traditions. European nineteenth-century nationalism had looked to the peasants and to folk art as the nation's soul, an attitude that carried over into the twentieth century in the form of museums filled with European folk art and the romanticization of a rural past as national heritage.[29] One of the things that stimulated this desire to seek out a folk past was the confidence of these nations in their level of civilization, expressed in collections of fine art, equally important in the creation of heritage. Zaire's priority was with the creation of an equivalent kind of high art, which is why the IMNZ clung to a so-called aesthetic approach in its displays and pushed Kuba culture to the fore.[30]

The lack of proper labels played into the idea of the Zairian nation as a natural entity, since it helped to divert attention away from variety and cultural difference in spite of the largely cultural arrangement of the objects. Cultural difference would be visible only to a trained

eye, reducing it to something of importance only to the scholar. For many visitors, the result would have been an impression of a valuable, vaguely precolonial—yet largely ahistorical—past. The "natural" unity of the cultures on display was again affirmed in the ethnographic map, the sharp contours of which were those of the nation.[31] The map (or rather, its contours) was the only reminder of colonialism in the room. The erasure of the impact of colonialism on the cultures on display was a staple of Western museum practices. Since Mobutu's authenticité campaign was also aimed at erasing the impact of the colonial era, the absence of references to Belgian colonialism is not surprising. The Zairian reproduction of that silence, however, took away the opportunity to confront that very colonialism in the country's past and its continued role in the construction of African cultures and identities.[32]

The goal of Mobutu's cultural policies was not merely to create a national cultural identity but also to advance a certain interpretation of Zairian citizenship, a far more active category than cultural identity. The notion that museums can be tools for the creation of citizens goes back to the very origin of the modern museum. Following Foucault's work on the relation between power and knowledge, scholars have turned to analyzing the ways in which the reordering of things inside the museum aimed to provide a model for life outside its walls. Tony Bennett, in his work on the origin of museums, argues that they were instrumental in the civic self-fashioning of newly enfranchised citizens in the Europe of the late nineteenth century.[33] This perspective is useful for understanding the role of IMNZ, although there were also some fundamental differences. Most important of these was the IMNZ's location itself, in the heart of the former empire, the same empire that served as the fundamental primitive "other" in opposition to which the identity and culture of the museum-visiting European was constructed. Also of importance was the fact that the kind of citizenship envisioned by the Mobutu regime came closer to the status of Zairians under colonial rule than it did to a democratic citizenship.

How did the African and postcolonial identity of the museum affect its role? There are two elements to be considered: the exhibition itself and the building in which it was housed. The latter differed significantly from the traditional museum building in Europe. In the case of art museums, in particular, the architecture of the building often contributed to its role as a "ceremonial monument;" the public location where the "rituals of remembrance," aimed at celebrating a glorious past, were completed. Such

a built environment was often characterized by grand and neoclassical designs that underlined the museum's identity as a "secular temple."[34] The modest building on the ABA campus certainly did not refer to a classical heritage. Nor was it located near the center of power in the city, as so many European museums were (although the IMNZ was). In fact, its location within the campus of the art school made it less accessible, since it was not visible from the street. What the location did suggest, however, was a link between the artistic creativity of the precolonial past (in the museum) and that of the future (at the academy.)

Museums were an avenue for public education about traditional cultures and for their promotion as national heritage. The act of visiting the museum is considered a ritual of modern citizenship.[35] The internal structure and taxonomy of the museum encouraged Zairian visitors to think about the material in a certain prescribed way. First and foremost, the objects were to be seen as art, inviting appreciation in a contemplative way. Casting the objects as art, and largely decontextualizing them, had the advantage of creating a certain distance between the objects and the Zairian visitors, casting them as modern citizens and as members of an urban middle class removed from the cultures on display. Art museums require visitors capable of recognizing the objects on display as art—or to see "the invisible order of significance that they have been arranged to represent."[36] In Pierre Bourdieu's words, "The work of art exists as such (i.e. as a symbolic object endowed with meaning and value) only if it is apprehended by spectators possessing the disposition and the aesthetic competence . . . required."[37]

Beyond the objects' categorization as art, one particular group dominated the displays: the Kuba. This built on a long colonial tradition that regarded Kuba culture as superior. Its presence in the representation of the nation was comparatively large, occupying a hegemonic center, followed by the Kongo peoples and surrounded by the Yaka, Pende, and Luba almost as an afterthought.[38] Not only was Kuba art considered superior; conveniently, so was its political organization. It was a kingdom in which the centralization of power had been fortified by the king's role in a system of indirect rule. This concentration of power, together with its cultural reputation and its disproportionate presence in the exhibitions of the IMNZ, made the Kuba loom large in the popular image of the traditional past, and they were easily co-opted into Mobutu's legitimation of central and undemocratic power as founded upon traditional values.[39]

To Western visitors and the Zairians who had visited art museums abroad, the displays would have been similar to art displays they had seen in museums in the West. The displays not only encouraged them to think about the aesthetic and cultural value of the pieces but also drove home the fact that it was a Zairian state institution that guarded these pieces and displayed them in much the same manner they would have been displayed abroad. This demonstrated the modernity of the state itself and of its claim to cultural guardianship of the nation.

For the IMNZ employees, the small museum on the campus of the Academy of Fine Arts was a prelude to a flagship museum for the country, a hope kept alive by the occasional surfacing of rumors about available buildings or foreign aid money. Looking back, several of the Zairian employees describe the IMNZ as a guardian of the nation's collective past and as a "broker of modernity" for the new nation. These convictions did not end with the decline of the Mobutu regime, and they even revived with the stabilization of the new regime. Many employees emphasize that a state cannot be respected on an international level without the possession of a national museum.[40] The fact that an art museum was preferred to a history museum can be attributed to the desire to capitalize on the fame of Zairian traditional art, as well as the belief that history was embedded in these objects. Thus possessing them also implied a possession of the past. This historical aspect of the objects' identities, however, remained passive in displays.

The IMNZ also participated in the organization of exhibitions around the city, particularly during the 1970s.[41] One of these was the Kinshasa fair—Foire Internationale de Kinshasa (FIKIN), held on the Kinshasa fairgrounds. Photos of the 1976 fair show a small, sparsely furnished and white space with a limited number of large, attractive pieces placed in coves along a wall. A large Pende statue of mother and child was flanked by two tall drums from the Kasai region.[42] The objects were separated by a wall hung with large pictures, one depicting a male drummer, the other what looks like a Luba dignitary. Another wall carried a photo of President Mobutu above a large slit drum from the Loi in Northern Zaire. The exposition had only four cases with objects. While the image (figure 5.10) we have is unclear, we can see at least one stone funerary statue, or ntadi, from the Lower Zaire. Although there were several photos in the exhibit, these do not seem to have been intended as ethnographic framing but as replacements for objects, since the IMNZ staff feared they were vulnerable to theft. Behind the cases were large

FIGURE 5.8. FIKIN exposition, Pende statue of mother and child, Kinshasa, July 1976. Box FIKIN Juillet 1976, Photo Archives IMNC. Courtesy of IMNC.

FIGURE 5.9. FIKIN exposition, Kinshasa, July 1976. Box FIKIN Juillet 1976, Photo Archives, IMNC. Courtesy of IMNC.

FIGURE 5.10. FIKIN exposition, Kinshasa, July 1976. Box FIKIN Juillet 1976, Photo Archives, IMNC. Courtesy of IMNC.

panels with photographs of additional objects, such as a Hemba chief's stool and Kuba masks. Alongside these were pictures of the archaeological digs of the IMNZ. No labels or explanations were provided, and the display of the objects and pictures seems to have been random.

As opposed to the colonial fairs (both in Belgium and Congo), the IMNZ avoided any display of crafts at the Kinshasa fairs. There was none of the nostalgia for traditional, rural life that was imprinted on exhibitions and museums in the colony, nor was there any sign of "native villages" or their inhabitants. Instead, the displays focused on a limited number of objects, displayed as singular pieces of art. With the displays at FIKIN, the IMNZ had the opportunity to reach a wider audience than it did with the museum on the ABA campus, but it was also an audience not necessarily naturally predisposed to viewing art.

Despite the differences with colonial fairs, there were also some important similarities. Both colonial and postcolonial fairs were a form of propaganda, mixing commerce and culture, and both were aimed at shaping a modern public. In a process that Carol Breckenridge has described as creating a "new object-centered mythology of rule," objects acquired new values and were used in the imagining of new communities.[43] The colonial section of the 1958 world exposition in Brussels displayed both the economic viability of Congolese crafts and the cultural and aesthetic value of its traditional art, but all in service to the promotion of Belgian colonialism. In FIKIN fairs, the attention was directed toward the value of traditional art, now valued as a symbol of national authenticity, the display of which by the Zairian state was now a sign of the maturity of the Zairian nation. And the audience's consumption of the displayed objects was art was part of its modern identity.

"DEEP AND DORMANT ROOTS": MODERN ART AS CULTURAL HERITAGE?

The AICA conference did more than serve as a platform for the promotion of Zaire as a guardian of its traditional art. Timidly, it also ventured into the area of Zairian modern art with a less elaborately produced exhibition of contemporary Zairian paintings and sculptures. The modern art exhibition was received with much less enthusiasm than the traditional art exhibit. A closer look at the way in which modern art was defined and received nonetheless reveals much about how national heritage was perceived and valued in the early 1970s, and under what circumstances modern art could be defined as authentic. Could it fulfill the same functions traditional Zairian art was forced into, or was it a more "resistant" category?

By the late 1950s part of the colonial cultural establishment recognized the potential of modern artistic productions to embody the spirit of Congolese identity and culture. Jean Vanden Bossche, the curator of the MVI in Leopoldville, saw potential in the paintings produced by some of the students at the fine arts academies in the country. The combination of "Bantu" spirit in their themes and European techniques in their methods of expression (oil painting in particular) qualified, according to Vanden Bossche, as representative of the modernizing Congo of the 1950s.[44] By the early 1970s, several of the same artists represented modern Zairian art at the AICA convention.

A small book accompanying the contemporary art exhibition at AICA introduced some of Zaire's leading artists. Its content emphasized the role of the state in providing the nation with access to "authentic culture." As opposed to traditional art, which was assumed to be merely "found" and collected, modern art was to be developed and produced. The image on the cover shows a red painting by Chenge Baruti in which the lanky figure of a "traditional" African kneels beside what looks like a glowing statue, while extending a (supplicating!) hand. Inside the cover is a picture of Mobutu and an image of a statue entitled *Le militant*

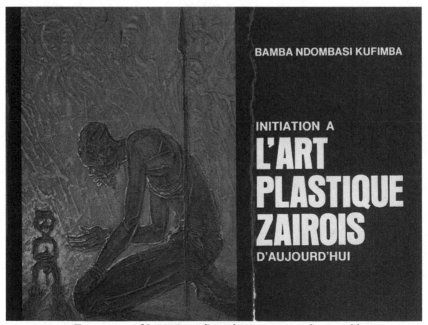

FIGURE 5.11. Front cover of *Initiation à l'art plastique zaïrois d'aujourd'hui* (Introduction to contemporary Zairian visual art), published for the AICA modern art exhibition, 1973. Painting by Chenge Baruti. (See also plate 1 in color gallery.)

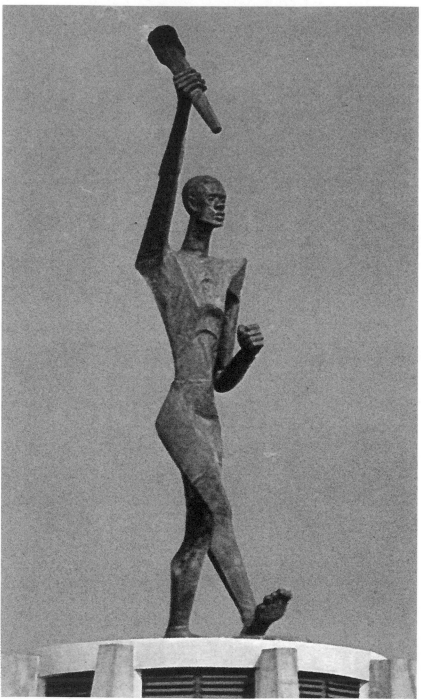

FIGURE 5.12. *Le Militant* (The militant), by Liyolo.

(The militant). The bronze statue depicts a male African figure striding forward while clutching a burning torch with the arm stretched upward, a common posture expressing strident conviction. These few images encapsulated much of the spirit in which modern art was presented at the AICA conference: "inspired" by tradition, combative in its advocacy of "authenticity," and associated with the "new state."

Curiously, the content of the book does not follow the tone of its opening pages. The author, Bamba Ndombasi Kufimba, a sculptor and professor of art, located the first modern Zairian artists in the context of Belgian colonialism and missionary schools. This explicit reiteration of the same genealogy of modern art as Vanden Bossche had identified in the 1950s ran counter to authenticité's goal of reversing the influence of the colonial era and emphasizing the traditional over the modern. Nonetheless, the influence of these schools was undeniable. Of the thirty-two artists introduced in Bamba's booklet, twenty-four were educated at the Academy of Fine Arts in Kinshasa and three at the academy in Lubumbashi, three were autodidacts, one went to school in Matadi, and one was educated abroad. Bamba emphasized the importance of Mobutu's support of "innumerable initiatives" for contemporary art in Zaire. He acknowledged the "great youth of our modern fine arts" and was convinced that "Zaire is acquiring a new awareness of its traditional art . . . perceived as a world of fine art that deserves its voice in the concert of international art."[45] An authentic modern art was grounded in the traditional. While attempting to circumvent colonialism, state-sanctioned modern Zairian art ended up with a philosophy that could be traced back to the art schools and museums of the late colonial era, promoting art of a "modern" or Western form, but with an "authentic" inspiration. Balancing tradition and modernism while remaining faithful to an "authentic" African identity was something many African artists struggled with in the aftermath of independence. The inexorable appropriation of African authenticity and art by Western modernism made this a difficult predicament, as did the dominant influence of Western art schools and workshops on the early post-independence generation of artists, as seen in the artists included in Bamba's book.

Although offering some state support, the Mobutu regime came nowhere close to the support extended to cultural development by the Senegalese president Senghor, particularly the development of a

modern art rooted in *Africanité*. This school of art, known as the École de Dakar, sought to develop a modern art style that was deeply African in its national, cultural and pan-African or racial identity. It (as well as Négritude) has been accused of reproducing colonial inequalities inherent in European modernist models influenced by cultural primitivism. Elizabeth Harney, in her study of Senghor's influence upon the production of modern Senegalese art, has argued that such an evaluation of the school lacks nuance and disavows the ways in which these artistic creations at times exceeded the limitations of Négritude and reflected a distinct Senegalese modernism.[46]

There was little in the modern art traditions of Zaire that impressed the foreign press at the AICA exhibition. The reviewer for *Arts d'Afrique Noire* regretted the "insufficiencies and contradictions. . . . The negro artists seem to have a lot of trouble escaping a certain totemic exoticism or the attraction of elongated figures circa 1925, or even more so, an expressionism of garish colors or else a feigned abstract painting style. What to say to these artists? They have to find their own painting style, beyond imitation."[47]

In the *New York Times* John Canaday wrote that the exhibit contained a "toe-the-line imitation of European and American modernism and . . . greeting-card Africanism." The exception was the painter Pili-Pili, who painted in a "kind of international-sophisticated-primitive style." Unfortunately, one could not find the likes of Pili-Pili among the sculptors, who only proved to the reporter that "the original tribal forms are no longer viable." A new kind of art had to grow from "very deep [and] dormant roots." Canaday suspected the areas in which Zaire would exhibit its authenticité first would be theater and dance, impressed as he was with the play performed by the National Theatre of Zaire and based upon "a tribal legend." Despite—or perhaps because—he did not understood a word of the Lingala in which the play was performed, he found it "utterly entrancing" and "genuinely African." Musicians accompanying the drama played without "a hint of anthropological re-creation." Surely, Canaday decided, the National Theatre of Zaire was proof that "ultimately, all must be well with authenticité."[48] Ironically, in his attempt to give an open-minded assessment of the event, the *New York Times* critic entangled himself in a web of postcolonial exoticism. Not only the foreign press was critical, however. Scandal ensued when even Joseph Cornet was overheard saying that Zairian artists were fifty years behind.

In the aftermath of the AICA conference and in response to the critiques, a group of artists united under the name of the *avant-gardistes zaïrois* in a search for a truly modern but authentic art in the context of the cultural revolution of the Mobutu regime. In their manifesto, they called for the country's ancestral heritage to serve as a solid basis for the creation of an art "blessed with a young blood [and] animated by a magic spirit. We wish to have our art recover its autonomy and its intrinsic personality, through a brutal dispossession, of all stereotypical formulas of foreign origin."[49] The group soon fell apart, although most of the artists continued their work individually.[50]

The Mobutu regime offered nowhere near the structural support artists enjoyed in Senghor's Senegal. The latter created a formal structure for the production of modern art, while the Mobutu regime only made timid and limited overtures in the direction of the creation of a new, Zairian modern art. This was a testament to the authoritarianism of the Mobutu regime and its fear of the ability of contemporary art to trespass the boundaries of an ideology and challenge from within— a development that eventually did take place within both Senegalese and Zairian artistic circles.[51]

Ironically, a new generation of modern artists developed right under the nose of Mobutu regime but remained outside the official art circuit. The Popular urban painters were usually of a different background than the modern painters represented in the AICA exhibition.[52] They were often self-taught and worked in a naturalist, almost cartoonish style on paintings that depicted scenes of urban life, the history of the country, and its politics. Their work serves as a running social and political commentary on past and present. Many worked for a middle-class African clientele until the economic crisis, and later for Western academics and visitors. Johannes Fabian, Ilona Szombati, and Bogumil Jewsiewicki have developed a considerable body of scholarship on these painters, in particular Tshibumba Kanda-Matulu and Chéri Samba.[53] Nowadays these artists are seen as the true chroniclers of Zaire, while the avant-gardistes zaïrois receive far less scholarly attention.

THE IMNZ AND MODERN ART

While the colonial Museum of Indigenous Life had started with a display of "new Congolese art" in the 1950s, it took until 1975 for the IMNZ to hire a curator of modern art. Although the modern art exhibition at the AICA conference in 1973 had not been a success with the

foreign press, it had alerted the cultural sector in Zaire to the potential of modern art as heritage.[54] Senghor's example had also illustrated the value of cultural development for international recognition and prestige. With the support of Cornet, who taught courses in modern African art at the ABA and at the university, the head of the Zairian AICA delegation, Célestin Badi-Banga Ne Mwine, was recruited to work for the IMNZ in the modern art section. Badi-Banga had been active as an art critic for the national television service, where he presented the programs *The Artist's Corner* and *Culture and Art*. Initially an enthusiastic supporter of authenticité, he published widely on the topic of Zairian modern art, initially in the context of Mobutu's cultural revolution.[55]

In his *Contribution à l'étude historique de l'art plastique zaïrois moderne* (Contribution to the historical study of modern Zairian visual art), published in 1977, Badi-Banga extended and modified the history of Zairian modern art presented by Bamba on the occasion of the AICA conference. While Bamba had pointed to the influence of the missionary art schools, Badi-Banga traced the seeds of modern Zairian art back further, to interactions with the Portuguese from the fifteenth to the eighteenth centuries, an Asian influence via the Portuguese, an Arab influence via traders from East Africa, and only later the schools and workshops of the Belgian colonial era. "The authentic artists' soul is dependent on both the contribution of African art and foreign art,"

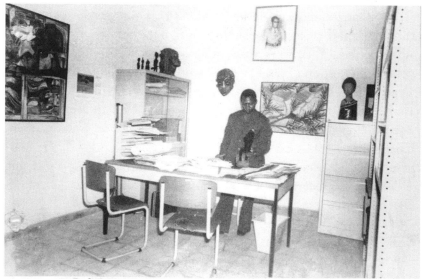

FIGURE 5.13. Badi-Banga in his office at the IMNZ, Kinshasa, n.d. [1970s]. R028–38, Photo Archives IMNC, photo by Nestor Seeuws. Courtesy of IMNC.

Badi-Banga argued. He reserved the real recovery of the Zairian artistic soul for the Mobutu era, ascribing to the latter the creation of a perfect balance between the cultural riches of the past and the national and international elements of the present.

Badi-Banga's views on the colonial art schools are somewhat contradictory. On the one hand, he credited them with stimulating the artists' interest in their own artistic heritage and protecting them from modern, non-African influences, thus guarding their authenticity. On the other hand, he criticized them for creating an African art for Europeans, claiming that "the westernized Zairian artist no longer produced in response to tribal needs but for foreign clients."[56]

There are similar tensions in Badi-Banga's treatment of the Mobutu era. He cites the 1967 Manifesto of the People's Revolutionary Movement (MPR) and the 1972 resolution of the second MPR congress as fundamental texts for the promotion of artistic production and protection in Zaire.[57] However, a closer look at Badi-Banga's text reveals an artistic community that reached back to the early 1960s—years before Mobutu's cultural revolution. The 1970s were instead about the search for international recognition of Zaire's modern art.

By 1977 Badi-Banga was disappointed with the inability of Zairian art to escape its "intellectual conformism." While writing in a language permeated with the vocabulary of authenticité, Badi-Banga was sufficiently critical to acknowledge both the shortcomings of Zaire's modern art scene and the need for international exchange, arguing for "the development of new roads founded on syncretism."[58]

Despite the hiring of Badi-Banga, the modern art section at the IMNZ developed only slowly. The lack of funds prevented him from acquiring much work. By 1980 there were 234 works in the modern art section: 88 paintings, 69 sculptures, 22 ceramics, 11 copper objects, 38 decorated calabashes, 2 pots, and 4 textile pieces. Of the 88 paintings, 27 were by painters from the older generation of the academy in Lubumbashi. In terms of the art market, these paintings were the most valuable ones in the collection, especially the three paintings by Pili-Pili and the pieces by Chenge Baruti. Two works were by painters associated with the colonial Alhadeff workshop. Only three students of the older generation of the academy in Kinshasa were included, in addition to one older autodidact from Lower Zaire (Nkusu). There were also three paintings by Moussa Diouf, the lead painter of the Kanyama circle. Based in the Kanyama township of Lusaka in Zambia, these

painters were especially active in the late 1970s, producing a lot of so-called airport art in an attempt to live from their art.[59] The bulk of the IMNZ's collection of paintings were by artists of the avant-gardiste movement, with which Badi-Banga had been closely involved. Eight of these painters were represented in the collection, for a total of twenty-six paintings. Mayemba led the pack with nine paintings, the maximum number of any artist in the IMNZ's collection. Only two of the Popular painters, Moke and Kapolongo, were included.

The sculptures in the IMNZ's collection are more difficult to ascribe to individual artists, since there are no names listed for many of the objects. Of the 69 sculptures, a couple of names can be traced to the avant-gardistes, notably Liyolo and Tamba, and 3 works to Lufwa, an artist of the older generation from Matadi. There were also 3 sculptures by Wuma, who was educated at the ABA in Kinshasa and became an instructor at the university. The majority of the ceramics belonged to the avant-gardistes: 16 of the 22 works and all of the copper objects were done by avant-gardistes, mostly by Mokengo.

None of the artists who produced the calabashes were identified, nor are the makers of the pots and textiles.[60] Their inclusion was interesting nonetheless. The lack of identification with an artist, and the very basic and vague descriptions seem to indicate that this is one of the few places where we see the continued presence of the crafts traditions the Belgian colonial regime was so interested in but which were far less in the spotlight under the Mobutu regime. The manner in which they were recorded, however, as well as their place at the bottom of the inventory list, suggests the marginal place they occupied in the interests of the museum.

So while the IMNZ possessed very little of the work of the Popular painters, by the 1980s these painters were the representatives of Zairian contemporary art abroad. Over time, the themes of their paintings, and the meanings assigned to them, changed. During the 1970s the memory of colonization and the violence of the 1960s still dominated as a subject, but in the 1980s these themes began to be overshadowed by the difficulties of daily life and the growing distance between the riches of the elite and the struggles of the majority of the population.[61] In their relationship with power, these painters were forced to be careful with the level of political—and sexual—explicitness of their work.

In many ways the very nature of the work of the Popular artists was a subversion of Western ideals of art and value. Not only did their

work repeat the same themes, but the same model was often painted again and again, with slight modifications along the way. After all, "the sale of many versions of the same subject was a proof of success."[62] The Popular painters also explicitly embraced the commodity status of their work, producing for patrons, both at home and abroad. This patronage relationship did not mean there was no creativity involved, but that it came from the interaction between the artists and society. Both Fabian and Jewsiewicki have argued that the painters and their (Zairian) patrons were sharing a process of "the structuring of common memories."[63]

While the Zairian avant-gardistes strived to comply with Western notions of artistic authenticity as the product of creative singularity, they were doomed to fail in the eyes of most foreigners. Had it not been for Badi-Banga, the Zairian avant-gardistes might have been swallowed by history; his publications and their presence in the IMNZ's collection kept them from sinking into obscurity. While for Western modernism the appropriation of African art (and authenticity) had been crucial, almost any adaptation of "Western" techniques or topics by African artists was considered inauthentic, or an inferior mimicry of Western artistic traditions.[64] This fundamental denial of access to the very modernity and authenticity embodied by the modern authentic art object was subverted by the Popular painters in their explicit embrace of repetition and the commodification of their work. As such, they repeated patterns of cultural production established in the context of the production of arts and crafts in the 1950s (see chapter 2), although they were received quite differently by the Western audience who saw them as authentic witnesses of Zairian society and history.

Despite their popularity with Western foreigners and despite the recognition of their importance by Badi-Banga, by the late 1970s the IMNZ owned very little work by the Popular painters.[65] Their (hidden) critiques of the contemporary society and political situation did not make them particularly popular with the regime, which in turn made it politically difficult for Institute for National Museums to acquire much of their work, although several of the employees were enthusiastic about the work on an individual basis. However, because of the growing demand for their work abroad, the selection of works for a 1982 IMNZ exposition in Paris focused entirely on the Popular artists (with the exception of one sculpture by Liyolo). Twenty-six paintings were included, but only eight of those came from the collection of the IMNZ, which had to rely

on private collectors to supplement the works. (One of these was Nestor Seeuws, a Belgian staff member of the IMNZ!)[66]

Although it represented a much smaller proportion of the museum's collection, modern art—and in particular painting—was often used in IMNZ exhibitions, even before Badi-Banga's arrival. Over the years, it was included in exhibitions at the FIKIN fair and in numerous expositions abroad, such as the First Pan-African Youth Festival in Tunis in 1973, an AICA exposition in Paris in 1975, and a fair in Lausanne.[67] The exposition in Lausanne, *Arts du Zaïre*, included both modern and traditional art and was designed to show that the art had evolved from its traditional origins. In terms of modern art, however, the emphasis was mostly on the painters from the schools of Wallenda and Romain-Desfossés.[68] The strong presence of modern pieces in exhibitions was mostly due to the increasing value of traditional art, which made it susceptible to theft. The IMNZ's staff also tended to be reluctant to create new exhibitions, because they saw the collection of traditional objects as unfinished and incomplete, and they preferred money and resources to go to collecting and research.

Years later Badi-Banga confessed his disappointment with the project of authenticité and the cultural politics of the republic: "The postcolonial period fed our hopes for the rehabilitation of our cultural patrimony so that the people could be reconciled with themselves and able to mobilize its creative genius." Unfortunately, those in power had impeded the IMNZ's projects, he complained, and "in the case of modern art, the country knew an exodus equal to that in traditional art. Seventeen years after the creation of the modern art section of the Institute of National Zairian Museums, the modern art section does not even contain a hundred works worthy of a large museum. Can we imagine in the future some kind of partial restitution of our modern art works?"[69] According to Badi-Banga, the Zairian state had failed not only in its guardianship of the country's modern heritage but also in its support of the IMNZ and thus of heritage in general.

Badi-Banga's assessment was correct. By the 1980s the museum institute relied mostly on international aid. Although it continued to represent the country and regime abroad, its national presence was negligible. The students of the academy had regular access to the museum on their campus in Kinshasa, but it attracted a mostly foreign audience made up of NGO workers and foreign diplomats. The museum in Lubumbashi had a more stable history, because of the wealthier and more permanent

foreign community in Lubumbashi and because it had a proper museum building. The small provincial museums in Kananga and Mbandaka struggled significantly. Being farther from the geographic centers of power in the country, and financially dependent on a central museum institute that was severely underfunded drastically limited opportunities. Modern art was not part of the collections of either place, although in Kananga the local arts school held temporary exhibits.

Despite the efforts and vigilance of its modern art curator, the IMNZ's collection reflected a limited understanding of the nation's heritage. The focus was on the preservation of traditional objects, instead of the support and collection of new art. Stuart Hall points out how this prevents a broader understanding of heritage (and thus of the nation represented by the heritage), since for artifacts "to be validated, they must take their place alongside what has been authorized as "valuable" on already established grounds in relation to the unfolding of a 'national' story whose terms we already know."[70] The "national story" that could be read into the collection of the institute focused on a "traditional" past and largely excluded the Popular painters, who were shaping a new image of the Zairian nation and its past. This image expressed colonial violence, political and economic chaos, Western exploitation, and the many insecurities of life in Zaire as a "counter-memory" or "collective social memory" against the official stories of the Mobutu regime, with which the IMNZ was, after all, associated.[71]

WHOSE HERITAGE? THE KUBA CONTROVERSY

During the 1980s, it was not only the government that undermined the IMNZ's authority; it was also contested from within the country. In 1984 Kot aMbweeky III, the Kuba king, also known as the Nyimi, contested the institute's possession of a number of Kuba objects. In a letter to the state commissioner of culture and arts, he demanded the "restitution of objects, stolen at the Court by [an] unknown [person]." The objects included two drums, a mask, a wisdom basket, a royal statue, and a metal anvil.[72] This complaint was the only one ever made by a Zairian community leader against the IMNZ in the name of a local culture. What makes this case even more interesting is that the complaint came from a community with whom Cornet had developed a close relationship over the years. By 1984 he had made six research trips and one collecting trip to the Kuba, and he regularly returned to the region until his departure from Zaire in 1994.[73] The demand also

brought to the fore the old issue of restitution, since the Nyimi explicitly cast his request in that term. This time, however, the IMNZ was on the receiving end of the demand.

By the time of the conflict between the IMNZ and the Kuba king, both the production of and the market in Kuba art had stratified significantly. Aside from the material produced for and owned by the royal family or other Kuba title-holders, the largest part of the objects produced were destined for sale to outsiders. The missionary art school, established during the colonial era, had helped canonize "real" Kuba art, for example in the form of a textbook for its students. *Elements d'art Bakuba*, published in 1959, codified the production of "real" Kuba pieces and geared it towards a number of "classic" Kuba examples.[74] Although the school had been nationalized under the Mobutu regime, it continued to function, and it contributed to the commodification of previously rare sculptures such as the ndop, the royal statues (while none of the originals remained in Kuba country).

Historically the Kuba king attempted to remain in control of local art production and sale: for example by allying with the art school, supporting production and sales cooperatives, and by sending sales representatives to cities such as Kinshasa, Lubumbashi, and Lusaka. Jan Vansina has argued that during the Mobutu era, Kuba art played an

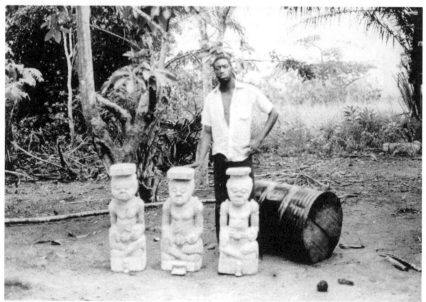

FIGURE 5.14. Kuba sculptor Sham Kwete with three *ndop* reproductions, 1974. R031–134, Photo Archives IMNC, photo by Manengo. Courtesy of IMNC.

"essential role in the survival of the kingdom" by providing the king with the income to reign, while many local artisans survived thanks to the income generated from the sale of their products.[75] Given the (relative) European respect for their political and artistic traditions, the Kuba had some success in maintaining this control.

The almost century-long removal and sale of objects owned by the king and his title-holders, however, continued in the 1970s and 1980s to such an extent that some of the Kuba dances and spectacles were no longer performed because the costumes had all been sold (several of them to the IMNZ).[76] This context helps explain why the Nyimi started contesting the IMNZ's possession of Kuba materials: it was the only cache of the materials that remained geographically close in comparison to all the objects that had departed for European collections and museums.

Ironically, the IMNZ's defense against the Nyimi's claims followed the lines of Tervuren's defense against Congolese demands for restitution, elaborating upon the legality of the manner in which the IMNZ had obtained the objects and arguing for the IMNZ's possession of Kuba art in the name of preservation and cultural guardianship of the objects as *national* culture. In other words, the Zairian state took on the role previously exercised by the Belgian state, replicating relations of colonial and postcolonial inequality on a national scale. While Belgium had relied on a discourse regarding the universal value of African art and its role as world heritage, Zaire adapted that argument to an overarching national structure.

Four of the objects demanded by the Kuba king could be traced to a lot that the IMNZ had received from the presidential office upon the creation of the museum institute. Powis had bought them during the turmoil after the death of Kuba king Mbope Mabintshi ma Kyeen.[77] Cahen had written to Powis in July 1970, warning him of a rumor that the new Nyimi, Kot aMbweeky III, wanted to open a store with Kuba objects in Kinshasa. He suggested immediate action might be necessary to save some of the most valuable material from going abroad, either by obtaining the material with a presidential order or by sending the University of Wisconsin scholar and Kuba specialist Jan Vansina to collect the material on his next visit. Powis followed Cahen's advice and wrote to the Nyimi, explaining the goal of the INMZ and emphasizing that the president was counting on the Nyimi's patriotic sentiments to fulfill his civic duty to sell Kuba heritage to the state. Powis

and the Kuba king met a week later, and Powis bought a number of objects for the museum institute, urging the Nyimi to come to him first if he needed money and wanted to sell in the future.[78]

The acquisitions of Kuba material had continued apace since Cornet made the kingdom his main subject of research. In 1972 he reported the gift of a royal tambour by the Kuba king to the IMNZ.[79] In 1973 Cornet reported that the Nyimi was experiencing family difficulties and that his power was waning, a situation some family members used to sell objects. Seizing this opportunity, the IMNZ acquired two drums and a number of costumes, arguing that the museum could prevent the material from leaving the country and give it a secure environment in which it could be preserved.[80]

Despite the IMNZ's fervor for collecting in Kuba country, Cornet helped recover a valuable *mutwoon* statue that was stolen from the court.[81] He was able to prevent its sale in Kinshasa and sent it back, emphasizing to the Nyimi that he "protected it from an intervention of the National Museums . . . [although] . . . this initiative will provoke unfavorable reactions for me. The *Mutwoom* is a piece of great artistic value and in presidential circles in particular, they wished to see it join the collections of the National Museum. The objection one has often made to my desire to restore your possession to you resides in the rather widespread conviction that you only wish to recover the fetish to resell it at an expensive price to foreigners. I know the sacred character of this treasure for your tradition well enough to be absolutely convinced of the opposite."[82]

By contrast, in 1984 Cornet depicted the Nyimi as an opportunist in search of financial gain, unable to care for and protect Kuba heritage properly. He established the legal provenance for the material the Kuba king sought to recover from the museum. In the case of the drums, acquired in 1973, he strongly denied ever having asked these to be sold "at the order of the President-Founder." Moreover, Cornet argued that "certain ancient royal Kuba objects are of major importance for the art history of Zaire and if they return to Mweka or Mushenge, they will no longer be safe." He was referring to both their physical safety and the risk of the objects being sold to foreign art dealers. Cornet also raised the question of why the Nyimi waited fourteen years before demanding restitution of the objects from the IMNZ. He knew the objects were at the museum institute and had visited its collections on several occasions. Cornet hinted that the reason might lie in the

considerable value that the objects had accrued in the past decade because of their inclusion in expositions by the IMNZ in Europe and the United States. This was indeed the case. *Art from Zaire,* which toured the United States in the late 1970s, and *Sura Dji,* an IMNZ exposition at the Musée des Arts Décoratifs in Paris in 1982, had driven up the already considerable interest in and price of Kuba objects on the international art market. In consequence, the Nyimi was turning himself into a veritable art dealer.[83] What Cornet omits from his interpretation of the situation, however, was the role his own book on royal Kuba art played in the further popularization of Kuba art. Moreover, the publication of the book had caused a rift between him and Georges Kwete Mwana, his longtime collaborator and member of the royal family. Since the latter was also Cornet's connection to the royal court, the falling out might have contributed to the animosity between the IMNZ and the Kuba king.[84]

Cornet kept repeating that "objects, infinitely precious for the national tradition, risk disappearing if the restitution of which the Nyimi talks, would become effective."[85] From the IMNZ's perspective, the Kuba art objects had come to embody a national tradition that trumped a regional or ethnic identity. While Cornet ostensibly privileged the cultural value of the objects (while certainly not being unaware of their financial value), the Nyimi privileged their value as economic resources and argued for his right as a traditional leader to use those resources as he saw fit, denying the state's claim on the material. Jan Vansina has argued that the Nyimi had been able to sustain his position thanks to Kuba art and the income it generated, particularly in the face of his declining official role under the Mobutu regime.[86]

What does not come through in the archival pieces is how the rest of the Kuba community responded to the loss of their heritage. The "dynastic women" in particular, led by the king's mother, were deeply upset with the assault on the royal art treasury—in which were the ceremonial skirts of the women of the court—going so far as threatening to depose the king to put a stop to the continuing disappearance of objects.[87] The pressure created by the regular visits of the IMNZ also started to generate tension.[88]

Pressured by his own court, the Nyimi repeated his demands several times over the next fifteen years. Lema Gwete, the museum's director at the time, accused him of simply bringing up the issue again every time a new commissioner of culture and arts entered office. By

the 1990s the list of objects under contention had grown to eighteen. In 1993 a meeting took place between the Nyimi, his lawyer, the Department of Culture and Arts, and the IMNZ. At this meeting the exact provenance of all the items under contention was established, with the IMNZ emphasizing the legality of their acquisitions. Among the objects were three royal statues (ndops), two of which had been sold to the presidency in 1970 (see above) and one that was transferred back from Belgium and handed over by Minister Van Elslande in 1976 (see chapter 3). In total, nine of the eighteen objects belonged to the lot transferred from the presidency in 1970, four were part of the transfer of objects from Belgium to Zaire, two were bought from the Nyimi himself, two others were bought in the field, and one was a gift to the IMNZ.[89] Director Lema Gwete repeated Cornet's suggestion that the heightened profile of the objects due to their inclusion in international expositions triggered the demands, since the Nyimi never indicated the objects were stolen before. In the end, the dispute died a silent death, and none of the objects were returned to the Kuba.

The IMNZ made a claim to cultural guardianship over the Kuba that closely resembled the efforts of the colonial administration. Although far less concerned with the regulation of the production of crafts than the colonial state, the IMNZ, as the representative of the Zairian state, claimed the role of the colonial state when it came to the display, preservation, and possession of Kuba art objects. Tervuren aimed to hold onto cultural guardianship on the basis of their ability to care for and display Zairian art, and the IMNZ reproduced that argument in their dealings with the Kuba king, despite their limited abilities to display the material to a national audience.

For the colonial state, the cultural value of Kuba art indicated the existence of a waning civilization capable of producing "art" but in need of guidance in order to maintain those artistic traditions, which in turn legitimized the presence of the colonizer as a cultural guardian. For the postcolonial state, the cultural value of the objects was translated into a political value when they were put in service of the creation of a national cultural identity and the legitimation of the modern state.[90] Cornet and Lema emphasized the Zairian and national character of Kuba art, obfuscating its regional identity; for the Kuba, on the other hand, the objects represented a local cultural identity, which in the king's opinion should lead to greater Kuba control of its value as both an economic and a cultural resource.

The Kuba arguments, however, merely challenged the legal status of the objects and did not engage the validity of the IMNZ's view of the objects as crucial to Zairian national art history. After all, that campaign was making the objects more valuable. In this regard as well, there is a parallel with the strategies used by Tervuren. By appealing to a more universal dimension of aesthetic appreciation for the objects, and by including them in the canon of art history, Tervuren extended their claim on Congolese objects in the postcolonial era as world heritage. Similarly, the Zairian museum institute emphasized the wider, national identity of Kuba art, absorbing its regional character.

Nor did the Kuba king make any claims about the religious or more general ritualistic significance of the objects. Such a claim would have played better on a global level, where demands from native communities to their national governments—particularly in former settler colonies like Australia, New Zealand, and the United States—in the name of their cultural significance were increasingly supported by international efforts, directed by UNESCO, to give legitimacy to these claims.[91] If read as an indication of the general political atmosphere, it is interesting that by the mid-1980s the Nyimi felt it possible to contest the IMNZ's representation of Zaire and even contest the state's possessions. The demands expose the marginalization of the IMNZ as a state institution but also underline the continued power of museums to generate value. The awareness with which the Kuba king and the IMNZ saw the museum's objects as tools to achieve larger goals is striking. The Kuba king did not appeal to a discourse about the rights of cultural communities to possess their own heritage; instead, his characterization of the IMNZ—and by extension the state—as plunderers and thieves illustrates the bankruptcy of the Mobutist version of the Zairian nation.

〜

THE LATE 1970s and 1980s witnessed the financial decline of the IMNZ, as well as its falling victim to the postcolonial power struggles between Belgium and the Mobutu regime. But the IMNZ also failed to live up to the role it envisioned for itself. Aspirations to contribute to the creation of Zairians as modern citizens, and simultaneously build a cultural identity rooted in tradition, ran aground.

Undermined by its inability to obtain a decent and easily accessible building in Kinshasa, and literally trapped on Mont Ngaliema in

a secluded, presidential space, the IMNZ was the hostage of national and international political power games. Yet mere structural causes, although important, do not explain the failure of the IMNZ to create a connection with its public. Its conservative attitude to displays, characterized by an aesthetic approach that emphasized the value of the objects as art, likely contributed. The same can be said for its inability to incorporate into the official national heritage the work of the Popular painters. These artists shaped a collective memory that challenged the official construction of the colonial past as irrelevant to the nation's identity, which denied people the ability to come to terms with the violence of that past and undermined the IMNZ's credibility as a repository of authenticity.

The contestation by the Kuba king of the institute's rightful ownership of some of the Kuba objects, using a discourse of theft and illegitimate appropriation instead of arguments about cultural identity and property, highlights how these cultural objects were again reduced to resources for exploitation and the accumulation of cultural objects—art—as property and value. This discourse cannot merely be blamed upon the economic aspects of the Zairian crisis but exposes the roots of "culture as property" in a system of exploitation that goes back to the reinvention of artifacts as art in the colonial era.

For the Zairian staff, what looked like the road to the middle class (for the technical staff) and the intellectual upper middle class (for the university-trained elite) ended in a quagmire that trapped people in state jobs that no longer provided a real income but where the pretense of a functioning state system was still required to mask the extreme exploitation of the Mobutist elite. In other words, although little research, education, and conservation was possible, one still had to go through the motions of performing one's position, and by extension, that of the IMNZ as an institute with a cultural praxis.

Success and riches in Zairian society became tied to the exploitation of economic resources by the state. In circumstances like these, it became difficult not to see the national collection first and foremost as a repository of financial and economic resources, to be exploited for personal advancement. Although many on the inside of the IMNZ *did* resist this corruption, it became increasingly difficult to keep outside exploitation at bay as objects disappeared into the abyss of the informal economy driven by the Western desire for African art.

Like the hollowed-out political process, in which democracy was reduced to a performance within the space of a one-party state, the elements that were to make up the cultural content of Zaire existed merely as shells. The Mobutist state had embarked upon its project as if museums were part of the "how to build a nation" kit distributed to the newly independent countries. By passing on this toolkit while withholding the very substance of cultural sovereignty—the acknowledgment of cultural guardianship—Belgium severely limited the chances of the museum institute to serve its theoretically prescribed role.

6 ⤳ Belgian Patrimony, Zairian Treasure, and American Heritage

The Transnational Politics of Congolese Art

IN 1967 the Walker Art Center in Minneapolis, together with the Tervuren museum, organized *Art of the Congo*, which toured numerous North American museums. The exhibition triggered a strong response in Congo, particularly in the presidential office. It was seen as a symbol of Belgium's continued ability to present itself as the guardian of Congo's heritage, and led to a renewed call for the restitution of Tervuren's art collections to Congo. It also illustrated the existence of an international audience for the country's traditional art and the value of exhibitions as an avenue through which cultural sovereignty (or at least the appearance of it) could be reclaimed.

This chapter focuses on the transnational nature of postcolonial "cultural flows" in the form of exhibitions, what they teach us about the multifaceted identities of cultural heritage, and the role they played in the cultural politics of the Mobutu regime. These international movements have their roots in the colonial era. As Frederick Cooper and Ann Laura Stoler concluded in the now classic introduction to *Tensions of Empire,* "The production of colonial knowledge occurred not only within the bounds of nation-states and in relation to their colonized subject populations but also transnationally, across imperial centers."[1] In other words, the space in which ideas about African art and culture evolved did not exist in isolation, nor were its boundaries limited to the metropole and the colony. In her work on nineteenth-century world

fairs in the British empire, Carol Breckenridge determined "transnational cultural flows" existed "at the heart of the imperium."[2] This chapter shows how these "cultural flows" were not restricted to the traditional imperial centers, and expanded in the postcolonial era.

In the late colonial period, the Belgians became fixated on the booming US market for African art and crafts. This market, as well as the growing scholarly community interested in African art in the United States, also made it possible for Zaire to envision traditional art as a tool of international cultural representation. These developments aligned with the changing Cold War political landscape, in which the United States played a dominant geopolitical role—especially in Congo, given their role in the first Congo crisis and their subsequent support of Mobutu's rise to power.[3] In short, the new role of the United States reconfigured the transnational space in which these objects moved.

A major difference between the colonial and postcolonial transnational flows was the increased agency of the former colonial "periphery."[4] Zaire inserted itself actively into world politics. As we saw in chapter 3, one way in which it was able to do this was through Mobutu's challenging of the universalist tendencies of the international conservation regime. Another was through the regime's efficient use of the American audience for African art. While these postcolonial cultural politics were deeply affected by new global dynamics, they were still complicated by the legacy of colonialism. Belgium's colonial cultural hegemony was not destroyed by decolonization but was challenged by Zaire's increasing orientation toward the United States.[5] By addressing American audiences, Zaire demonstrated its identity as an American ally for whom transatlantic ties were a way out of its past as a European colony.

Four exhibitions of Congolese art in the United States will be discussed in order to trace the contours of the cultural flows that animated the postcolonial world. Each of these exhibitions—*Art of the Congo* (1967–69), *Art from Zaire* (1976–78), *A Survey of Zairian Art: The Bronson Collection* (1978), and *The Four Moments of the Sun: Kongo Art in Two Worlds* (1981)—represents a phase in the expanding global role of Congolese heritage. The objects in these exhibitions functioned respectively as artistic heritage with a universal appeal, national heritage representative of a nation's right to cultural sovereignty, commodified cultural capital available to wealthy American collectors but also museum visitors, and lastly as American heritage.

Despite the centrality of the nation in the organizing themes of these exhibitions, the context of their presentation clearly transcended national boundaries in multiple ways. In particular, they demonstrate the importance of the American audience before whom these exhibitions performed a variety of messages. It was not just audience and objects that connected across national boundaries, however. We must also take into account the international nature of the world in which collectors, scholars, and museum professionals circulate. In the postcolonial era these interactions were enriched by the extension of this network onto the African continent, demonstrated here by the active participation of the IMNZ in the creation of exhibitions, but also by the increasing importance of American academia in the world of African art studies.

AFRICAN ART IN THE USA

African objects first made an appearance in US museum collections in the late nineteenth century. While in some art museums they were classified as part of "primitive arts," most museums housed them in departments of ethnology, where they were used as the basis for the construction of representations of African cultures at large. By the 1920s, under the influence of European Modernist artists' interest in African art, private galleries also started taking an interest. As a result, the aesthetics of African objects started receiving more attention. Around the same time, the Harlem Renaissance also helped introduce African art to an African American audience, for whom the objects acquired significance as cultural heritage. The 1935 exhibition *African Negro Art* at the Museum of Modern Art introduced the Modernist trend in the display of African art to a broader audience, with a selection of objects that included mostly sculptural pieces with an abstract quality, and little to no contextual information about the objects. In the following decades, this trend clearly impacted displays in art museums around the country but also stimulated a growth in the number of private collectors, several of whom contributed significantly to museum collections. Sometimes private collections, like the one created by Nelson Rockefeller, led to the establishment of specialized museums, in this case the Museum of Primitive Art in New York in 1954.[6]

Although the duality between Modernist and ethnographic displays of African art persisted, the political context in which the exhibitions in this chapter took place was very different from that of the first half of the

twentieth century. The disappearance of the colonial empires in Africa, along with the rise of a new global order in which the United States and the USSR were the dominant powers, contributed to an increased American interest in and interaction with the non-Western world. This was reflected in, for example, the creation and success of the Peace Corps program, several alumni of which, not coincidentally, went on to study African arts and cultures in graduate school. The rise within the United States of the civil rights movement and later Black Power and the Black Arts movements also played a important role in the increased interest in Africa, particularly in the African American community.

In the time frame covered in this chapter (roughly 1966 to 1982), the collection, study, and exhibition of African art in the United States expanded significantly. The United States became an important center of gravity in the production of knowledge about African art. In anthropology, the study of Africa had been on the rise under the influence of Melville Herskovits, particularly after his creation of an African studies program at Northwestern University in 1948. Although still in its infancy, the discipline of African art history started gaining ground in the late 1950s and 1960s. Influenced by scholars such as Roy Sieber and Robert Farris Thompson, young scholars were encouraged to go beyond the study of museum collections and apply fieldwork paradigms from anthropology to the study of African art history. By the 1980s, a sizeable generation of American scholars working on Zairian art and culture (either as anthropologists or art historians) emerged. Among them were, for example, Allen Roberts, studying the Tabwa; Mary Nooter Roberts, researching Luba art; David Binkley, Patricia Darish, and Ramona Austin, working on the Kuba; and Zoe Strother, studying Pende art and culture. At the same time, in Europe, and in particular in Belgium, the field was receding somewhat. Symptomatic was the move of Jan Vansina and Daniel Biebuyck, prominent scholars of Kuba and Lega cultures respectively, to positions at American universities.[7]

As Christa Clarke and Kathleen Bickford Berzock have pointed out, "The boundaries that defined African art for the modernists began to be challenged and reshaped in the 1960s."[8] This shift was visible, for example, in the pages of the publication *African Arts*, which covered a broad range of subjects that included modern art, architecture, and practices and objects previously regarded as "crafts," such as basketry and textile weaving. The shift away from modernist interpretations and displays of African art was also visible in the museum world, where

African art increasingly received space in permanent galleries devoted only to African art, and not to "primitive arts" in general. Also significant was the opening of the Museum of African Art in Washington, DC, in 1964. Its founder, Warren Robbins, a former diplomat, created the museum with the express goal of using art to educate the American audience about Africa and its cultures. When Robbins engaged the Smithsonian Institution in negotiations involving an incorporation of the museum in 1978, the importance of African art as the heritage of the African-American community was also emphasized.[9] It is in the context of these growing audiences, political changes, and broadening interpretations of African art that the exhibitions of Congolese art in this chapter need to be considered.

"ART OF THE CONGO: MAGIC BEYOND OUR REACH"

Belgium's colonial-era emphasis on Congolese art as a promotional tool and commercial product continued after—and despite—Congolese independence.[10] In 1967 the RMCA and the Walker Art Center in Minneapolis organized the traveling exhibition *Art of the Congo*, which toured North America until 1969, going from the Walker Art Center to the Baltimore Museum of Art, the Museum of Primitive Art in New York, the Dallas Museum of Fine Arts, the Milwaukee Art Museum, and the Montreal Museum of Fine Arts.

The plans for the exhibition arose during the Belgian sojourns of Martin Friedman, director of the Walker Art Center.[11] Friedman's interest in African art dated back to his days as an assistant curator at the Brooklyn Museum, where the African art collection contains early and important Congolese objects.[12] At the Brooklyn Museum Friedman had taken up the study of Congolese art with the support of the Belgian-American Foundation. At the time, the foundation was led by Clark Stillman, himself an avid collector of Congolese art.[13] In 1964–65 Friedman continued his study of Congolese art at the RMCA in Tervuren on a Ford Foundation fellowship. It was during this stay, and with Stillman's support, that the idea of creating an exhibition for the American museum market ripened.

With Congo's restitution demands looming over Tervuren, the museum's curators were hesitant about such an exhibition, realizing it might draw the ire of Congo. The opportunity proved too tempting, however, for the RMCA, which was struggling with its identity in

the aftermath of Congolese independence. An international display of its collections would "serve to establish the eminence of Tervuren's great Congo collection" and be an international demonstration of the RMCA's relevance as a center for the study of Congo.[14] Presenting the objects as universally admired art—in addition to promoting the scientific relevance of the collection—would serve these goals and help create distance between the RMCA's collection and its country of origin. After all, the collection was also considered to be Belgian patrimony, which Friedman alluded to when he wrote that "this is the most important exhibition in America associated with Belgium since the remarkable Flemish painting exhibition of a few years ago undertaken by the Detroit museum."[15]

The politics of Congolese-Belgian relations interfered in myriad ways with the organization of the exhibition. For example, the tense relations with Congo came to the surface when Cahen erroneously believed Friedman planned on sending a special invitation to Congolese dignitaries for the exhibition's opening.[16] Up in arms, Cahen wrote,

> I particularly stressed that if you wanted Congolese representation, you should invite representatives of all African states. . . . If any *special* invitation goes out to Congo, whether to the government or not, we might have a lot of unnecessary trouble. . . . I see the presence of Africans purely as invitees for courtesy's sake, not as special representatives. The exhibition is arranged between museums, not between states. . . . I am sorry to have to say that, failing this, we would have to reconsider our arrangements.[17]

This exchange makes clear the extent to which Cahen realized the potential political problems that could be caused by Belgium and the Tervuren museum acting as the representatives of Congolese culture.[18]

The catalog accompanying the exhibition included articles by Friedman, Albert Maesen, and Clark Stillman. Friedman's article, "African Art and the Western View," focused, despite the title, largely on the significance of the objects for their makers and on their symbolism.[19] Its point of departure, however, was the inspiration Cubist painters found in the "abstract" forms of African art and the pervasive influence of "primitivism" in modern art in general. Many of the participating museums' press releases and promotional materials approached the art from this angle. The Milwaukee Art Museum even organized a children's arts program that focused on the influence of the

"absolute primitiveness" of African art "on the art of Europe." A set of photographs that included masks and statues from Congo and art from Pablo Picasso, Modigliani, Matisse, and others visually demonstrated this influence.[20] Clearly, the organizers did not trust the exhibition material in and of itself to be of interest to the museum-going public. As James Clifford has argued, "The scope and underlying logic of the 'discovery' of tribal art [by Western artists] reproduces hegemonic Western assumptions rooted in the colonial and neocolonial epoch."[21] Despite taking place in the late 1960s, the contextualization of the exhibition shows a clear continuation of "primitivism," or the veneration of the objects by the West on the basis of their being cast as the representation of "natural," unrestrained, and "authentic" cultures. In reality, these views reflected deeply embedded historical and political relations of inequality. Friedman's comments on the objects, which he called "strongly expressionistic" and "emotional material of great individuality," demonstrate that he was still approaching Congolese culture from a Modernist angle.

Albert Maesen's contribution to the catalog, on the other hand, was a dry, factual explication of the political, religious, and stylistic variety of Congolese culture. His approach to the material fits Tervuren's postcolonial reinvention of itself as a place of scientific study and expert preservation. This attitude was of course political. In the context of Congo's claims on the collections, Tervuren wanted to distance itself, particularly in international circles, from its identity as colonial institution and a tool of colonial propaganda.

Maesen's contribution was political in more than one way. His approach to diversity within Congolese cultures also differed from that of Friedman. The latter referred to differences among various Congolese cultures in an unself-conscious way. Maesen, on the contrary, emphasized Congo as a unit. In spite of starting with a statement about the rich diversity of cultures and stylistic expression in the country, Maesen continued without making many distinctions between the different cultural regions in the large country.[22]

The colonial context in which the objects reached the Belgian museum is absent from all three of the articles. Especially in Clark Stillman's case, this omission required some impressive maneuvering, given the focus of his article on the Western life of Congolese art objects, from the early contact by the Portuguese to the role of the early

ethnologists, missionaries, and ethnographic and art museums.[23] From describing the arrival and influence of the Portuguese on the Congo coast with precision, his text moves to an account of the Congo in the early twentieth century in which Belgians play a central role, although it is never explained to the reader how they came to dominate the area, nor why exactly they were there. The end result is a history of the creation of museum collections—particularly that of Tervuren—in which they appear to be a natural phenomenon.

The replacement of colonial history with a historical vacuum in which Congolese cultures exist as timeless entities implied the absence of a culturally relevant Congolese present. Friedman appears to have little confidence in the "newly emerging countries" to bring forth a relevant cultural scene, since he asserts that the African artist can either "create a 'folkloric' product . . . that is . . . a vapid travesty on a noble past" or "he can turn his back on these completely and become a provincial European or American imitator."[24]

The 200 objects in the exhibition came from across the Congo. Friedman selected 170 pieces, to which curators Albert Maesen and Huguette Van Geluwe added another 30. The usual bias toward objects from the south and southwest of the country was evident, although fourteen of the objects came from the north. The inclusion of the Togbo from the Northwest and Mbole from the Central North, in particular, was unusual. The catalog started with the Kongo and moved via the Lower Congo and the Bandundu area to the Kasai, in the direction of the Katanga region, up again via the Lualaba River to the Kivu, north via the Lega to the Mangbetu and Zande in the northeastern corner, and finally to the northwest. With a couple of exceptions (a crucifix and a funerary figure from the Kongo, some metalwork from the Luba, and two ivory pendants from the Pende), all the objects were made of wood. They were mostly masks and statues. Despite Cahen's initial apprehension regarding the museum's ability to send material to the United States because of Congolese claims, there were some of the museum's top pieces among those sent to Minneapolis, including one of the Luba stools, some Pende pendants, a male Mangbetu statue, and a Lega mask. Others, however, were not of the best quality that Tervuren possessed—for example, the Kuba *Mwaash a Mboy* mask.

The catalog entries, prepared by Huguette Van Geluwe, explicitly mentioned the provenance of each item. Tracing the ownership and

acquisition of each of the pieces not only established their "pedigree" but also proffered a legal barrier against Congo's demands.[25] These different "origin" stories often became as important as the ethnographic origins of the pieces, and authenticity came to rely on the historical trajectory of the pieces in the West. Inadvertently, by recording their removal from Congo and their rebirth as museum possessions in the West, detailing their provenance also inscribed the pieces with the imperial history so carefully avoided elsewhere in the exhibition.

At the Walker Art Center, the exhibition's installation was sober and uncluttered. Spotlights drew the eye to the objects set against darkly colored walls at different heights, some on separate small pedestals. The labeling was kept to a minimum. Don Morrison of the *Minneapolis Star* lauded the approach and credited it with "provoking us to use our eyes."[26] The physical organization differed from the catalog's layout, where the objects were classified according to cultural group. In Friedman's installation, the arrangement of the objects appears to be a mix between typological and cultural affiliation. The walls in figure 6.1, for example, are lined with masks from a variety of areas, although there appears to be some regional coherence (which may have been the result of Friedman combining objects that looked similar.) In figure 6.3, we also see a configuration of objects that relies on a mix between cultural and typological affiliation. On the right are a series of seats from a variety of areas, while there are two Pende objects on the far left, separated from the seats by two Kongo house posts. One effect of Friedman's approach is that the different cultures become more convincing in their Congolese identity. Although it could be read as a display of cultural diversity, the dominant framework was still Congolese.

A stilled Congo emerged from these displays, in which emphasis was on the value of the pieces, bathed in pools of light, as art. Most objects were displayed at or slightly below eye level, allowing the visitor a direct confrontation with the object. The prime importance of the visual and aesthetic experience was underlined by the fact that some objects were oriented sideways, away from the visitor, in order to emphasize their form. (See figure 6.2 and the masks at the end of the back wall in figure 6.1.)

This emphasis on the objects as art is also clear from the responses in the press, although a residual exoticism lingered. The reviewer in the *Minneapolis Star* wrote that this was not a show you could call

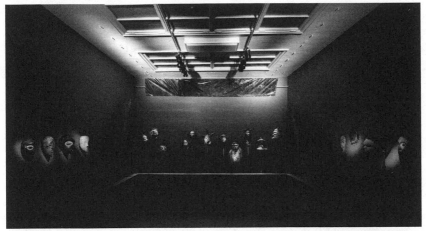

FIGURE 6.1. *Art of the Congo*, Walker Art Center. Eric Sutherland for Walker Art Center, Minneapolis, MN. Courtesy of Walker Art Center.

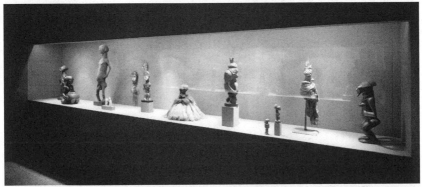

FIGURE 6.2. *Art of the Congo*, Walker Art Center. Eric Sutherland for Walker Art Center, Minneapolis, MN. Courtesy of Walker Art Center.

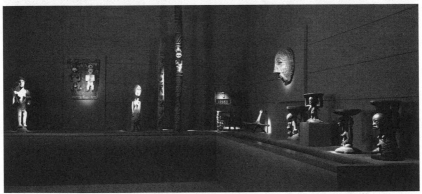

FIGURE 6.3. *Art of the Congo*, Walker Art Center. Eric Sutherland for Walker Art Center, Minneapolis, MN. Courtesy of Walker Art Center.

"'beautiful' in the pretty sense. Rather, it is exciting and awesome art with a powerful emotional impact that evokes a vigorous new set of aesthetics for us."[27] The *Minneapolis Tribune*, under the title "Art Outweighs Ethnology," also emphasized the objects' power as art and wrote that "the uses and traditions of the works are fascinating, but since we're talking about art there is no need to go into them here." The reporter moves on, however, to describe the "grotesqueness of the fetishes [and] the awesomeness of the masks."[28] The ambiguous nature of the attitude toward the objects can also be seen in the comments of Dallas Museum of Fine Arts director Merrill C. Rueppel, who described the art as "sophisticated and abstract," while simultaneously assuring a journalist at the *Dallas Morning News* that they would make the show "as spooky as possible."[29] Hilton Kramer of the *New York Times* was the only reviewer to remark that "our appreciation of these arts turns on an uneasy awareness of the bloody history and the complex motives that have brought the objects of these distant and alien cultures to our fascinated attention" and acknowledged "the conflicting attitude that lies in our appreciation of primitive art—the mixture of condescension, admiration and arrogance that is inseparable from our experience of this art." Yet, a few sentences later, he described the objects as "beauties derived from cruel practices and savage emotions."[30]

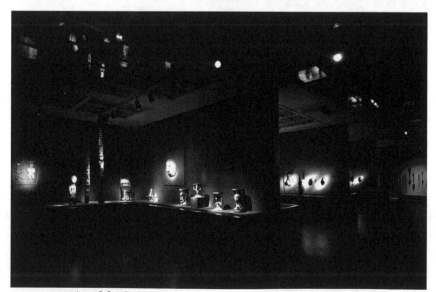

FIGURE 6.4. *Art of the Congo*, Walker Art Center. Eric Sutherland for Walker Art Center, Minneapolis, MN. Courtesy of Walker Art Center.

The other museums on the tour installed the material in similar ways. At times, objects were grouped by culture, but in other displays it was the visual attractiveness of the arrangement of the objects that appears to have determined the composition of their installation, not any connection to the objects they were grouped with. The strangest element of the display was the positioning of a series of masks on stakes (see figure 6.5; plate 2).[31] It elevated the pieces almost above the visitors' line of sight and emphasized the disembodiment of the masks. Their users were replaced with stakes, the floating heads an expression of their absence.

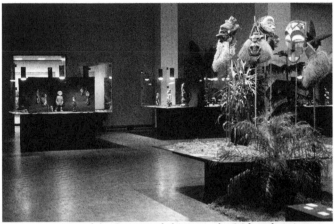

FIGURE 6.5. *Art of the Congo*, exhibition at the Milwaukee Art Museum, December 12, 1968–January 26, 1969. Courtesy of the Milwaukee Art Museum. (See also plate 2 in color gallery.)

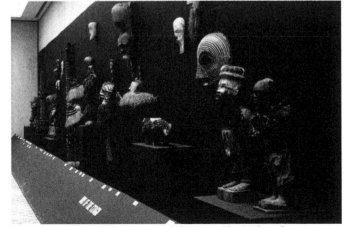

FIGURE 6.6. *Art of the Congo*, exhibition at the Milwaukee Art Museum, December 12, 1968–January 26, 1969. Courtesy of the Milwaukee Art Museum. (See also plate 3 in color gallery.)

Coming a mere seven years after Congolese independence, the exhibition did exactly what the Tervuren staff worried it might do: it triggered a new episode in the conflict over cultural restitution between Belgium and Congo. The objects included in the exhibition became the specific target of a demand for restitution from the Mobutu regime, reigniting a debate that would drag on for more than a decade (see chapter 3). In the long run, Congo also benefited from the exhibition, however, which helped to affirm Congolese traditional art as universally relevant and helped make it popular with museum curators.

Art of the Congo affirmed Tervuren's reputation as the guardian of Congolese art, extending colonial patterns well into the postcolonial era, and it made American audiences and museums complicit in this project under the guise of scientific interest, preservation, and the (universal) admiration for art. The same regime of value that had operated in the art displays at Tervuren in the late colonial era determined the parameters within which the objects operated in *Art of the Congo*. It also helped establish the Walker Art Center as a national player on the American museum scene. The demise of the colonial ties between Congo and Belgium offered Tervuren the opportunity to continue to build on the disconnect between contemporary Congo and "traditional" Congo they had constructed through their exhibitionary practices in the late 1950s, securing itself in the position of protector of the Congolese past and of Congolese cultural authenticity. *Art of the Congo* illustrates the development of the "authentic" image of Congo as one where the objects were separated from the subjects—the citizens of the nation of Congo.

"PORTRAIT OF A PEOPLE": MASTERPIECES FROM ZAIRE

The Mobutu regime did not easily forget its displeasure at the RMCA's organization of *Art of the Congo*.[32] When the opportunity presented itself to organize a Zairian version of the exhibition, the regime was eager to take it. Composed by the IMNZ and organized with the help of the American Federation of Arts (AFA) and the African-American Institute in New York City (AAI),[33] *Art from Zaire* was the star exhibition of the IMNZ and toured major art museums in the United States and Canada.[34] In language similar to that used to describe *Art of the Congo*, the AFA press release announced *Art from Zaire* as the exhibition of one hundred previously unseen masterpieces from the storerooms of

the IMNZ, the "largest and most important loan of traditional art ever made by an African nation." It emphasized that the pieces were unique and had never been shown in the United States, or anywhere else for that matter.[35]

In contrast to *Art of the Congo*, this exhibition had a slew of corporate sponsors. They included the National Endowment for the Arts, Chase Manhattan Bank, Exxon, Mobil, the Gulf Oil Foundation, and the Samuel H. Kress Foundation. Most revealing, however, was the sponsorship of the investment company Leon Tempelsman & Son. Maurice Tempelsman, who was of Belgian descent and had fled Antwerp at the start of World War II, served on the board of the AAI. He ran Lazare Kaplan International Inc., the largest diamond company in the United States, and was a close contact of Mobutu's for several decades.[36]

Although the majority of the African-American Institute's activities were geared toward providing Africans with educational opportunities, it maintained the African Art Exhibition Program to educate Americans about Africa. *Art from Zaire* was part of a series organized to introduce Americans to the art of Africa. Previous exhibitions included *Art of Nigeria*, *Art of the Sahel*, *African Arts of Today*, *Art of Angola*, and *Art of Mozambique*. The series began in 1973 with the founding mission to "understand and appreciate the cultural and artistic heritage of [Africa], advance the African efforts to preserve their national artistic treasures and make them know at home and abroad."[37]

In preparation for the exhibition, African art collector Irwin Hersey and Frank Ferrari, vice president of the AAI, visited the IMNZ in March of 1975.[38] As with previous requests for exhibitions, Cornet and Cahen felt the IMNZ was not yet ready for large exhibits.[39] In this case, they were also worried because the commissioner of culture and arts, Mbamba Yoma, also insisted on participating in the Second Black Art and Culture Festival in Lagos, which was planned around the same time as the exhibition in the United States.[40] The presidential office, however, was very happy with the American interest in an exhibition, since this was exactly the kind of public role they wanted to see the IMNZ and its collections play.

At the insistence of the Zairian government, Cornet and Hersey went ahead with the selection of the objects. The guiding principles for the selection were first and foremost the aesthetic value and rarity of the pieces. Secondly, they aimed for a geographic coverage, with various styles presented (the exhibition covered 26 different groups). Finally, they were

careful to include some lesser-known objects in order to encourage interest in the exhibition from connoisseurs and demonstrate the IMNZ's role in the development of new knowledge about Zairian art.

The result was a selection of one hundred pieces dubbed the "masterworks" of the IMNZ. Except for a few ceramics, some archaeological material, and some metal objects, all of the objects were sculptural pieces made out of wood and ivory. This selection in materials was especially interesting, considering the rich collection of Kuba textiles and costumes in the IMNZ's possession, but not surprising, given the emphasis on sculptural objects in the early years of African art scholarship and collecting. The exhibition's subtitle, 100 *Masterworks from the National Collection*, did double work. On the one hand, it publicly reclaimed guardianship from Tervuren by referring to a national collection, establishing the IMNZ as the successor of the Belgian RMCA. On the other hand, it maintained the focus on the objects as high art, reclaiming the language of "masterpiece," previously used in connection with the RMCA's collection, but shifting its association to the nation of Zaire.

An interesting point of difference with *Art of the Congo* was the section of archaeological objects from the Iron Age. It reflected the IMNZ's efforts (in cooperation with Tervuren) to establish archaeology as a viable field in Zaire. The inclusion of archaeological materials in an art exhibition like this one challenged the lack of historical depth of older images of African artistic cultures and anchored the nation in a deeper past. Although its separate presentation from the other objects did not allow the development of a clear historical narrative, the archaeological section nonetheless added a certain historical dimension.

Also different from older exhibitions was the insertion of Kuba culture into a clearly defined historical framework. Based upon the work by Jan Vansina, and to a lesser extent Joseph Cornet, there was a growing scholarly consensus on a historical chronology for Kuba history. While most of the cultures and objects in the catalog were discussed with no reference to change or historical context, relying instead on an ethnographic present in which these cultures seemed to exist indefinitely, several of the royal Kuba objects were chronologically situated by referencing the kings under whose reigns they had been made.[41] This confirmed that the reputation of Kuba art and culture as exceptional was continuing to grow.

Despite Cornet's ambition that the exhibition be as geographically wide-ranging as possible, the twenty-six groups represented in the

material were concentrated in the Southwest of the country. Objects from the East and Northeast were very few, with some from the Boa, Ngbaka, and Ngombe. Hersey explained that this was a reflection of the content of the IMNZ's collection. "The plain truth," he wrote, "is that, because of the rapidly expanding world market for African art, important works from these cultures have virtually disappeared from even the most remote villages."[42] Hersey used this angle to expand upon Mobutu's quest for restitution, his speech on the issue to the UN, and the agreement between the museum in Tervuren and Zaire about the possible return of some pieces. He hoped the exhibition would help the IMNZ to fill the gaps in its collection by inspiring donations from museums and private collectors.[43]

In following with his international agenda, Mobutu's foreword framed the exhibition with reference to the cause of cultural restitution for colonial "looting." Interestingly, however, his text presented the exhibition as the result of cultural restitution: "Most of the works of art we are now exhibiting are generous gifts from people who have understood that we have been plundered—people, who knew that, in order to teach our children about the achievements of our parents and grandparents, it was necessary for us to recover these objects."[44] Cahen, as the director of the RMCA and former director of the IMNZ, took issue with this plainly inaccurate statement—the objects were in fact collected or bought by the IMNZ with the help of the RMCA—but his protestations received little to no attention.[45]

Clearly, the exhibition *Art from Zaire* was not merely about art. It was also about the Mobutu regime's international campaign for restitution and its construction of Zaire's cultural sovereignty. The latter depended not only on national but also on international and particularly North American audiences. The exhibition was intended to show "a black nation stating its national identity through the medium of art . . . demonstrating both a profound respect for her African heritage and an effort to relate it to the 20th century."[46] The media eagerly quoted Mobutu's words, delivered by the commissioner of culture and arts at the show's opening in New York, describing authenticité as "a readiness to look at their own heritage, to seek out their ancestral values."[47]

Many of the articles devoted to the exhibition commented on the matter of restitution. Most simply repeated Mobutu's and Hersey's statements. Eleanor Munro, art critic and writer for the *New Republic*, was the only one who really explored the restitution argument. She

suggested that "these fragile works must bear a double weight of significance—as still worshipped images in a living tradition at home, and as tokens abroad in the international game of politics." But Munro also validated concerns of museum curators and collectors about the preservation of the objects in Zaire and the value of teaching collections in the West. What was being discounted, she argued, was that "an authentic audience for [African art] today is the long-expatriated black in search of its own identity," which certainly was another argument for keeping African art in the United States.[48]

Art of the Congo looms large behind *Art from Zaire.* While the 1967 catalog showed a black-and-white close-up of a Songye mask with oversize features and bulging eyes against a black background, the 1976 catalog has a colored picture of a Kete mask with fine features against a bright blue background (plate 4). The first was the type of mask popular with Modernist artists, but the second was an unusual and lesser-known piece, probably chosen to demonstrate the ability of the IMNZ to scientifically advance the study of Congolese cultures by bringing "new" objects to the attention of a global audience. An Africanization of the catalog descriptions and labels in the *Art from Zaire* catalogue illustrated the Zairization of the approach to the objects, with the African names of objects now provided as well as the location or group from which the object was collected.

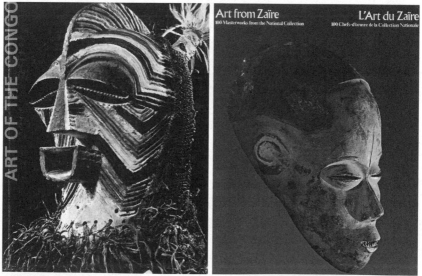

FIGURE 6.7. Catalog covers for *Art of the Congo* and *Art from Zaire.* Walker Art Center and RMCA, 1967; AAI and IMNZ, 1976. (See also plate 4 in color gallery.)

A comparison of the regions and cultures included in the two ex-hibitions reveals both the strengths and the blind spots of the IMNZ's collection. *Art from Zaire* showcased some 'recent discoveries'—for ex-ample, a large Yaka mask and a long Lengola figure (see figure 6.8)—as well as several Kongo ntadi. This assertion of new contributions en-abled the IMNZ to demonstrate their role as a scientific institution. By claiming their own expertise in the field and advancing knowledge about African cultures, they were also able to distinguish themselves from Tervuren. On the other hand, several of the more popular and well-known genres were missing. There were, for example, no Mangb-etu, Zande, or Lega objects, nor were there any of the nail statues (*nkisi nkondi*) for which the Kongo region was so renowned.

FIGURE 6.8.
Lengola figure,
Art from Zaire
installation,
Indianapolis
Museum of Art,
1977. Exhibition
Records, IMA
Archives. Courtesy
of Indianapolis
Museum of Art.

Once the objects arrived in New York, the AAI produced mounts and bases and even paid for the restoration of a number of pieces. The mounting, however, was later criticized by Daniel Biebuyck, a Belgian professor of anthropology at the University of Delaware who specialized in Zairian cultures. He regretted the setup because "it unduly interferes with the forms and the aesthetic effects they are meant to convey. These artificial devices should be discarded and an attempt to present art works in new ways, some of which might approximate the actual manner in which they are viewed by their own users and patrons."[49]

The space available for the exhibition in the African-American Institute was limited to two small rooms and a corridor, resulting in a crowded display. The objects were displayed in isolation from one another, without elaborate contextualization. Small labels listed only the object's name, location of origin, size, material, and dimensions. The display was organized in service to the objects' identity as pieces of art according to Western standards, without much regard for their function or cultural origin. One display of masks (righthand side of figure 6.9) was clearly arranged according to typological characteristics, but without regard for the different functions of the masks. Specialists like Biebuyck lamented the lack of conceptual framework: although effective in creating "a certain aesthetic image," this approach lacked "the vital cultural image."[50]

Since there was no general installation plan, each museum came up with its own spatial organization of the pieces. As a result, the same hundred objects were used to make up displays that varied from the purely aesthetic to a mix between aesthetic and anthropological.[51] As a consequence, the exhibition looked quite different from museum to museum. For example, Indianapolis Museum of Art curator Peggy S. Gilfoy decided to organize the displays more systematically than the AAI and created displays around four categories of material: royal arts, arts connected to ancestral worship, art from secret societies, and art related to protection and divination.[52] To Gilfoy, the audience's understanding of the use and meaning of the objects was of primary importance: "The art of Zaire is the product of various subcultures within the country. Our organization, based on the function of the objects in their own culture, may help visitors to the exhibition here gain a better understanding of this generally unfamiliar art."[53] As a former MA student

of one of the foremost African art specialists in the States, Roy Sieber at Indiana University, Gilfoy was bound to be more sensitive to the background of the objects. She called on local collectors of African art, including Roy Sieber and Harrison Eiteljorg, to fill some of the gaps in the IMNZ's material. The additions included textiles and hats from Sieber and the Indiana University Museum, a Lega mask, a Bembe mask, and a Kongo nail figure.[54] Additionally, the museum organized a series of events around the exhibition: films, an educational program, talks (including one from Yale University African art specialist Robert Farris Thompson), and performances.

Because Gilfoy's goal was to use the exhibition as a vehicle for the education of the museum's audience on the topic of Zairian cultures, the installation of the objects was also approached differently. A number of large photographs were used to situate the objects in their original contexts. For example, a large picture of the Kuba king went along with the objects from the Kuba Royal collection (figure 6.11; plate 5). An image depicting a Pende dancer with a *gitenga* mask was displayed alongside several Pende masks (figure 6.12; plate 6). No explanation accompanied the images, however, so it was left to the visitor to imagine their connection to the objects—although this inclusion of images of masked Zairian bodies, displayed next to art objects, created a certain, although muted, contextualization of the objects.

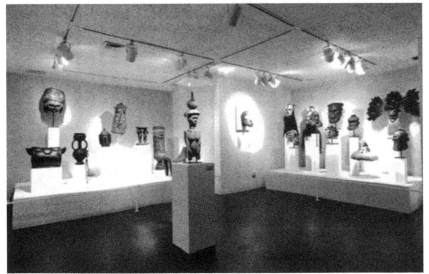

FIGURE 6.9. *Art from Zaire,* AAI, 1976. Courtesy of the Africa-America Institute.

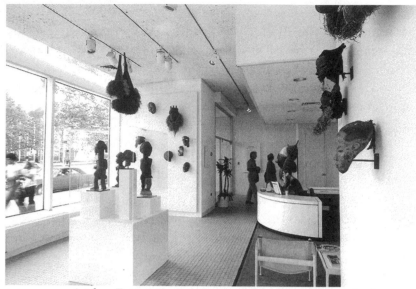

FIGURE 6.10. *Art from Zaire*, AAI, 1976. Courtesy of the Africa-America Institute.

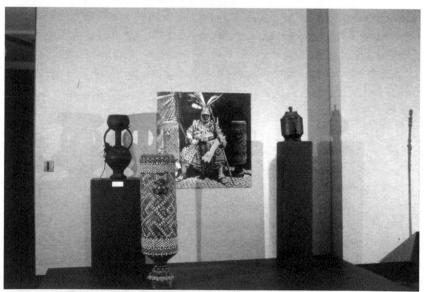

FIGURE 6.11. Kuba objects, *Art from Zaire* installation, Indianapolis Museum of Art, 1977. Exhibition Records, IMA Archives. Courtesy of Indianapolis Museum of Art. (See also plate 5 in color gallery.)

FIGURE 6.12. Pende objects, along with image of dancer wearing *Gitenga* mask. *Art from Zaire* installation, Indianapolis Museum of Art, 1977. Exhibition Records, IMA Archives. Courtesy of Indianapolis Museum of Art. (See also plate 6 in color gallery.)

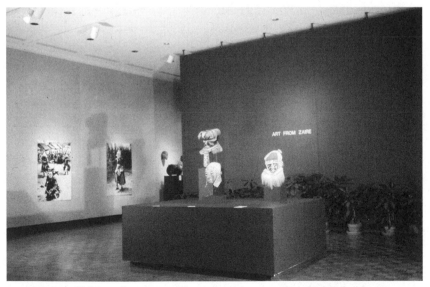

FIGURE 6.13. Kuba masks, along with two large images of masked Kuba dancers in the background, *Art from Zaire* installation, Indianapolis Museum of Art, 1977. Exhibition Records, IMA Archives. Courtesy of Indianapolis Museum of Art. (See also plate 7 in color gallery.)

The New Orleans Museum of Art and the High Museum in Atlanta took an approach similar to that of the Indianapolis Museum of Art. Both added Central African material from their reserves and local collectors to complement *Art from Zaire*. The New Orleans curator, William Fagaly, also chose to use the same photographs as the Indianapolis museum. The practice of including local collections allowed the curators to shape the exhibition and also helped to draw a local audience. In the case of private collections, it was a benefit for both sides. For the museum, it was an opportunity to form ties with local collectors, which could lead to future donations; for the collectors, having their possessions included in an exhibition would probably appreciate those possessions' value.

Other museums, like the Ontario Gallery of Art in Toronto, chose a more aesthetically oriented approach that emphasized the objects' identity as art. Keeping the labeling to an absolute minimum in combination with a bright, white space maximized the visitor's aesthetic and visual experience and emphasized the singularity of the objects, as did the arrangement of the larger objects, lining the walls or grouped in the middle of the space into small islands of objects. In certain cases, this meant that masks of the same culture were aligned into groups of two or three, but aside from the Kuba objects, no real effort was made to organize the bigger objects according to culture or region. The smaller objects, however, were partly organized according to the cultural origin of the objects, particularly the Kongo and Kuba pieces. This reflected the strengths of the IMNZ's collection but also, of course, the privileging of the Kuba tradition as artistically superior. Given the absence of the more "dramatic" nkisi nkondi of the Kongo and the presence of the more serene stone grave markers (or ntadi), two metal crucifixes that demonstrated the early impact of Christianity in the area, and a series of stone bracelets, the Kongo peoples' image was better developed and broader than that of other Zairian cultures in the exhibition.

What these different approaches to the same set of objects illustrates is their multiple identities: that as art, cultural artifact, valuable collector's item, and Zairian heritage. Their value lay in their ability to generate aesthetic admiration, knowledge, and financial worth, all elements that underlined their ability to act as resources for the promotion and construction of postcolonial Zairian sovereignty. Although the initial intent of the exhibition had been to focus on the objects as masterpieces with an exceptional aesthetic value, the IMNZ does not

appear to have been much bothered by the varied presentations of the material, as long as the broader framing of the material as Zairian was not endangered. This is also reflected in the identities of the museums that participated: as opposed to *Art of the Congo*, *Art from Zaire* toured not only art museums but also the Afro-American museum in Philadelphia and the Natural History Museum of Los Angeles County.

The Western regime of values that manifested itself in the process of the conversion from artifact to art and that constructed cultural authenticity as a dominant legitimizing feature became an indicator of political legitimacy for the newly independent nation when deployed on an international scale. The authenticity projected upon the materiality of the objects included in the exhibitions became symbolic of the authenticity of the ownership of the objects. This demonstration of the Zairian nation's ability to value roots in traditional culture and act as its own cultural guardian legitimized its character as a nation.

Susan Vogel, in her review of the exhibition, recognized that it showed "a black nation exporting its art (temporarily) for ideological, political, and probably economic reasons."[55] Politically, the *Art from Zaire* exhibition took place at a convenient time. American-Zairian relations had soured after Mobutu accused the CIA of planning a coup against him and expelled the American ambassador in 1975, following the latter's public criticism of the regime. But the United States came to Mobutu's aid during the regime's struggle with the destabilized Shaba (Katanga) region in 1977 and 1978. The subpar performance of his own army during the invasions in Shaba made Mobutu painfully aware of the continuing importance of his relations with the United States.[56]

The openings of the exhibition in its different locations reveal the various functions *Art from Zaire* fulfilled. In New York and Washington, especially, the opening took on a political character. The Zairian commissioner of culture and arts, Mbamba Yoma, and Lema Gwete of the IMNZ both attended the opening in New York. Gwete's presence—the institution's representation by a citizen of Zaire and not a Belgian—symbolized the government's commitment to the Zairization of the public image of the IMNZ.[57] In her opening speech, Mbamba Yoma described the exhibition as an occasion to get to know the Zairian people and to see beyond the stereotype of the mineral-rich but conflicted former colony. She also lauded Mobutu's policy of authenticité, repeating the highlights of his UN speech on restitution. While listing

the achievements of the IMNZ, she emphasized how the country's cultural riches translated into its authentic national identity.[58]

The New York opening was graced by the attendance of such luminaries as Amyas Ames of Lincoln Center, Mrs. Jacob Kaplan, president of the AFA, and Betty Shabazz, Malcolm X's widow. At the opening of the exhibition in the Museum of African Art in Washington, DC, there were even more dignitaries present. Warren Robbins, the museum's director and a former diplomat, was an avid networker in the political world and envisioned the exhibition as "a rallying point to bring key Americans together with representatives from Zaire to help create a climate for closer, more amiable ties and more effective working relationships."[59] His ambitions were reflected in the guest list and in the audience of almost six hundred for the opening: Senator Hubert H. Humphrey, an avid supporter of the museum was there, as was the mayor. But probably the most talked-about guest of the evening was Henry Kissinger, who, according to the *Washington Post* reporter, inundated Robbins with questions about the exhibit.[60]

The exhibition's Philadelphia stop was in the newly opened Afro-American Historical and Cultural Museum. It was the only museum on the tour devoted to African-American life and culture. The acting director, Adolphus Ealey, took an anthropological approach to the objects and organized them around a village concept. He emphasized the need to look at the objects in the light of African culture, not Western evaluations of art.[61] The national, Zairian context was downplayed in favor of the more general African identity of the objects, illustrating the potential of the objects to serve as the heritage of a broader, global, Africanness.

Whereas *Art of the Congo* had played to an older, Modernist paradigm in which African art was valued because of its impact on European artists, *Art from Zaire* illustrates a decline in emphasis on hat framework. Compared with the mid- to late 1960s, African art no longer needed the connection to European art in order to have its significance acknowledged, and yet it did not stand on its own, either. References to European modern art were replaced by a rhetoric about the universal value of art that integrated the objects on display into the universal heritage of mankind. The implication was that the viewer's humanity formed enough of a basis for appreciating the objects as objects of beauty. However, when it came to displays, as we've seen, some of the participating museums still relied heavily on Modernist aesthetics.

In spite of the universalization of the objects' aesthetic appeal, the exhibition nonetheless also served a specifically national goal. As the Mobutu regime intended, the objects were now a conduit for channeling attention to Zaire and its cultural policies. More than art or ethnography, the objects were now recognized as the heritage of an African nation. The cultural diversity represented in the displays faded into the background to the benefit of one national identity. This was reflected not only in the uniformity of display but also in journalistic comments, for example, "The exhibit [illustrates] *a* unique artistic style of 26 tribes."[62] The multiple ("ancient" cultures, cultural diversity, and various sets of peoples) became the singular (the national collection, a people, a heritage, and the Black African nation). Not quite the "Ethnicity, Inc." — or, more appropriately, the "Nation, Inc." — the Comaroffs have described in *Ethnicity, Inc.*, (particularly because the latter focused on so-called ethno-commodities, sometimes also described as "ethnic arts" or "tourist arts"), the Mobutu regime's appropriation of objects from various cultures into "Zairian art," and its use of this representation of Zaire abroad, was based on a similar approach to culture as property.[63]

The rhetoric about restitution, pushed alongside the discourse about Zaire sponsoring a healthy and successful museum institute, culminated in an image of Zaire as a nation taking charge of its past, and thereby of its future. Out of all the press the exhibition garnered, only one article associated Zaire with violence and war.[64] As a promotion of the Republic of Zaire, then, the 1976 exhibition was a remarkable success. This was in sharp contrast to 1967, when the Tervuren museum nervously avoided any reference to the nation of Congo. That exhibition had been intended as a legitimizing narrative for Tervuren as the guardian of a cultural heritage, in the form of aesthetically appealing art and valuable scientific specimens that were to be seen as separate from any Belgian colonial past.

In the case of *Art from Zaire*, the fact that the objects came from the IMNZ's collection helped guarantee their authenticity in the eyes of the North American audiences. This was the case whether they were displayed as art or as ethnographic specimens. In the 1976 exhibition, the IMNZ successfully replaced the Belgian museum as a repository of authenticity. This time, the objects' authenticity was based, not upon a long Western possession, but on the fact that they had been collected in the field by a Zairian museum institute. The inclusion of several lesser-known styles and objects only heightened the credibility of the IMNZ as a place with privileged access to "authentic" Zairian cultures.

Moreover, the use of these cultures in the creation of an authentic national cultural identity through the ideology of authenticité was unquestioned as a premise. In the context of this exhibition, Zaire successfully claimed the torch of cultural guardianship.

The exhibition was also a press event in Zaire itself. Expositions of Zairian art in Europe and the United States, regardless of who organized them, were a common newspaper item in the Zairian press in the 1970s, which liked to point out the admiration that existed for Zairian traditional art abroad, so the event of an exhibition in the United States, organized by the IMNZ, did not pass unnoticed. While rehashing the French-language press release of the AAI, local press accounts made a point of mentioning the American politicians and notables present at the openings. The daily *Elima* reported the presence of Richard Clark, a Democratic senator from Iowa and president of the senatorial commission on African affairs.[65] *Salongo* quoted AAI president William Cotter, who called the exhibition an "extraordinary testimony of the rich cultural patrimony of the Zairian people," and reported that Warren Robbins, director of the Washington museum, praised the ability of the exposition to help the American people understand Africa.[66]

The exposition was deemed a success by all involved. It had received extensive press coverage in the United States. In Europe, museums in Sweden, France, and Spain expressed interest in having it travel to their countries, as did the organizers of the 1979 Biennale in Berlin. Its tour through the United States was extended, but in Zaire the Department of Culture and Arts was upset that the extension (made at a higher level in the government) caused the project to go over budget.[67] With no budget left and with a lack of interest from the presidential office, no European tour took place, an indication of the declining importance of the European versus the American audience.[68]

ZAIRIAN ART AS AMERICAN CULTURAL CAPITAL

Art from Zaire was followed by several other exhibitions about Zairian traditional art, organized in the United States but often with the cooperation of the IMNZ. IMNZ's adjunct director Joseph Cornet, who had traveled to the United States along with the exhibition, had made many and valuable contacts. American collectors, scholars, the press, and museum professionals were all taken by the scholar, regardless of his lack of English, who "in his dark trousers, black necktie and white working coat . . . [looked] more like a family doctor than a priest or

African art expert."[69] He crisscrossed the United States during the exhibition's tour, visiting African collections at American museums and giving lectures at Northwestern and Indiana Universities.

The first result of these contacts was Cornet's authorship of the catalog for an exhibition of the Bronson collection. Organized by the North Carolina Museum of Art, and cosponsored by the Bronsons and the National Endowment for the Arts, and visiting the Museum of African Art in Washington, DC, and the Natural History Museum of Los Angeles County, the exhibition showcased the collection of the Bronson family, owners of a California sportswear company. The Bronsons were relative newcomers on the scene of African art collectors, but in about eight years they amassed a sizable collection of Zairian art. They explained that they were interested in Zairian art because of its affinities with contemporary art and design. Pete Lee, curator at the LA county museum, speculates that being among the first African art collectors on the West Coast also appealed to the Bronsons. It set them apart, since most serious African art collectors in the United States were based on the East Coast.[70]

The cultural capital the Bronsons were displaying by becoming collectors of African art was enhanced by involving Cornet in the selection of objects for the exhibition and by choosing him to write the catalog. He provided a form of legitimacy for the relatively new collection. Although Lee Bronson emphasized that Europe and not Africa was now the proper source for African art, Cornet provided a link to the African continent. Bronson claimed that he wanted to resist merely acquiring "masterpieces," thus attempting to distance himself from other, more "traditional" African art collectors.

Making a scientific contribution to the study of Zairian art was another of the Bronsons' professed goals, and one of the reasons they engaged Cornet. In the catalog Cornet created a new generation of refinements upon the stylistic zones still based on Olbrechts's original subdivision of the country (see chapter 1). The catalog's introduction framed the material by nation (as Zairian), by "tribal origin," and by style group, although Cornet struggled to make the difference between the last two clear. The actual listing of the objects, however, both in the catalog and in the exhibition, was by region.[71] Although the Zairian identity of the pieces was clearly an organizing principle for the collection and for the exhibition, the show was not as explicitly about Zaire as *Art from Zaire* had been. Instead, Zairian traditional cultures were an avenue for the promotion of the cultural capital of the Bronsons.

The response of the African art scholar Daniel Biebuyck to the ex-hibition's catalog makes the weaknesses of this approach clear. First, he criticized the hubris of private collectors, since "no privately owned group of artworks is capable of sustaining even a shadow of a global survey." He also took issue with the uncritical reliance on "ethnic" maps: "Will it ever be possible to reduce to maps the precise territorial distribution of 'tribal' groups?"[72] Although the latter remark does not constitute a critique of the "tribe/style" conflation, it does indicate an awareness of the distance between lived identities in Zaire and their solidification into maps.

In general, the critical reception of the Bronson collection exhibition was far less positive then the reception of *Art from Zaire*. The design of the displays literally ensconced these representatives of Zaire's cultural riches within the country's natural resources: the backdrop in the cases were cov-ered with a shimmering copper foil, and the exhibition as a whole was set in an environment with dark walls and palm fronds. The design drew the ire of several reviewers for "impos[ing] a very deliberate designer's vision upon the display."[73] The *Washington Post* and the *Los Angeles Times* both criticized the displays as outdated. The art historical approach "seemed inadequate. A small label won't do. There needs to be a creative, under-lying idea, a more complex intellectual underpinning," the *Washington Post* reviewer wrote.[74] William Wilson, the reviewer for the *Los Angeles Times*, described "disco-environment set of glowwormy colors" and the "poor Zairian art cowering behind . . . unnecessary visual cosmetics." He concluded that although "Zairian art has aesthetic power that is the artistic equivalent of a hunk of raw uranium," it did not benefit from being dis-played as if it were "in a padded vitrine at Tiffany's."[75] Clearly, the display of the private collection played remarkably less well with the specialized au-dience than *Art from Zaire* had. With the broader audience, the exhibition appears to have been a success, however. Despite the fact that it was the second exhibition of Zairian art in two years at the LA County museum, it was a very successful event in terms of visitor numbers.[76]

Zairian art was not merely a form of cultural capital for wealthy collectors, however. The LA county museum, which was host to both *Art from Zaire* and the exhibition of the Bronson collection, encour-aged its audience to think of Zairian art as a form of cultural capital that was attainable for them. Flyers and advertisements promoted "au-thentic" Zairian crafts, for sale in the museum shop.[77] Promotional im-ages for the sale used Kuba masks (see figures 6.14 [plate 8] and 6.15), an indication of the growing popularity of Kuba art with the American

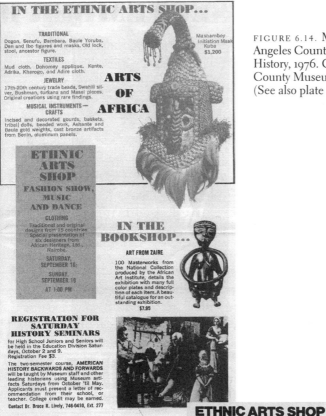

FIGURE 6.14. Museum shop flyer, Los Angeles County Museum of Natural History, 1976. Courtesy of Los Angeles County Museum of Natural History. (See also plate 8 in color gallery.)

FIGURE 6.15. Ethnic Arts Shop advertisement, *Terra* 15 (1) (Summer 1976). Courtesy of Los Angeles County Museum of Natural History.

audience, but also a testament to the robust artistic and crafts scene that produced these objects.[78]

Kuba art had a history of commodification and appropriation in the United States. The 1923 exhibition *Primitive Negro Art*, at the Brooklyn Museum, served as inspiration for textile and other designers. Steward Culin, the Brooklyn Museum's first curator of ethnology, in collaboration with the editors of *Women's Wear*, established a design laboratory at the museum, where designers could work with the museum's collection. Among the results were a line of women's dresses at the Bonwit Teller department store, as well as blankets inspired by Kuba textiles, and also garden furniture inspired by Chokwe chairs and hats inspired by Mangbetu headdresses. Many of these designs were sold by the museum.[79] Although the Bronsons claimed to be inspired by African art in the design of their own textiles, I have been unable to trace and direct visual evidence of this. Like at the Brooklyn Museum in the 1920s, however, African art continued to inspire popular design. The Museum of African Art in Washington, DC, for example, collaborated with Bloomingdale's in 1975 to create a "Kente collection" of clothes and textiles, inspired by the Ghanaian cloth and "authenticated" by the museum.[80]

In 1976 the LA museum sold what it called "authentic antiquities" from a range of cultures, including the Kuba, along with textiles, jewelry, musical instruments, even clothing in their "ethnic arts shop." The advertising assured buyers that "all antiquities have been cleared for export by the country of origin" and that "background and authenticity" were guaranteed, a particularly striking note, given the political context of the *Art from Zaire* exhibition.[81]

ZAIRIAN ART AS AMERICAN HERITAGE: THE FOUR MOMENTS OF THE SUN

A more thematic and contextualized approach to the display of African art had certainly not disappeared, however, despite the continued impact of the Modernist paradigm. *The Four Moments of the Sun: Kongo Art in Two Worlds*, the next American exhibition in which the IMNZ participated, confirmed the increasing importance of African art as an academic and scientific resource in the United States but also emphasized the importance of Kongo art, in particular, to the cultures of the Americas, and hence its identity as American heritage. Organized by the National Gallery and created by the Yale scholar

Robert Farris Thompson in collaboration with IMNZ's Joseph Cornet, the objects in the exhibition consisted mostly of funerary objects from the Lower Zaire region. The stone funerary sculpture of that region was one of the highlights of the IMNZ collection, in addition to being one of Cornet's research interests. Another focus of the exhibit, however, was the connections between Kongo cultures and African diaspora cultures via the transatlantic slave trade, central to Thompson's own scholarly interests.[82]

The African objects for this exhibition included mostly stone funerary statues (ntadi or *bitumba*), ceramic grave markers, and a number of cloth and jute mummies resembling large puppets. Although a portion of the objects came from the IMNZ, in particular the bitumba and ceramic vessels, other museums, such as the Ethnographic Museum of Gothenburg in Sweden and the Detroit Institute of Arts, also provided material for the exhibition. Although the displays made room for the admiration of the aesthetic value of the pieces, the goal of the exhibition was an in-depth exploration of Kongo cultures and the connections between Kongo visual traditions and those of African diaspora cultures—a very different premise from the exhibitions discussed above.

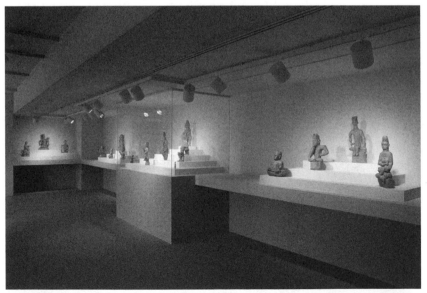

FIGURE 6.16. Installation photograph from the exhibition *The Four Moments of the Sun: Kongo Art in Two Worlds*, on view at the National Gallery of Art August 30, 1981–May 31, 1982. Courtesy of National Gallery of Art, Washington, DC, Gallery Archives. (See also plate 9 in color gallery.)

In terms of basic design, however, *The Four Moments of the Sun* did not differ much from the previous exhibitions. The creators avoided crowding the displays, so each of the objects could receive the attention it deserved, placed against a backdrop with contrasting white and dark colors. The scientific goals of the exhibition, however, required the objects to be grouped into types (ceramic grave markers, stone sculptures, cloth mannequins, etc.). Although the aesthetic appeal of the objects certainly mattered, equally if not more important was their function as embodiments of certain cultural traditions. Pictures and images were also used quite differently in this exhibition. Large pictures and plaques with contextual information not only accompanied the displays, in certain sections of the exhibition they were the central elements of the display (see figures 6.17 and 6.19; plates 10 and 12).

One of the biggest differences from the other exhibitions discussed here is the fact that only one subset of the many Zairian cultures was involved. Comprising various local cultures that stretched across the coastal area of Zaire, Angola, and the Republic of Congo, Kongo cultures had certain unifying traits, largely because of the past influence of the Kongo kingdom in the coastal region. In this exhibition, however, "Kongo art" was referred to in a singular form, although the labels in the displays did differentiate between various groups.

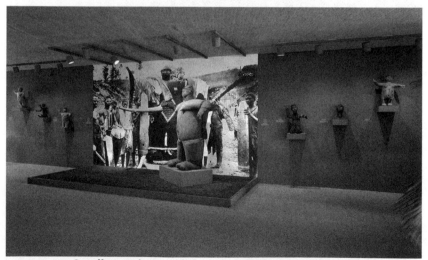

FIGURE 6.17. Installation photograph from the exhibition *The Four Moments of the Sun: Kongo Art in Two Worlds*, on view at the National Gallery of Art August 30, 1981–May 31, 1982. Courtesy of National Gallery of Art, Washington, DC, Gallery Archives. (See also plate 10 in color gallery.)

Despite the more obvious absence of the national framework, the nation Zaire did frame the exhibition. This was clear in Mobutu's foreword to the catalog and in the presence of Zairian dignitaries at the opening of the exhibition. Kaweta Milombe Sampassa, the commissioner of culture and arts, hoped the exhibition would help with the country's international image: "When people talk about our wealth, they think of raw materials—our zinc, cobalt and diamonds. We also think our art is a resource." The Zairian ambassador also hoped the exhibition would help "balance the often negative picture of Zairian economic mismanagement and political corruption."[83] Zaire didn't just mark the contextualization of the exhibition, it also shaped the content. As Jan Vansina noted, although Kongo cultures existed across national borders, Thompson and Cornet focused on the material found within the national boundaries of Zaire.[84] So although not exclusively "Zairian," the Kongo cultures were framed as such.

Kongo funerary culture was one of the areas in which the IMNZ had been able to distinguish itself from other collections of Zairian art, both in terms of collected objects and in terms of scientific research, so the exhibition presented an excellent opportunity for the IMNZ to profile itself as a museum institute with an international reputation.[85] With an entire section on the influence of Kongo cultures on African American

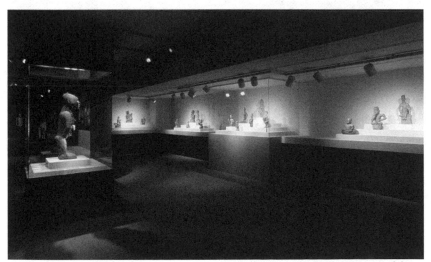

FIGURE 6.18. Installation photograph from the exhibition *The Four Moments of the Sun: Kongo Art in Two Worlds,* on view at the National Gallery of Art August 30, 1981–May 31, 1982. Courtesy of National Gallery of Art, Washington, DC, Gallery Archives. (See also plate 11 in color gallery.)

and other African diaspora cultures in the Americas, *The Four Moments of the Sun* also represented yet another shift in the representation of Zairian art as heritage, in this case as the heritage of the Americas. This heritage was located not only in the past, demonstrated through the history of the transatlantic slave trade, but also in the present, in Thompson's references to the influence of African, and in particular Kongo, cultures on music cultures across the Americas. This transatlantic angle had distinct political advantages for the Zairians. Mobutu hoped it would help African Americans "reestablish contact with their ancestors" and "revive true ties of kinship" between citizens from the United States and Zaire.[86]

The singling out of an African American audience by Mobutu was significant, particularly in its suggestion that Zaire was a place of ancestry and belonging. While this was the first exhibition where Mobutu explicitly made these connections (although the American media had made them during *Art from Zaire*), it was not the first time Zaire singled out the African American community as one of kinship. The organization of the famed boxing match between Muhammad Ali and George Foreman in 1974 in Kinshasa was also aimed (in part) at the grabbing the attention of the African American community.[87] In the case of *The*

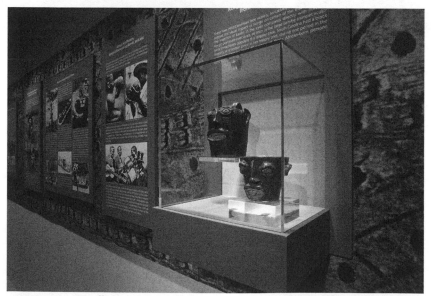

FIGURE 6.19. Installation photograph from the exhibition *The Four Moments of the Sun: Kongo Art in Two Worlds*, on view at the National Gallery of Art August 30, 1981–May 31, 1982. Courtesy of National Gallery of Art, Washington, DC, Gallery Archives. (See also plate 12 in color gallery.)

Four Moments of the Sun, the very content of the exhibition confirmed culture as the location of kinship and helped establish African art and culture as a source of academic interest for the understanding of contemporary America.

The understanding of cultural authenticity implicit in *The Four Moments of the Sun* also set it apart from the previous exhibitions discussed here. By connecting an African past to an American present, Thompson and Cornet broke with a model that located cultural authenticity in an African past, or at best an ethnographic present under severe threat of either colonial or postcolonial modernity. Instead, Kongo cultures are linked to hybrid and even contemporary cultures in the Americas. The approach acknowledges what James Clifford describes as an "interconnected world system [in which] local structures produce *histories* rather than simply yielding to History" and represents an important epistemological shift.[88]

⬅

ALONG WITH the changed political power balance of the Cold War, the center of gravity for the production of knowledge on African art shifted. While it was Mobutu's intention that the IMNZ take over the role of Tervuren as a locus of scientific activities surrounding Zairian art and anthropology, in reality the locus of scholarship production moved to the United States, which also became the focus of the regime's exhibitionary politics. The latter were aimed at taking control of the country's cultural representation and thereby reclaiming a form of cultural sovereignty. The focus on a foreign exhibition market over a national audience from the mid-1970s on confirms that "discourses on Zairian national identity were produced for *international* consumption as much, if not more so, than for a domestic audience," as Kevin Dunn has argued.[89]

From the 1967 *Art of the Congo* to the 1981 *The Four Moments of the Sun*, the political significance of the ability to display and represent Congolese art and culture was undeniable. While *Art of the Congo* underwrote an essentially colonial world order, *Art from Zaire* formed a clear attempt by Zaire to reclaim that cultural representation. Cornet's collaboration with the Bronsons, and his and the IMNZ's involvement with *The Four Moments of the Sun*, demonstrated the success, albeit a limited one, of that reclamation project. But the fundamental shift, seen clearly through close analysis of the transitions between these exhibitions over time, was the movement from a Belgian domination of

the representation of the former colony's cultures to the dominance of North American audiences, museums, collectors, and scholars, and the Mobutu regime's attempts to capitalize on these. That the exhibitions were successful is visible in part in the fact three of them took place within a span of five years, all involving major US museums.

This book started with Congolese objects that were curios, war trophies, souvenirs, trade objects, and gradually museum and art objects. This multiplicity in identities developed further over the years, always in connection to broader, often political, goals. The context in which they did was invariably one that included their movement and display. This chapter has demonstrated that while the objects played the role of artistic masterpieces, they also took on the role of Zairian national heritage and were representative of (American) personal wealth and cultural capital, as well as American and universal heritage, all in the context of the Cold War.

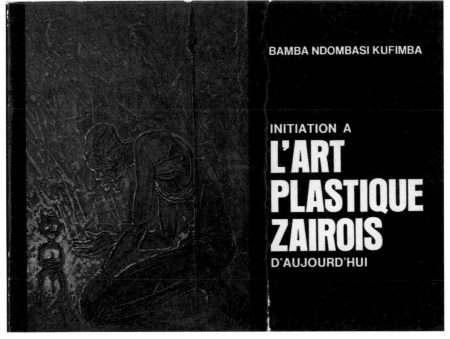

PLATE 1. Front cover of *Initiation à l'art plastique zaïrois d'aujourd'hui* (Introduction to contemporary Zairian visual art), published for the AICA modern art exhibition, 1973. Painting by Chenge Baruti.

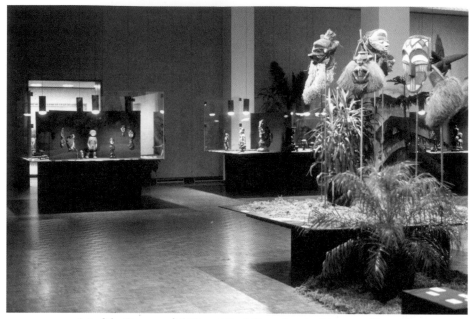

PLATE 2. *Art of the Congo*, exhibition at the Milwaukee Art Museum, December 12, 1968–January 26, 1969. Courtesy of the Milwaukee Art Museum.

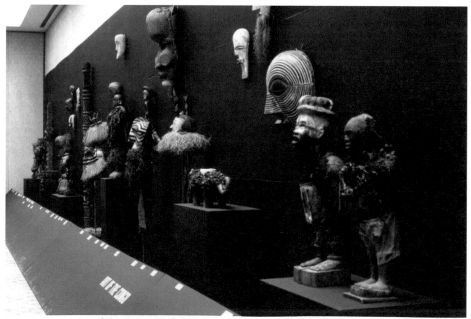

PLATE 3. *Art of the Congo*, exhibition at the Milwaukee Art Museum, December 12, 1968–January 26, 1969. Courtesy of the Milwaukee Art Museum.

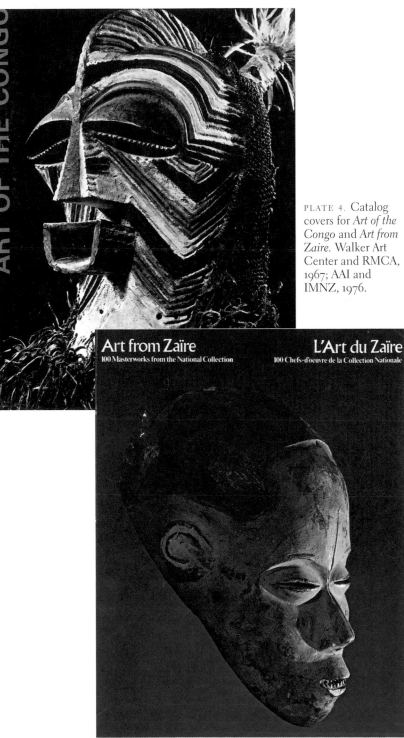

PLATE 4. Catalog covers for *Art of the Congo* and *Art from Zaïre*. Walker Art Center and RMCA, 1967; AAI and IMNZ, 1976.

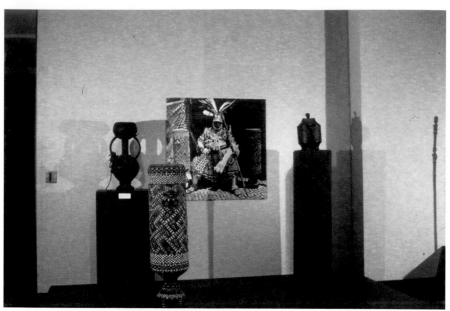

PLATE 5. Kuba objects, *Art from Zaire* installation, Indianapolis Museum of Art, 1977. Exhibition Records, IMA Archives. Courtesy of Indianapolis Museum of Art.

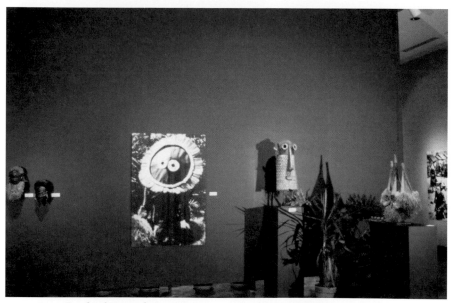

PLATE 6. Pende objects, along with image of dancer wearing *Gitenga* mask. *Art from Zaire* installation, Indianapolis Museum of Art, 1977. Exhibition Records, IMA Archives. Courtesy of Indianapolis Museum of Art.

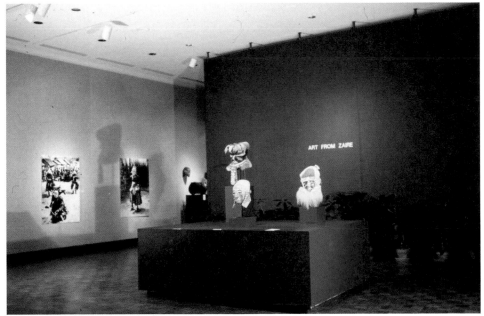

PLATE 7. Kuba masks, along with two large images of masked Kuba dancers in the background, *Art from Zaire* installation, Indianapolis Museum of Art, 1977. Exhibition Records, IMA Archives. Courtesy of Indianapolis Museum of Art.

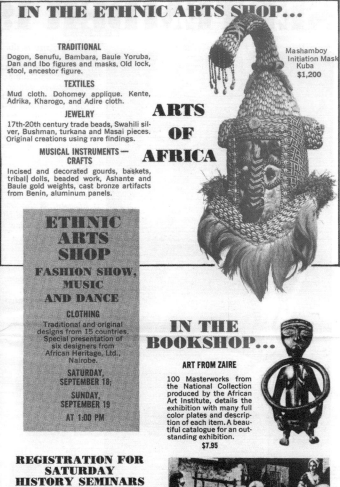

IN THE ETHNIC ARTS SHOP...

TRADITIONAL
Dogon, Senufu, Bambara, Baule Yoruba, Dan and Ibo figures and masks, Old lock, stool, ancestor figure.

TEXTILES
Mud cloth. Dohomey applique. Kente, Adrika, Kharogo, and Adire cloth.

JEWELRY
17th-20th century trade beads, Swahili silver, Bushman, turkana and Masai pieces. Original creations using rare findings.

MUSICAL INSTRUMENTS — CRAFTS
Incised and decorated gourds, baskets, tribal dolls, beaded work, Ashante and Baule gold weights, cast bronze artifacts from Benin, aluminum panels.

Mashamboy Initiation Mask Kuba $1,200

ARTS OF AFRICA

ETHNIC ARTS SHOP
FASHION SHOW, MUSIC AND DANCE

CLOTHING
Traditional and original designs from 15 countries. Special presentation of six designers from African Heritage, Ltd., Nairobe.

SATURDAY, SEPTEMBER 18;

SUNDAY, SEPTEMBER 19

AT 1:00 PM

IN THE BOOKSHOP...

ART FROM ZAIRE

100 Masterworks from the National Collection produced by the African Art Institute, details the exhibition with many full color plates and description of each item. A beautiful catalogue for an outstanding exhibition. $7.95

REGISTRATION FOR SATURDAY HISTORY SEMINARS

for High School Juniors and Seniors will be held in the Education Division Saturdays, October 2 and 9. Registration Fee $3.

The two-semester course, **AMERICAN HISTORY BACKWARDS AND FORWARDS** will be taught by Museum staff and other leading historians using Museum artifacts Saturdays from October 'til May. Applicants must present a letter of recommendation from their school, or teacher. College credit may be earned.

Contact Dr. Bruce R. Lively, 746-0410, Ext. 277

MEETINGS OF SOCIETIES

CONCHOLOGICAL CLUB OF SOUTHERN CALIFORNIA
Dr. James H. McLean, Sponsor
Wednesday, Sept. 8, 7:30 PM, Lounge

ORCHID SOCIETY OF SOUTHERN CALIFORNIA
Mr. Robert Spangenberg, Sponsor
Monday, Sept. 13, 8:00 PM, Auditorium & Lounge

LORQUIN ENTOMOLOGICAL SOCIETY
Dr. Charles L. Hogue, Sponsor
Friday, Sept. 24, 8:00 PM, Lounge

PLATE 8. Museum shop flyer, Los Angeles County Museum of Natural History, 1976. Courtesy of Los Angeles County Museum of Natural History.

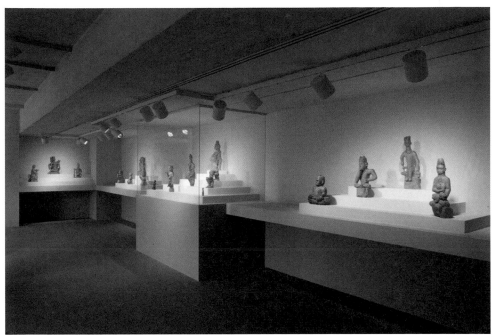

PLATE 9. Installation photograph from the exhibition *The Four Moments of the Sun: Kongo Art in Two Worlds*, on view at the National Gallery of Art August 30, 1981–May 31, 1982. Courtesy of National Gallery of Art, Washington, DC, Gallery Archives.

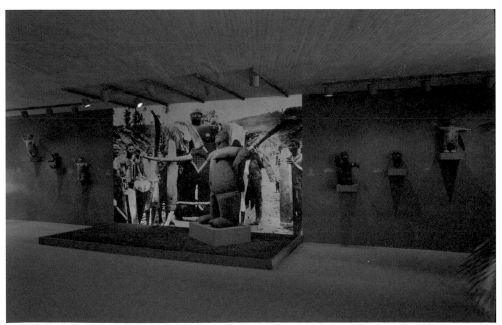

PLATE 10. Installation photograph from the exhibition *The Four Moments of the Sun: Kongo Art in Two Worlds*, on view at the National Gallery of Art August 30, 1981–May 31, 1982. Courtesy of National Gallery of Art, Washington, DC, Gallery Archives.

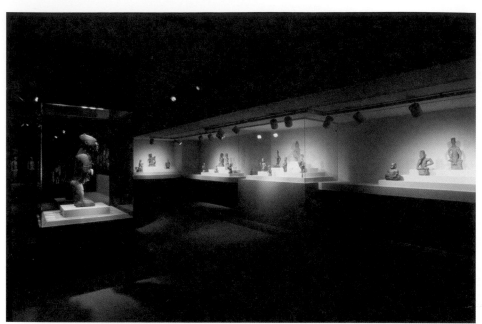

PLATE 11. Installation photograph from the exhibition *The Four Moments of the Sun: Kongo Art in Two Worlds*, on view at the National Gallery of Art August 30, 1981–May 31, 1982. Courtesy of National Gallery of Art, Washington, DC, Gallery Archives.

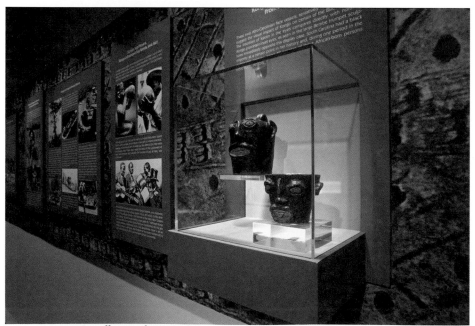

PLATE 12. Installation photograph from the exhibition *The Four Moments of the Sun: Kongo Art in Two Worlds*, on view at the National Gallery of Art August 30, 1981–May 31, 1982. Courtesy of National Gallery of Art, Washington, DC, Gallery Archives.

CONCLUSION

Colonial and Postcolonial Legacies

BY POPULARIZING the changing interpretations of Congolese ob-
jects as art and as resource, the Museum of the Belgian Congo helped
force a broader change of perspective on the value of "traditional"
Congolese cultures. This transition accompanied a change in colonial
policies regarding culture—away from the older "civilizing mission"
and toward what I have termed cultural guardianship—in which the
protection and preservation of traditional cultures became both part of,
and a justification for, the continued colonial presence of Belgium in
the Congo. This guardianship was exercised by the museum in Tervu-
ren, but it was also translated into a "politics of aesthetics" intended to
guide colonial cultural politics for the protection of traditional artistic
production in the Congo. Although these politics encouraged mod-
est initiatives in the form of artisanal workshops, art schools, and local
museums, they were fraught with tension between the colonial gov-
ernment in the metropole and colonial communities on the ground.
Local Congolese leaders, such as the Kuba king and the Lunda Mwata
Yamvo, also attempted to seize upon the political potential of the role
of protector of cultural heritage by trying to create their own museums
or by controlling local art schools.

The political role of art as heritage also impacted Congolese
ideas about decolonization and cultural sovereignty. Congolese, and
later Zairian, demands for the cultural restitution of the collections
from the Tervuren museum cast the need to reclaim guardianship
in literal terms, but the Mobutu regime also engaged the power of
guardianship symbolically through the cultural politics of authentic-
ité. Ostensibly aimed at restoring "traditional" cultural authenticity
to Zairian life, in reality authenticité entailed an appropriation of

colonial epistemes for the construction and justification of postcolonial systems of power.

One tool for the construction of postcolonial cultural sovereignty was the Institute for National Museums in Congo (IMNZ), responsible for the creation of a national collection of traditional art, a research agenda that would reclaim the production of knowledge about traditional cultures, and a national and international exhibition program. Founded with the initial support of the Royal Museum for Central Africa (RMCA) in Belgium, the IMNZ became a battleground for the implementation of cultural decolonization, both nationally and internationally. Its international exhibition activities—and particularly those geared towards the United States—were motivated by a desire to wrest the political and cultural authority to represent Congolese traditional cultures from Belgium, an agenda that was at least partially (if temporarily) successful.

This book establishes that the cultural politics of decolonization were an avenue through which authoritarian power structures of the colonial state, relying on the language and symbols of guardianship, were reproduced in the cultural narratives employed in the postcolonial state's search for legitimacy. By drawing attention to the chronological and thematic limitations of previous approaches to the history of Congolese decolonization, I demonstrate how decolonization was also a long-term struggle over categories—in this case, cultural categories. But the crux of the struggle was not so much about the content or definition of such categories as authenticity or art, which remained relatively stable, but the *right* or *ability* to define the categories. The power dynamics that determined access and rights to these categories during the postcolonial era were situated in a global context in which the transnational cultural flows that had taken shape during colonialism expanded and shifted under the influence of the cultural politics of the Mobutu regime.

Despite initial enthusiasm, particularly from an educated elite, for the politics of authenticité, the IMNZ failed to truly connect to a national audience. The reasons for this failure are manifold, but they include the quick decline in support from the Mobutu regime for its national activities. By the mid 1970s, the regime had reformulated its cultural ideology as "Mobutism," oriented more to the figure of the president than to an overall cultural identity. In combination with the economic crisis, the resulting loss of patronage greatly reduced the budget of the

IMNZ. The museum's conservative attitude to displays and exhibition practices likely also contributed to its lack of national traction, however. The exhibitions show us that authenticité failed to create a new aesthetic vision; it had little effect on the way objects were displayed or contextualized, which continued to rely heavily on Western paradigms of art display. The main difference between the 1967 *Art of the Congo* and 1976 *Art from Zaire* exhibitions lay in their political messages: while the first had been a postcolonial display of colonial rationales for cultural guardianship, the 1976 exhibition was a successful international promotion of the cultural sovereignty of Mobutu's regime.

The ideas for which museums were sometimes incubators, and sometimes conduits, affected an audience far beyond its visitors. Museums are part of a broader apparatus (or "culture complex") that develops and promotes (public) culture.[1] It is in the social life of cultural knowledge that we can most clearly see how museums affected societies at large. As this book has demonstrated, the knowledge practices that grew out of this cultural knowledge were wrapped up in social, economic, and political fields.

The Museum of the Belgian Congo, which was to become the Royal Museum of Central Africa (RMCA), was part of a system set up to justify and promote colonialism. It was also a place in which ideas about the "other" were developed (by scientists) and popularized (through displays), ideas that circulated far beyond their immediate consumption by museum goers. Even after the formal end of Belgian colonialism in Central Africa, the museum remained relevant. Simply by continuing to operate as before it signaled to the Belgian (and Congolese) populations the continuation of its role as a cultural guardian. The impact of ideas about the value of Congolese art and cultural authenticity developed in the context of colonial museums and systems of knowledge lived on beyond the colonial era and their profound influence on postcolonial interpretations of cultural sovereignty by the Mobutu regime is clear.

The fact that museums are but one part of a broader culture complex means that only one piece of a larger puzzle is offered in this book. While there are scholars—for example, Johannes Fabian, Didier Gondola, Bogumil Jewsiewicki, and Bob White—who have explored other aspects of Zairian cultural life, particularly in the realm of popular culture, much work remains to be done if we want to create a complete picture of Zairian culture-making during the Mobutu era.[2] Much of the existing literature focuses on either modern art or the music scene.

Other possible avenues of research include urban theater, film, dance, and literary scenes in the Zaire of the 1970s, as well as institutions such as television stations, libraries, and archives.

⏎

NOT LONG after my first arrival in Kinshasa, I joined a group of museum employees who were enjoying an afternoon breeze in one of the few places in Kinshasa where that is possible: on the slopes of Mont Ngaliema, behind the buildings of the IMNZ. With a majestic view of the Malebo pool and the cities of Kinshasa and Brazzaville laid out across the water, it is one of the most serene places in the city. For about a week, I had been trying to obtain permission to photograph some of the exhibition photos I had found tucked away in the filing cabinets with the museum's (largely obsolete) inventory. I had been on the hunt for one of the many people it was suggested whose permission I should ask and had now met the third person who introduced himself as *le directeur* to me. With the naive bewilderment of somebody who was relatively new to the country, I sat down next to one of the museum's young assistants I had befriended and related my woes. After hearing me out, he chuckled and softly replied: "*Il y a trop de directeurs au musée*" (there are too many directors in the museum). As I later discovered, there were in fact four at the time (there was a vacancy for the fifth).

My friend's reply was a reference to the famous line "*Il y a trop de chefs dans ce pays*" (there are too many chiefs in this country) that the Congolese are fond of saying.[3] It refers to the extensive, yet hollow, power structures that exploded under the Mobutu regime but have their roots in the colonial constructions of "native" leadership. A consequence of the corruption and patrimonialism that characterized the state by the end of Mobutu's reign, it is one of the legacies that continue to hobble the country. The comment also aptly characterized the museum institute as a legacy of the Mobutu regime. It had become a source of (second-rank) political posts and appointments. Its collection was exploited in the fashion of the country's vast mineral wealth: financially valuable objects disappeared from the storerooms and found their way into the black hole of the illegal economy, at times with insider help.

By the late 1970s the IMNZ and forms of state memorialism in general were irrelevant in the face of far more powerful forms of popular memory that circulated in Congolese society. These memories,

expressed among others by the Popular painters, did not adhere to the national narrative in which a generalized "traditional" past silenced the experience of colonialism. Instead, they connected the authoritarianism of the colonial and Mobutu regimes, which was exactly what Mobutu's cultural politics had set out to obscure.[4]

The deterioration of the IMNZ's relevance and the final evaporation of any lingering appreciation for the politics of authenticité are the main reasons for this book's ending in the early 1980s. Although the international exhibitions continued for some years, life at the IMNZ in the 1980s became very quiet, with little to no national exhibitions or collecting activities.[5] Ironically, even though the presidential office had largely abandoned the IMNZ, the population was unwilling to embrace an institution that was seen as closely associated with the regime.

Cultural life in Zaire did not, however, come to a standstill. The gap left by inoperative national institutions like the IMNZ was filled by francophone, foreign-led centers and organizations such as the Institut Français (the Halle de l'Etoile in Lubumbashi and Halle de la Gombe in Kinshasa), the Centre Wallonie-Bruxelles, and the the Organisation Internationale de la Francophonie, which dominated the cultural scene.

The collaboration between the museum in Tervuren and those in Zaire disappeared during the 1980s, although the Belgian state continued to pay the salaries of several of the Belgian employees of the IMNZ until Mobutu expelled them along with all Belgian "technical aid workers" in 1992. It was not until some years after the fall of the Mobutu regime that the ties between the IMNZ and the RMCA were renewed. The collaboration was no longer focused on Kinshasa but on the museum in Lubumbashi, where the RMCA successfully reconstituted an educational department. The contacts and collaborations between the institute in Kinshasa, officially still the main seat of the IMNZ in Congo, and the RMCA have been intermittent and not always successful.

While the IMNZ struggled, the 1980s and 1990s were a relatively uneventful period for the RMCA. Attention for the colonial past was at a nadir in Belgium, but the museum continued drawing relatively large numbers of visitors (there is scarcely a schoolchild in Belgium that has not been to Tervuren). Although it initially attempted to escape its identity as a colonial museum by broadening its collection and activities beyond the former Belgian colonies to the entire continent of Africa, its core identity and activities continue to be organized around Central Africa.

Controversy about Belgium's colonial past erupted in the late 1990s, spurred by, among others, the publication of Adam Hochschild's *King Leopold's Ghost* and a resurgence of the debate about Belgian involvement in the murder of Lumumba.[6] As a silent but tangible reminder of the colonial past, the RMCA was drawn into these debates and invited criticism for its inability to decolonize its displays and critically reflect upon its own role in that past.[7] In an effort to come to terms with its own and the country's imperial history, the RMCA organized *The Memory of the Congo: The Colonial Era*, a large exhibition in 2005.[8] In the public sphere, some found the exhibition to be too critical while others thought it not critical enough of Belgium's colonial past. These debates laid bare the divided nature of Belgian society when it comes the country's colonial history. The existence of a public debate of any sort, however, was a significant improvement on the silence of the 1980s and much of the 1990s.[9]

While the RMCA and Belgium are struggling with their colonial pasts, the IMNC in Kinshasa succeeded in opening a small public gallery on Mont Ngaliema in 2010, naming it after its former director Joseph Cornet. With practical help from Tervuren, as well as from some local sponsors, the gallery presented a thematically organized exhibition of highlights from its collections. The displays, organized around themes such as "The Art of Power," "Communications with Ancestors," and "From Childhood to Adulthood," are bare-bones, but are generally successful in representing the collections the IMNC has gathered

FIGURE 7.1. Salle Joseph Aurélien Cornet, IMNC, Kinshasa, 2011. Photo by author.

FIGURE 7.2. Statue of Leopold II, outside the IMNC on Mont Ngaliema in Kinshasa, 2011. Photo by Augustin Bikale.

since its inception (although the acquisition of the bulk of the material on display took place in the 1970s).[10]

While the collections of Tervuren are now considered to be part of Belgian, Congolese, and world heritage, the IMNC has also broadened its use of the category "heritage," by bringing the colonial past of the city into its backyard. During the *authenticité* campaign, the Belgian colonial monuments that had been spread across the city were dismantled and discarded. The IMNC restored them and has now, with financial backing of the UN mission to Congo, installed several of the statues in the park surrounding the museum institute on Mont Ngaliema. (The very same park that used to hold Mobutu's gardens and zoo.) One of these statues represents Leopold II on his horse. (Its twin sits in the square that previously was the center of the colonial government in Brussels.) While Leopold II has, both inside and outside of Belgium, become a controversial figure that often stands in for Belgian colonialism overall, the IMNC doesn't reject the statue as a representation of colonial suppression, but instead has incorporated it into its collection as Congolese heritage. With the integration of its colonial past into the country's heritage, the IMNC now operates with a radically different interpretation of the past than the cultural ideology under which it was created.

Expeditions IMNZ Kinshasa, 1970–90

There were a total of 119 expeditions between 1970 and 1990 (some combined with the Royal Museum of Central Africa).

TYPE

Musicology: 20
Collecting: 17
Ethnographic/ethnological: 73
Archeology: 8
Archives: 1
Modern tombs: 1

PERSONNEL

Cornet: 41
Seeuws: 9
Cahen: 2
Quersin: 12
Hénault:16
Only Belgian and foreign researchers: 46
With Congolese personnel: 38
Only Congolese personnel: 34
Zola: 20 (2 solo)
Boilo: 4 (1 solo)
Kalema: 3 (1 solo)
Lema: 10 (5 solo)
Badi-Banga: 2
Malutshi: 6 (3 solo)

Shaje: 2
Esole: 9 (4 solo)
Muya: 1
Nzembele: 1
Kasongo: 3
Bope: 2
Lemba: 7
Kivuvu: 4
Volanka: 3
With outside researchers:
Monni Adams: 2
Luc de Heusch: 2
Dunja Hersak: 1
Robert Farris Thompson: 2
Erika Schultzman: 1?

With RMCA: 9
Pierre De Maret: 4
Paul Timmermans: 1
Jos Gansemans: 2
Jean-Luc Vellut: 1

ACCORDING TO REGION (SOME MIXED)

Kasai: 20 (Songye 1, Occidental 4, Oriental 2, Kuba 10, Illebo 1)
Equator: 14 (Ubangi 3, Ingende 1)
Shaba/Katanga:11 (Kalemie 1, Nord 1)
Lower Zaire: 49 (Mayombe 1, Boma 8, Woyo 2)
Kivu: 2
Nord Zaire: 1
Haut Zaire: 8
Kinshasa: 5 (Teke 1)
Bandundu : 23 (Nord 1, Sud 1, Teke 6, Oshwe 2, Kikwit 1)

BY YEAR

1971: 6
1972: 6
1972–73: 2
1973: 14

1974: 14
1974–75: 1
1975: 19
1975–76: 2
1976: 15
1976–77: 1
1977: 4
1977–78: 1
1978: 3
1978–79: 1
1979: 11
1980: 9
1981: 5
1981–82: 1
1982: 1
1983: 0
1984: 1
1986: 1
1987: 0
1988: 0
1989: 1
1990: 1

Notes

INTRODUCTION:
CONGOLESE HISTORY AND THE POLITICS OF CULTURE

1. In October 1971 Congo was renamed Zaire, a name the country shed again after the demise of the Mobutu regime in 1997. Since this book covers several decades, I use the name that is historically appropriate to the context in which it is used.

2. Benedict Anderson, *Imagined Communities: Reflections on the Origin and Spread of Nationalism* (New York: Verso, 1991).

3. Pierre Bourdieu, *The Field of Cultural Production: Essays on Art and Literature*, ed. Randal Johnson (New York: Columbia University Press, 1993). Cultural politics indicates any kind of thoughts, ideas, organizing, or actions that are related to culture. These include, but are not limited to, cultural policies, which are policies made by either the state or other institutional actors (such as museums, schools, NGOs) geared specifically at the stimulation, regulation, or control of cultural activities.

4. The museum, originally named Musée du Congo, was renamed Musée du Congo Belge in 1908, Musée Royal du Congo Belge in 1952, and finally Musée Royal de l'Afrique Centrale in 1960.

5. Fernando Coronil, "Can Postcoloniality Be Decolonized? Imperial Banality and Postcolonial Power," *Public Culture* 5, no. 1 (Fall 1992): 104.

6. Since the early 1990s, there has been an explosion of scholarship on transnationalism. For more on defining and situating transnational history, see, for example, C. A. Bayly, Sven Beckert, Matthew Connelly, Isabel Hofmeyr, Wendy Kozol, and Patricia Seed, "AHR Conversation: On Transnational History," *American Historical Review* 111, no. 5 (2006): 1440–64; Patricia Clavin, "Defining Transnationalism," *Contemporary European History* 14, no. 4 (2005): 421–39; Deborah Cohen and Maura O'Connor, "Comparative History, Cross-National History, Transnational History: Definitions," in *Comparison and History: Europe in Cross-National Perspective*, ed. Cohen and O'Connor (New York: Routledge, 2004), ix–xxiv.

7. This is particularly evident in the scholarship on America and transnationalism, much of which has demonstrated how a transnational perspective can reveal aspects of a national history previously hidden. See, for example, Ian Tyrrell, "Reflections on the Transnational Turn in United States History: Theory and Practice," *Journal of Global History* 4, no. 3 (2009):

453–74; Thomas Bender, ed., *Rethinking American History in a Global Age* (Berkeley: University of California Press, 2002); and David Thelen, "The Nation and Beyond: Transnational Perspectives on United States History," *Journal of American History* 86, no. 3 (1999): 965–75. See also Paul Kramer's recent overview of American transnational and imperial history, "Power and Connection: Imperial Histories of the United States in the World," *American Historical Review* 116, no. 5 (December 2011): 1348–92.

8. This trend also risks erasing or concealing global inequalities. *Past and Present* recently devoted a volume to the topic "Centering the Transnational South"; see Matthew Hilton and Rana Mitter, "Introduction," in Supplement 8, *Past and Present* 218 (2013): 7–28.

9. This is not to say that Congolese societies had no concept of "art" or aesthetic appreciation—they most certainly did, although it might not align with Western interpretations of the concept.

10. John M. Janzen, "The Tradition of Renewal in Kongo Religion," in *African Religions: A Symposium*, ed. Newell Booth (New York: Nok Publications, 1977), 69–114; "Renewal and Reinterpretation in Kongo Religion," in *Kongo across the Waters*, ed. Susan Cooksey, Robin Poynor, and Hein Vanhee (Gainesville: University of Florida Press, 2013), 132–42.

11. Cécile Fromont, "By the Sword and the Cross: Power and Faith in the Arts of the Christian Kongo" in Cooksey et al., *Kongo across the Waters*, 28–31, and "Dance, Image, Myth and Conversion in the Kingdom of Kongo, 1500–1800," *African Arts* 44, no. 4 (Winter 2011): 54–65.

12. Cécile Fromont, "Under the Sign of the Cross in the Kingdom of Kongo: Religious Conversion and Visual Correlation in Early Modern Central Africa," *RES: Anthropology and Aesthetics* 59–60 (Autumn 2011): 109–23. For more on Kongo art and culture, see Wyatt MacGaffey, *Kongo Political Culture: The Conceptual Challenge of the Particular* (Bloomington: Indiana University Press, 2000); John K. Thornton, *The Kongolese Saint Anthony: Dona Beatriz Kimpa Vita and the Antonian Movement 1684–1706* (Cambridge: Cambridge University Press, 1998); Robert Farris Thompson and Joseph Cornet, *Four Moments of the Sun: Kongo Art in Two Worlds* (Washington DC: National Gallery of Art, 1981); and Cécile Fromont, *The Art of Conversion: Christian Visual Culture in the Kingdom of Kongo* (Chapel Hill: University of North Carolina Press, 2014). For a wide-ranging introduction to Kongo art and culture in Africa and in the Americas, see Cooksey et al., *Kongo across the Waters*.

13. Joseph C. Miller, *Way of Death: Merchant Capitalism and the Angolan Slave Trade, 1730–1830* (Madison: University of Wisconsin Press, 1988), 71.

14. On the Atlantic impact of Kongo cultures, see John Thornton, *Africa and Africans in the Formation of the Atlantic World, 1400–1680* (Cambridge: Cambridge University Press, 1992), and *A Cultural History of the Atlantic World, 1250–1820* (Cambridge: Cambridge University Press, 2012); also, John Thornton and Linda Heywood, *Central Africans, Atlantic Creoles, and the Foundation of the Americas* (Cambridge: Cambridge University Press, 2007),

and James H. Sweet, *Recreating Africa: Culture, Kinship and Religion in the African-Portuguese World, 1441–1770* (Chapel Hill: University of North Carolina Press, 2006).

15. Ezio Bassani and William Buller Fagg, *Africa and the Renaissance: Art in Ivory* (Munich: Prestel, 1989); Nichole N. Bridges, "Transatlantic Souvenirs: A Dialogue of Slavery and Memory in Kongo-Inspired Relief Sculpture," in Cooksey et al., *Kongo across the Waters*, 90–97.

16. Jan Vansina, *Paths in the Rainforests: Toward a History of Political Tradition in Equatorial Africa* (Madison: University of Wisconsin Press, 1990), and *Kingdoms of the Savanna: A History of Central African States until European Occupation* (Madison: University of Wisconsin Press, 1966).

17. Thomas Q. Reefe, *The Rainbow and the Kings: A History of the Luba Empire until 1891* (Berkeley: University of California Press, 1981), 98.

18. Mary H. Nooter, "Fragments of Forsaken Glory: Luba Royal Culture Invented and Represented (1883–1992) (Zaire)," in *Kings of Africa: Art and Authority in Central Africa*, ed. Erna Beumers and Hans-Joachim Koloss (Maastricht: Foundation Kings of Africa, 1992), 79–89. Mary Nooter Roberts and Allen F. Roberts, "Audacities of Memory," and Allen F. Roberts, "Peripheral Visions," in *Memory: Luba Art and the Making of History*, ed. Mary Nooter Roberts and Allen F. Roberts (New York: Museum for African Art, 1996), 17–48 and 221–45. On secrecy and African art, see Mary H. Nooter, *Secrecy: African Art That Conceals and Reveals* (New York: Museum for African Art, 1993).

19. Miller, *Way of Death*, 10.

20. On the Swahili-Arab slave and ivory trade, see Edward Alpers, *Ivory and Slaves in East Central Africa* (Berkeley: University of California Press, 1975), and Abdul Sheriff, *Slaves, Spices and Ivory in Zanzibar: Integration of an East African Commercial Empire into the World Economy, 1770–1873* (Athens: Ohio University Press, 1987). For a discussion of the cultural exchange between central and eastern Africa, see Allen Roberts, "Movement of Ideas and Forms between Central and Eastern Africa," in *Shangaa: Art of Tanzania*, ed. Gary van Wyk (New York: QCC Art Gallery, City University of New York, 2013).

21. Joseph Miller, "Central Africa during the Era of the Slave Trade, c. 1490s–1850s," in *Central Africans and Cultural Transformations in the American Diaspora*, ed. Linda Heywood (Cambridge: Cambridge University Press, 2002), 21–69; Hugues Legros, *Chasseurs d'ivoire: Une histoire du royaume yeke du Shaba (Zaïre)* (Brussels: Editions de l'Université de Bruxelles, 1996); Reefe, *Rainbow and the Kings*, 189–192.

22. Italics in original. Roberts and Roberts, *Memory*, 19–20; David A. Binkley and Patricia J. Darish, "'Enlightened but in Darkness': Interpretations of Kuba Art and Culture at the Turn of the Twentieth Century," in *The Scramble for Art in Central Africa*, ed. Enid Schildkrout and Curtis A. Keim (Cambridge: Cambridge University Press, 1998), 52.

23. Jan Vansina, *Being Colonized: The Kuba Experience in Rural Congo, 1880–1960* (Madison: University of Wisconsin Press, 2010), 43–44, 182; Binkley

and Darish, "'Enlightened but in Darkness,'" 37–62. For more on Kuba art, see the extensive scholarship by Jan Vansina, as well as Monni Adams, "Kuba Embroidered Cloth," *African Arts* 12, no. 1 (November 1978): 14–39, and "18th-Century Kuba King Figures," *African Arts* 21, no. 3 (May 1988): 32–38; John Mack, *Emil Torday and the Art of the Congo, 1900–1909* (London: British Museum Publications, 1991); Joseph Cornet, *Art Royal Kuba* (Milan: Edizioni Sipiel Milano, 1982); David Binkley and Patricia Darish, *Kuba*, Visions of Africa Series (Milan: 5 Continents Editions, 2009).

24. In the case of the Kuba, this admiration went back to reports by explorers such as Ludwig Wolf and Emil Torday and was carried on by several Belgian territorial administrators. Binkley and Darish, "'Enlightened but in Darkness,'" and Vansina, *Being Colonized*, 178–209. For the Mangbetu, see Curtis A. Keim, "Artes Africanae: The Western Discovery of 'Art' in Northeastern Congo," in Schildkrout and Keim, *Scramble for Art in Africa*, 109–32. In the case of the Luba, the idea of a supposed precolonial "empire" and a unitary history of the Luba emerged in a similar context, and it affected ideas about the potential for indirect rule in the area by colonial administrators. See, for example, Georges Van der Kerken, *Les sociétés bantoues du Congo Belge et les problèmes de la politique indigène* (Brussels: Bruylant, 1920), and Edmond Verhulpen, *Baluba et les Balubaïsés du Katanga* (Antwerp: L'Avenir Belge, 1936). The scholarship of Frans Olbrechts, discussed at length in the first chapter, clearly illustrates this trend: "authentic" Congolese art was a product of the past, endangered by the impact of Western modernity.

For an example of how ideas about decline influenced administrators' opinions about the less celebrated cultures of central Congo, see Aléxis Bertrand, "Quelques notes sur la vie politique, le développement, la décadence des petites sociétés bantou du basin central du Congo," *Revue de l'Institut de Sociologie de Bruxelles* 1 (1920): 75–91, or Georges Van der Kerken's image of a precolonial and unspoiled "garden of eden" in *L'Ethie Mongo*, 2 vols. (Brussels: IRCB, 1944).

25. On the artificial separation of precolonial and colonial history, see Bogumil Jewsiewicki and V. Y. Mudimbe, "Africans' Memories and Contemporary History of Africa," in *History Making in Africa: History and Theory: Studies in the Philosophy of History* 32 (1993): 1–11.

26. James Clifford, "Objects and Selves—an Afterword" in *Objects and Others: Essays on Museums and Material Culture*, ed. George W. Stocking Jr. (Madison: University of Wisconsin Press, 1985), 242.

27. V. Y. Mudimbe, *The Invention of Africa: Gnosis, Philosophy and the Order of Knowledge* (Bloomington: Indiana University Press, 1988), 189; Johannes Fabian, *Time and the Other: How Anthropology Makes Its Object* (New York: Columbia University Press, 1983), 1.

28. Mudimbe argues that from the 1950s onward, "African history" emerged as a new concept and "a radical transformation of anthropological narratives . . . [took place that] . . . valorizes the diachronic dimension as part of knowledge about African cultures and encourages new representations of

the 'native,' who previously was a mere object within European historicity" (Mudimbe, *The Invention of Africa*, 177). My main focus, however, will be on the continued role of the older paradigm.

29. The scholarship on colonialism, anthropology, and museums is ample, but it has focused mostly on museums in the West and is usually limited to the colonial period. See, for example, Tony Bennett, *Pasts Beyond Memory: Evolution, Museums and Colonialism* (New York: Routledge, 2004); Flora Edouwaye S. Kaplan, ed., *Museums and the Making of "Ourselves": The Role of Objects in National Identity* (London: Leicester University Press, 1994); Robert Lumley, ed., *The Museum Time Machine: Putting Cultures on Display* (London: Routledge, 1988); Sharon Macdonald and Gordon Fyfe, eds., *Theorizing Museums: Representing Identity and Diversity in a Changing World* (Cambridge: Blackwell, 1996); Sally Price, *Primitive Art in Civilized Places* (Chicago: University of Chicago Press, 1989); George Stocking Jr., ed., *Colonial Situations: Essays on the Contextualization of Ethnographic Knowledge* (Madison: University of Wisconsin Press, 1991); and Stocking, *Objects and Others*.

For British museums, see Annie E. Coombes, *Reinventing Africa: Museums, Material Culture and Popular Imagination in Late Victorian and Edwardian England* (New Haven, CT: Yale University Press, 1994). On German museums: H. Glenn Penny, *Objects of Culture: Ethnology and Ethnographic Museums in Imperial Germany* (Chapel Hill: University of North Carolina Press, 2002). On French museum culture: Nélia Dias, *Le Musée d'Ethnographie du Trocadéro (1878–1908): Anthropologie et muséologie en France* (Paris: Editions CNRS, 1991); Maureen Murphy, *De l'imaginaire au musée: Les arts d'Afrique à Paris et à New York (1931–2006)* (Dijon: Les Presses du reel, 2009); Alice L. Conklin, *In the Museum of Man: Race, Anthropology, and Empire in France, 1850–1950* (Ithaca, NY: Cornell University Press, 2013).

30. Agbenyega Adedze, "Symbols of Triumph: IFAN and the Colonial Museum Complex in French West Africa (1938–1960)," *Museum Anthropology* 25, no. 2 (2000): 50–60.

31. Paul Basu, "A Museum for Sierra Leone? Amateur Enthusiasms and Colonial Museum Policy in British West Africa," in *Curating Empire: Museums and the British Imperial Experience*, ed. Sarah Longair and John McAleer (Manchester: Manchester University Press, 2012), 157.

32. A. E. Afigbo and S. I. O. Okita, *The Museum and Nation Building* (Owerri, Nigeria: New African Publishing, 1985); Claude Daniel Ardouin, "Culture, Museums, and Development in Africa,'" in *The Muse of Modernity: Essays on Culture as Development in Africa*, ed. Philip G. Altbach and Salah Hassan (Trenton, NJ: Africa World Press), 181–208; Flora Edouwaye S. Kaplan, "Nigerian Museums: Envisaging Culture as National Identity," in Kaplan, *Museums and the Making of "Ourselves,"* 45–78; Agbenyega Adedze, "Museums as a Tool for Nationalism in Africa," *Museum Anthropology* 19, no. 2 (1995): 61–62.

33. While some of these concerns are unique to Africa, or to more regional circumstances, some of these questions—particularly those concerned with

decolonizing displays—are similar to the ones museums professionals in the West are grappling with.

34. Claude Daniel Ardouin and Emmanuel Arinze, eds., *Museums and the Community in West Africa* (Washington, DC: Smithsonian Institution Press, 1995); Claude Daniel Ardouin, ed., *Museums and Archeology in West Africa* (Washington, DC: Smithsonian Institution Press, 1997); Claude Daniel Ardouin and Emmanuel Arinze, eds., *Museums and History in West Africa* (Washington, DC: Smithsonian Institution Press, 2000); ICOM, *What Museums for Africa? Heritage in the Future: Benin, Ghana, Togo, November 18–23, 1991, Proceedings of the Encounters* ([Paris?]: International Council of Museums, 1992). Other publications are the result of symposiums or collaborations with European museums. See, for example, Anne Marie Bouttiaux, ed., *Afrique: Musées et patrimoines pour quels publics?* (Paris: Culture Lab Editions, Karthala, 2007).

35. The journals *Museum International* and *Museum Anthropology* have been the most prominent outlets for a slow trickle of articles on these issues. Some examples: Enid Schildkrout, "Museums and Nationalism in Namibia," *Museum Anthropology* 19, no. 21 (1995): 65–77; Arianna Fogelman, "Colonial Legacy in African Museology: The Case of the Ghana National Museum," *Museum Anthropology* 31, no. 1 (2008): 19–27; Adedze, "Museums as a Tool"; Steven Nelson, "Collection and Context in a Cameroonian Village," *Museum International* 59, no. 3 (2007): 22–30. See also Patrick Effiboly, "Les musées béninois d'hier à demain," in *Dieux, rois et peuples du Bénin: Arts anciens du littoral aux savanes*, ed. H. Joubert and C. Vital (Paris: Somogy Editions d'Art, 2008), 126–32.

36. The field is slightly more active for North Africa. See Katarzyna Pieprzak, *Imagined Museums: Art and Modernity in Postcolonial Morocco* (Minneapolis: University of Minnesota Press, 2010).

37. Some short pieces exist on the museum in Lubumbashi: Guy De Plaen, "Le Musée de Lubumbashi: Un musée zaïrois tout à fait particulier," *Museum International* 41, no. 2 (1989): 124–28; Henri Bundjoko Banyata, "Le Musée de Lubumbashi comme lieu de sociabilité et d'élaboration culturelle," in *Tout passe: Instantanés populaires et traces du passé à Lubumbashi*, ed. Danielle de Lame and Donatien Dibwe dia Mwembu, Cahiers Africains 71 (Paris: L'Harmattan, 2005), 301–22; and Maarten Couttenier, "Between Regionalization and Centralization: The Creation of Musée Léopold II in Elisabethville (Musée National de Lubumbashi),Belgian Congo (1931–1961)," *History and Anthropology* 25, no. 1 (2014): 71–101.

38. Ciraj Rassool, "The Rise of Heritage and the Reconstitution of History in South Africa," *Kronos* 26 (August 2000): 1–21.

39. Leslie Witz, *Apartheid's Festival: Contesting South Africa's National Pasts* (Bloomington: Indiana University Press, 2003); Sara Byala, *A Place That Matters Yet: John Gubbins's Museum Africa in the Postcolonial World* (Chicago: University of Chicago Press, 2013); Annie E. Coombes, *History after Apartheid: Visual Culture and Public Memory in a Democratic South Africa* (Durham, NC: Duke University Press, 2003).

40. The work of South African scholar Ciraj Rassool has been particularly important in translating critical knowledge about the past into cultural practices and representations for the present and future. See, for example, Ciraj Rassool, *Recalling Community in Cape Town: Creating and Curating the District Six Museum* (Cape Town: District Six Museum, 2001); Martin Legassick and Ciraj Rassool, *Skeletons in the Cupboard: South African Museums and the Trade in Human Remains, 1907–1917* (Cape Town: South African Museum, 2000), and Ciraj Rassool, "Community Museums, Memory Politics, and Social Transformations in South Africa: Histories, Possibilities, and Limits," in *Museum Frictions: Public Cultures/Global Transformations*, ed. Ivan Karp, Corinne A. Kratz, Lynn Szwaja, and Tomás Ybarra-Frausto (Durham, NC: Duke University Press, 2007).

41. A series of edited books completed under the leadership of Ivan Karp reflects this critical turn of the field. See Ivan Karp and Steven D. Lavine, eds., *Exhibiting Cultures: The Poetics and Politics of Museum Display* (Washington, DC: Smithsonian Institution Press, 1991); Ivan Karp, Christine Mullen Kraemer, and Steven Lavine, eds., *Museums and Communities: The Politics of Public Culture* (Washington, DC: Smithsonian Press, 1992); and Karp et al., *Museum Frictions*.

See also Susan Vogel and Mary Nooter Roberts, eds., *Exhibition-ism: Museums and African Art* (New York: Museum of African Art, 1994).

42. Tony Bennett, *Making Culture, Changing Society* (London: Routledge, 2013), 30, 45.

43. Bruno Latour, *Science in Action* (Cambridge, MA: Harvard University Press, 1987), and *Reassembling the Social: An Introduction to Actor-Network Theory* (Oxford: Oxford University Press, 2005).

44. Bennett, *Making Culture*, 1, 30.

45. Schildkrout and Keim, *Scramble for Art in Central Africa*.

46. Nicholas Thomas, *Entangled Objects: Exchange, Material Culture, and Colonialism in the Pacific* (Cambridge, MA: Harvard University Press, 1991), 176.

47. James Clifford, "Of Other Peoples: Beyond the 'Salvage' Paradigm," in *Discussions in Contemporary Culture*, ed. Hal Foster (New York: New Press, 1987), 123; Ruth Phillips, "Exhibiting Africa after Modernism: Globalization, Pluralism, and the Persistent Paradigms of Art and Artifact," in *Museums after Modernism: Strategies of Engagement*, ed. Griselda Pollock and Joyce Zemans (Oxford: Blackwell, 2007), 80–103.

48. For more on the transformation of ethnographic artifacts into art, see Shelly Errington, *The Death of Authentic Primitive Art and Other Tales of Progress* (Berkeley: University of California Press, 1998); Susan Vogel, ed., *Art/Artifact: African Art in Anthropology Collections* (New York: Center for African Art, 1988); Price, *Primitive Art in Civilized Places*; James Clifford, *The Predicament of Culture: Twentieth-Century Ethnography, Literature and Art* (Cambridge: Harvard University Press, 1988), 189–251.

49. Introduced by Arjun Appadurai to acknowledge the multiple dimensions at work in acts of exchange, the concept *regimes of value* acknowledges

that "the degree of value coherence may be highly variable from situation to situation, and from commodity to commodity." Arjun Appadurai, "Introduction: Commodities and the Politics of Value," in *The Social Life of Things: Commodities in Cultural Perspective*, ed. Appadurai (Cambridge: Cambridge University Press, 1988), 14–15. In *The Empire of Things*, Fred Myers and his coauthors develop the concept further by shifting the emphasis to the "multiple, coexisting and variously related 'regimes of value.'" Fred R. Myers, ed., *The Empire of Things: Regimes of Value and Material Culture* (Santa Fe: School of American Research Press, 2002), 6. The philosophical foundation of these ideas can be traced to Baudrillard's work on object value systems. For an exploration of the use and exchange value of African art, see Bogumil Jewsiewicki, "De l'art africain et de l'esthétique: Valeur d'usage, valeur d'échange," *Cahiers d'Études Africaines* 36, nos. 141–42 (1996): 257–69.

50. This regime of values, of course, tells us little to nothing about the role, meaning, and history of these objects in their societies of origin.

51. William Rubin, ed., *"Primitivism" in 20th Century Art: Affinity of the Tribal and the Modern*, 2 vols. (New York: Museum of Modern Art, 1984); Errington, *Death of Authentic Primitive Art*; Frances Press Connelly, *The Sleep of Reason: Primitivism in Modern European Art and Aesthetics, 1725–1907* (University Park: Pennsylvania State University Press, 1995); Clifford, *Predicament of Culture*.

52. Sidney Littlefield Kasfir, "African Art and Authenticity: A Text with a Shadow." *African Arts* 25, no. 2 (July 1992): 41–53.

53. James Clifford, "Of Other Peoples," 124.

54. Henri Kamer, "The Authenticity of African Sculptures" (1974): 5, http://www.randafricanart.com/Authenticity_of_African_Sculptures_Henri _Kamer.html, accessed 4 July 2013.

55. For more on "the mystique of connoisseurship," see Price, *Primitive Art in Civilized Places*.

56. There is little historical work on the Western market in African art and its collectors and art dealers. Although we have individual stories, there is need for a systematic study of its growth, trends, and so forth. For an introduction and a number of interviews, see Raymond Corbey, *Tribal Art Traffic: A Chronicle of Taste, Trade and Desire in Colonial and Post-colonial Times* (Amsterdam: Royal Tropical Institute, 2000).

57. Clifford, *Predicament of Culture*, 229.

58. Christopher Steiner, *African Art in Transit* (Cambridge: Cambridge University Press, 1994).

59. See chapter 4.

60. The fact that entire regimes of value turn on this concept is demonstrated by the disruptive potential of so-called tourist art, made with the express purpose of being sold to visitors. In the past couple of decades, scholars have demonstrated the constructed and deeply contradictory nature of the categories of "real," "tourist," and "fake" African art. See Paula Ben-Amos, "A

la recherche du temps perdu: On Being an Ebony-Carver in Benin," in *Ethnic and Tourist Arts: Cultural Expressions from the Fourth World*, ed. Nelson H. Graburn (Berkeley: University of California Press, 1976), 320–33; Steiner, *African Art in Transit*; and Bennetta Jules-Rosette, "What Is 'Popular'? The Relationship between Zairian Popular and Tourist Paintings," in *Art pictural zaïrois*, ed. Bogumil Jewsiewicki (Sillery, Québec: Editions du Septentrion, 1992), 41–62.

61. Frederick Cooper, "Possibility and Constraint: African Independence in Historical Perspective," *Journal of African History* 4, no. 2 (2008): 176.

62. On France's invention of the historical category of decolonization, see Todd Sheppard, *The Invention of Decolonization: The Algerian War and the Remaking of France* (Ithaca, NY: Cornell University Press, 2006).

63. John D. Hargreaves, *Prelude to the Partition of West Africa* (London: Macmillan, 1963), 244. Older scholarship depicts decolonization as a political or economic story focused on political leadership and nationalist movements. More recent scholarship has included the role of women, rural populations, youth, and labor movements in the struggles for independence, and it studies the varied meanings accorded to decolonization and sovereignty. See for example the scholarship of James R. Brennan, Elizabeth Schmidt, Jean Allman, and Frederick Cooper.

64. See, for example, Crawford Young, *Politics in the Congo: Decolonization and Independence* (Princeton, NJ: Princeton University Press, 1965); Herbert F. Weiss, *Political Protest in the Congo: The Parti Solidaire Africain during the Independence Struggle* (Princeton, NJ: Princeton University Press, 1967); René Lemarchand, *Political Awakening in the Congo* (Berkeley: University of California Press, 1964); Ilunga Kabongo, "The Catastrophe of Belgian Decolonization," in *Decolonization and African Independence: The Transfers of Power, 1960–1980*, ed. Prosser Gifford and Wm. Roger Louis (New Haven, CT: Yale University Press, 1988), 381–400; Jean Stengers, "La Belgique et le Congo: Politique coloniale et décolonisation," in *Histoire de la Belgique contemporaine, 1914–1970* (Brussels: La Renaissance du Livre, 1975), 391–440; Zana Aziza Etambala, *Congo 55–65: Van Koning Boudewijn tot President Mobutu* (Tielt, Belgium: Lannoo, 1999); Zana Aziza Etambala, *De teloorgang van een modelkolonie: Belgisch Congo, 1958–1960* (Leuven, Belgium: Acco, 2009); and Jean-Luc Vellut, "De dekolonisatie van Kongo 1945–1965," in *Algemeene geschiedenis van de Nederlanden*. Part 15, *De nieuwste tijd*, ed. A. F. Manning, H. Balthazar, and J. De Vries (Haarlem: Fibula-Van Dishoeck, 1982), 401–14. More recent articles, based on the African Studies Association forum on the fiftieth anniversary of Congolese independence, are in *African Studies Review* 55, no. 1 (2012).

65. Not everyone follows this chronology exactly. An exception is Georges Nzongola-Ntalaja, who describes the period of 1963–68 as the "second independence movement": see *The Congo from Leopold to Kabila: A People's History* (London: Zed, 2007). A small body of literature that deals with economic decolonization has also hinted at a different chronology, one that stretches

beyond the country's political independence. Kivulu Sabakinu, "La spécificité de la colonisation et de la décolonisation du Zaïre," in *Belgique/Zaïre: Une histoire en quête d'avenir: Actes des rencontres de Bruxelles, ULB, 7–8–9 octobre 1993*, ed. Gauthier de Villers (Brussels: Institut Africain-CEDAF, 1994), 27–39; J.-P. Peemans, "Imperial Hangovers: Belgium—The Economics of Decolonization," *Journal of Contemporary History* 15, no. 2 (1980): 257–86.

66. I am inclined to side with David Newbury, seeing it as a continuing process even today. David Newbury, "The Continuing Process of Decolonization in the Congo: Fifty Years Later," *African Studies Review* 55, no. 1 (2012): 131–41.

67. Ngũgĩ wa Thiong'o, *Decolonizing the Mind: The Politics of Language in African Literature* (Oxford: James Currey, EAEP, Heinemann 1981), 16.

68. David Lowenthal, *The Heritage Crusade and the Spoils of History* (Cambridge: Cambridge University Press, 1998), 13. See also Barbara Kirshenblatt-Gimblett, *Destination Culture: Tourism, Museums, and Heritage* (Berkeley: University of California Press, 1998), 149–76.

69. Zoe Strother, "Iconoclash: From 'Tradition' to 'Heritage' in Global Africa," *African Arts* 45, no. 3 (2012): 1.

70. Bogumil Jewsiewicki and V. Y. Mudimbe, "Meeting the Challenge of Legitimacy: Post-independence Black Africa and Post-Soviet European States," *Daedalus* 124, no. 3 (1995): 191–207.

71. See John Merryman, ed., *Imperialism, Art and Restitution* (Cambridge: Cambridge University Press, 2010); Moira G. Simpson, *Making Representations: Museums in the Post-colonial Era* (London: Routledge, 1996); Jeanette Greenfield, *The Return of Cultural Treasures* (Cambridge: Cambridge University Press, 1989); as well as the UNESCO journal *Museum* and the *International Journal of Cultural Property*. For the African context, see Peter Schmidt and Roderick MacInctosh, eds., *Plundering Africa's Past* (Bloomington: Indiana University Press, 1996); Ferdinand de Jong and Michael Rowlands, eds., *Reclaiming Heritage: Alternative Imaginaries of Memory in West Africa* (Walnut Creek, CA: Left Coast Press, 2007).

72. Peter Probst, *Osogbo and the Art of Heritage: Monuments, Deities, and Money* (Bloomington: Indiana University Press, 2011). See also the special issue of *African Arts* edited by Probst (45, no. 3, Autumn 2012), and particularly its introduction by Zoe Strother.

73. The interpretation of heritage as cultural patrimony ("national" heritage, or *patrimoine*) emerged in the aftermath of the French Revolution. See Françoise Choay, *The Invention of the Historic Monument* (Cambridge: Cambridge University Press, 2001). For the purposes of this book, heritage in the form of museum collections of art and ethnography is most important. More broadly, however, heritage today also includes intangible forms of "tradition," such as songs, rituals, and celebrations. Regardless of its form, heritage always involves the creation of a usable past that can be passed on.

74. Ana Filipa Vrdoljak, *International Law, Museums and the Return of Cultural Objects* (Cambridge: Cambridge University Press, 2008), 207; Jeanette Greenfield, *The Return of Cultural Treasures*, 259.

75. Barbara Kirshenblatt-Gimblett, "World Heritage and Cultural Economics," in Karp et al., *Museum Frictions*, 161–202.

76. Solidified at the 1972 World Heritage Convention. See Ralph Slatyer, "The Origin and Development of the World Heritage Convention," *Monumentum* 3, no. 16 (1984): 1–8.

77. Michael G. Schatzberg, *Political Legitimacy in Middle Africa: Father, Family, Food* (Bloomington: Indiana University Press, 2001), 135; Kevin C. Dunn, *Imagining the Congo: The International Relations of Identity* (New York: Palgrave Macmillan, 2003), 105–29.

78. V. Y. Mudimbe, *The Idea of Africa* (Bloomington: Indiana University Press, 1994), 148–49.

79. I borrow the expression "looking like a state," which is a play on David Scott's "seeing like a state," from Steven Pierce, who employed it to describe the effects of Nigerian practices of corruption on the state. See Steven Pierce, "Looking Like a State: Colonialism and the Discourse of Corruption in Northern Nigeria," *Comparative Studies in Society and History* 48, no. 4 (2006): 887–912.

80. Ann Laura Stoler, "Colonial Archives and the Arts of Governance," *Archival Science* 2, nos. 1–2 (2002): 87.

CHAPTER 1: THE VALUE OF CULTURE

1. Anonymous, "Bezoekersaantallen," *Congo-Tervuren* 1, no. 2 (1955): 2; no. 3–4 (1956): 5; no. 4 (1960); and population numbers, United Nations Statistics division. The year of the World Exposition in Brussels, 1958, was an exception with only 1.6 percent.

2. Literally, *mise en valeur* translates as "valorization." It refers to the exploitation and development of the colony's economic resources, officially so that the colonizer could recuperate its investment in the colonial project. Although art objects became associated with the *mise en valeur* of the colony, I do not want to suggest that they reached the same economic status as for example the mining resources of the country did.

3. Jean-Luc Vellut, "La violence armée dans l'État Indépendant du Congo," *Cultures et Développement* 1, nos. 3 and 4 (1984): 671–707.

4. Other land grants went to Congo Railway Company and the Union Minière du Haut Katanga, which obtained the mining rights in the Katanga region in 1906. Jean Stengers and Jan Vansina, "King Leopold's Congo, 1886–1908," in *The Cambridge History of Africa*, vol. 6, *From 1870 to 1905*, ed. Roland Oliver and G. N. Sanderson (Cambridge: Cambridge University Press, 1985), 337–45.

5. Jean Stengers, "King Leopold's Imperialism," in *Studies in the Theory of Imperialism*, ed. R. Owen and B. Sutcliffe (London: Longman, 1972), 248–76; Daniel Vangroenweghe, *Rood Rubber: Leopold II en Zijn Kongo* (Brussels: Elsevier, 1985).

6. For a discussion of local Belgian colonial expositions, see Matthew G. Stanard, *Selling the Congo: A History of European Pro-Empire Propaganda*

and the Making of Belgian Imperialism (Lincoln: University of Nebraska Press, 2012), 27–88.

7. For more on the 1897 exhibition, see Maurits Wynants, *Van hertogen en Kongolezen: Tervuren en de koloniale tentoonstelling 1897* (Tervuren: KMMA, 1997).

8. For more on the *cité coloniale*, see Lieven De Cauter, Lode de Clercq, and Bruno de Meulder, "Van 'Exposition Coloniale' naar 'Cité Coloniale': Tervuren als Koloniale Site," in *Het museum van de natie: Van kolonialisme tot globalisering*, ed. Herman Asselberghs and Dieter Lesage (Brussels: Gevaert, 1999), 45–71.

9. Sabine Cornelis, "Le Musée du Congo belge, vitrine de l'action coloniale (1910–1930)," in *Du musée colonial au musée des cultures du monde*, ed. Dominique Taffin (Paris: Maisonneuve et Larose, 2000), 72.

10. Marcel Luwel, "Van onafhankelijk Congo tot Belgisch Congo," *Congo-Tervuren* 5, no. 1 (1959): 6.

11. Alice L. Conklin, "Civil Society, Science, and Empire in Late Republican France: The Foundation of Paris's Museum of Man," *Osiris*, 2nd ser., 17 (2002): 255–90; Annie E. Coombes, *Reinventing Africa: Museums, Material Culture and Popular Imagination in Late Victorian and Edwardian England* (New Haven, CT: Yale University Press, 1994); H. Glenn Penny, *Objects of Culture: Ethnology and Ethnographic Museums in Imperial Germany* (Chapel Hill: University of North Carolina Press, 2002); Nélia Dias, *Le Musée d'Ethnographie du Trocadéro (1878–1908): Anthropologie et muséologie en France* (Paris: Editions CNRS, 1991); Robert Aldrich, *Vestiges of the Colonial Empire in France: Monuments, Museums and Colonial Memories* (New York: Palgrave Macmillan, 2005), 196–290.

12. Adam Hochschild's popular book brought the history of the rubber exploitation to a broader audience. Adam Hochschild, *King Leopold's Ghost: A Story of Greed, Terror and Heroism in Colonial Africa* (Boston: Houghton Miffin, 1998). Some Belgian scholars objected to his description of the events as a genocide and have disputed the number of deaths. See for example, Jean Stengers, *Congo: Mythes et réalités* (Brussels: Éditions Racine, 1989). Aldwin Roes has traced the debate, pointing out the need for "a more precise geography of the impact of the impact and experience" instead of a "sterile polemic about aggregated numbers." Aldwin Roes, "Towards a History of Mass Violence in the Etat Indépendant du Congo, 1885–1908," *South African Historical Journal* 62, no. 4 (2010): 634–70. On the Belgian debate surrounding the transfer of the colony to the Belgian state, see Vincent Viaene, "Reprise-Remise: De Congolese identiteitscrisis van België rond 1908," in *Congo in België: Koloniale cultuur in de metropool*, ed. Vincent Viaene, David Van Reybrouck, and Bambi Ceuppens (Leuven: Universitaire Pers Leuven, 2009), 43–62.

13. For the early history of the museum, see Maarten Couttenier, *Congo tentoongesteld: Een geschiedenis van de Belgische antropologie en het museum van Tervuren (1882–1925)* (Leuven: Acco, 2005); Cornelis, "Le Musée

du Congo Belge," 71–85; Dirk Thys Van Den Audenaerde, "Het Africa Museum te Tervuren: Een Historisch Overzicht," in Van Den Audenaerde, *Africa Museum Tervuren* (Tervuren: KMMA, 1998), 13–24; Marcel Luwel, "Histoire du Musée Royal du Congo Belge à Tervuren," *Belgique d'Outremer* 14, no. 289 (April 1959): 209–12; Marcel Luwel, "Histoire du Musée Royal du Congo Belge à Tervuren," *Congo-Tervuren* 6, no. 2 (1960): 30–49. For a broader approach to the story of the museum, see the essays collected in Asselberghs and Lesage, *Het museum van de natie.*

14. Jean Stengers, "La Belgique et le Congo: Politique coloniale et décolonisation," in *Histoire de la Belgique contemporaine, 1914–1970*, ed. John Bartier et al. (Brussels: La Renaissance du Livre, 1975), 392.

15. Bogumil Jewsiewicki, Yvette Brett, and Andrew Roberts, "Belgian Africa," in *The Cambridge History of Africa*, vol. 7, *From 1905 to 1940*, ed. A. D. Roberts (Cambridge: Cambridge University Press, 1986), 460–93.

16. Réne Devisch, "Colonial State Building in the Congo, and Its Dismantling," *Journal of Legal Pluralism* 30, no. 42 (1998): 224. For an account of the impact of the medicalization of the Congolese body by the colonial state, see Nancy Rose Hunt, *A Colonial Lexicon of Birth Ritual, Medicalization, and Mobility in the Congo* (Durham, NC: Duke University Press, 1999).

17. Jean-Luc Vellut, "De dekolonisatie van Kongo, 1945–1965," in *Algemeene geschiedenis van de Nederlanden*, Part 15: *De nieuwste tijd*, ed. A. F. Manning, H. Balthazar, and J. De Vries (Haarlem: Fibula–Van Dishoeck, 1982), 404–6.

18. For a comparison of colonial regimes, see Crawford Young, *The African Colonial State in Comparative Perspective* (New Haven, CT: Yale University Press, 1994).

19. The *évolués* were a Westernized Congolese elite social class. A minority, many of them had civil service jobs and were seen as the result of the civilization mission, having adapted their lifestyles and cultural customs to Western culture. From 1948 on, the status of évolué could be confirmed by obtaining a "social merit card," awarded upon demonstrating a sufficiently "evolved" and "civilized" lifestyle. Although they occupied an elevated social position with regard to the rest of the Congolese population, they did not possess any political rights in the colonial system and continued to be subject to (unofficial) systems of segregation. Several évolués occupied positions of leadership in the struggle for independence. Georges Nzongola-Ntalaja, *The Congo from Leopold to Kabila: A People's History* (London: Zed, 2002), 41.

20. Vellut, "De dekolonisatie van Kongo," 401–14; Mathieu Zana Aziza Etambala, *De teloorgang van een modelkolonie: Belgisch Congo, 1958–1960* (Leuven, Belgium: Acco, 2008), 17–49; and Stengers, "La Belgique et le Congo," 415–19.

21. Bogumil Jewsiewicki, "African Peasants in the Totalitarian Colonial Society of the Belgian Congo," in *Peasants in Africa: Historical and Contemporary Perspectives*, ed. Martin A. Klein (Beverly Hills: Sage, 1980), 45–75; Bogumil Jewsiewicki, "Rural Society and the Belgian Colonial Economy,"

in *History of Central Africa*, ed. David Birmingham and Phyllis M. Martin (London: Longman: 1983), 2:95–125.

22. On the *mise en valeur* of the French colonies, and the relationship of *mise en valeur* to the civilizing mission, see Alice L. Conklin, *A Mission to Civilize: The Republican Idea of Empire in France and West Africa, 1895–1930* (Stanford: Stanford University Press, 1997).

23. Susan Stewart, "Death and Life, in That Order, in the Works of Charles Willson Peale," in *Cultures of Collecting*, ed. John Elsner and Roger Cardinal (London: Reaktion, 1994), 204.

24. Anthony Alan Shelton, "The Collector's Zeal: Towards an Anthropology of Intentionality, Instrumentality and Desire," in *Colonial Collections Revisited*, ed. Pieter ter Keurs (Leiden: CNWS, 2007), 37.

25. Pieter ter Keurs, "Theory and Practice of Colonial Collecting," in ter Keurs, *Colonial Collections Revisited*, 5.

26. The remaining 15 percent are objects from different African regions, largely obtained after independence in an attempt to diversify the collection. Hein Vanhee, "Niet-Europese collecties," in *Over collecties 2*, ed. Annick Hus, An Seurich, and Alexander Vander Stichele (Brussels: Agentschap Kunsten en Erfgoed, 2012), 143; and Anne-Marie Bouttiaux, "De ethnografische collecties van het Afrika Museum," in Van Den Audenaerde, *Africa Museum Tervuren*, 54.

27. An ongoing process of digitization and completion of the museum catalog should make a more exact study of the origins of the ethnographic collection possible in the near future. Personal correspondence Hein Vanhee, 8 May 2014. For more on the development of the new database, see Seth van Hooland and Hein Vanhee, "Van steekkaart tot webinterface: De Evolutie van metadatabeheer binnen de erfgoedsector," in *Erfgoed 2.0 Nieuwe Perspectieven*, ed. Bart de Hil and Jeroen Walterus (Brussels: Pharo, 2009), 87–105. Former museum collaborator Boris Wastiau discussed the origins of the collections in more general terms in *Exit Congo Museum* (Tervuren: RMCA, 2000) and *Congo-Tervuren, Aller-Retour* (Tervuren: RMCA, 2001). The subject is also briefly touched upon in Patricia Van Schuylenbergh, "Découverte et vie des arts plastiques du Congo dans la Belgique des années 1920–1930," in *Rencontres artistiques Belgique-Congo, 1920–1950*, ed. Patricia Van Schuylenbergh and Françoise Morimont (Louvain-la-Neuve, Belgium: Centre d'Histoire de L'Afrique, 1995), 1–64: and Anne Leurquin, *Utotombo: Kunst uit zwart Afrika in privé-bezit* (Brussels: Vereniging voor Tentoonstellingen van het Paleis der Schone Kunsten, 1988).

28. This analysis is based upon the information available in the museum's card and digital catalogs. (RMCA, Dept. of Culture and Society, card and digital object catalogs.) The 1995 exhibition was initially intended to be a "hidden treasures" exhibition, composed of exceptional objects hidden away in the storerooms. The final product however, included objects that were part of the permanent displays. Gustaaf Verswijver, Els De Palmenaer, Viviane Baeke, and Anne-Marie Bouttiaux-Ndiaye, eds., *Schatten uit het Afrika-Museum, Tervuren* (Tervuren: KMMA, 1995).

29. Another sixteen were the result of a trade of objects with the Royal Museums of Art and History and three were deposited at the museum (which implies free use but not ownership). If an object was bought, it does not necessarily mean that the market value was paid. Sometimes the sum was symbolic, or some objects of a larger collection were paid for, while the rest was received as a gift.

30. The 1910s and 1950s are exceptions, with thirty-two and thirty-eight objects registered, respectively. These aberrations track to the opening of the museum building in 1910 and the 1958 world exhibition in Brussels, both of which caused an influx of donations.

Many of the objects have only incomplete information. In numerous cases, for example, the description only mentions when the object was registered at the museum. The analysis was complicated by the fact that sometimes object descriptions have vague or broad time frames connected to them. The classifications according to time of collection or registration are not representative of the museum's ethnographic collection as a whole, as this set is skewed toward objects collected at an earlier date that are more likely considered to be "authentic" and thus more likely to be regarded as "treasures."

31. Couttenier, *Congo tentoongesteld*, 67.

32. Ibid., 75; Wastiau, *Congo-Tervuren, Aller-Retour*, 6. The agents of the Congo Free State were not only tasked with collecting for Belgium, they also gathered more than 3,500 for the American Museum of Natural History in New York. Enid Schildkrout and Curtis A. Keim, "Objects and Agendas: Re-collecting the Congo," in *The Scramble for Art in Central Africa*, ed. Enid Schildkrout and Curtis A. Keim (Cambridge: Cambridge University Press, 1998), 22.

33. On the relation between expedition, travel, and occupation in the exploration of Central Africa, see also Johannes Fabian, *Out of Our Minds: Reason and Madness in the Exploration of Central Africa* (Berkeley: University of California Press, 2000).

34. Allen F. Roberts, *A Dance of Assassins: Performing Early Colonial Hegemony in the Congo* (Bloomington: Indiana University Press, 2013).

35. Roberts, *Dance of Assassins*, 159.

36. Couttenier, *Congo tentoongesteld*, 174–75.

37. Its presence steadily grew in Belgian academia under the banner of "colonial sciences," which included a variety of disciplines, such as geography, history, economy, and agricultural sciences. For more on the invention of colonial sciences in Belgium, see Marc Poncelet, *L'invention des sciences coloniales belges* (Paris: Karthala, 2008).

38. The presence of Belgians in the colony grew exponentially, from 430 in 1890 to 25,679 in 1940, and roughly quadrupling between 1940 and 1958. Isidore Ndaywel è Nziem, *Nouvelle histoire du Congo: Des origines à la République Démocratique* (Kinshasa: Afrique Éditions; Brussels: Le Cri, 2008), 361.

39. Schildkrout and Keim, "Objects and Agendas," 21.

40. Walter Benjamin, *The Arcades Project* (Cambridge: Belknap Press of Harvard University Press, 1999), 205.

41. Although Leopold II encouraged Belgian Catholic missionaries to take the lead in the "civilizational" process in Congo, American and British Protestants were also present in the region. By 1908 the Catholics had 52 mission stations and 670 posts in the country, versus 40 Protestant stations. Stengers and Vansina, "King Leopold's Congo," 346.

42. Wastiau, *Congo-Tervuren, Aller-Retour*, 7.

43. Leo Bittremieux, letter of 27 August 1909, quoted in Luc Vandeweyer, "Missionary-Ethnographer," in *Mayombe: Ritual Sculptures from the Congo*, ed. Jo Tollebeek (Tielt, Belgium: Lannoo, 2010), 39. The objects are still in the possession of the university.

44. For the postcolonial controversy on the Kangu museum collection, see chapter 4.

45. For more on *minkisi*, see Wyatt MacGaffey, "Complexity, Astonishment and Power: The Visual Vocabulary of Kongo *Minkisi*," *Journal of Southern African Studies* 14, no. 2 (1988): 188–203, and "The Eyes of Understanding: Kongo *Minkisi*," in *Astonishment and Power*, ed. Wyatt Macgaffey and Michael Harris (Washington, DC: Smithsonian Institution Press, 1993), 21–103.

46. Hein Vanhee, "Agents of Order and Disorder: Kongo Minkisi," in *Re-Visions: New Perspectives on the African Collections of the Horniman Museum*, ed. Karel Arnaut (London: Horniman Museum & Garden, 2001), 91–92, 101–2.

47. This was the case across the African continent. See, for example, Patrick Harries, *Butterflies and Barbarians: Swiss Missionaries and Systems of Knowledge in South-East Africa* (Athens: Ohio University Press, 2007); John M. Cinnamon, "Missionary Expertise, Social Science, and the Uses of Ethnographic Knowledge in Colonial Gabon," *History in Africa* 33 (2006): 413–32. For Congo, see David Maxwell, "The Soul of the Luba: W.F.P Burton, Missionary Ethnography and Belgian Colonial Science," *History and Anthropology* 19, no. 4 (2008): 325–51; John M. Janzen, "Laman's Congo Ethnography: Observations on Sources, Methodology, and Theory," *Africa* 42, no. 4 (1972): 316–28; Vandeweyer, "Missionary-Ethnographer, 36–43.

48. Wastiau, *Exit Congo Museum*, 21–22.

49. Johan Lagae, " 'Het echte belang van de kolonisatie valt samen met dat van de wetenschap': Over kennisproductie en de rol van wetenschap in de Belgische colonial context," in *Het geheugen van Congo: De koloniale tijd*, ed. Jean-Luc Vellut (Tervuren: Snoeck-KMMA, 2005), 131–38.

50. Johannes Fabian, "Curios and Curiosities," in Schildkrout and Keim, *Scramble for African Art*, 79–100.

51. Annie Coombes detected a similar competition with a nationalist edge in the collecting of Benin bronzes around the turn of the century. Coombes, *Reinventing Africa*, 60.

52. Couttenier, *Congo tentoongesteld*, 274.

53. RMCA, Dept. of Culture and Society, Ethnographic Files, Carnet Maesen (35) 1953. Julien Volper, *La part indomptée: Les masques d'homme-fauve des Luba* (Liège: Antroposys, 2009), 9.

54. Interview Marc Leo Felix, 3 September 2012, Watermaal.

55. Patricia Van Schuylenbergh, "Découverte et vie des arts," and Anne Leurquin, "De verspreiding van het Afrikaanse Object." in *Utotombo: Kunst uit zwart Afrika in privé-bezit,* ed. Anne Leurquin (Brussels: Vereniging voor Tentoonstellingen van het Paleis der Schone Kunsten, 1988).

56. Raymond Corbey, *Tribal Art Traffic: A Chronicle of Taste, Trade and Desire in Colonial and Post-colonial Times* (Amsterdam: Royal Tropical Institute, 2000), 37–53.

57. RMCA, Dept. of Culture and Society, "Verslag over de werkzaamheden van de afdeling voor volkenkunde over het jaar 1956," Boek Etnografie 1956. In order to finance this increased buying aganda, Olbrechts created the Vrienden van het Museum (Friends of the Museum) organization in 1951, after the example of American museums. The Friends of the Museum raised money and helped the museum acquire choice pieces.

58. Corbey, *Tribal Art Traffic,* 37–54, 99–105.

59. On salvage anthropology, see James Clifford, "On Ethnographic Allegory," in *Writing Culture: Poetics and Politics of Ethnography,* ed. James Clifford and George E. Marcus (Berkeley: University of California Press, 1986), 98–121.

60. The idealization of "pure" and "traditional" cultures, untouched by the West, was partially a product of the idealization of traditional and rural cultures so pervasive in Western intellectual and cultural traditions. Bambi Ceuppens references this idealization of the rural and unspoiled Congolese subject in her argument about the deep disconnect between Congolese subjects and Belgian administrators, colonials, and missionaries. See Bambi Ceuppens, *Congo Made in Flanders? Koloniale Vlaamse visies op "blank" en "zwart" in Belgisch Congo* (Ghent: Academia Press, 2003), 298, 345.

61. Sharon Macdonald, "Theorizing Museums: An Introduction," *Theorizing Museums: Representing Identity and Diversity in a Changing World,* ed. Sharon Macdonald and Gordon Fyfe (Oxford: Blackwell, 2006), 4.

62. This is not to say that the removal and recontextualization of objects did not occur in and among African societies; it did.

63. Couttenier, *Congo tentoongesteld.* However, physical anthropology did not disappear from the scene completely. See also Daniel P. Biebuyck, "Olbrechts en de dageraad van de professionele antropologie in België," in *Frans M. Olbrechts, 1899–1958: Op zoek naar kunst in Afrika,* ed. Constantine Petridis (Antwerp: Etnografisch Museum van Antwerpen, 2001), 109.

64. Couttenier, *Congo tentoongesteld,* 149–51.

65. Congolese men and women were brought to Belgium to populate this village. A number of them succumbed to health problems in Belgium's chilly climate and were buried in Tervuren. Not until 1947 were their graves moved from nonsacred ground to the traditional cemetery. See Maarten Couttenier, *Als muren spreken: Het museum van Tervuren, 1910–2010* (Tervuren: KMMA, 2010), 152–53; and Filip De Boeck, "Beyond the Grave: History, Memory and Death in Postcolonial Congo/Zaïre," in *Memory and the Postcolony: African Anthropology and the Critique of Power,* ed. Richard Werbner (London: Zed, 1998), 21–58.

66. Anne-Marie Bouttiaux, "Des mises en scène de curiosités aux chefs-d'oeuvre mis en scène: Le Musée Royal de l'Afrique à Tervuren: Un siècle de collections," *Cahiers d'Études Africaines* 39, nos. 155/156 (1999): 597–600; Cornelis, "Le Musée du Congo Belge."

67. Couttenier, *Congo tentoongesteld*, 297. The belief in an Egyptian origin of sub-Saharan African art was not uncommon in the late nineteenth and early twentieth centuries. Coombes has shown a similar response emerging in Britain in relation to the influx of Benin bronzes into the British museums after the British Punitive Expedition of 1897. See Coombes, *Reinventing Africa*, 7–28.

68. Couttenier, *Congo tentoongesteld*, 305–6.

69. A. de Hauleville and J. Maes, quoted in Cornelis, "Musée du Congo belge," 75.

70. The room was referred to by different names. On the postcard (figure 1.5) the Flemish name *Inlandsche Kunst* can be translated as "indigenous art" or "native art," while the French name, *Salle d'Art Nègre*, means "Hall of Negro Art." In the 1936 museum guide, both names are used.

71. Schouteden, *Geïllustreerde gids van het museum van Belgisch Congo*, 2nd ed. (Tervuren: Museum van Belgisch Congo, 1936, 1946), 44. The museum published guidebooks in 1910, 1925, and 1936. The 1936 version was reproduced until 1948. RMCA, Dept. of History and Politics, Museum Archive, Ellen Van Impe, "De Inrichting van de Publieke Zalen vanaf 1910," unpublished document (2002), page 2, box "opstel zalen."

72. David A. Binkley and Patricia J. Darish, "'Enlightened but in Darkness': Interpretations of Kuba Art and Culture at the Turn of the Twentieth Century," in *The Scramble for Art in Central Africa*, ed. Enid Schildkrout and Curtis A. Keim (Cambridge: Cambridge University Press, 1998). Mangbetu objects were among the other traditions that made the transition to art earlier, although they are not mentioned in the 1936 description of the Indigenous Art room. Curtis A. Keim, "Artes Africanae: The Western Discovery of 'Art' in Northeastern Congo," in Schildkrout and Keim, *Scramble for Art in Africa*, 109–32.

73. Although Olbrechts participated in Melville Herskovits's course on Africa, he oriented his own research at Columbia toward Boas's study of Native American cultures. Mireille Holsbeke, "In de Groote Wazige Bergen bij een Indianenstam: De Jonge Olbrechts in Amerika," in *Frans M. Olbrechts*, 62–83. For more detail on the influence of Boas on Olbrechts, see Sarah Van Beurden, "The Value of Culture: Congolese Art and the Promotion of Belgian Colonialism (1945–1959)," *History and Anthropology* 24, no. 4 (December 2013): 472–92.

74. Adriaan Claerhout, "De Antwerpse Kongo-Kunst Tentoonstelling," *Congo-Tervuren* 4, no. 4 (1958): 72.

75. Ibid, 73.

76. Constantine Petridis, "Kongo-Kunst in Antwerpen," in Petridis, *Frans M. Olbrechts*, 176–77. During the 1930s, Olbrechts also made his first trips

to the African continent. The first was in the company of botanist Houzeau de Lehaie to French West Africa in 1933 and the second, in 1938–39, to the Ivory Coast, was envisioned as a field test for the Boasian style method he had developed for the Antwerp exhibition.

77. Although the work was finished in 1939, publication was delayed by World War II until 1946. Unfortunately, *Plastiek van Kongo* was not readily available in French until 1959 and in English until 1982. (A 1966 English translation only had a limited availability.) Translator's foreword, in Franz M. Olbrechts, *Congolese Sculpture* (New Haven, CT: Human Relations Area Files, Inc., 1982), v–vi.

78. Differences between the 1937 exhibition and *Congolese Sculpture* are a more elaborate subdivision of the regions and the development of the Northwest as a separate area (Petridis, "Kongo-Kunst in Antwerpen," 178–79).

79. For example, the Songye and Chokwe styles, classified under Luba by Olbrechts, have developed into their own branches. For a more detailed description of post-Olbrechts scholarship, see Petridis, "Kongo-Kunst in Antwerpen," 180–87.

80. Ruth B. Phillips, "Fielding Culture: Dialogues between Art History and Anthropology," *Museum Anthropology* 18, no. 1 (1994): 41; Petridis, "De Morfologische Benadering," 125–27; and Biebuyck, "African Art Studies since 1957: Achievements and Directions," *African Studies Review* 26, nos. 3 and 4 (1983): 102.

81. "Langgezichtstijl van Buli," Olbrechts, *Plastiek van Kongo* (Antwerp: Uitgeverij Standaard, 1946), 64–70. The style soon became personified as the "Master of Buli," despite doubts by subsequent scholars that the sculptures can be attributed to one person rather than, as Olbrechts initially suggested, a workshop. François Neyt, Bernard de Grunner, and Louis de Strycker have speculated that the sculptures can be attributed to the village of Kateba, of the Hemba, a subgroup or neighboring community of the Luba (Petridis, Cat. 1: "Kunst Van Kongo," in *Frans M. Olbrechts*, cat. 51). Consequently, the "Master of Buli" is now also referred to as the "Master of Kateba."

82. Daniel Crowley, "Stylistic Analysis of African Art: A Reassessment of Olbrechts' 'Belgian Method,'" *African Arts* 9, no. 2 (January 1976): 49.

83. Ibid.

84. Frans M. Olbrechts, "Westerse invloed op de inheemse kunst in Afrika?" in *Voordrachten Koninklijke Musea voor Schone Kunsten van België 1940–1941* (Brussels: KMSK, 1942), 4–24.

85. Ibid., 24.

86. Sidney Kasfir condemned this tendency to conflate ethnic identity with artistic style (the "one tribe-one style model," as she calls it) so prevalent in African art history, although she places the blame squarely on anthropology and its concept of "tribe," which in turn was a product of colonial rule. Sidney Littlefield Kasfir, "One Tribe, One Style? Paradigms in the Historiography of African Art," *History in Africa* 11 (1984): 163–93. See also Eric Hobsbawm and Terence Ranger, eds., *The Invention of Tradition* (Cambridge: Cambridge

University Press, 1983); Anderson, *Imagined Communities: Reflections on the Origin and Spread of Nationalism* (New York: Verso, 1991); and Leroy Vail, ed., *The Creation of Tribalism in Southern Africa* (Berkeley: University of California Press, 1991).

87. Joseph Maes had denied Olbrechts access to the Tervuren collections previous to Olbrechts's employement there, partly due to the animosity between both men. Claerhout, "De Antwerpse Kongo-Kunst," 72.

88. Ceuppens, *Congo Made in Flanders?*, 169.

89. James Clifford, *The Predicament of Culture: Twentieth-Century Ethnography, Literature, and Art* (Cambridge, MA: Harvard University Press, 1988), 5.

90. An updated series of guidebooks published in 1967 did include ethnography.

91. *Congo-Tervuren* 6, no. 2 (1960): 70.

92. Personal communication with Maarten Couttenier, 23 June 2008.

93. *Congo-Tervuren* 6, no. 2 (1960): 70.

94. RMCA, Dept. of History and Politics, Annual Reports,: *Jaarverslag Ethnografie*, 1948, 5.

95. Frans M. Olbrechts, *Quelques chefs-d'oeuvre de l'art africain des collections du Musée Royal du Congo Belge, Tervuren* (Tervuren: Royal Museum of Belgian Congo, 1952).

96. Clifford, *Predicament of Culture*, 222–29.

97. "Very often what is shown is the collections itself." Barbara Kirchenblatt-Gimblett, *Destination Culture: Tourism, Museums, and Heritage* (Berkeley: University of California Press, 1998), 20.

98. Arjun Appadurai, "Introduction: Commodities and the Politics of Value," in *The Social Life of Things: Commodities in Cultural Perspective*, ed. Appadurai (Cambridge: Cambridge University Press. 1988), 28.

99. Sally Price, *Primitive Art in Civilized Places* (Chicago: University of Chicago Press, 1989), 56.

100. The 1963 picture was taken to document the displays before they were modernized. Since no large changes in the room were reported between 1958 and 1963, we can assume we have a fairly accurate image of how the Congo art room looked in the late 1950s.

101. Art rooms comparable to this one appeared in French ethnographic museums as early as the 1930s. The country had a much stronger Primitivist movement in modern art than Belgium did, which contributed considerably to the greater push for the aesthetization of African object displays in a museum setting. For France, see Alice L. Conklin, *In the Museum of Man: Race, Anthropology, and Empire in France, 1850–1950* (Ithaca, NY: Cornell University Press, 2013), and Daniel J. Sherman, *French Primitivism and the Ends of Empire, 1945–1975* (Chicago: University of Chicago Press, 2011), 21–32.

102. Bambi Ceuppens argued that even among former colonials, knowledge about Congolese cultures, and especially their diversity, was surprisingly limited. Ceuppens, *Congo Made in Flanders?*, 431–69.

103. Price, *Primitive Objects in Civilized Places*, 84.

104. Shelly Errington, *The Death of Authentic Primitive Art and Other Tales of Progress* (Berkeley: University of California Press, 1998), 113.

105. Clifford, *Predicament of Culture*, 215. For more on the creation of modernist "authenticity," see John Warne Monroe, "Surface Tensions: Empire, Parisian Modernism and 'Authenticity' in African Sculpture, 1917–1939," *American Historical Review* 117, no. 2 (April 2012): 445–75.

106. Price, *Primitive Art in Civilized Places*, 25. See also Fred R. Myers, "Introduction: the Empire of Things," in *The Empire of Things: Regimes of Value and Material Culture*, ed. Myers (Santa Fe: School of American Research Press, 2001), 35.

107. Patricia Morton, *Hybrid Modernities: Architecture and Representation at the 1931 Colonial Exposition, Paris* (Cambridge, Massachusetts, MIT Press, 2000), and Sherman, *French Primitivism*, 15–16.

108. On colonial humanism, see Gary Wilder, *The French Imperial Nation-State: Negritude and Colonial Humanism between the Two World Wars* (Chicago: University of Chicago Press, 2005).

109. Tony Bennett, *Birth of the Museum: History, Theory and Politics* (New York: Routledge, 1995), 179.

110. Ibid.

111. Barbara Saunders, "Congo-Vision," in *Science, Magic and Religion: The Ritual Process of Museum Magic*, ed. Mary Bouquet and Nuno Porto (New York: Berghahn, 2004), 75–94; Mary Jo Arnoldi, "De Sculpturale Versiering in de Rotonde van het Koninklijk Museum voor Midden-Afrika," in Vellut, *Het geheugen van Congo*, 180–84, and Arnoldi, "Koloniale kunst: De Belgische beeldhouwers in Congo (1911–1960)," in *Le Congo et l'art belge*, ed. Jacqueline Guisset (Tournai: La Renaissance du Livre, 2003), 226–29.

112. This discussion is based mostly upon a guidebook produced in 1959. The arrangement of the room, with the separation between prehistory and anthropology, dates from some time in 1958. It is unclear what exactly the room looked like before 1958, although the few photos available suggest the prehistory displays remained mostly the same. Maarten Couttenier, "Fysieke antropologie in België en Congo, 1883–1964: Levende tentoonstellingsobjecten," in *De exotische mens: Andere culturen als amusement*, ed. Bert Sliggers and Patrick Allegaert, (Tielt: Lannoo, 2009), 110.

113. This was similar to the displays in the Musée de l'Homme. Conklin, *In the Museum of Man*.

114. Couttenier, "Fysieke antropologie," 108–9; Arnoldi, "Koloniale kunst." Similar sculptures made by Malvina Hoffman for the "Races of Mankind" exhibition at the Field Museum in Chicago were removed by the 1960s. Tracy Lang Teslow, "Representing Race: Artistic and Scientific Realism," *Science as Culture* 5, no. 1 (1995): 12–38.

115. Phillippe Marechal, "De Afdeling Geschiedenis van de Belgische Aanwezigheid Overzee," in Van Den Audenaerde, *Africa Museum Tervuren*, 239–44; interview Phillippe Marechal, October 2005, Tervuren.

116. RMCA, Dept. of History and Politics, Annual Reports: *Geschiedenis*, 1959.

117. The closing was not related to the violence.

118. Herman Lebovics describes a similar evolution in France. See Herman Lebovics, *Bringing the Empire Back Home: France in the Global Age* (Durham, NC: Duke University Press, 2004).

119. Stanard, *Selling the Congo*, 110.

CHAPTER 2: GUARDIANS OF HERITAGE

1. Jean Vanden Bossche, "Le Musée de la Vie Indigène, Léopoldville, Congo Belge," *Museum* 8, no. 2 (1955): 84.

2. I derive "civilizing ritual" from the combination of Sally Price's *Primitive Art in Civilized Places* (Chicago: University of Chicago Press, 1989) and Carol Duncan's view on (art) museum visits as "rituals of citizenship." Carol Duncan, *Civilizing Rituals: Inside Public Art Museums* (London: Routledge, 1995), and Carol Duncan, "Art Museums and the Ritual of Citizenship" in *Exhibiting Cultures: The Poetics and Politics of Museum Display*, ed. Ivan Karp and Steven Levine (Washington, DC: Smithsonian Institution Press), 88–103.

3. Pierre Bourdieu, "The Historical Genesis of a Pure Aesthetic," *Journal of Aesthetics and Art Criticism* 46 (1987): 201–10.

4. "Cultural politics" refers to all activities and debates surrounding the organization, regulation and steering of cultural activities. The cultural politics in this chapter all revolve around Congolese "traditional" art and crafts.

5. It is not my intention to give an exhaustive overview of all museum and artisanal initiatives in the colony but to address more specific questions.

The scholarship on colonial cultural politics with regard to art in Congo is limited, although a recent surge in interest is promising. Sabine Cornelis has devoted attention to the history of art academies in the colony (see, for example, Sabine Cornelis, "Birth of Academicism," in *Anthology of African Art: The Twentieth Century*, ed. N'Goné Fall and Jean Loup Pivin (New York: Distributed Art Publishers, 2002), 165–66. For the newer work, see Elisabeth L. Cameron, "Coming to Terms with Heritage: Kuba Ndop and the Art School of Nsheng," *African Arts* 45, no. 3 (Autumn 2012): 28–41; Maarten Couttenier, "Between Regionalization and Centralization: The Creation of Musée Léopold II in Elisabethville (Musée National de Lubumbashi), Belgian Congo (1931–1961)," *History and Anthropology* 25, no. 1 (2014): 72–101. On the Kuba, see also Jan Vansina, "La survie du royaume Kuba à l'époque coloniale et les arts," *Annales Aequatoria* 28 (2007): 5–29. On missionary cultural politics, see Françoise Morimont, "L'Africanisation de l'art Chrétien du Congo Belge, 1919–1950," *Enquêtes et Documents d'Histoire Africaine* 12 (1995): 63–110.

6. Ruth B. Phillips and Christopher B. Steiner, eds., *Unpacking Culture: Art and Commodity on Colonial and Postcolonial Worlds* (Berkeley: University of California Press, 1999), 3–4.

7. Fred R. Myers, ed., *The Empire of Things: Regimes of Value and Material Culture* (Santa Fe: School of American Research Press, 2001), 34.

8. Phillips and Steiner, "Art, Authenticity and the Baggage of Cultural Encounter," in *Unpacking Culture*, 15.

9. AA BuZa, COPAMI Files, "Koninklijk Arrest, 23 Januari 1935," Porte-feuille 4787, lias 1/1.

10. Gaston-Denys Périer, *Les arts populaires du Congo Belge* (Brussels: Office de Publicité, Collection Nationale, 8th ser.), 5.

11. Gaston-Denys Périer, *La colonisation pittoresque* (Brussels: L'Edition, 1930,) 5. For more on his career at the Ministry of Colonies, see his memoires: Gaston-Denys Périer, *Les flèches du Congophile: Mémoires d'un employé au Ministère.* (Brussels: Editions L'Afrique et le Monde, 1957). He unleashed a veritable avalanche of publications on the topic of Congolese art in both colonial and metropolitan journals (twenty-five between 1922 and 1930). AA BuZA, COPAMI, "Articles et études de Gaston-Denys Périer sur l'art nègre du Congo Belge," n.d., Portefeuille 4796.

12. Jean-Luc Vellut, "La peinture du Congo-Zaïre et la recherche de l'Afrique innocente," in *60 ans de peinture au Zaïre*, ed. Joseph Cornet et al. (Brussels: Les Editeurs d'Art Associés, 1989), 639–40.

13. In the aftermath of the Great Depression, the total number of expatri-ates in Congo rose from 6,991 to 25,679, 3,615 and 17,676 of which, respec-tively, were Belgian. This represented a jump from 51.7 to 68.8 percent of all westerners in the Belgian Congo. Isidore Ndaywel è Nziem, ed., *Nouvelle his-toire du Congo: Des origines à la République Démocratique* (Kinshasa: Afrique Éditions; Brussels: Le Cri, 2008), 361. The most significant jump in numbers takes place only after World War II.

14. It is worth noting here that Périer only traveled to the colony once, in 1950, when he visited Elisabethville. See Gaston-Dénis Périer, "A la commis-sion pour la protection des arts et métiers indigènes: Rapport du Secrétaire sur sa visite à Elisabethville," *Zaire: Revue Congolaise* 9, no. 10 (December 1950): 3–15. (Note: the spelling of Périer's first name varies between "Gaston-Deny," "Gaston-Denys," "Gaston-Denis," and "Gaston-Dénis" according to the source.)

15. The application of the 1939 law disappointed because the sites selected for protection under the legislation included mostly Western monuments and buildings.

16. AA BuZa, COPAMI files, PV Scéane Copami, 20 January 1940, porte-feuille 4788, lias 3/3.

17. Jean Vanden Bossche, "Le Musée de la Vie Indigène, Léopoldville, Congo Belge," *Museum* 8, no. 2 (1955): 82–84. Adrien Vanden Bossche came to the colony in 1926 and worked for the government printing service until he became curator in 1936. Jeanne Maquet-Tombu had a PhD in art history and was the wife of the governor of the province of Leopoldville. After her return to Belgium she became a member of COPAMI, making her one of the few people active in both AAI and COPAMI. UTexLéo also had a practical interest in the museum's activities, since it was interested in exploring "indig-enous" textile patterns for their *pagnes*.

18. Vanden Bossche, "Le Musée de la Vie Indigène," 82–84. Because of the absence of the museum's archives (which largely disappeared upon the

museum's closing in 1965), I am unable to give a more detailed description of the collection process. Fragments of the MVI's catalog can be found at the IMNC in Kinhsasa, but infortunately the catalog cards do not contain sufficient information on the collection of the objects.

19. Maquet-Tombu, "Le Musée de la Vie Indigène," 110.

20. AA BuZa, COPAMI files, "Negerkunst. Een Museum in Belgisch-Kongo," 21 April 1937, portefeuille 4799, lias 6/2.

21. Annie Coombes describes a similar system of classification of ethnographic material used in British museums from the late nineteenth century until the 1930s. Annie E. Coombes, *Reinventing Africa: Museums, Material Culture and Popular Imagination in Late Victorian and Edwardian England* (New Haven, CT: Yale University Press, 1994), 118–20.

22. These missionary museums could be found in, for example, Kinambi near Kikwit in Bandundu Province, Bukavu in the Kivu region, Luluabourg and Mbudji Maji in the Kasai and various places in Lower Congo and the Equatorial Province. An estimated total of fifteen of these smaller museums existed between 1939 and 1950.

AA BuZa, COPAMI files, Rapport 1940, portefeuille 4788, lias 3/2; Ferdinand Mbambu Makuka, "La problématique du musée en République Démocratique du Congo, vue par un muséologue" (unpublished manuscript, Kinshasa, 2006), 50–51.

23. MNL, Museum Archive, Muya wa Bitanko, "Le musée de Lubumbashi: Bref historique" (unpublished manuscript, Lubumbashi, 1999). For a complete history of the founding of the museum in Lubumbashi, see Couttenier, "Between Regionalization and Centralization."

24. MNL, Museum Archive, Correspondance du Procureur général, 5 octobre 1951, folder, n.p.

25. Jean-Luc Vellut, "Hégémonies en construction: Articulations entre état et entreprises dans le bloc colonial Belge (1908–1960)," *Canadian Journal of African Studies* 16, no. 2 (1982): 315; Jean-Luc Vellut, "De dekolonisatie van Kongo 1945–1965," in *Algemeene geschiedenis van de Nederlanden*, Part 15, *De nieuwste tijd*, ed. A. F. Manning, H. Balthazar, and J. De Vries (Haarlem: Fibula–Van Dishoeck, 1982), 401–11, and Jean-Luc Vellut, "Aperçu des relations Belgique-Congo (1885–1960)," in *Le Congo et l'art Belge 1880–1960*, ed. Jacqueline Guisset (Tournai: La Renaissance du Livre, 2003), 32–35. Just as cultural policies started their development in the 1930s but did not truly take off until after the war, the same can be said of many social policies. The Fonds du Bien-être Indigène (Fund for Indigenous Well-Being), for example, was founded in the 1930s but accelerated its actions in the 1950s. Vellut, "Aperçu des relations Belgique-Congo," 35. The plan came on the heels of the creation of the "welfare state" in Belgium itself, established with a law named after Achiel Van Acker (Belgian minister of labor and social affairs at the time) in December of 1944.

26. Vellut, "Aperçu des relations Belgique-Congo," 34.

27. Ndaywel è Nziem, *Nouvelle histoire du Congo*, 361.

28. Marie-Bénédicte Dembour, *Recalling the Belgian Congo. Conversations and Introspection* (New York: Berghahn, 2000), 143–48. It should be noted, however, that her interviewees were all "territorial agents," a subset of colonial officials who mostly worked in rural areas.

29. Renato Rosaldo, *Culture and Truth: The Remaking of Social Analysis* (Boston: Beacon, 1993), 62–89.

30. Phillips and Steiner, "Art, Authenticity and the Baggage of Cultural Encounter," in *Unpacking Culture*, 9–13. The same cannot be said for economic modernity, since they clearly had a role to play as consumers.

31. AA BuZa, COPAMI files, Adrien Vanden Bossche "Des cooperatives artisanales à caractère artistique," 1951, portefeuille 4788, lias 3/7.

32. Nicholas Thomas, *Entangled Objects: Exchange, Material Culture, and Colonialism in the Pacific* (Cambridge, MA: Harvard University Press, 1991), 153–62 and 176–80.

33. Jean-Luc Vellut, "Colonial Kitsch," in Fall and Pivin, *Anthology of African Art*, 160.

34. Bogumil Jewsiewicki, "Rural Society and the Belgian Colonial Economy," in David Birmingham and Phyllis M. Martin, eds., *History of Central Africa* (London: Longman: 1983), 2:123–24. Vellut, "De dekolonisatie van Kongo," 408–9.

35. Bogumil Jewsiewicki, "African Peasants in the Totalitarian Colonial Society of the Belgian Congo," in *Peasants in Africa: Historical and Contemporary Perspectives*, ed. Martin A. Klein (Beverly Hills: Sage, 1980), 57–60 and 69–72; Bogumil Jewsiewicki, "Rural Society and the Belgian Colonial Economy," 101, 117–20.

36. It was Périer who had truly been ahead of the curve when in 1929 he used the term *art vivant* in his defense of the value of painters Lubaki and Djilatendo's work. Gaston-Denys Périer, "L'art vivant des nègres: Un imagier Congolais," *Cahiers de Belgique* 2, no. 7 (July 1929): 256–59; and Pierre Halen, "Les douze travaux du Congophile: Gaston-Denys Périer et la promotion de l'africanisme en Belgique," *Textyles: Revue des lettres belge de langue française* 17–18 (2000): 141–42.

By the 1950s, the membership of AAI and COPAMI overlapped slightly, in the person of Jeanne Maquet-Tombu, who joined COPAMI upon her return to Belgium.

37. Marshall Mount has argued that in comparison with other African colonies in sub-Saharan Africa, these schools were among the first, and that they were influential as examples. Marshall Ward Mount, *African Art: The Years since 1920* (Bloomington: Indiana University Press), 83.

38. Wallenda created St. Luc in 1943 in Matadi as a school of applied arts. When the school moved to Leopoldville in 1949, however, it gradually reinvented itself as an academy of fine arts. Joseph Cornet, "Histoire de la peinture zaïroise à Kinshasa," in *La naissance de la peinture contemporaine en Afrique Centrale, 1930–1970* (Tervuren: RMCA, 1992), 19–24. Joseph Cornet, "La peinture à Kinshasa," in Cornet et al., *60 ans de peinture au Zaïre*, 165–66.

39. Pierre Romain-Defossés (1887–1954) came to Congo from Paris in 1941, after spending time in Brazaville and in the Kivu. Mount, *African Art*, 220.

40. Wim Toebosch, "L'école d'Elisabethville," in *Naissance de la peinture*, 13–18; Wim Toebosch, "Pierre Romain-Defossés," in Cornet et al., *60 ans de peinture au Zaïre*, 59–71; Remi De Cnodder, "L'Ecole de Lubumbashi," in *60 ans de peinture au Zaïre*, 73–107; Mount, *African Art*, 74–79. Jean Vanden Bossche, "Pierre Romain Defossés et son Académie d'Art Populaire," *Brousse*, no. 6 (1955): 17–25. Sabine Cornelis has argued that Romain-Desfossés's personal painting style deeply influenced his students, as did his belief that using tales as inspiration for paintings would make them more authentically Congolese. Cornelis, "Birth of Academicism," 166.

41. Laurent Moonens was trained at the Brussels Academy of Fine Art and the Higher Institute for Decorative Arts. Between 1948 and 1951 he taught painting in Leopoldville. Mount, *African Art*, 221.

42. AA BuZa, COPAMI files, "Note de Monsieur Moonens," 1953–54, portefeuille 4788, lias 3/7.

43. AA BuZa, COPAMI files, "Note de Monsieur Moonens," n.d., portefeuille 4788, lias 3/3.

44. AA BuZa, COPAMI files, "Note Nève," 1952, 4795, 52–53, and "Note sur le problème de la vitalité des arts congolais," 1953, portefeuille 4788, lias 3/7,

45. AA BuZa, COPAMI files, Robert Verly, "Suggestions favorables au sauvetage de ce qu'il y aurait de valuable dans l'art traditionnel des indigènes du Congo Belge," n.d. [1950s], portefeuille 4788, 3/7.

46. Herman Lebovics has shown how a similar fear of the impact of modernization—and hence political awakening—in the French empire led to attempts to reroot Vietnamese villagers in their rural environments, for example by reforming education "in the context of their culture." Herman Lebovics, *True France: The Wars over Cultural Identity, 1900–1945* (Ithaca, NY: Cornell University Press, 1992), 98–134.

47. The same train of thought led to a dislike of the population of evoluées among certain Belgians, because their identities were "inauthentic." Bambi Ceuppens, *Congo Made in Flanders? Koloniale Vlaamse visies op "blank" en "zwart" in Belgisch Congo* (Ghent: Academia Press, 2003), 342.

48. Primary education remained the focus of the Belgian colonial education system. In the 1950s efforts were made to extend the system more widely into secondary education, with limited results. Marc Depaepe and Lies Van Rompaey, *In het teken van de bevoogding: De educatieve actie in Belgisch-Kongo (1908–1960)* (Leuven-Apeldoorn: Garant, 1995), 153–68.

49. T. J. Jackson Lears, *No Place of Grace: Antimodernism and the Transformation of American Culture 1880–192.* (New York: Pantheon, 1981), xiii.

50. AA BuZa, COPAMI files, Note guidelines, n.d., portefeuille 4797, lias 5/1/10.

51. *Les Cooperatives Indigènes au Congo Belge* (Kalima: AIMO, 1950).

52. Jewsiewicki, "Rural Society and the Belgian Colonial Economy," 100–101.

53. AA BuZa, COPAMI files, Communication de Madame Maquet-Tombu, 7 October 1953, portefeuille 4787, lias 3/7.

54. AA BuZa, COPAMI files, letter from Buisseret, 28 October 1954, portefeuille 4796, lias 1954–55.

55. AA BuZa, COPAMI files, "Réflexions soumises à COPAMI pas M.R. Verly,"1954, portefeuille 4796, lias 1954–55, and "avant projet," portefeuille 4796, lias 1954–55.

56. AA BuZa, COPAMI files, Adrien Vanden Bossche "Des cooperatives artisanales à caractère artistique," p. 4, 1951, portefeuille 4788, lias 3/7.

57. Viviane Baeke, Henry Bundjoko, and Joseph Ibongo, "L'évolution des regards sur l'art congolais au travers de la genèse des musées coloniaux et post-coloniaux à Kinshasa," unpublished paper.

58. See Christopher Steiner's *African Art in Transit* (Cambridge: Cambridge University Press, 1994) for a description of the functioning of the trade in African art and crafts in West Africa. Similar work on Central Africa has yet to appear.

59. Jan Vansina, *Being Colonized: The Kuba Experience in Rural Congo* (Madison: University of Wisconsin Press, 2010), 228–35, 274–75; and "La Survie," 18; Cameron, "Coming to Terms with Heritage."

60. Christopher B. Steiner and Ruth B. Phillips, "Art, Authenticity and the Baggage of Cultural Encounter," in Phillips and Steiner, *Unpacking Culture*, 9–16. Steiner, *African Art in Transit*, 7–10; Bennetta Jules-Rosette, *The Messages of Tourist Art: An African Semiotic System in Comparative Perspective* (New York: Plenum, 1984).

61. Bennetta Jules-Rosette, "What Is 'Popular'? The Relationship between Zairian Popular and Tourist Paintings," in *Art pictural zaïrois*, ed. Bogumil Jewsiewicki (Sillery, Québec: Editions du Septentrion, 1992), 49. John L. Comaroff and Jean Comaroff, *Ethnicity, Inc.* (Chicago: University of Chicago Press: 2009).

62. AA BuZa, COPAMI files, letter from Ministère des Colonies to Jadot, 1 March 1956, portefeuille 4797, lias 5/1/4.

63. Verly was an admirer of the museum in Dundo, across the border in Angola. This museum was the result of a collaboration between local cultural organizations and the Companhia de Diamantes de Angola. Verly was perhaps hoping for a similar collaboration in Tshikapa.

64. AA BuZa, COPAMI files, "Rapport de la délégation envoyée au Congo Belge et Ruanda-Urundi," 1957, portefeuille 4797, lias 5/2. In 1959, twenty-four workshops were reported around Thsipkapa. AA BuZa, COPAMI files, Jean Vanden Bossche, Rapport Tshikapa, 1959, portefeuille 4796, lias 57–60.

65. Among the other workshops and schools in existence in 1957, but not visited by the COPAMI delegation, were workshops in Stanleyville (today's Kisangani), Katako Kombe (Upper Kasai, in the very center of the country) and Kapanga-Musumba in the Katanga region, where Lunda material was sold.

66. AA BuZa, COPAMI files, "Rapport de la délégation envoyée au Congo Belge et Ruanda-Urundi," 1957, portefeuille 4797, lias 5/2; "African Natives Art Gets Big Boost by American," clipping, 25 December 1955, portefeuille 4799, lias 6/2.

67. From 1938 until 1951 Mushenge had a workshop for raffia textiles run by the Salesian sisters. The artisanal school was created in 1951 in Mweka, but moved to Mushenge after a year upon the request of the Nyimi. The cooperative was created in 1954. Personal correspondence Jan Vansina, 15 July 2012; Vansina, *Being Colonized*, 294.

68. These were some of the first publications on Kuba art. Torday worked in the colony in 1907 and researched and collected for the British Museum. David A. Binkley and Patricia J. Darish, "'Enlightened but in Darkness': Interpretations of Kuba Art and Culture at the Turn of the Twentieth Century," in *The Scramble for Art in Central Africa*, ed. Enid Schildkrout and Curtis A. Keim (Cambridge: Cambridge University Press, 1998), 40–41.

69. Cameron, "Coming to Terms with Heritage," 29.

70. AA BuZa, COPAMI files, Atelier Mushenge, 1955, portefeuille 4797, lias 5/1; "Een Verdienstelijk Initiatief te Musenge (Kongo), *Het Volk*, 28 November 1954; "Rapport de la délégation envoyée au Congo Belge et Ruanda-Urundi," 1957, portefeuille 4797, lias 5/2.

71. Vansina, *Being Colonized*, 294.

72. The difference between artisanal workshops and arts schools was not always clear. Several of the smaller missionary art schools in reality functioned more like craft workshops.

73. While it is true that one of their members was a member of the church (Nève), considering the extent of the Catholic Church's involvement in the colony, and keeping in mind that several missionaries developed an early interest in Congolese cultures, this was a minimal representation. This conflict between COPAMI and Catholic schools reflects a wider conflict between Catholics and Liberals in Belgian politics about education.

74. "La Hotte," *Brousse*, no. 8 (1956): 5.

75. The ethnographic museums are listed in Lema Gwete, "Acquisition et choix des objets africains traditionnels: Expérience de l'Institut des Musées Nationaux du Zaïre," *Arte in Africa 2*, ed. Enzio Bassani and Gaetano Speranza (Florence: Centro di Studi di Storia delle Arti Africane, 1991), 82.

76. R. N. B., "Une visite au Musée de la Vie Indigène à Léopoldville," *Brousse*, no. 3–4 (1946): 9–19.

77. AA BuZa, COPAMI files "Communication de Madame Maquet-Tombu," 7 October 1953, portefeuille 4787, lias 3/7.

78. R. N. B., "Une visite au Musée," 9–19.

79. Jean Vanden Bossche had a formal background in art history, having been a student of Tervuren director Frans Olbrechts at the University of Ghent. The museum seems to have been somewhat of a family occupation. Adrien Vanden Bossche's wife also worked there, while Jean's mother-in-law manned the sales counter. Jean remained at the museum until 1961, when he

left Africa and took up a position with the Unesco Institute of Education in Hamburg. From 1971 until 1985 he worked for the Bernard Van Leer Foundation in Den Hague, where he also worked with the Museum of Education (Museon).

80. Vanden Bossche, "Le Musée de la Vie Indigène."

81. Célestin Badi-Banga ne Mwine, *Contribution à l'étude historique de l'art plastique zaïrois moderne* (Kinshasa: Editions Malayika, 1977), 54–55.

82. For example, between April and October 1952 the museum had 6,432 Congolese visitors and 8,048 Europeans ("La Hotte," *Brousse*, no. 2 [1952]: 11); between March and October 1955, 3,158 Europeans and 1,992 Congolese ("La Hotte," *Brousse*, no. 7 [1955]: 7). From late 1955 until early 1957, the number of Congolese visitors dropped significantly, the reason for which is unclear. It is possible that the location of the museum at that time was in a neighborhood not very accessible to the Congolese public.

83. Maquet-Tombu, "Le Musée de la Vie Indigène," 110.

84. René Lemarchand, *Political Awakening in the Congo* (Berkeley: University of California Press, 1964), 57–58; Guy Vantemsche, *Congo: De impact van de kolonie op België* (Tielt, Belgium: Lannoo, 2008), 67–68.

The rather vague concept of a "Belgian-Congolese community" was first introduced by the Christian Democrats in 1952. It referred to both a new society in the colony, as well as the ties that existed between the colony and Belgium. Vantemsche, *Congo*, 69–70.

85. Léopoldville had a separate museum of prehistory on the campus of Lovanium University, run by Brother Hendrik Van Moorsel.

86. Gaston-Denys Périer, "Rapport du Secrétaire sur la visite à Elisabethville," *Zaire*, December 1950. The 1957 delegation also visited and repeated this criticism but they acknowledged that the museum clearly drew an indigenous audience alongside its Western audience.

87. Waldecker was a German with a doctorate in philosophy who relocated to Congo. He enjoyed the protection of the colony's governor-general during the war, and he eventually obtained Belgian citizenship. For more on him and the MLII, see: Couttenier, "Between Regionalization and Centralization."

88. The museum was designed by Claude Strebelle, who led an office of locally residing architects named Yenga (Swahili for "to build"). Johan Lagae, "From 'Patrimoine Partagé' to 'Whose Heritage'? Critical Reflections on Colonial Built Heritage in the City of Lubumbashi, Democratic Republic of Congo," *Afrika Focus* 21, no. 1 (2008): 21.

89. AA BuZa, COPAMI files, Note Périer, April 1954, portefeuille 4788, lias 3/7.

90. AA BuZa, COPAMI files, 2nd project, March 1954, portefeuille 4788, lias 3/7.

91. Unfortunately, there is no documentation that tells us how the curators in Elisabethville responded to this plan, especially since they stood to lose even more autonomy.

92. AA BuZa, COPAMI files, PV 7 October 1953, portefeuille 4788, lias 3/7.

93. AA BuZa, COPAMI files, PV 7 April 1954 and PV 9 December 1953, portefeuille 4788, lias 3/7. See also Anonymous, "A la Commission pour la Protection des Arts et des Métiers Indigènes," *Brousse*, no. 5 (1954): 7–8.

94. Ironically, these opinions did not stop Verly from collecting for the Royal Museums for Art and History in the Angola-Congo border region, a matter Vanden Bossche did not waste any time remarking upon. AA BuZA, COPAMI files, letter from Lavachery to Jadot, 25 October 1955, portefeuille 4788, lias 3/3. Olbrechts used these events to have Verly discredited. The conflict between both men escalated into legal proceedings, but Verly was eventually reinstated as a member of COPAMI. Interview with Michel Verly (Robert Verly's son), 22 August 2012, Kasterlee.

95. AA BuZA, COPAMI files, "Réflexions soumises à COPAMI par M.R. Verly," 1954, portefeuille 4796, lias 1954–55.

96. This did not mean the idea was entirely forgotten. The structure of the Institute for National Zairian Museums, created in the postcolonial era, resembles the blueprint for the Office of Museums of Indigenous Life. See chapters 3 and 4.

97. A royal collection had existed since the start of the century, although part of the collection was destroyed in a fire in 1912. Mushenge had a small museum that was open in the late 1940s, and possibly earlier, but closed by the early 1950s. AA BuZa, COPAMI files, Atelier Mushenge, 1955, portefeuille 4797, lias 5. Vansina, *Being Colonized*, 178–209; personal correspondence Jan Vansina, 15 July 2012.

98. The basis for this museum would be the royal collection (or what was left of it after a 1912 fire destroyed parts of it). Most of the collection is now dispersed. Personal correspondence Jan Vansina.

99. AA BuZa, COPAMI files, "Rapport de la délégation envoyée au Congo Belge et Ruanda-Urundi," 1957, p. 25, portefeuille 4797, lias 5/2.

100. An earlier collection created at the court of the Mwata Yamvo in the 1930s had been transferred to the museum in Elisabethville. The Mwata Yamvo (Jan Vansina uses the term Mwaant Yaav) did not have as much autonomy as the Kuba king. Jan Vansina, *Kingdoms of the Savanna: A History of Central African States until European Occupation* (Madison: University of Wisconsin Press, 1966), 80–81. AA BuZa, COPAMI files, "Rapport de la délégation envoyée au Congo Belge et Ruanda-Urundi," 1957, p. 25, portefeuille 4797, lias 5/2.

101. AA BuZa, COPAMI files, letter from Réprensentants de la population du territoire to Robert Verly, 8 November 1958, portefeuille 4797, lias 5-1-4. Because of Belgium's reluctance to allow political activities in Congo, many of the political parties started as cultural organizations.

102. Frederick Cooper and Laura Ann Stoler, "Between Metropole and Colony: Rethinking a Research Agenda," in *Tensions of Empire: Colonial Cultures in a Bourgeois World*, ed. Frederick Cooper and Laura Ann Stoler (Berkeley: University of California Press, 1997), 6–7.

103. Paul Timmermans, "Le Musée d'Art et de Folklore à Luluabourg, Congo," *Museum* 13, no. 2 (January–December 1960): 92–97. At the end of Verly's three-year contract in 1959, 662 objects had been collected, funding found, and architectural plans drawn up, but the situation was at a standstill. AA BuZA, COPAMI, [Jean Vanden Bossche] "Rapport sur la mission du conservateur du Musée de la Vie Indigène à Tshikapa," 1959, portefeuille 4796, lias 1957–60.

104. Interview Rik Ceyssens, 10 August 2011, Helchteren.

105. AA BuZa, COPAMI files, "Rapport de la délégation envoyée au Congo Belge et Ruanda-Urundi, 1957," portefeuille 4797, lias 5/2.

106. There had been progress in terms of planning in Jadotville, Gungu, and Bukavu, but no museums had actually opened their doors. Bukavu had a museum of ethnography and geology in the interwar period, but after the dissolution of the local AAI, the objects were sent to the MVI in Leopoldville. In Stanleyville, a museum was under construction in 1959.

On Paul Timmermans and the museum in Luluabourg, see Jan Raymaekers, "Het Museum voor Kunst en Folklore van Luluaburg." *Bulletin des Séances: Académie Royale des Sciences d'Outre-Mer/ Mededelingen Zittinge. Koninklijke Academie voor Overzeese Wetenschappen* 59, nos. 2–4 (2013): 243–82.

107. Timmermans, "Le Musée d'Art et de Folklore," 96.

108. In France, the term *folklore* became associated with the ethnographic study of rural French culture. In fact, the term *folklore* emerges more frequently in the context of Congolese art and crafts toward the end of the 1950s, in all likelihood as a recognition of artisanal production as a living tradition, and not a mere recycling of past artistic production. Lebovics, *True France*, and Lebovics, *Imperialism and the Corruption of Democracies* (Durham, NC: Duke University Press, 2006), 27; Daniel J. Sherman, *French Primitivism and the Ends of Empire, 1945–1975* (Chicago: University of Chicago Press, 2011), 22, 28–30.

109. Jean Vanden Bossche, "Le Musée de la Vie Indigène," 84.

110. AA BuZA, COPAMI files, "L'exposition artisanale au Musée de la Vie Indigène" [1952,] portefeuille 4796, lias 1952–53.

111. AA BuZA, COPAMI files, Proposal Lamoral, September 1959, portefeuille 4796, lias 1957–60.

112. J. F. Iyeki, "L'art congolais," *Brousse*, no. 10 (1957): 25–29.

113. AA BuZA, COPAMI files, "Catalogue biennale 1956," portefeuille 4798, lias 5/5/2; JVDB, "Biennale des arts congolais," 1956, portefeuille 4797, lias 5/1/10; Jean Vanden Bossche, "La Biennale des Arts de la Province de Léopoldville," *Brousse*, no. 10 (1957): 11–19.

114. Vanden Bossche, "Le Musée de la Vie Indigène," 84.

115. Bennett, *Making Culture, Changing Society* (London: Routledge, 2013), 49–69, 53.

116. A trip during which Bolamba also visited the Tervuren museum. AA BuZA, COPAMI files, PV 2 June 1953, portefeuille 4788, lias 3/7.

117. AAI's journal, *Brousse*, founded in 1939, had five Congolese contributors in a total of fifty-three contributors, of which Bolamba was the most active. For more on *Brousse*, see Pierre Halen, "Une revue coloniale de culture congolaise: *Brousse* (1935–1939–1959)," in *Actes de la première journée d'études consacrée aux littératures "européennes" à propos ou issues de l'Afrique centrale*, Etudes Francophones de Bayreuth (Bayreuth: Universität Bayreuth, 1994), 3:68–91, AAI was not the only cultural organization in the colonial capital: painter and actor Mongita created Lifoco (Ligue Folklorique Congolaise — Congolese Folkloric League), which put on several plays.

118. Young, *Politics in the Congo: Decolonization and Independence* (Princeton, NJ: Princeton University Press, 1965), 296, 304.

119. Flemish missionaries Gustaaf Hulsaert and Edmond Boelaert contributed significantly to the formation of the Mongo unification movement in part by emphasizing the value of traditional life and culture for a Mongo future. Bolamba went on to a political career after independence and served as a minister in several governments. Young, *Politics in the Congo*, 280, 400.

120. In another illustration of the lack of political realism of the COPAMI members, Périer still referred to the Congolese as "our pupils" in a letter. AA BuZa, COPAMI files, letter from Périer to Jadot, 17 April 1960, portefeuille 4796, lias 1957–60.

121. AA BuZa, COPAMI files, note from COPAMI to Minister, 21 March 1960, portefeuille 4796, lias 1957–60.

122. AA BuZa, COPAMI files, "Rapport de la délégation envoyée au Congo Belge et Ruanda-Urundi, 1957," portefeuille 4797, lias 5/2.

CHAPTER 3: THE ART OF (RE)POSSESSION

1. "Notre Préalable a la table ronde economique," *Notre Kongo*, 3 April 1960.

2. In October 1971, Congo was renamed Zaire, a name the country shed again after the demise of the Mobutu regime in 1997. Since this book covers several decades, I use the name that is historically appropriate to the context in which it is used.

3. ANC, AICA Files. Address of Mobutu to the opening session of the 1973 AICA conference in Kinshasa, *Compte Rendu in Extenso n. 3*.

4. Bogumil Jewsiewicki, "De la nation indigène à l'authenticité: La notion d'ordre public au Congo 1908–1990," *Civilizations* 40, no. 2 (1992): 102–27.

5. Jean-François Bayart, *The Illusion of Cultural Identity* (Chicago: University of Chicago Press, 2005), 19.

6. The first appeared in *Notre Kongo* in late March and was repeated on 3 April and 10 December 1960. *Le Drapeau Rouge*, the newspaper of the Belgian Communist Party, picked it up in its 26 March 1960 edition, as did the journal *Pourquoi Pas?* on 1 April 1960.

7. Kivulu Sabakinu, "La spécificité de la colonisation et de la décolonisation du Zaïre," in *Belgique/Zaïre: Une histoire en quête d'avenir: Actes des rencontres de Bruxelles, ULB, 7–8–9 octobre 1993*, ed. Gauthier de Villers

(Brussels: Institut Africain-CEDAF, 1994); Guy Vantemsche, *Congo: De impact van de kolonie op België* (Tielt, Belgium: Lannoo, 2008), 211–13; Marcel Zimmer, "Les finances coloniales jusqu'en 1960 et leurs conséquences," in *Histoire des finances publiques en Belgique*, vol. IV-2, ed. Max Frank (Brussels: Publications de l'Institut Belge des Finances Publiques, 1988), 968–71; Frans Buelens, *Congo 1885–1960: Een financieel-economische geschiedenis* (Berchem, Belgium: EPO, 2007), 332.

The Belgian state likely dragged its feet deliberately so its former colonial enterprises could restructure and rearrange their finances. Vita Foutry and Jan Neckers, *Als een wereld zo groot waar uw vlag staat geplant* (Leuven: Instructieve Omroep-BRT, Nauwelearts, 1986).

8. RMCA, Dept. of Culture and Society, IMNZ files, Lucien Cahen, "Geschiedenis," folder IMNZ-MRAC Apport.

9. Cahen (1912–82), quickly climbed the museum's ladder, starting in 1947 in the museum's Department of Geology and being named director in 1958. Before coming to the museum world, he worked in Congo as a geologist and served in the colony's army during World War II. For more on Cahen, see Dirk Thys Van Den Audenaerde,"In Memoriam Lucien Cahen," *Africa-Tervuren* 28, no. 4 (1982).

10. RMCA, Dept. of Culture and Society, IMNZ files, Lucien Cahen, "Contentieux Mémorandum," n.d. [early 1960s], folder IMNZ-MRAC Apport.

11. Ibid. Emphasis in original.

12. Ibid. Emphasis in original.

13. Vantemsche, *Congo*, 213; Foutry and Neckers, *Als een wereld*, 130.

14. Born Joseph-Désiré Mobutu, he later renamed himself Mobutu Sese Seko Kuku Ngbendu wa Za Banga. He first appeared on the political stage as a journalist and as Lumumba's personal aide. Appointed chief of staff, he led a successful coup during the Congo Crisis (and was involved in Lumumba's murder) but returned power to a civilian government. He led another coup in 1965, remaining in power until 1997.

15. The Union Minière supplied the Manhattan Project with uranium during World War II.

16. Vantemsche, *Congo*, 213–29; Crawford Young and Thomas Turner, *The Rise and Decline of the Zairian State* (Madison: University of Wisconsin Press, 1985), 373–74.

17. He led a garrison of the Force Publique and became the right-hand officer of André Schöller and Hendrik Cornelius, governors-general of the Belgian Congo. He transitioned from working for the colonial government into an advisory role to Congolese politicians after independence, at first working for Kasavubu and then Mobutu, but he was paid by the Belgian "Military Technical Aid" until 1975.The figure of Powis de Tenbossche is shrouded in mystery. A popular rumor has it that he was an illegitimate child of King Leopold III of Belgium, making him a half-brother of King Baudouin. Mobutu's entourage certainly did not discourage this rumor—Mobutu himself liked to refer to Powis as "a Belgian prince." See Archive Ministry of Defense, Brussels,

Stamkaart Powis de Tenbossche; Jan Anthonissen, "De koningen van de Congo," *Humo* 14 (1999): 30–35; Oscar Coomans de Brachène, ed., *Etat resent de la noblesse belge, annuaire de 1996* (Brussels: Etat Présent, 1996), 317; and Vantemsche, *Congo*, 226.

18. Powis kept a correspondence with the Belgian royal court. Unfortunately, this correspondence is in the Royal Archives and is not accessible to researchers.

19. Vanthemsche, *Congo*, 226.

20. Staff at Tervuren had been apprehensive about this exhibition, rightly worrying that it would again draw attention to the debate about the *contentieux*. Interview Huguette Van Geluwe, 28 December 2010, Oostende.

21. RMCA, Dept. of History and Politics, IMNZ files, letter from Cahen to Powis, 12 December 1969, folder J. Powis de TenBossche, box 15-2-77.

22. RMCA, Dept. of History and Politics, IMNZ files, letter from Cahen to President Mobutu, 10 October 1970, folder J. Powis de Ten Bossche, box 15-2-77.

23. RMCA, Dept. of History and Politics, IMNZ files, letter from Cahen to Minister of National Education, 21 May 1970, folder J. Powis de TenBossche, box 15-2-77.

24. The Institut des Musées Nationaux du Congo (IMNC) was within months renamed the Institut des Musées Nationaux du Zaïre (IMNZ). The institute was envisioned as an overarching structure for all museums in the Congo (a number of smaller former colonial museums still existed). The main seat in Kinshasa would collect anthropological and art objects for a collection to be displayed in a future flagship museum in Kinshasa. (The latter was never built.) See chapters 4 and 5.

25. IMNZ, *Rapport 1970–71* (Kinshasa: IMNZ, 1972).

26. Cahen would spend about three months per year at the IMNC, with an adjunct director residing permanently in Kinshasa.

27. On art museums as tools for the creation of citizenship, see Carol Duncan, *Civilizing Rituals: Inside Public Art Museums* (London: Routledge, 1995).

28. Interviews, IMNZ, *Rapport 1970–1* and *Rapport 1971–2* (Kinshasa: IMNZ, 1973).

29. RMCA, Dept. of History and Politics, IMNZ files, Note sur un projet de Centre de Formation muséologique en Afrique, Paris. 17 December 1970, folder ICOM/UNESCO, box 15-2-77.

30. RMCA, Dept. of History and Politics, IMNZ files, letter from Varine-Nohan to Cahen, 12 August 1970 and Note sur un projet de Centre de Formation muséologique en Afrique, Paris, 17 December 1970, folder ICOM/UNESCO, box 15-2-77.

31. Bob White distinguishes three phases in the development of Zaire's discourse about cultural policies: from 1965 to 1969, marked by economic nationalism; from 1970 to 1974, characterized by the full development of Mobutu's cultural politics; and the period after 1974, which saw the introduction

of "Mobutism," the culmination of Mobutu's teaching in a generalized doctrine but marked by increasing abuses of power (my research roughly confirms this chronology). Bob W. White, "L'incroyable machine d'authenticité: L'animation politique et l'usage public de la culture dans le Zaire de Mobutu," *Anthropologie et Sociétés* 30, no. 2 (2006): 48.

32. A good overview of the history of authenticité is still missing. Bob White has discussed the ideology in the context of state-sponsored musical and dance performances in *Rumba Rules: The Politics of Dance Music in Mobutu's Zaire* (Durham: Duke University Press, 2008) and "L'incroyable machine de l'authenticité," 43–63. Congolese historian Isidore Ndaywel è Nziem gives short overviews in his *Histoire générale du Congo: De l'héritage ancien à la République Démocratique* (Louvain-La-Neuve: Ducelot,), 706–26, and *Nouvelle histoire du Congo: Des origines à la République Démocratique* (Kinshasa: Afrique éditions; Brussels: Le Cri, 2008), 534–43. A short reflection is provided in W. N. Z. Mukulumanya, "Authenticité: Mythe ou identité?" in *Authenticité et développement* (Paris: Éditions Présence Africaine, 1982), 65–96. See also Kevin C. Dunn, *Imagining the Congo: The International Relations of Identity* (New York: Palgrave Macmillan, 2003), 108–20. Most of this work refers to authenticité in urban settings. Little work exists that examines its impact in rural areas (an exception: Allen F. Roberts, "'Authenticity' and Ritual Gone Awry in Mobutu's Zaire: Looking beyond Turnerian Models," *Journal of Religion in Africa* 24, no. 2 [1994]: 134–59). Additionally, the literature generally fails to mention attempts to use Zaire's traditional arts in this discourse, despite Ken Adelman's recognition in 1975 of their role. Kenneth Lee Adelman, "The Recourse to Authenticity and Negritude in Zaire," *Journal of Modern African Studies* 13, no. 1 (1975): 134–39. For more on the *spectacles d'animation politique*, see Kapalanga Gazungil Sang'Amin, *Les spectacles d'animation politique en République du Zaïre* (Louvain-la-Neuve, Belgium: Cahiers Théâtre Louvain, 1989).

33. Ironically, Young and Turner notice how the terms evolved into class concepts, indicating membership in a privileged class. Young and Turner, *Rise and Decline of the Zairian State*, 117.

34. White, "L'incroyable machine de l'authenticité," 53.

35. Jewsiewicki and Mudimbe, 'Meeting the Challenge of Legitimacy: Post-Independence Black Africa and Post-Soviet European States," *Daedalus* 124, no. 3 (1995): 191–207.

36. Tony Bennett, *Making Culture, Changing Society* (London: Routledge, 2013), 39.

37. ANC, MPR Files, Glossaire idéologique du MPR, 1986 .

38. White, "L'incroyable machine d'authenticité," 53. For more on the *spectacles d'animation politique*, see Kapalanga, *Les spectacles d'animation politique*.

39. Bokonga Ekanga Botembele, *La politique culturelle en République du Zaïre* (Paris: Unesco Press, 1975), 15–46.

40. Adelman, "The Recourse to Authenticity."

41. Elizabeth Harney, *In Senghor's Shadow: Art, Politics and the Avant-Garde in Senegal, 1960–1995* (Durham, NC: Duke University Press, 2004), 5.

42. Young and Turner, *Rise and Decline of the Zairian State*, 215–16; Dunn, *Imagining Congo*, 118.

43. Young and Turner, *Rise and Decline of the Zairian State*, 209.

44. Bayart, *Illusion of Cultural Identity*, 26.

45. ANC, MPR Files, Mobutu, Message du Président de le République au Partie Frère du Sénégal. Ministère de l'information, p8, 14 February 1971.

46. Zairization was followed by phases of "radicalization" and "retrocession" in which some companies were returned to previous owners under certain conditions.

47. White, *L'incroyable machine de l'authenticité*, 49.

48. Botembele, *La politique culturelle en République du Zaïre*, 41. Mobutu's cultural revolution can also be read as an attack upon the Catholic Church and Christianity as imports from the West. The church, not coincidentally, was one of the major power bastions in the country.

49. White, *Rumba Rules*, 65–96.

50. ANC, AICA Files, Address by Mobutu to opening session of 1973 AICA conference in Kinshasa, *Compte Rendu in Extenso n. 3- AICA.*

51. James Clifford, *The Predicament of Culture: Twentieth-Century Ethnography, Literature, and Art* (Cambridge, MA: Harvard University Press, 1988), 244.

52. T. Turner, "Clouds of Smoke: Cultural and Psychological Modernization in Zaire," in *Zaire: The Political Economy of Underdevelopment*, ed. Guy Gran (New York: Praeger, 1979), 69–83; Bayart, *Illusion of Cultural Identity*, 39; Achille Mbembe, *On the Postcolony* (Berkeley: University of California Press, 2001), 119.

53. Michael G. Schatzberg, *Political Legitimacy in Middle Africa: Father, Family, Food* (Bloomington: Indiana University Press, 2001), 135.

54. Célestin Badi-Banga ne Mwine, "Sortir du sinistre culturel," in *Quelle politique culturelle pour la Troisième République du Zaïre?*, ed. Guy Gran (Kinshasa: Bibliothéque Nationale du Zaïre, 1992–93), 117–24; interview Shaje A. Tshiluila, 14 September 2011, Kinshasa; interviews Célestin Badi-Banga ne Mwine, 18 May 2006 and 2 September 2011, Kinshasa.

55. These topics emerge in the press with regularity between 1972 and 1976–77, although gradually the attention becomes less serious/in depth and more propagandistic. See, for example, N'Zita Mabiala, "Authenticité," *Elima*, 2 February 1976; Osango-Mbela, "Ce qu'on attendait des intellectuels zaïrois sur le recours à l'authenticité," *Elima*, 13 March 1973; "Les Jalons du recours à l'authenticité," *Salongo*, 13 August 1973; Nzuzi Nzita, "Les characteristiques de l'art nègre," 15 August 1973; Joseph Cornet, "L'aspect culturel de l'art zaïrois," *Salongo*, 5 May 1976; "Les impératifs et motivations de la recherche dans le cadre du recours à l'authenticité," *Salongo*, 9 July 1976; Botolo Magoza Ma Dobo, Makamu Ngangula Mbela, and Manzombi Pibwa Samba, "La question d'une 'science Africaine,'" *Zaïre-Afrique* 15, no. 95 (May 1975): 259–60.

For more on authenticity and modern Zairian art, see chapter 5.

The academic journal *Zaïre-Afrique* (formerly *Congo-Afrique*) is perhaps the best place to trace the impact of authenticité as an intellectual project. Sometimes authenticité was adressed explicitly—see, for example, Ngoma-Binda, "Pour une orientation authentique de la philosophie en Afrique" *Zaïre-Afrique* 17, no. 113 (March 1977): 143–58, and Kapumbe Kongha, "Constat de l'authenticité zaïroise aujourd'hui: Analyses et réflexions critiques," *Zaïre-Afrique* 18, no. 127 (September 1978): 411–18—but more often articles engaged the topic by, for example, discussing what "African values" were.

56. Janvier Musongela, "Redécouvrir notre folklore," *Congo-Afrique* 10, no. 44 (April 1970): 224–27.

57. *Uhuru/L'éclair Etingelle (Organe bi-mensuel de combat et d'opinion du parti de la revolution populaire de Congo-Kinshasa)*, n.d. [1975]; *Le Libérateur (Organe du parti révolutionnaire Marxiste du Congo-Kinshasa)* [1973] I am grateful to Mathieu Zana Etambala for directing my attention to these newspapers, which are kept in the Independent Congo library of the department of History and Politics at the RMCA.

58. "Le Congo ou le Zaïre?" *Le Libérateur* 1(1973).

59. Interview Eugénie Nzembele Safiri, 31 August 2011, Kinshasa; interview Shaje A. Tshiluila; interview Badi-Banga ne Mwine.

60. Interview Kama Funzi Mudindambi, 10 May 2006, Kinshasa.

61. White, "L'incroyable machine de l'authenticité," 46. See chapter 4 for more on Mobutism.

62. Willame, Jean-Claude, *L'Automne d'un despotism: Pouvoir, argent, et obéissance dans le Zaïre des années quatre-vingt* (Paris: Karthala, 1992).

63. "L'intellectuel et son insertion dans les activités culturelles et artistiques," *Salongo*, 2 January 1976; "Clôture du conference de l'art zaïrois," *Salongo*, 27 May 1976.

64. J. H. Merryman, "Two Ways of Thinking about Cultural Property," *American Journal of International Law* 80, no. 4 (1996): 831–53.

65. Ana Filipa Vrdoljak, *International Law, Museums and the Return of Cultural Objects* (Cambridge: Cambridge University Press, 2008), 207; Jeanette Greenfield, *The Return of Cultural Treasures* (Cambridge: Cambridge University Press, 1989), 259.

66. Vrdoljak, *International Law*, 207.

67. David Lowenthal, *The Heritage Crusade and the Spoils of History* (Cambridge: Cambridge University Press, 1998), 242; Barbara Kirshenblatt-Gimblett, "World Heritage and Cultural Economics," in *Museum Frictions: Public Cultures/Global Transformations*, ed. Ivan Karp, Corinne A. Kratz, Lynn Szwaja, and Tomás Ybarra-Frausto (Durham, NC: Duke University Press, 2007), 161–202.

68. RMCA, Dept. of Culture and Society, IMNZ files, Ipoto, Mémoire explicatif, Distr. Générale, A/9199 (Nations Unies, 5 November 1973), 2–3, folder UN resolutie (UN resolution).

69. RMCA, Dept. of Culture and Society, IMNZ files, Projet de Résolution, Distr. Générale, A/9199 (Nations Unies, 5 November 1973), folder UN resolutie (UN resolution.)

70. RMCA, Dept. of Culture and Society, IMNZ files, Panama Representative to the General Assembly, Provisional Verbatim Record of the 2206th Meeting of the 26th Assembly, 18 December 1973, folder UN resolutie (UN resolution.).

71. It should be noted, however, that Belgium did not ratify the UNESCO 1970 convention until 1999 and was thus under no obligation to abide by it.

72. A. Burnet, "Le Musée de Tervuren collabore avec celui de Kinshasa sans être privé par lui de pièces essentielles," *Le Soir*, 8 November 1973.

73. RMCA, Dept. of Culture and Society, IMNZ files, Cahen, "Geschiedenis," folder IMNZ-MRAC Apport.

74. RMCA, Dept. of Culture and Society, IMNZ files, letter from Cahen to Ministry of Foreign Affairs, 28 October 1974, folder lijsten, correspondence, et al. Apport (2), box Restitutie RDC '70-'80.

75. For some examples, see Nzuzi Nzita, "Ce que sera l'expo d'art ancien," *Salongo*, 12 September 1973; Oissa-Fum 'Ukany Iyolela, "Retour au bercail de la statuette ndobh," *Salongo*, 15 April 1976; Moaka Toko, "La protection des oeuvres d'art," *Elima*, 21 March 1973; Bokeme Molobay, "L'art zaïrois n'est pas en retour," *Salongo*, 4 October 1973; Joseph Cornet, "L'aspect culturel de l'art zaïrois," *Salongo*, 5 May 1975; "La préservation de notre passé culturel," *Salongo*, 14 February 1977; Moaka Toko, "La protection des oeuvres d'art," *Elima*, 21 March 1973; Nlaba Ntonto, "Qui sauvera l'art azande," *Elima*, 8 September 1976; Kiekie M. Ngebay, "La restitution des biens culturels volés ou exportés," *Elima*, 5 December 1976; M. T. B., "Ère nouvelle pour la révalorisation de notre patrimoine culturel," *Elima*, 23 September 1977.

76. Interview Tshiluila. On 15 March 1971, the state of Zaire had instated Law 71-016 for the protection of cultural goods, including monuments, sites, and art production. It defined the state as the owner of immovable cultural heritage and decreed it illegal to export any object considered to be part of the cultural heritage of the state. See IMNZ, *IMNZ Rapport 1970–1971* (Kinshasa: IMNZ, 1972), 10–20. Unfortunately, the application of this law was erratic at best.

77. Gauthier de Villers, *De Mobutu à Mobutu: Trente ans de relations Belgique-Zaïre* (Brussels: De Boeck, 1995), 63–65; Ibou Diaïte, "La coopération Belgo-zaïroise: Le maquillage d'une domination," in *Conflit Belgo-Zaïrois*, ed. Ibrahima Baba Kaké (Paris: Présence Africaine, 1990), 135–64; Vanthemsche, *Congo*, 255–59.

78. RMCA, Dept. of Culture and Society, IMNZ files, Position zaïroise au colloque d'UNESCO à Venise, April 1976, folder 2, folder lijsten, correspondence, et al. Apport (2) box Restitutie RDC 70–80.

79. RMCA, Dept. of Culture and Society, IMNZ files, Notes Cahen, n.d., folder IMNZ-MRAC Apport.

80. Ibid.

81. Joseph Cornet claims Blondeau collected it in 1924. Boris Wastiau places the moment of collection between 1925 and 1930. The statue probably represents King Mbop a'Kyeen, who died at the end of the nineteenth century.

The "authenticity" of the various later generations of ndop is heavily debated. See Jan Vansina, "Ndop: Royal Statues among the Kuba," in *African Art and Leadership*, ed. Douglas Fraser and Herbert M. Cole (Madison: University of Wisconsin Press, 1972), 41–53; Wastiau, *Congo-Tervuren, Aller-Retour* (Tervuren: RMCA, 2001), 22–23; David A. Binkley and Patricia J. Darish, *Kuba*, Visions of Africa Series (Milan: 5 Continents Editions, 2009), 31–34 and 120; Joseph Cornet, "African Art and Authenticity," *African Arts* 9, no. 1 (October 1975): 52–55; and Cornet, *Art Royal Kuba* (Milan: Edizioni Sipiel Milano, 1982), 50–125.

82. Bayart, *Illusion of Cultural Identity*, 26.

83. RMCA, Dept. of Culture and Society, IMNZ files, List of objects belonging to the Musée de la Vie Indigène, signed by Albert Maesen and Jean Vanden Bossche, 11 August 1960, folder lijsten, correspondence, et al. Apport (2) folder 2, box Restitutie RDC, 1970–1980; and letter from Maesen to Alma Robinson, 18 April 1978, folder Contentieux+ Historique

84. The museum passed into the hands of the Congolese state upon the departure of its director, Jean Vanden Bossche, in 1961.

85. RMCA, Dept. of Culture and Society, IMNZ files, letter from Cahen to Ministry of Foreign Affairs, 14 February 1977, and notes from phone conversation between M. Jaenen and M. Maesen, 10 March 1977, folder 1e Expedition, box Restitutie RDC 1970–1980, emphasis in original.

86. The IRSAC was a Belgian research institute with branches in Congo and Rwanda. Its research activities consisted mostly of linguistic and social anthropology. Jan Vansina also wrote extensively about his time there in his autobiography *Living with Africa* (Madison: University of Wisconsin Press, 1994).

87. Dirk Thys Van den Audenaerde, "Het Museum te Tervuren: Een Historisch Overzicht," in *Africa Museum Tervuren*, ed. Van den Audenaerde (Tervuren: KMMA, 1998), 19–20.

88. For a complete annotated list of these 114 objects, see Wastiau, *Aller-Retour*,15–54.

89. Institut des Musées Nationaux du Congo (IMNC) Kinshasa, Museum Archive, letter from A. Lebrun, Ministry of Foreign Affairs to the Belgian Embassy in Kinshasa, 15 June 1982, unmarked folder.

90. Interview Huguette Van Geluwe; interview Tshiluila.

91. Saloni Mathur, *India by Design: Colonial History and Cultural Display* (Berkeley: University of California Press, 2007), 139.

92. Huguette Van Geluwe, "Belgium's Contribution to the Zairian Cultural Heritage," *Museum* 31, no. 1 (1979): 32–37. Ironically, one of the archival boxes in the RMCA archives that holds the material concerning the shipments has "restitution" (*restitutie*) written on it in large letters.

93. Interview with Nestor Seeuws, Ghent, 5 October 2005, and personal correspondence with Boris Wastiau, 28 February and 6 March 2012. In 2000, Wastiau, then a curator at the RMCA, devoted a small volume to the 114 objects that came from the Tervuren collections. Wastiau, *Congo-Tervuren, Aller-Retour*.

94. Kwame Anthony Appiah, *Cosmopolitanism: Ethics in a World of Strangers* (New York: Norton, 2006), 115–35.

95. http://icom.museum/fileadmin/user_upload/pdf/ICOM_News/2004-1/ENG/p4_2004-1.pdf. Last accessed 7 August 2013.

96. Kwame Opoku, "Is the Declaration on the Value and Importance of the 'Universal Museums' Now Worthless? Comments on Imperialist Museology." http://www.museum-security.org/opoku_universal_museums.htm. Last accessed 8 August 2013.

97. Homi K. Bhabha, *The Location of Culture* (London: Routledge, 1994), 51–52.

98. Bayart, *Illusion of Cultural Identity*, 71–77.

CHAPTER 4: MOBUTU'S MUSEUM

1. Carol A. Breckenridge, "The Aesthetics and Politics of Colonial Collecting: India at World Fairs," *Comparative Studies in Society and History* 31, no. 2 (April 1989): 211. Breckenridge is referencing colonial collecting and displaying practices with these words, but I believe they are equally suitable to this situation.

2. Lyn Schumaker, *Africanizing Anthropology: Fieldwork, Networks, and the Making of Cultural Knowledge in Central Africa* (Durham, NC: Duke University Press, 2001); Helen Tilley, *Africa as a Living Laboratory. Empire, Development and the Problem of Scientific Knowledge, 1870–1950* (Chicago: University of Chicago Press, 2011). See also Jean-Hervé Jezequal, "Voices of Their Own? African Participation in the Production of Knowledge in French West Africa, 1910–1950," in *Ordering Africa: Anthropology, European Imperialism and the Politics of Knowledge*, ed. Helen Tilley and Robert Gordon (Manchester: University of Manchester Press, 2007), 145–73; Sara Pugach, "Of Conjunctions, Comportment and Clothing: The Place of African Teaching Assistants in Berlin and Hamburg, 1889–1919," in Tilley and Gordon, *Ordering Africa*, 119–44.

3. Dipesh Chakrabarty, *Provincializing Europe: Postcolonial Thought and Historical Difference* (Princeton, NJ: Princeton University Press, 2000).

4. Mwamba, "Les musées: Des véritables centres d'animation culturelle," *Salongo*, 29 January 1973.

5. The museums in Leopoldville and Elisabethville had diminished operations, but the museum in Luluabourg expanded after the end of the Kasai civil war in 1963.

6. Vanden Bossche's departure coincides with the start of the civil war. Interestingly, during the 1960s, the number of Belgian visitors declined but that of American visitors rose steeply. The museum closed its doors on 7 December 1965. IMNC, Library Collection, *Livre D'Or du Musée de la Vie Indigène*.

7. ANC, MPR files, Interview du Chef de l'Etat Mobutu Sese Seko Kuku Ngbendu Wa La Banga, accordée à un groupe de journalistes Belges à Kinshasa, 25 October 1973.

8. Interview with Kama Funzi Mudindambi, 10 May 2006, Kinshasa.

9. Interview Rik Ceyssens, 10 August 2011, Helchteren. Interview Isak Kisimba Mwaba, 13 April 2006, Lubumbashi.

10. The wealthy mining province of Katanga declared its secession from Congo a mere two weeks after Congolese independence. Moïse Tshombe led the secession with the tacit support of the Belgian government and the US embassy, who saw an opportunity to safeguard their interest in the region's mining riches. The Congolese government, led by Patrice Lumumba, asked for the UN's intervention.

11. Henri Bundjoko Banyata, "Le musée national de Lubumbashi comme lieu de sociabilité et d'élaboration culturelle," in *Tout Passe: Instantanés populaires et traces du passé à Lubumbashi*, ed. Danielle de Lame and Donatien Dibwe dia Mwembu, Cahiers Africaines 71 (Paris: L'Harmattan, 2005).

12. Interview Isak Kisimba Mwaba, 13 April 2006, Lubumbashi.

13. Cornet arrived in Congo at the age of forty-five, after having completed his PhD in architectural history on the Romanesque cathedral of Tournai. Louis de Strycker, "In Memoriam, Joseph-Aurélien Cornet," *African Arts* 37, no. 2 (2004): 10; interview Joseph Cornet by Léon Verbeek, 15 September 2002, Liège.

14. Seeuws grew up in the Flemish city of Ghent as one of the many children in an upper-class family active in the regional industry. After finishing degrees in law, history, and eastern languages, he left for Congo in 1956 to work as a territory administrator in the Oschwe region, for a period of two years, and later as a legal adviser in Elisabethville. Interview Nestor Seeuws, 5 October 2005, Ghent.

15. He ran a jazz club in Brussels prior to leaving for Zaire. Quersin died in 1993. www.jazzinbelgium.com/musician/benoit.quersin, last accessed 12 September 2012; phone interview with Alex Shoumatoff, 15 September 2012.

16. Gary Steward, *Rumba on the River: A History of the Popular Music of the Two Congos* (New York: Verso, 2000), 84, 87–88. Hénault died in 2011.

17. See chapter 3 for more on Powis.

18. Barthélémy Bisengimana Rema was a Tutsi of Rwandan origin, educated at the Lovanium University in Kinshasa, where he was one of the first two students to graduate as civil engineers. He became head of the Presidential Office in May of 1969, a post he held until February 1977. Crawford Young and Thomas Turner, *The Rise and Decline of the Zairian State.* (Madison: University of Wisconsin Press, 1985), 167; Ndaywel è Nziem, *Histoire Générale du Congo*, 703–4.

19. Kama says that he spent a total of twelve years in politics. He worked for Mushiete, a playwright, when the latter was a minister of culture and arts in 1968. It is unclear when exactly he left the presidential office, but there is no correspondence with him after 1975, when the Institute passed to the authority of the department of culture and arts. Interview Kama.

20. Higher education was only developed toward the end of the colonial era in Congo. The first university, Lovanium, was established in Leopoldville in 1954 by the Catholic University of Leuven in Belgium, and the secular University of Elisabethville was created in 1956 but had not yet graduated students

at the time of independence. The universities were reorganized as the National University of Zaire under Mobutu in 1971, after clashes between the students and the Mobutist state. See Ruben Mantels, "De klacht van Nkunda: Over universiteiten, kolonisatie en dekoloniatie in Belgisch-Congo," *Studium* 3, no. 2 (2010): 61–73; and René Devisch, "The University of Kinshasa: From Lovanium to Unikin," in *Higher Education in Postcolonial Africa: Paradigms of Development, Decline and Dilemmas*, ed. Michael O. Afoláyan (Trenton, NJ: Africa World Press, 2007), 17–38.

21. By the time of his death in 2004 he was slowly being rehabilitated into the museum. Annemieke Van Damme-Linseele, "Homage to Dr. Alphonse Lema Gwete," *African Arts* 38, no. 1 (Spring 2005): 10.

22. She started her career at the museum in Lubumbashi but was moved to the headquarters of the IMNZ in Kinshasa in the early 1970s. *Africa's Who's Who* (London: Africa Books, 1996), 1408; interview Shaje A. Tshiluila, 14 September 2011, Kinshasa.

23. Jean Lemba, who was hired with the idea of integrating him into the scientific staff, was fired in 1976 for unauthorized use of a vehicle belonging to the IMNZ.

24. He eventually completed his PhD in anthropology and is still employed by the IMNC today, despite his rumored association with art smuggling scandals. RMCA, Dept. of History and Politics, IMNZ files, letter from Nestor Seeuws to Lucien Cahen, 26 December 1973, folder 1973, box 28-II-77.

25. Interview Marcel Bétu, 8 May 2006, Kinshasa; interview N'Kanza Lutayi, 3 May 2006, IMNC Kinshasa. Both N'kanza and Bétu still work at the museum.

The museum's current director, Joseph Ibongo, arrived at the institute in the 1980s and studied modern Zairian art under the guidance of Cornet.

26. RMCA, Dept. of History and Politics, IMNZ files, letter from Cahen to Cornet, 15 October 1974, folder Affaire Bope Valentin, box "personeel" (staff).

27. RMCA, Dept. of History and Politics, IMNZ files, letter from Varine-Nohan to Cahen, 12 August 1970, folder ICOM/UNESCO, box 15-2-77.

28. Boilo, head of the museum in Mbandaka, and Rik Ceyssens, a former collaborator with the Kananga museum, confirm this was the case. Interview Boilo Mbula Yomamo, 2 September 2011, Kinshasa; interview Ceyssens.

29. RMCA, Dept. of History and Politics, IMNZ files, Correspondence Cahen-de Poerck, 1970, folder Lubumbashi, box 15-2-77.

30. Mwamba, "Les musées: Des véritables centres d'animation culturelle," *Salongo*, 29 January 1973.

31. Yamaïna, "L'AICA à la rencontre de l'Afrique," *Elima*, 20 September 1973; Mbamba Toko W., "Pour une révalorization des nos arts plastiques," *Elima*, 20 January 1977.

32. Daniel J. Sherman, *French Primitivism and the Ends of Empire, 1945–1975* (Chicago: University of Chicago Press, 2011), 65. In Christopher Steiner's description of the French West African art market, African middlemen already

traveled to France in the 1950s to sell to European art dealers. Because of strict limitations on travel for Congolese subjects, this kind of traffic did not occur between Congo and Belgium. Christopher Steiner, *African Art in Transit* (Cambridge: Cambridge University Press), 5–7.

33. Interview Ceyssens; interview Kisimba Mwaba.

34. Raymond Corbey, *Tribal Art Traffic: A Chronicle of Taste, Trade and Desire in Colonial and Post-Colonial Times* (Amsterdam: Royal Tropical Institute, 2000), 75; and Steiner, *African Art in Transit,* 7. The same occurred in former French colonies: Denise Paulme, "Les Collections d'Afrique Noire depuis 1945," *Objets et Mondes: Revue du Musée de l'Homme* 1, no. 1 (1961): 41–42.

35. IMNZ, *IMNZ Rapport 1970–1971* (Kinshasa: IMNZ, 1972), 10–20. The gains from this tax went to the Ministry of Arts and Culture. RMCA, Dept. of History and Politics, IMNZ files, Arrête, 1975, Article 4, box 15-2-77.

36. This was the case with, for example, Luba seats, popularized by Frans Olbrechts's description of the "Master of Buli." Hence, the making of replicas flourished.

37. Corbey, *Tribal Art Traffic,* 75–77, 172; interview Marc Leo Felix, 3 September 2012, Watermaal.

38. While the contextual information made a piece more reliable for museums, or in the process whereby it was sold to collectors, once the objects become embedded in western collections, this context is muted in favor of a different provenance, namely that of the object's journey though the collections of western art dealers, collectors and museums.

39. Loyola New Orleans (LOY NOLA), Special Collections, Cornet files, letter from Cahen to Seeuws, 30 August 1971, Binder Correspondance "C."

40. Interview Felix.

41. RMCA, Dept. of History and Politics, IMNZ files, letter from Cahen to Seeuws, 30 August 1971, folder Courrier 1971, box 15-2-77.

42. Christopher Steiner, in his study of the postcolonial art market in former French West Africa, has demonstrated how well African traders understood—and manipulated—the parameters of "authenticity" in their interactions with buyers. Steiner, *African Art in Transit,* 101–6.

43. RMCA, Dept. of History and Politics, IMNZ files, letter from Kama to Cahen, 4 October 1973, folder Mobutu, Bisengimana, Kama, box 15-2-77.

44. Guy de Plaen of the museum in Lubumbashi was also opposed to working with foreign dealers and was known to refuse collaboration with collectors with whom the museum in Kinshasa worked. RMCA, Dept. of History and Politics, IMNZ files, letter from Cahen to Cornet, 26 July 1973, folder Lubumbashi, box 15-2-77.

45. Interview Alan Davis (former American diplomat in Zaire), February 2006, Washington, DC; LOY NOLA, Cornet Files, Correspondence between Davis and Cornet, Binder Correspondance "D" Bill Bertrand on inspiration for collecting and the Cornet and Hénault's philosophy of preservation in "Restoring an African Art Collection," *Global Health Newsletter* 8, no. 1

(Spring–Summer 2008): 6–7. Bertrand, an epidemiologist who spent time in Zaire in the 1980s and 1990s, donated a part of his collection to the Southern University in New Orleans.

46. RMCA, Dept. of History and Politics, IMNZ files, letter from Seeuws to Cornet, 30 January 1973, folder 1973, box 28-II-77.

47. Interview Ceyssens.

48. On Kuba art as an export product, see table 3.3 in Lobo Bundwoong, *Afrikanische Gesellschaft im Wandel: Soziale Mobilität und Landflucht in Zaire* (Frankfurt a.M.: Brandes & Apsel, 1991), 33–34.

49. Janet MacGaffey has described these activities as the "rent-seeking activities of state personnel." Janet MacGaffey, *The Real Economy of Zaire: The Contribution of Smuggling and Other Unofficial Activities to National Wealth* (Philadelphia: University of Pennsylvania Press, 1991), 33.

50. RMCA, Dept. of History and Politics, IMNZ files, letter from Cornet to Bokonga, 15 July 1975, folder Ministerie van Kultuur Congo, box 15-2-77.

51. Interview Felix.

52. LOY NOLA, Cornet Files, letter from Cahen to Cornet, 5 April 1971, binder correspondence "C."

53. RMCA, Dept. of History and Politics, IMNZ files, letter from Seeuws to Cahen, 14 April 1971, folder 1971, box 28-11-77. Kerchache later achieved fame as a collector and for inspiring French president Jacques Chirac to build the (much-criticized) Museum of Quai Branly. See Sally Price, *Paris Primitive: Jacques Chirac's Museum on the Quai Branly* (Chicago: University of Chicago Press, 2007).

54. LOY NOLA, Cornet Files, letter from Cahen to Cornet, 5 April 1971, binder correspondence "C." The letter also mentions Pierre and Jean-Claude Vidal of Belgium (possibly related to art dealer George Vidal in Paris), as well as Alain Chaffin and Alain Schoffel, who posed as French students. Duponcheel published *Esthétique Nègre* in 1970 (by Cowries Galleries, Brussels).

55. RMCA, Dept. of History and Politics, IMNZ files, letter from Seeuws to Kama and Cahen, 30 April 1973, folder Mobutu, Bisengimana, Kama, box 15-2-77.

56. RMCA, Dept. of History and Politics, IMNZ files, letter from Seeuws to Cahen, 2 October 1975, folder/box Amb. Burundi.

57. Guy Gran, ed., *Zaire: The Political Economy of Underdevelopment* (New York: Praeger, 1979); Michael G. Schatzberg, *Politics and Class in Zaire: Bureaucracy, Business and Beer in Lisala* (New York: Africana, 1980).

58. Probably a Yombe statue. See Joseph Cornet, *Kongo: Objets de bois, objets d'ivoir* (Paris: Galerie Leloup, 1998), 34–35, for a similar example.

59. RMCA, Dept. of History and Politics, IMNZ files, Dossier vol Boma, folder/box Amb-Burundi.

60. RMCA, Dept. of History and Politics, IMNZ files, Correspondence Collection Scheut, folder Collection des Crucifix, box "personeel."

61. At this point de Plaen was made the provisional head of the museum. RMCA, Dept. of History and Politics, IMNZ files, letter from Cornet to Cahen, 7 June 1972, folder 1972, box 28-II-1977.

62. RMCA, Dept. of History and Politics, IMNZ files, letter from Cornet to Cahen, 7 November 1972, folder 1972, box 28-II-1977.

63. RMCA, Dept. of History and Politics, IMNZ files, letter from Cahen to Cornet, n.d., folder courrier adressé à l'IMNZ, box 28-II-1977.

64. RMCA, Dept. of History and Politics, IMNZ files, letter from Cornet to Cahen, 26 December 1972 and letter from Lema Gwete to Cahen, 7 June 1973, folder courrier adressé à l'IMNZ, box 28-II-1977.

65. Personal correspondence Allen F. Roberts, 30 March 2009.

66. The—notorious—security service of the Zairian state, feared by its population. Michael G. Schatzberg, *The Dialectics of Oppression in Zaire* (Bloomington: Indiana University Press, 1988), 38–48.

67. Interview Guy de Plaen, 2 January 2007, Wellin.

68. All documents and correspondence concerning the theft can be found in RMCA, Dept. of History and Politics, IMNZ files, folder Lubumbashi, box 15-2-77.

69. Media coverage tends to mention the higher number of objects collected. It is very difficult to get an exact estimate, since the catalog in Kinshasa is now incomplete. Employees of the IMNZ tend to place the number of acquired objects around 35,000. See the appendix for a complete overview of the expeditions.

70. There are no records remaining for the expeditions that left from the Lubumbashi museum.

71. The exception are Cornet's research journals. They are now among his papers in the Special Collections of the J. Edgar and Louise S. Monroe Library at Loyola University in New Orleans. However, they do not document IMNZ missions but are focused on his personal research on the Kuba in the Kasai.

72. RMCA, Dept. of History and Politics, IMNZ files, letter from Seeuws to Cornet, 26 February 1972, folder 1972, box 28-II-77.

73. Frederick Starr and Herbert Lang already reported "fakes" in the early twentieth century. Schildkrout, "Personal Styles and Disciplinary Paradigms," 181–85, 189–91.

74. RMCA, Dept. of History and Politics, IMNZ files, letter from Seeuws to Cahen, 4 August 1971, folder 1971, box 28-II-77.

75. Christopher Steiner notes the Senegalese became active as (art) traders because they had the privilege of being able to move freely around French West Africa as soldiers. By the 1950s three West African groups were particularly active in the African art market: the Wolof of Senegal, the Hausa, and the Mande, all communities that were traditionally involved with trading. Steiner, *African Art in Transit*, 4–5. The information about the presence of Senegalese traders in Eastern Zaire in the 1970s suggests that the Wolof had extended their trade into central Africa by that time.

76. RMCA, Dept. of History and Politics, IMNZ files, letter from Seeuws to Cornet, 19 April 1972, folder 1972, box 28-II-77.

77. RMCA, Dept. of History and Politics, IMNZ files, letter from Seeuws to Cornet, 13 May 1972, folder 1972, box 28-II-77.

78. Interview Zola Kwandi Mpungu Mayala, 2 June 2006, Kinshasa.

79. RMCA, Dept. of History and Politics, IMNZ files, letter from Seeuws to Cornet, 30 January 1973, folder1973, box 28-II-77.

80. Seats supported by kariatides, also found among the Luba. François Neyt and Louis de Strycker, *Approche des arts Hemba* (Villiers-le-Bel, France: Arts d' Afrique Noire, 1975), 40.

81. RMCA, Dept. of History and Politics, IMNZ files, letter from Seeuws to Cornet, 2 May 1972, folder1972, box 28-II-77.

82. Schumaker, *Africanizing Anthropology*, 90–226. Donna Haraway, *Primate Visions: Race, Gender and Nature in the World of Modern Science* (New York: Routledge, 1989), 46–54; and Roger Sanjek, "Anthropology's Hidden Colonialism: Assistants and Their Ethnographers," *Anthropology Today* 9, no. 2 (1993): 13–18.

83. Interview Zola.

84. Interview Eugénie Nzembele Safiri, 31 August 2011.

85. RMCA, Dept. of History and Politics, IMNZ files, letter from Seeuws to Cornet, 13 May 1972, folder 1972, box 28-II-77.

86. Katanga was renamed Shaba under the Mobutu regime, although the use of its earlier name never completely disappeared. It was renamed Katanga in 1997.

87. IMNZ, *Rapport 1970–1971*, 31–38.

88. Among the Mangbetu, the producing of material commissioned by Europeans already existed at the start of the twentieth century. Schildkrout and Keim make the point that this did not mean the production existed solely for outsider interest. Enid Schildkrout and Curtis A. Keim, *African Reflections: Art from Northeastern Zaire* (New York: American Museum of Natural History, 1990), 19, 26–27.

89. RMCA, Dept. of History and Politics, IMNZ files, letter from Seeuws to Cornet, 5 February 1973, folder 1973, box 28-II-77.

90. RMCA, Dept. of History and Politics, IMNZ files, letter from Seeuws to Cahen, 9 February 1973, folder 1973, box 28-II-77.

91. RMCA, Dept. of History and Politics, IMNZ files, letter from Seeuws to Cornet, 13 May 1972, folder 1972, box 28-II-77.

92. Interview N'Kanza Lutayi; interview Bétu.

93. LOY NOLA, Cornet Files, letter from Cahen to Seeuws, 30 August 1971, binder correspondance "C."

94. Interview Ceyssens.

95. RMCA, Dept. of History and Politics, IMNZ files, letter from Cahen to Cornet, 31 May 31 1971, folder 1971, box 28-II-1977.

96. Although this was the case in Zaire, it was not universally so. In some locations, locally situated material and traditions could be integrated into the cultural tourism, a somewhat different kind of heritage economy. Barbara Kirshenblatt-Gimblett, "World Heritage and Cultural Economics," in *Museum Frictions: Public Cultures/Global Transformations*, ed. Ivan Karp, Corinne A. Kratz, Lynn Szwaja, and Tomás Ybarra-Frausto (Durham, NC: Duke University Press, 2007), 183.

97. Kirshenblatt-Gimblett, "World Heritage and Cultural Economics," 183.

98. This kind of nationalization process was not unique to Zaire. In Ghana, traders deemed to be "foreign" were ousted, and the privileges of nationals in industry were also pushed in places like Nigeria and Uganda. Zairization did not affect all foreign-owned companies. Its content was vague but affected light industry, plantations, and the commercial sector the most (Young and Turner, *Rise and Decline of the Zairian State*, 327–28, 342).

99. MacGaffey, *Real Economy of Zaire*, 28, and "State Deterioration and Capitalist Development: The Case of Zaire," in *African Capitalists in African Development*, ed. Bruce J. Berman and Colin Leys (London: Lynne Rienner, 1994), 191–93.

100. RMCA, Dept. of History and Politics, IMNZ files, Correspondence between Lucien Cahen and Kama Funzi Mudindambi, 1973–1975, folder Mobutu–Bisengimana–Kama, box 15-2-77; interview Kama Funzi Mudindambi, 10 May 2006, Kinshasa.

101. RMCA, Dept. of History and Politics, IMNZ files, letter from Kama to Cahen, 24 April 1974, folder Mobutu–Bisengimana–Kama, box 15-2-77.

102. RMCA, Dept. of History and Politics, IMNZ files, letter from Cahen to Kama, 13 June 1976, and response, s.d., folder Mobutu–Bisengimana–Kama, box 15-2-77.

103. Which included ethnographic, archeological, biological, and geological research, among others.

104. RMCA, Dept. of History and Politics, IMNZ files, letter from Cahen to Kama, 8 November 1974, folder courrier reçu de l'IMNZ, box 28-II-77.

105. RMCA, Dept. of History and Politics, IMNZ files, letter from Kama to Cahen, 12 March 1974, folder Mobutu–Bisengimana–Kama, box 15-2-77.

106. RMCA, Dept. of History and Politics, IMNZ files, letter from Cahen to Kama, 8 November 1974, folder Mobutu–Bisengimana–Kama, box 15-2-77.

107. RMCA, Dept. of History and Politics, IMNZ files, letter from Cahen to Cornet, 14 June 1974, folder Planification des Missions, box 28-II-1977.

108. Cahen's son, Daniel Cahen, was also an archeologist who participated in fieldwork in Zaire via the RMCA and IMNZ. RMCA, Dept. of History and Politics, IMNZ files, Correspondence between Cahen and Cornet, 1975–76, folder/box Amb. Burundi; interview Daniel Cahen, 9 August 2010, Eigenbrakel.

109. RMCA, Dept. of History and Politics, IMNZ files, "Note confidentielle sur l'organisation et l'évolution de L'Institut des Musées Nationaux du Zaïre" (Cahen), 31 October 1973, folder Mobutu–Bisengimana–Kama, box 15-2-77.

110. RMCA, Dept. of History and Politics, IMNZ files, letter from Kama to Cahen, 29 November 1974, folder Mobutu–Bisengimana–Kama, box 15-2-77.

111. Interview De Plaen.

112. RMCA, Dept. of History and Politics, IMNZ files, letter from Cornet to Cahen, 27 October 1974, folder Planification des Missions, box 28-II-1977.

113. Which he saw through the perspective of the ethnography section, with Maesen and Van Geluwe, who were both Flemish. Interview Felix; personal correspondence Jan Vansina, 6 July 2013.

114. My interviews with Shaje, Nzembele, Bétu, Zola, Kama, and Felix confirm this growing distrust of the Belgian staff in Kinshasa by Tervuren.

115. Frederick Cooper and Laura Ann Stoler, eds., *Tensions of Empire: Colonial Cultures in a Bourgeois World* (Berkeley: University of California Press, 1997), 8–9.

116. Devisch, "University of Kinshasa," 19; Osango-Mbela, "Ce qu'on attendait des intellectuels zaïrois sur le recours à l'authenticité," *Elima*, 13 March 1973.

117. Osango-Mbela, "Ce qu'on attendait des intellectuels zaïrois sur le recours à l'authenticité," *Elima*, 13 March 1973.

118. Lema at the Catholic University of Leuven under the guidance of Albert Maesen, the others at the Free University of Brussels.

119. Among those affiliated with IRSAC were Jan Vansina and Daniel Biebuyck. See Jan Vansina, *Living with Africa* (Madison: University of Wisconsin Press, 1994).

120. Joseph Cornet, *Art Royal Kuba* (Milan: Edizioni Sipiel Milano, 1982).

121. Cornet managed to have a part of the royal compound disassembled and transported to the IMNZ in Kinshasa, where it still sits in the storerooms.

122. It should be noted no European ever occupied the position of assistant researcher or technician. Schumaker came to the same conclusion in her book on the research activities at the Livingstone-Rhodes Institute in Northern Rhodesia (Zambia). Says Schumaker, "The only continuity was that all research assistants in the RLI's history *were* Africans" Schumaker, *Africanizing Anthropology*, 192. Italics in original.

123. Interview Eugénie Nzembele Safiri, 31 August 2011, Kinshasa.

124. "On n'a pas confiance, on a confiance aux Européens . . . il y a un mépris." Interview Nzembele.

125. Schumaker, *Africanzing Anthropology*, 192.

126. Interview Nzembele.

127. Interview Tshiluila. Lema Gwete did his doctoral fieldwork with the Teke, but in later years he also spent time in different regions of the country.

128. Aside from Lema Gwete's doctoral thesis on the sculpture of the Teke, there was N'Kanza research on metal working in the Lower Zaire, and Esol'eka Likote's in the Bandundu region with the Ntomba. Interview N'Kanza Litayi; IMNC, Museum Archive, Nestor Seeuws, "Rapport concernant les travaux des consultants nationaux," 1986.

129. IMNC, Museum Archive, Nestor Seeuws, "Rapport concernant les travaux des consultants nationaux," 1986.

130. Interview Cahen; Henry John Drewal, "African Art Studies Today," in *African Art Studies, the State of the Discipline*, ed. Rowland Abiodun (Washington, DC: National Museum of African Art, 1990), 40.

131. Although *authenticité* was supplanted by Mobutism, it did not entirely disappear. The mass *animation culturelle et politique* happenings continued to exist, but they were now often openly rituals for the celebration of the "big chief," which is clear from the content of the performances Kapalanga

describes in his work (although he does not draw this conclusion.) Kapalanga, *Les spectacles d'animation politique en République du Zaïre* (Louvain-la-Neuve, Belgium: Cahiers Théâtre Louvain, 1989), 149–225.

132. M. Catharine Newbury, "Dead and Buried or Just Underground? The Privatization of the State in Zaire," *Canadian Journal of African Studies* 18, no. 1 (1984): 114.

133. Young and Turner, *Rise and Decline of the Zairian State*, 216–17.

134. Michael G. Schatzberg, *Political Legitimacy in Middle Africa: Father, Family, Food* (Bloomington: Indiana University Press, 2001).

135. Diyembwa Kumpovela, "Promouvoir le role du musée en tant qu'institution nationale d'instruction," *Salongo*, 6 December 1972; Moaka Toko, "La protection des oeuvres d'art," *Elima*, 21 March 1973; Ngoy Kikungula wa Maloba, "Le Musée de l'Equateur et ses problèmes," *Elima*, 1 February 1976; N'Zita Mabiala, " L'exposition des Musées Nationaux: Un échec?" *Elima*, 22 July 1976.

136. The ordinary budget went from 74,538.42 zaires for nine months in 1971, 115.248 zaires for 1972, 222,386.66 zaires in 1973, 241.918,04 zaires in 1974, and 311,753.98 zaires in 1975. RMCA, Dept. of History and Politics, IMNZ files, Budgets 1971–75, folders budgets, box 15-2-77. Unfortunately, there are no budget numbers available after the IMNZ went to the Department of Culture and Arts in 1975.

137. RMCA, Dept. of History and Politics, IMNZ files, letter from Cornet to Cahen, 26 April 1976, folder/box Amb. Burundi.

138. RMCA, Dept. of History and Politics, IMNZ files, letter from Cahen to Powis, 13 May 1975, folder courrier adressé à l'IMNZ, box 28-II-1977.

139. RMCA, Dept. of History and Politics, IMNZ files, letter from Cornet to Citoyenne Mbamba Yowa Mabinda Kapinga, 15 July 1975, folder commissariat d'état, box 15-2-77.

140. IMNC, Museum Archive, letter from Seeuws to Powis, 19 March 1976, folder Arrangement particulier Belgique-Zaïre.

CHAPTER 5: CIVILIZING CITIZENS?

1. Ruth B. Phillips and Christopher B. Steiner, "Art, Authenticity and the Bagage of Cultural Encounter" in *Unpacking Culture: Art and Commodity in Colonial and Postcolonial Worlds*, ed. Ruth B. Phillips and Christopher B. Steiner (Berkeley: University of California Press, 1999), 10.

2. Carol Breckenridge illustrates how colonial collecting in India influenced the representation and placement of objects in the service of commerce and the British modern nation-state and created new modes of valuing that were radically different from those of the past. I investigate whether the postcolonial status of the Zairian state was accompanied by such a shift. Carol Breckenridge, "The Aesthetics and Politics of Colonial Collecting: India at World Fairs," *Comparative Studies in Society and History* 31, no. 2 (April 1989): 195–96.

3. Geeta Kapur, "Contemporary Cultural Practice. Some Polemical Categories," in *The Third Text Reader on Art, Culture and Theory*, ed.

Rasheed Araeen, Sean Cubitt, and Sardar Ziauddin (London: Continuum, 2002), 22.

4. Bernard Toulier, Johan Lagae, and Marc Gemoets, *Kinshasa: Architecture et paysage urbains* (Paris: Somogy éditions d'art, 2010), 38–39, 110–111. On the relationship between the colonial built environment and the postcolonial cityscape, see Johan Lagae, "Colonial Encounters and Conflicting Memories: Shared Colonial Heritage in the Former Belgian Congo," *Journal of Architecture* 9, no. 2 (Summer 2004): 173–97.

5. Henri Puyts had two local architects working for him, Raymond Sion and Justin Mukwanga. RMCA, Dept. of History and Politics IMNZ files, folder Bouwplannen (Building plans), box 15-2-77.

6. Tony Bennett, *The Birth of the Museum: History, Theory and Politics* (New York: Routledge, 1995), 75.

7. Although Bennett referred specifically to the late nineteenth century in his description of the exhibitionary complex, the concept has bee applied by many other museum scholars to different contexts. See Barbara Kirshenblatt-Gimblett, "Exhibitionary Complexes," and Tony Bennett, "Exhibition, Difference and the Logic of Culture," in *Museum Frictions: Public Cultures/Global Transformations*, ed. Ivan Karp, Corinne A. Kratz, Lynn Szwaja, and Tomás Ybarra-Frausto (Raleigh, NC: Duke University Press, 2007), 35–45 and 46–69.

7. RMCA, Dept. of History and Politics, IMNZ files, letter from Puyts to Cahen, 8 October 1970, Folder Bouwplannen, box 15-2-77.

8. INMZ, *IMNZ Rapport 1970–1971* (Kinshasa: IMNZ, 1972), 24. Altough not explicitly mentioned, it appears ethnographic collections would also be part of the museum's collections.

9. RMCA, Dept. of History and Politics, IMNZ files, letter from Powis to Cahen, s.d. folder Powis, box 28-II-77.

10. RMCA, Dept of History and Politics, IMNZ files, letter from Powis to Cahen, 3 February 1973, folder Powis, box 28-II-77.

11. RMCA, Dept. of History and Politics, IMNZ files, letter from Cahen to Nadaillac, Centre d'Etudes Nucléaires de Grenoble, n.d. (1971), folder 1971, box 28-II-77.

12. AICA is an organization under the patronage of UNESCO that works to promote the global freedom and diversity of art criticism. Many of its activities have been geared toward the support of modern art movements in developing countries.

13. Participating countries were the German Democratic Republic and the German Federal Republic, Argentina, Belgium, Brazil, the United Kingdom, Canada, the United States of America, France, the Netherlands, Italy, Japan, Mexico, Romania, Switzerland, Yugoslavia, and Sweden. There were international organizations from the OAU, the European Council, UNESCO, and UNICEF.

14. John Canaday, "Kinshasa: Extraordinary Congress," *New York Times*, 8 October 1973.

15. RMCA, Dept. of History and Politics, IMNZ files, letter from Cahen to Cornet, n.d., folder 1973, box 28-II-77.

16. Institut des Musées Nationaux du Zaïre, *Trésors de l'art traditionnel* (Kinshasa: IMNZ, 1973), 8.

17. Ibid., 9.

18. Bokonga Ekanga Botembele, "Preface," in ibid., 1–2.

19. Ibid.

20. The drum is probably Loi, from the Equator region. A very similar one can be found in the Tervuren collection (see Gustaaf Verswijver, Els De Palmenaer, Viviane Baeke, and Anne-Marie Verswijver, eds., *Schatten uit het Afrika-Museum Tervuren* (Tervuren: RMCA, 1995), 394.

21. Interview Shaje A. Tshiluila, 14 September 2011, Kinshasa.

22. This was probably due to Joseph Cornet's good connections there. It was at the academy that he started his career in Congo, and he continued to teach a course on modern African art there.

23. Interview Boilo Mbula Yomamo, 2 September 2011.

24. The same drum is now a part of the new permanent exhibition installed in one of the IMNC buildings on Mont Ngaliema in 2010. Sarah Van Beurden, "Forty Years of IMNC: 11 March 1970–11 March 2010," *African Arts* 45, no. 4 (Winter 2012): 90–93.

25. For the productive relationship "between mask and flag," see Ima Ebong, "Negritude: Between Mask and Flag: Senegalese Cultural Ideology and the 'École de Dakar,'" in *Africa Explores: 20th Century African Art*, ed. Susan Vogel and Ima Ebong (New York: Center for African Art, 1991), 198–209.

26. This approach was of course not invented at the IMNZ. It reflected the general state of research in African art history and anthropology. Sidney Little Kasfir described and criticized the paradigm in "One Tribe One Style? Paradigms in the History of African Art," *History in Africa* 11 (1984): 163–93.

27. Shelly Errington, *The Death of Authentic Primitive Art and Other Tales of Progress* (Berkeley: University of California Press, 1998), 162–70.

28. The latter was one of the responses to the Benin bronzes, which flooded into the UK in the aftermath of the Punitive Expedition (1897) and the plundering of the Benin capital. Annie E. Coombes, *Reinventing Africa: Museums, Material Culture and Popular Imagination in Late Victorian and Edwardian England* (New Haven, CT: Yale University Press, 1994), 22–28.

29. Herman Lebovics, *True France: The Wars over Cultural Identity, 1900–1945* (Ithaca, NY: Cornell University Press, 1992), 135–62; Richard Handler, "On Having Culture: Nationalism and the Preservation of Quebec's Patrimoine," in *Objects and Others: Essays on Museums and Material Culture*. Ed. George W. Stocking Jr. (Madison: University of Wisconsin Press, 1985),192-217.; Ernst Gellner, *On Nations and Nationalism*. (Ithaca, NY: Cornell University Press, 1983).

30. Errington, *Death of Authentic Primitive Art*, 139–41, 179–80.

31. On labels, see "The Limits of Detachment," in Barbara Kirshenblatt-Gimblet, *Destination Culture: Tourism, Museums, and Heritage* (Berkeley:

University of California Press, 1998), 30–34. On maps as national symbols, see Benedict Anderson, *Imagined Communities: Reflections on the Origin and Spread of Nationalism* (New York: Verso, 1991), 170–78.

32. Annie E. Coombes, "The Object of Translation: Notes on 'Art' and Autonomy in a Postcolonial Context," in *The Empire of Things: Regimes of Value and Material Culture*, ed. Fred R. Myers (Santa Fe: School of American Research Press, 2001), 233.

33. Tony Bennett, *Birth of the Museum: History, Theory and Politics* (New York: Routledge, 1995).

34. I borrow these terms from Carol Duncan. "Art Museums and the Ritual of Citizenship," in *Exhibiting Cultures: The Poetics and Politics of Museum Display*, ed. Ivan Karp and Steven Lavine (Washington, DC: Smithsonian Institution Press, 1991), 88–103.

35. Ibid.

36. Bennett, *Birth of the Museum*, 165.

37. Pierre Bourdieu, "The Historical Genesis of a Pure Aesthetic," *Journal of Aesthetics and Art Criticism* 46 (1987): 202.

38. For a comparison, see Errington on the role of the Aztecs as glorified ancestors of Mexicans. Errington, *Death of Authentic Primitive Art*, 170–79.

39. Jan Vansina, *Being Colonized: The Kuba Experience in Rural Congo* (Madison: University of Wisconsin Press), 2010. Mobutu's own origin as a Ngbandi did not result in a disproportionate attention to the culture. Schatzberg, in his discussion of political legitimacy and power in central Africa, links the use of political imaginary such as the figure of the chief-father, to interpretations of "traditional" African cultures. Schatzberg, *Political Legitimacy in Middle Africa: Father, Family, Food* (Bloomington: Indiana University Press), 2001.

40. Interview Tshiluila; interview Eugénie Nzembele Safiri, 31 August 2011, Kinshasa; interviews Célestin Badi-Banga ne Mwine, 18 May 2006 and 2 September 2011, Kinshasa; interview Kama Funzi Mudindambi, 10 May 2006, Kinshasa. Quote from Tshiluila. Not everybody speaks openly about the current regime, but the feeling of abandonment by the government, going back many decades, is palpable. Just as the Kabila regime goes through the motions of government, so do many employees go through the motions that accompany their identity as state employees and museum professionals without attaching any content or substance to them.

41. No precise record of all exhibitions the IMNZ partook in survived, and the information that can be culled from the photo archives is equally scant. None of the interviewees could give an exact overview of what other exhibitions in Zaire the IMNZ participated in. During the 1970s, in addition to the FIKIN expositions, the IMNZ participated in an exposition on traditional forms of money at the National Bank of Zaire. In 1978, an exhibition of the stone funerary art of the lower Zaire took place in the Center for International Commerce. Cornet, *Pierres sculptées du Bas-Zaïre* (Kinshasa: IMNZ, 1978).

42. *Kibuadi kia muketo kia kwambata*, a rooftop statue signaling the status of the inhabitant's house as leader. The statue is from the eastern Pende region.

See Daniel Biebuyck, *The Arts of Zaire, Volume 1: Southwestern Zaire* (Berkeley: University of California Press, 1985), ill, 89–90. And for a similar, but very weathered example, see Warren M. Robbins and Mary Ingram Nooter, *African Art in American Collections* (Washington, DC: Smithsonian Institution Press, 1989), 399. The statue is about one meter, or just over three feet, in height and rests upon a base with geometrical decoration. The one at the IMNZ was made especially for the museum by sculptor Kaseya Tambwe Makumbi in 1974 during a collecting trip made by Nestor Seeuws (see figure 4.1). For more on the sculptor, see Zoe Strother, *Inventing Masks: Agency and History in the Art of the Central Pende* (Chicago: University of Chicago Press, 1998), 134.

43. Breckenridge, "Aesthetics and Politics of Colonial Collecting," 211.

44. See chapter 2.

45. Bamba Ndombasi Kufimba, *Initiation à l'art plastique zaïrois d'aujourd'hui* (Kinshasa: Editions Lokele, 1973), 23–24.

46. Elizabeth Harney, *In Senghor's Shadow: Art, Politics and the Avant-Garde in Senegal, 1960–1995* (Durham, NC: Duke University Press, 2004).

47. "Congrès de L'A.I.C.A. à Kinshasa," *Arts d'Afrique Noire* 4 (1973): 14.

48. John Canaday, "Zaire in Search of Its Identity," *New York Times*, Sunday, 14 October 1973.

49. Célestin Badi-Banga ne Mwine, *Contribution à l'étude historique de l'art plastique zaïrois moderne* (Kinshasa: Editions Malayika, 1977), 118; Badi-Banga ne Mwine, "Emergence d'une nouvelle plastique Congolaise (paper presented at Art, Minorities, and Majorities symposium, Dakar, 2–3 July 2003). http://www.aica-int.org/spip.php?article369&var_recherche=badibanga (last accessed 13 September 2013); Cornet, "La Peinture à Kinshasa," in 60 *ans de peinture au Zaïre*, ed. Joseph Cornet et al. (Brussels: Les Editeurs d'Art Associés, 1989), 140.

50. Interviews Badi-Banga ne Mwine.

51. Ebong, "Negritude"; Harney, *In Senghor's Shadow*.

52. Léon Verbeeck and his collaborators juxtapose them with academic painters, implying that the popular painters can be characterized by their lack of academic training. Johannes Fabian, Ilona Szombati, Bennetta Jules-Rosette and others use the term "popular painters," while Bogumil Jewsiewicki prefers the term "urban painters," arguing that "popular" is not entirely appropriate given their "bourgeois" aspirations. V. Y. Mudimbe has argued the denomination "popular" is too vague, and also suggests there is a clear connection between the missionary art of the colonial art schools and the Popular painters on the level of their messages, which in their own way are all testimonies. V. Y. Mudimbe, "Et si nous renvoyions à l'analyse le concept d'art populaire," in *Art pictural zaïrois*, ed. Bogumil Jewsiewicki (Sillery, Quebec: Editions du Septentrion, 1992), 25–28. Bogumil Jewsiewicki, "Painting in Zaire: From the Invention of the West to the Representation of the Social Self," in Vogel and Ebong, *Africa Explores*, 141; Léon Verbeek, *Les arts plastiques de l'Afrique contemporaine: 60 ans d'histoire à Lubumbashi* (Paris: L'Harmattan, 2008); and Johannes Fabian, "Popular Culture in Africa," in

Readings in African Popular Culture, ed. Karin Barber (Bloomington: Indiana University Press, 1997), 18; Bennetta Jules-Rosette, "What Is 'Popular'? The Relationship between Zairian Popular and Tourist Paintings," in Jewsiewicki, *Art pictural zaïrois*, 41–62.

53. Johannes Fabian, *Remembering the Present: Painting and Popular History in Zaire* (Berkeley: University of California Press, 1996), and Bogumil Jewsiewicki, *Chéri Samba: The Hybridity of Art* (Westmount, Québec: Gallerie Amrad African Art Publications, 1995), in addition to many articles and chapters.

54. Susan Vogel prefers the term *international* over *modern* or *contemporary* art, since the term *contemporary art* excludes traditional art made today, and because these artists work for an international audience. She suggests grouping artists according to one of two ideologies instead of describing them in terms of schools and masters: the first group "asserts the right of Africans to make whatever art they choose—including works resembling European art—and rejects the notion that their art must be recognizable as 'African.' The second, articulated by Senghor as Négritude, holds that African artists should reject outside influences and materials and draw on their inner Africanness." Vogel, "International Art," 182–85. It seems to me one approach does not exclude the other, and the maintaining of a historical perspective in the overview of African art is important, given the prevalent erasure of that dimension in histories of African art.

55. He also taught at the National Institute of Arts (Institut National des Arts, INA) and the Academy of Fine Arts in Kinshasa. Badi-Banga ne Mwine remained active in the international world of modern art via his membership in AICA and ICOM. Serious health problems caused him to retreat from his job at the IMNC, but he still ran a local art center in Kinshasa (Centre Espace Akhenaton) and continued to be a contact for young Congolese artists seeking connections with the international art world. In 2006 he worked for DAK'ART, the sixth biennale of Contemporary African art. Badi-Banga ne Mwine passed away in June 2013. LOY NOLA, Cornet Files, Badi-Banga, C.V., n.d., binder correspondence "C" interviews Célestin Badi-Banga ne Mwine, 18 May 2006 and 2 September 2011, Kinshasa.

56. Badi-Banga ne Mwine, *Contribution*, 88.

57. The presidential office financed his book's publication. Colonel Powis facilitated the appearance by recommending it to Mobutu, who contributed a foreword and donated the funds for its publication. Interview Badi-Banga ne Mwine. Badi-Banga ne Mwine puts the amount of money Mobutu put into the publication at $20,000.

58. Badi-Banga ne Mwine, *Contribution*, 114, 220.

59. On the Kanyama painters, see Jules-Rosette, "What Is 'Popular'?," 41–62.

60. IMNC, Museum Archive, Badi-Banga ne Mwine, "Section d'art modern, Inventaire de la collection, arrêté au 31 décembre 198[?]." While scholarship on Zairian painters is easily found, little is available on sculpture, with the exception of Marshall Ward Mount in his *African Arts: The Years since 1920* (Bloomington: Indiana University Press, 1973) and Allen F. Robert's "A

Note on Contemporary Popular Sculpture in Southeastern Zaire," in Jewsiewicki, *Art pictural zaïrois*, 63–70.

61. Johannes Fabian and Ilona Szombati-Fabian produced an elaborate overview of the different themes in "Art, History and Society: Popular Painting in Shaba, Zaire," *Studies in the Anthropology of Visual Communication* 3, no. 1 (1976): 1–21. As a genre, Popular painting in Shaba (Katanga) peaked between 1966 and 1976, according to Fabian. In Jewsiewicki's work (focused more on the Kinois painter Chéri Samba) the scene in Kinshasa extended into the 1980s and 1990s. Fabian, *Remembering the Present*, 196. Jewsiewicki, "Painting in Zaire," 130–51. See also Verbeek's detailed chapter on themes in Lubumbashi's art in *Les arts plastiques*, 135–268.

62. Chéri Samba, quoted in Jewsiewicki, "Painting in Zaire," 131.

63. Fabian, *Remembering the Present*, 196; Jewsiewicki, "Painting in Zaire," 135.

64 Harney, *In Senghor's Shadow*, 95.

65. As Bogumil Jewsiewicki has pointed out, the modern art scene in Zaire became heavily dependent on outside, and mostly Western, interest and money. Jewsiewicki, *Art pictural zaïrois*,16.

66. Célestin Badi-Banga ne Mwine, "Peinture populaire zaïroise," in *Sura Dji: Visages et racines du Zaïre*, ed. François Mathey, Claude Mollard, Michel Phalippou, and Joseph Cornet (Paris: Musée des Arts Décoratifs, 1982), 151–64. Jewsiewicki suggests that the international attention the Popular painters received at the *Sura Dji* exhibition was what drew the regime's attention to the work, which Jewsiewicki connects to a decline in funding for the IMNZ. While it is true that *Sura Dji* made the government aware that the Popular painters could have the ability to shape an international image of Zaire the government would not be able to control, the funding for the IMNZ was under attack before the *Sura Dji* exhibition. Jewsiewicki, *Chéri Samba*, 38.

67. A catalog with the title *Moments de l'art zaïrois* was written by Badi-Banga ne Mwine and Bamba for the Paris exhibition. I have been unable to locate a copy of this catalog.

68. RMCA, Dept. of History and Politics, IMNZ files, letter from Cornet to Kama, 6 June 1974, folder Mobutu, Bisengimana, Kama, box 15-2-77.

69. Badibanga Ne-Mwine, "Sortir d'un sinistre culturel," in *Quelle politique culturelle pour la Troisième République au Zaïre?* ed. I. Ndaywel è Nziem (Kinshasa: Bibliothéque Nationale du Zaïre, 1992–93), 117, 118.

70. Stuart Hall, "Whose Heritage? Un-settling 'The Heritage,' Re-Imagining the Post-Nation," in *The Third Text Reader on Art, Culture and Theory*, ed. Rasheed Araeen, Sean Cubitt, and Sardar Ziauddin (London: Continuum, 2002), 73.

71. I am referring to Richard Werbner's understanding of popular countermemorialism as commemoration of that which the state seeks to suppress in buried memory, and Filip de Boeck's elaboration on this process in the context of Zaire: Richard Werbner, "Beyond Oblivion: Confronting Memory Crisis," and Filip De Boeck, "Beyond the Grave: History, Memory and Death

in Postcolonial Congo/Zaïre" in *Memory and the Postcolony: African Anthropology and the Critique of Power*, ed. Richard Werbner (London: Zed, 1998), 1–17 and 21–31. On Popular painters as the narrators of history and memory, see Bogumil Jewsiewicki and Barbara Plankensteiner, *An/Sichten: Malerei aus dem Kongo, 1990–2000* (Vienna: Springer-Verlag, 2001); T. K. Biaya, "L'impasse de crise zaïroise dans la peinture populaire urbaine, 1970–1985," in *Art et politiques en Afrique noir*, ed. Bogumil Jewsiewick (Ottawa: Canadian Association of African Studies, Safi, 1989), 95–120. On Tshibumba Kanda Matulu, see Fabian, *Remembering the Present*.

72. Cited in IMNC, Museum Archive, Joseph Cornet, "Rapport sur les objets d'origine royale kuba se trouvant à l'Institut des Musées Nationaux," 14 June 1984. Unfortunately, I was not able to recover the original letter by the Nyimi.

Kot aMbweeky III is sometimes also referred to as Kot René and was still in power as of 2012.

73. IMNC, Museum Archive, "Relève des Missions de Terrain effectuées par ou en collaboration avec l'IMNZ depuis 1970." Joseph-Aurélien Cornet, "Une mission fructueuse, ou comment j'ai pu apprendre beaucoup chez les Bakuba," *Antiquités: Journal des Antiquaires* (2000): 22–23.

74. Elizabeth Cameron points out that the book was published in French and Baluba—neither of which is native to the Kuba. This is a clear indication of the diversified student body of the school. Elizabeth L. Cameron, "Coming to Terms with Heritage: Kuba Ndop and the Art School of Nsheng," *African Arts* 45, no. 3 (Autumn 2012): 36.

75. Jan Vansina, "La survie du royaume Kuba à l'époque coloniale et les arts," *Annales Aequatoria* 28 (2007): 18, 20.

76. Ibid., 20.

77. The precarious process of succession, in which there were usually several contenders for the throne, often caused instability after the death of a king. Georges Kwete Mwana, the research assistant of Cornet, also mentions in his memoires that the king's possessions had been subject to pillage by family members upon his death. According to him, much of it was sold to "the Americans in Bulape," where they worked for a Presbyterian church. George Kwete Mwana, *Souvenirs d'un prince Kuba du Congo (1913–1970)* (Paris: L'Harmattan, 2010), 132–33.

78. RMCA, Dept. of History and Politics, IMNZ files, Correspondence Cahen-Powis, May–July 1970, folder Powis, box 28-II-77. The Kuba store did in fact open in Kinshasa. Vansina, "La survie," 18–19.

79. RMCA, Dept. of History and Politics, IMNZ files, letter from Cornet to Cahen, 7 June 1972, folder 1972, box 28-II-77.

80. RMCA, dept. of History and Politics, IMNZ files, letter from Cornet to Cahen, 16 May 1973, folder 1972, box 28-11-77.

81. A statue of Songye origin but kept at the Royal Kuba court.

82. LOY NOLA, Cornet Files, letter from Cornet to the Nyimi, 5 February 1972, folder Kuba correspondence and photos. Jan Vansina relates the same story in "La survie," 19.

83. Vansina, "La survie," 19.

84. It is unclear what exactly caused the falling out. Kwete Mwana was the son of king Kot aMabiinc maKyeen, who reigned from 1919 to 1939.

85. IMNC, Museum Archive, Cornet "Rapport."

86. Vansina, "La survie," 19–20.

87. In the Kuba kingdom, royal succession was determined by matrilineal descent and the women of the royal family, particularly the mother of the king, had important—although largely symbolic—positions.

88. Personal correspondence Jan Vansina, 6 July 2013.

89. IMNC, Museum Archive, letter from Lema Gwete to Commissioner of Culture and Arts, 1994.

90. Myers, *Empire of Things*, 7–8.

91. See for example the Aboriginal and Torres Strait Islander Heritage Amendment Act of 1984 and the Native American Graves Protection and Repatriation Act (NAGPRA) in the United States in 1990. Moira G. Simpson, *Making Representations: Museums in the Post-colonial Era* (London: Routledge, 1996), 191–214. Of course, these countries had far more established national identities by this time than recently decolonized African nations like Zaire did, hence these demands were less threatening to them.

CHAPTER 6: BELGIAN PATRIMONY, ZAIRIAN TREASURE, AND AMERICAN HERITAGE

1. Frederick Cooper and Laura Ann Stoler, eds., *Tensions of Empire: Colonial Cultures in a Bourgeois World* (Berkeley: University of California Press, 1997), 13.

2. Carol Breckenridge, "The Aesthetics and Politics of Colonial Collecting: India at World Fairs," *Comparative Studies in Society and History* 31, no. 2 (April 1989): 197.

3. On the role of the USA in Congo crisis, see for example: Crawford Young, "United States Policy toward Africa: Silver Anniversary Reflections," *African Studies Review* 27, no. 3 (September 1984): 1–17; David N. Gibbs, *The Political Economy of Third World Intervention: Mines, Money and U.S.Policy in the Congo Crisis* (Chicago: University of Chicago Press, 1991); Madeleine Kalb, *The Congo Cables: The Cold War in Africa—from Eisenhower to Kennedy* (New York: Macmillan, 1982); and Emmanuel Gerard and Bruce Kuklick, *Death in the Congo: Murdering Patrice Lumumba* (Cambridge: Harvard University Press, 2015). On the American relation with Mobutu's Zaire, see Sean Kelly, *America's Tyrant: The CIA and Mobutu of Zaire* (Washington, American University Press, 1993); and Michael G. Schatzberg, *Mobutu or Chaos? The United States and Zaire, 1960–1990* (Lanham, MD: University Press of America, 1991).

4. Matthew Hilton and Rana Mitter, "Introduction," in Supplement 8, *Past and Present* 218 (2013): 7–28.

5. Not that the Zairian-American relation was without its conflicts and tensions. The early 1970s, in particular, were a time when Mobutu sought to

assert a leadership role for himself in the nonalignment movement. His travel to China in 1973 influenced the 1974 Zairian "radicalization." Schatzberg, *Mobutu or Chaos?*, 63–64.

6. Another example is the collection of the de Menils in Houston. For an introduction to African art in American museums, see Christa Clarke and Kathleen Bickford Berzock, "Representing African Art in American Art Museums: A Historical Introduction" in *Representing Africa in American Art Museums: A Century of Collecting and Display*, ed. Kathleen Bickford Berzock and Christa Clarke (Seattle: University of Washington Press, 2011), 3–19.

7. Henry John Drewal, "African Art Studies Today," in *African Art Studies, the State of the Discipline*. ed. Rowland Abiodun, (Washington DC: National Museum of African Art, 1990), 29–62; and Daniel Biebuyck, "African Art Studies since 1957: Achievements and Directions," *African Studies Review* 26, nos. 3 and 4 (1983): 99–118. Unfortunately this trend took a dive with the decline in stability of Zaire by the late 1980s and early 1990s, which continued for most of the 1990s.

8. Clarke and Berzock, "Representing African Art," 11.

9. The museum reopened on the mall as part of the Smithsonian in 1987. On racialized discourses and African art in the United States, see Carol Magee, *Africa in the American Imagination: Popular Culture, Racialized Identities and African Visual Culture* (Jackson: University of Mississippi Press, 2012), 19–22. For more on the history of the National Museum of African Art, see David Binkley et al., "Building a National Collection of African Art: The Life History of a Museum," in Berzock and Clarke, *Representing Africa*, 265–88.

10. The subheading of this section is from Hilton Kramer, "The Art of the Congo: Magic beyond our Reach," *New York Times*, 2 June 1968.

11. Martin Friedman started working at the Walker Art Center in 1958 as a curator and became director in 1961. At the time of his retirement in 1990, the center had grown from a provincial institution to a player on the international art scene.

12. William Siegmann, "A Collection Grows in Brooklyn," in Berzock and Clarke, *Representing Africa*, 62–80.

13. Clark Stillman was a cultural attaché at the American embassy in Brussels during the 1930s, when he and his wife started to collect African art. They became friends with Frans Olbrechts, who helped them build a collection. The Clark and Frances Stillman Collection of Congo Sculpture is at the Dallas Museum of Art now. Roselyn Adele Walker, *The Arts of Africa at the Dallas Museum of Art* (New Haven, CT: Yale University Press, 2010), 13–15.

14. RMCA, Dept. of History and Politics, Museum Archive, D9, Exhibitions, letter from Friedman to Cahen, 29 November 1966, File Kunst van Kongo.

15. RMCA, Dept. of History and Politics, Museum Archive, D9, Exhibitions, letter from Friedman to Boalaerts, cc Cahen and Baron Scheyven, 25 April 1967, File Kunst van Kongo.

16. Ibid.

17. RMCA, Dept. of History and Politics, Museum Archive, D9, Exhibitions, letter from Cahen to Friedman, 28 April 1967, File Kunst van Kongo.

18. And it did, in fact, cause problems. See chapter 3. Interview Huguette Van Geluwe, 28 December 2010, Oostende.

19. Martin Friedman, "African Art and the Western View," in Walker Art Center, *Art of the Congo* (Minneapolis: Walker Art Center: 1967), 7–9.

20. *Reflections of the Congo*, pamphlet, 1969, Milwaukee Art Museum.

21. James Clifford, *The Predicament of Culture: Twentieth-Century Ethnography, Literature, and Art* (Cambridge, MA: Harvard University Press, 1988), 197.

22. Albert Maesen, "Congo Art and Society," in Walker Art Center, *Art of the Congo*, 5–16. The article suffers from multiple translation errors, according to Friedman, due to the fact that Maesen sent in his article too late. RMCA, Dept. of History and Politics, Institutional Archive, Exhibitions, letter from Friedman to Van Geluwe, 22 January 1968, File "Kunst Van Kongo."

23. Clark Stillman, "Congolese Art in Europe and America," in *Art of the Congo*, 11–12.

24. Friedman, "African Art and the Western View," 9.

25. The "pedigree" or the "authenticated line of descent" of an object established its ownership journey,but also listed the exhibition and publications it had been part of. Sally Price, *Primitive Art in Civilized Places* (Chicago: University of Chicago Press, 1989), 100–107.

26. Don Morris, "Fine Congo Art Is Augmented by its Display," *Minneapolis Star*, 10 November 1967.

27. Ibid.

28. Mike Steele, "Art Outweighs Ethnology: Congo Show Is Theatrical," *Minneapolis Tribune*, 12 November 1967.

29. John Neville, "'Art of Congo' to be Fair Show at Museum," *Historical Dallas Morning News*, 18 September 1968.

30. Hilton Kramer, "Art of the Congo."

31. Photos for at least three of the locations the exhibition visited show this arrangement: the Walker Art Center (back wall of the space with masks in figure 7.1), the Baltimore Museum of Art, and the Milwaukee Art Museum.

32. The subheading of this section is from David Welby, "Portrait of a People," *Key to Toronto*, April 1977.

33. Curently named the Africa-America Institute. A nonprofit multiracial organization founded in 1953 by members of Lincoln and Howard Universities and dedicated to the engagement between Africa and America.

34. It opened at the African-American Institute in New York in October 1975 and went on to the National Museum of African Art in Washington, DC, the Natural History Museum of Los Angeles County, the Afro-American Museum in Philadelphia, the Art Gallery of Ontario in Toronto, the Carnegie Institute in Pittsburgh, the Dayton Art Institute, the Indianapolis Museum of Art, the High Museum of Art in Atlanta, and finally the New Orleans Museum of Art in 1978. AFA, Itinerary Art from Zaire. Today the museum in Philadelphia is called the African American Museum.

35. Edward P. Taylor Research Library & Archives, Art Gallery of Ontario fonds, Exhibitions: Curatorial, AFA Press Release, "Art Masterpieces from Zaire to Be Shown," File: Art from Zaire, File#2—Organization, Publicity and Promotion, box 125.

36. The friendship was rumored to have been very profitable to both Mobutu and Tempelsman. Edward P. Taylor Research Library & Archives, Art Gallery of Ontario fonds, Exhibitions: Curatorial, AFA Press Release, "Art Masterpieces from Zaire to Be Shown," File: Art from Zaire, File#2—Organization, Publicity and Promotion, box 125; Young and Turner, *Rise and Decline of the Zairian State*, 171, 176, 303, 438. Schatzberg, *Mobutu or Chaos?*, 86.

37. IMNC, Museum Archive, French press release AAI, 16 April 1975, folder USA. See also AAI, *Annual Report 1976* (New York: AAI, 1976)

38. Hersey, born Herskowitz, served as a Japanese linguist in the army during World War II and worked as an editor for Fairchild and Hearst Publications. He was a collector and appraiser of African art and coedited *Arts d'Afrique Noire*.

39. RMCA, Dept. of History and Politics, IMNZ files, letter from Cornet to Cahen, 24 April 1975, folder courrier reçu de l'IMNZ, box 28-II-77.

40. Commissioner Bokonga Botembele became commissioner of national orientation in January of 1975 and was replaced by Mbamba Yowa Mabinda Kapinga as commissioner of culture and arts.

41. See numbers 63 and 64 in the catalog *Art from Zaire* (New York: African-American Institute, 1976), 89.

42. Irwin Hersey, "Introduction," *Art from Zaire*, 16.

43. The is no evidence that American museums or collectors, Hersey included, donated anything to the IMNZ.

44. Mobutu Sese Seko, "Foreword," *Art from Zaire*, 10.

45. RMCA, Dept. of History and Politics, IMNZ files, letter from Cahen to Cornet, 13 October 1975, folder/box Amb. Burundi.

46. "The Seat of Life," *Toronto Directory*, (n.d.), 32

47. "African Art in its only Canadian showing" *Contrast*, March 10, 1977.

48. Eleanor Munro, "Art and Politics: Masterpieces from Zaire," *New Republic*, 15 November 1975.

49. Daniel Biebuyck, "An Exhibition 'Art from Zaire 100 Masterworks from the National Collection' at the African-American Institute (New York)," *African Arts* 9, no. 2 (January 1976): 62–63.

50. Biebuyck, "An Exhibition," 62–63.

51. Edward P. Taylor Research Library and Archives, Art Gallery of Ontario Fonds Catalog List, Exhibitions: Curatorial, 5, File Art from Zaire, File 4—Exhibition Data, box 12.

52. Peggy Stoltz Gilfoy (1936–1988) was curator of ethnographic art and textiles at the Indianapolis Museum of Art. See Theodore Celenko, "In Memoriam: Peggy S. Gilfoy," *African Arts* 25, no. 3 (1992): 41.

53. "Indianapolis Museum of Art-Collection from Zaire," *Winchester News Gazette*, 3 December 1977, 89.

54. "African Art in Indiana Collections," *Antiques and the Arts Weekly*, 30 December 1977.

55. Susan Vogel, "Zairian Authenticity," *Art Forum* 14, no. 10 (Summer 1976): 38.

56. Schatzberg, *Mobutu or Chaos?*, 66–67.

57. The Americans arranged a six-week stay for Cornet and IMNZ staff member Maltushi, but the Zairian government, unsatisfied with this representation, paid for Lema Gwete's and Commissioner Mbamba Yowa's travel to the United States. IMNC, Report by Cornet, "Exposition Itinérante," 31 May 1978, folder USA.

58. E. J. Kahn, "Art from Zaire," *New Yorker*, 20 October 1975.

59. SIA, NMAA–Jean M. Salan Records, letter from Warren M. Robbins to Robert Keating, 26 February 1976, folder Art from Zaire, box 1.

60. Dorothy Gilliam, "Crushing Throng amid the Politics of African Art," *Washington Post*, 12 March 1976.

61. Nessa Forman, "From Africa . . . Superb Artifacts," *Philadelphia Bulletin*, 6 February 1977, 14.

62. Lauretta Forsythe, "Art from Zaire," *Toronto Star Week*, 9 April 1977. Emphasis added.

63. John L. Comaroff and Jean Comaroff, *Ethnicity, Inc.* (Chicago: University of Chicago Press, 2009). For more on "ethnic arts," see *Ethnic and Tourist Arts: Cultural Expressions from the Fourth World* by Nelson H. H. Graburn (Berkeley: University of California Press, 1976). More recent work includes Priscilla Boniface and Peter J. Fowler, *Heritage and Tourism in 'the Global Village'* (London: Routledge, 1993); Ruth B. Phillips and Christopher B. Steiner, eds., *Unpacking Culture: Art and Commodity in Colonial and Postcolonial Worlds* (Berkeley: University of California Press, 1999).

64. Linda Crabtree, "Unique Collection from Zaire displayed at AGO," *St. Catharines Standard*, 26 April 1977.

65. "Exposition d'objets d'art zaïrois à New York," *Elima*, 11 October 1975.

66. "Art du Zaïre," *Salongo*, 23 October 1975, 7.

67. IMNC, Museum Archive, letter from Cornet to Jane Jacqz of the AAI, 25 August 1976, folder USA. Sadly, today at least eight of the objects included in *Art from Zaire* have disappeared from the IMNZ. They tend to be the smaller pieces, such as one of the Kuba cups, a round mask from the Katanga region, a rare Kuba statue, one of the most beautiful Hemba seats, a carved mosquito chaser from the Kongo, a Suka and a Yaka statue, and one of the metal Kuba scepters. Numbers 19, 30, 35, 53, 66, 72, 90 and 92 of the catalog *Art from Zaire* (New York: African-American Institute, 1976).

68. This is not to say that there was no interest in the European audience. In 1980 the IMNZ accepted an invitation from the Übersee-Museum in Bremen for a *Kunst aus Zaïre* exhibition, and in 1982 *Sura Dji: Visages et racines du Zaïre* took place in the Musée des Arts Décoratifs in Paris.

69. NMAA, Warren M. Robbins Library, clippings, DSF, "Belgian Brother Uncovers Zaire's Disappearing Past—in the Bush and in the United States" (draft).

70. Interview Pete Lee, 26 June 2014, telephone.

71. There were nine regions, a subdivision created by Cornet in 1971 for *Art of Africa: Treasures from the Congo* (New York: Praeger, 1971). These included the Lower River region, the Kwango region (south of the capital), the Kwilu-Kasai, the Kasai-Sankuru, the Upper River region, East Central region, and the Uele and Ubangi regions in the north.

72. Daniel P. Biebuyck, "A Survey of Zairian Art: The Bronson Collection by Joseph Cornet," *African Arts* 12, no. 2 (February 1979): 81–82.

73. John Povey, "A Survey of Zairian Art: The Bronson Collection," *African Arts* 12, no. 3 (May 1979): 79.

74. Jo Ann Lewis, "The Moments of the Sun; Zairian Moments of the Sun; Sculpted Spirits and Symbolic Masks From a Zairian Chief's Regalia," *Washington Post*, 26 July 1978.

75. William Wilson, "Art Review: Zairian Collection Showcased," *Los Angeles Times*, 4 December 1978.

76. Interview Pete Lee.

77. The history of museum shops and their role in the promotion and sale of "heritage" or "global" arts is an interesting subject that deserves to be the subject of more study. Unfortunately, as I have noticed in my own research, few museums appear to have kept records of their stores. Of all of the museums visited by the exhibitions in this chapter, I have only been able to confirm the existence of the sale of African arts and crafts at the Los Angeles County Museum of Natural History and the Museum of African Art in Washington, DC.

78. Although I have been unable to trace the supply source of the museum, Pete Lee (the curator of ethnography and later director of the museum in LA) recalls they worked with small local importers (sometimes even missionaries or travelers) who had contacts in the regions where the objects were made. Interview Pete Lee.

79. Siegmann, "Collection Grows in Brooklyn," 66–67.

80. SIA, REC UNIT 634: Notes, Office of the Director, National Museum of African Art, September 1975, folder 64–84, box 2.

81. "Ethnic Arts Shop, Arts of Africa," *Terra: The Members Magazine of the Natural History Museum of Los Angeles County* 15, no. 1 (Summer 1976).

82. This exhibition, along with Thompson's research into the influence of other African cultures on African Diaspora cultures, led to the publication in 1984 of Thompson's influential *The Flash of the Spirit: African and Afro-American Art and Philosophy* (New York: Vintage, 1984). Although Thompson's work played an important role in establishing African Diaspora studies, his work was also criticized for advancing theories unsupported by the evidence. Susan Cooksey, Robin Poynor, and Hein Vanhee, "Kongo across the Waters: Introduction," in *Kongo across the Waters*, ed. Cooksey, Poynor, and Vanhee (Gainesville: University of Florida Press, 2013), 6.

83. Jacqueline Trescott, "Images of Zaire," *Washington Post*, 11 September 1981.

84. Jan Vansina, "The Four Moments of the Sun: Kongo Art in Two Worlds by Robert Farris Thompson; Joseph Cornet," *African Arts* 16, no. 1 (November 1982): 30.

85. The stone figures had been the subject of an exhibition in Zaire itself in 1978 at the *Centre de Commerce International du Zaïre* (International Trade Center of Zaire), and the New York gallery "African Sculpture Unlimited" from March to June in 1981, months before the start of The Four Moments of the Sun in August. Joseph Cornet, *Pierres Sculptées du Bas-Zaïre* (Kinshasa: IMNZ, 1978); Fred Benson and Joseph Cornet, *Stone Ntadi Sculpure of Bas-Zaire* (New York: African Sculpture Unlimited, 1981). The last publication was a rough translation of Cornet's *Pierres Sculptées*.

86. Quoted in John Coppola, "The Four Moments of the Sun: Kongo Art in Two Worlds," *Topic* 137 (1982): 45–46.

87. Dunn, *Imagining the Congo: The International Relations of Identity* (New York: Palgrave Macmillan, 2003), 125.

88. James Clifford, "Of Other Peoples: Beyond the 'Salvage' Paradigm," in *Discussions in Contemporary Culture*, ed. Hal Foster (New York: New Press, 1987), 126. Emphasis in original.

89. Dunn, *Imagining the Congo*, 116.

CONCLUSION: COLONIAL AND POSTCOLONIAL LEGACIES

1. Tony Bennett, *Making Culture, Changing Society* (London: Routledge, 2013).

2. See for example: Bob W. White, *Rumba Rules: The Politics of Dance Music in Mobutu's Zaire* (Durham: Duke University Press, 2008); Bogumil Jewsiewicki, *Chéri Samba: The Hybridity of Art/L'hybridité d'un Art* (Westmount, Québec: Gallerie Amrad African Art Publications, 1995); Johannes Fabian, *Power and Performance and Remembering the Present: Ethnographic Explorations through Proverbial Wisdom and Theatre in Shaba, Zaire* (Madison: University of Wisconsin Press, 1990); Didier Gondola. "Popular Music, Urban Society and Changing Gender Relations in Kinshasa, Zaire (1950–1990)," in *Gendered Encounters*, ed. Maria Grosz-Ngaté and Omari H. Kokele (London: Routledge, 1996), 65–84; and Didier Gondola, "Tropical Cowboys: Westerns, Violence and Masculinity among the Young Bills of Kinshasa," *Afrique & Histoire* 7 (May 2009): 75–98.

3. Bob White recounts a similar anecdote in *Rumba Rules*. He calls it "splintering" and describes it as a central dynamic in Congolese popular music circles. White, *Rumba Rules*, 195.

4. Bogumil Jewsiewicki, "Historical Memory and Representation of New Nations in Africa," in *Historical Memory in Africa: Dealing with the Past, Reaching for the Future in an Intercultural Context*, ed. Mamdou Diawara, Bernard Lategan, and Jörn Rüsen (New York: Berghahn, 2010), 59.

5. In 1980 the IMNZ collaborated on *Kunst aus Zaire*, an exhibition in the Übersee Museum in Bremen and in 1982 on *Sura Dji Visages et Racines du Zaïre* in the Musée des Arts Décoratifs in Paris.

6. For more on these controversies, see Geert Castryck, "Whose History Is History? Singularities and Dualities of the Public Debate on Belgian Colonialism," in *Europe and the World in European Historiography*, ed. Csaba Lévai (Pisa: Edizioni Plus, Pisa University Press, 2006), 71–88; Adam Hochschild, *King Leopold's Ghost: A Story of Greed, Terror and Heroism in Colonial Africa* (Boston: Houghton Mifflin, 1998).

7. See, for example, Jean Mutemba Rahier, "The Ghost of Leopold II: The Belgian Royal Museum of Central Africa and Its Dusty Colonialist Exhibition," *Research in African Literature* 34, no. 1 (Spring 2003): 58–84; Véronique Bragard and Stéphanie Planche, "Museum Practices and the Belgian Colonial Past: Questioning Memories of an Ambivalent Metropole," *African and Black Diaspora: An International Journal* 2, no. 2 (July 2009): 181–91; and Véronique Bragard, "Indépendance! The Belgo-Congolese Dispute in the Tervuren Museum," *Human Architecture: Journal of the Sociology of Self-Knowledge* 9, no. 4 (2011): 93–103.

8. This was preceded by the 2001 *Exit Congo Museum*, which addressed the colonial creation of the museum's collections. Boris Wastiau, *Exit Congo Museum* (Tervuren: RMCA, 2001); Jean-Luc Vellut, ed., *Het geheugen van Congo: De koloniale tijd* (Tervuren: Snoeck-KMMA, 2005).

9. At the time of this writing, Tervuren has closed its doors for an extensive renovation that will expand the building and promises to update the content of the permanent displays.

10. For more on the new gallery, see Van Beurden, "Forty Years of IMNC."

Bibliography

INTERVIEWS BY THE AUTHOR

Célestin Badi-Banga ne Mwine, 18 May 2006 and 2 September 2011, Kinshasa
Marcel Bétu, 8 May 2006, Kinshasa
Boilo Mbula Yomamo, 2 September 2011, Kinshasa
Daniel Cahen, 9 August 2010, Eigenbrakel
Rik Ceyssens, 10 August 2011, Helchteren
Alan Davis, February 2006, Washington, DC
Guy de Plaen, 2 January 2007, Wellin
Marc Leo Felix, 3 September 2012, Watermaal
Charlie Hénault (with Viviane Baeke), 27 December 2010, Belgium
Kama Funzi Mudindambi, 10 May 2006, Kinshasa
Pete Lee, 26 June 2014, telephone
Isak Kisimba Mwaba, 13 April 2006, Lubumbashi
Phillippe Marechal, October 2005, Tervuren
Ferdinand Mbambu Makuka, 15 October 2006, Kinshasa
N'Kanza Lutayi, 3 May 2006, IMNC Kinshasa
Eugénie Nzembele Safiri, 31 August 2011, Kinshasa
Nestor Seeuws, 5 October 2005, Ghent
Shaje'a A. Tshiluila, 14 September 2011, Kinshasa
Alex Shoumatoff, 15 September 2012, telephone
Huguette Van Geluwe, 28 December 2010, Oostende
Michael Verly, 22 August 2012, Kasterlee
Zola Kwandi Mpungu Mayala, 2 June 2006, Kinshasa

INTERVIEW BY LÉON VERBEEK

Joseph Cornet, 15 September 2002, Liège

PERSONAL CORRESPONDENCE

Maarten Couttenier, 23 June 2008
Allen F. Roberts, 30 March 2009
Hein Vanhee, 8 May 2014
Jan Vansina, 15 July 2012 and 6 July 2013
Boris Wastiau, 28 February and 6 March 2012

MAIN ARCHIVAL SOURCES

Afrikaans Archief Ministerie van Buitenlandse Zaken (Africa Archive, Ministry of Foreign Affairs), Brussels (AA BuZa)
 COPAMI Files
Archives Nationales de la République Démocratique du Congo (National Archives of the Democratic Republic of Congo), Kinshasa (ANC)
 MPR Files
 AICA Files
Art Gallery of Ontario
 Edward P. Taylor Research Library and Archives, Art Gallery of Ontario Fonds
Dayton Art Institute
 Museum Archives
Indianapolis Museum of Art, Indianapolis
 IMA Archives, Exhibition Records
Institut des Musées Nationaux du Congo (Institute of National Museums of Congo), Kinshasa (IMNC)
 Museum Archive
 Library Collection
 Photo Archives
Los Angeles County Museum of Natural History
 Museum Archive, Exhibition records
Loyola University, J. Edgar and Louise S. Monroe Library, New Orleans (LOY NOLA)
 Special Collections, Joseph-Aurélien Cornet Files
Milwaukee Art Museum, Milwaukee
 Museum Archives
Musée National de Lubumbashi (National Museum of Lubumbashi), Lubumbashi (MNL)
 Museum Archive
National Gallery of Art, Washington, DC
 Gallery Archives, Files *The Four Moments of the Sun*
National Museum of African Art, Warren M. Robbins Library, Washington, DC (NMAA)
 Exhibition Files and Catalogues
 Clippings Collection
Royal Museum for Central Africa, Tervuren (RMCA)
 Central Administration
 Personeelsdossiers (staff files)
 Department of History and Politics
 IMNZ Files
 Jaarverslagen (yearly reports)
 Museumarchief (museum archive)
 Department of Culture and Society
 IMNZ Files

Boeken etnografie (Correspondence and reports, ethnography)
Photo Archives
Etnografische dossiers (Ethnographic Files): carnets Maesen (note-books Maesen)
Card and digital object catalogues
Smithsonian Institution Archives (SIA)
 National Museum of African Art Records
Walker Art Center, Minneapolis
 Museum Archive, Exhibition records 1940–80

MAIN NEWSPAPERS AND MAGAZINES

Brousse: Organe Trimestriel des "Amis de l'Art Indigène" du Congo Belge
Congo-Afrique/Zaïre-Afrique
Congo-Tervuren /Africa-Tervuren
Courrier d'Afrique
Elima: Quotidien du Soir
Le Libérateur: Organe du Parti Révolutionnaire Marxiste du Congo-Kinshasa
New York Times
Notre Kongo: Organe de l'Abako
Le Progrès
Salongo: Quotidien du Matin
Uhuru/L'Éclair Etingelle: Organe Bi-mensuel de Combat et d'Opinion du Parti de la Révolution Populaire de Congo-Kinshasa.

BOOKS AND ARTICLES

Adams, Monni. "18th-Century Kuba King Figures." *African Arts* 21, no. 3 (May 1988): 32–38.
———. "Kuba Embroidered Cloth." *African Arts* 12, no. 1 (November 1978): 14–39.
Adedze, Agbenyega. "Museums as a Tool for Nationalism in Africa." *Museum Anthropology* 19, no. 2 (1995): 58–64.
———. "Symbols of Triumph: IFAN and the Colonial Museum Complex in French West Africa (1938–1960)." *Museum Anthropology* 25, no. 2 (2000): 50–60.
Afigbo, A. E., and S. I. O. Okita. *The Museum and Nation Building.* Owerri, Nigeria: New Africa Publishing, 1985.
Africa's Who's Who. London: Africa Books, 1996.
Aldrich, Robert. *Vestiges of the Colonial Empire in France: Monuments, Museums and Colonial Memories.* New York: Palgrave Macmillan, 2005.
Alpers, Edward. *Ivory and Slaves in East Central Africa.* Berkeley: University of California Press, 1975.
Ames, Michael M. *Cannibal Tours and Glass Boxes: The Anthropology of Museums.* Vancouver: University of British Columbia Press, 1992.
Anderson, Benedict. *Imagined Communities: Reflections on the Origin and Spread of Nationalism.* New York: Verso, 1991.

Anthonissen, Jan. "De koningen van de Congo." *Humo* 14 (1999): 30–35.

Appadurai, Arjun. "Introduction: Commodities and the Politics of Value." In *The Social Life of Things: Commodities in Cultural Perpective,* edited by Arjun Appadurai, 3–63. Cambridge: Cambridge University Press, 1988.

———, ed. *The Social Life of Things: Commodities in Cultural Perspective.* Cambridge: Cambridge University Press, 1988.

Appiah, Kwame Anthony. *Cosmopolitanism: Ethics in a World of Strangers.* New York: Norton, 2006.

———. *In My Father's House: Africa in the Philosophy of Culture.* New York: Oxford University Press, 1992.

Apter, Andrew. *The Pan-African Nation: Oil and the Spectacle of Culture in Nigeria.* Chicago: University of Chicago Press, 2005.

Ardouin, Claude Daniel. "Culture, Museums, and Development in Africa." In *The Muse of Modernity: Essays on Culture as Development in Africa,* edited by Philip G. Altbach and Salah Hassan, 181–208. Trenton, NJ: Africa World Press.

———, ed. *Museums and Archeology in West Africa.* Washington, DC: Smithsonian Institution Press, 1997.

Ardouin, Claude Daniel, and Emmanuel Arinze, eds. *Museums and the Community in West Africa.* Washington, DC: Smithsonian Institution Press, 1995.

———, eds. *Museums and History in West Africa.* Washington, DC: Smithsonian Institution Press, 2000.

Arnaut, Karel. "Art and the African World: A Historical Analysis of their Interconnection." *Journal of the Anthropological Society of Oxford* 22, no. 2 (1991): 151–65.

———, ed. *Re-Visions: New Perspectives on the African Collections of the Horniman Museum.* London: Horniman Museum & Garden, 2001.

Arnoldi, Mary Jo. "De sculpturale versiering in de rotonde van het Koninklijk Museum voor Midden-Afrika." In *Het geheugen van Congo: De koloniale tijd,* edited by Jean-Luc Vellut, 180–84. Tervuren: Snoeck-KMMA, 2005.

———. "Koloniale kunst: De Belgische beeldhouwers in Congo (1911–1960)." In *Le Congo et l'art belge,* edited by Jacqueline Guisset, 226–29. Tournai: La Renaissance du Livre, 2003.

Art from Zaire. New York: African-American Institute, 1976.

Asselberghs, Herman, and Dieter Lesage, eds. *Het museum van de natie: Van kolonialisme tot globalisering.* Brussels: Gevaert, 1999.

Badi-Banga ne Mwine, Célestin. *Contribution à l'étude historique de l'art plastique zaïrois moderne.* Kinshasa: Editions Malayika, 1977.

———. "Emergence d'une nouvelle plastique congolaise." Paper presented at Art, Minorities, and Majorities symposium, Dakar, 2–3 July 2003. Last accessed 13 September 2013. http://www.aica-int.org/IMG/pdf/14.badibangafr.pdf.

——. "Painture populaire zaïroise." In Sura Dji, *Visages et racines du Zaïre*, edited by Francois Mathey, Claude Mollard, Michel Phalippou, and Joseph Cornet, 151–64. Paris: Musée des Arts Décoratifs, 1982.

——. "Sortir d'un sinistre culturel." In *Quelle politique culturelle pour la Troisième République au Zaïre?*, edited by I. Ndaywel è Nziem, 117–24. Kinshasa: Bibliothèque Nationale du Zaïre, 1992–93.

Baeke, Viviane, Henry Bundjoko, and Joseph Ibongo. "L'évolution des regards sur l'art congolais au travers de la genèse des musées coloniaux et postcoloniaux à Kinshasa." Unpublished paper.

Bassani, Ezio, and William Buller Fagg. *Africa and the Renaissance: Art in Ivory*. Munich: Prestel, 1989.

Basu, Paul. "A Museum for Sierra Leone? Amateur Enthusiasms and Colonial Museum Policy in British West Africa." In *Curating Empire: Museums and the British Imperial Experience*, edited by Sarah Longair and John McAleer, 145–67. Manchester: Manchester University Press, 2012.

Baudrillard, Jean. *The Conspiracy of Art: Manifestos, Interviews, Essays*. New York: Semiotext(e), 2005.

Bawele, Mumbanza Mwa, and Sabakinu Kivilu. "Historical Research in Zaire: Present Status and Future Perspectives." In *African Historiographies: What History for Which Africa?*, edited by Bogumil Jewsiewicki and David Newbury, 224–34. Beverly Hills, CA: Sage, 1986.

Bayart, Jean-François. *The Illusion of Cultural Identity*. Chicago: University of Chicago Press, 2005.

——. *The State in Africa: The Politics of the Belly*. 2nd ed. Cambridge: Polity, 2009.

——. "L'Hypothèse totalitaire dans le Tiers mode: Le cas de l'Afrique noire." In *Totalitarismes*, edited by Guy Hermet et al., 201–14. Paris: Economica, 1984.

Bayly, C. A., Sven Beckert, Matthew Connelly, Isabel Hofmeyr, Wendy Kozol, and Patricia Seed. "AHR Conversation: On Transnational History." *American Historical Review* 111, no. 5 (2006): 1440–64.

Ben-Amos, Paula. "A la recherche du temps perdu: On Being an Ebony-Carver in Benin." In *Ethnic and Tourist Arts: Cultural Expressions from the Fourth World*, edited by Nelson H. Graburn, 320–33. Berkeley: University of California Press, 1976.

Bender, Thomas, ed. *Rethinking American History in a Global Age*. Berkeley: University of California Press, 2002.

Benjamin, Walter. *The Arcades Project*. Cambridge: Belknap Press of Harvard University Press, 1999.

——. "The Work of Art in the Age of Mechanical Reproduction." In *Aesthetics: A Reader in Philosophy of the Arts*, edited by David Goldblatt and Lee B. Brown, 72–75. 2nd ed. Upper Saddle River, NJ: Pearson–Prentice Hall, 2005.

Bennett, Tony. *Birth of the Museum: History, Theory and Politics*. New York: Routledge, 1995.

———. "The Exhibitionary Complex." In *Culture/Power/History: A Reader in Contemporary Social Theory*, edited by Nicholas B. Dirks, Geoff Eley, and Sherry B. Ortner, 123–54. Princeton, NJ: Princeton University Press, 1994.

———. *Making Culture, Changing Society*. London: Routledge, 2013.

———. *Pasts Beyond Memory: Evolution, Museums and Colonialism*. New York: Routledge, 2004.

Benson, Fred, and Joseph Cornet. *Stone Ntadi Sculpture of Bas-Zaire*. New York: African Sculpture Unlimited, 1981.

Benton, Tim, ed. *Understanding Heritage and Memory*. Manchester: Manchester University Press, 2010.

Bernard, Toulier, Lagae Johan, and Gemoets Marc. *Kinshasa: Architecture et paysage urbains*. Paris: Somogy, 2010.

Bernault, Florence. *Démocraties ambiguës en Afrique centrale: Congo-Brazzaville, Gabon, 1940–1965*. Paris: Éditions Karthala, 1996.

Bertrand, Aléxis. "Quelques notes sur la vie politique, le développement, la décadence des petites sociétés bantou du basin central du Congo." *Revue de l'Institut de Sociologie de Bruxelles* 1 (1920): 75–91.

Bertrand, William. "Restoring an African Art Collection." *Global Health Newsletter* 8, no. 1 (Spring–Summer 2008): 6–7.

Berzock, Kathleen Bickford, and Christa Clarke, eds. *Representing Africa in American Art Collections: A Century of Collecting and Display*. Seattle: University of Washington Press, 2011.

Beumers, Erna, and Hans-Joachim Koloss, eds. *Kings of Africa: Art and Authority in Central Africa. Collection Museum für Völkerkunde Berlin*. Maastricht: Foundation Kings of Africa, 1992.

Bhabha, Homi K. *The Location of Culture*. London and New York: Routledge, 2004.

Biaya, T. K. "L'Impasse de crise zaïroise dans la peinture populaire urbaine, 1970–1985." In *Art et politiques en Afrique noir*, edited by Bogumil Jewsiewicki, 95–120. Ottawa: Canadian Association of African Studies, Safi, 1989.

Biebuyck, Daniel P. "African Art Studies since 1957: Achievements and Directions." *African Studies Review* 26, nos. 3 and 4 (1983): 99–118.

———. "Olbrechts en de dageraad van de professionele antropologie in België." In *Frans M. Olbrechts, 1899–1958: Op zoek naar kunst in Afrika*, edited by Constantine Petridis, 102–14. Antwerp: Etnografisch Museum van Antwerpen, 2001.

———. *The Arts of Zaire*. Vol. 1: *Southwestern Zaire*. Berkeley: University of California Press, 1985.

———. *The Arts of Zaire*. Vol. 2: *Eastern Zaire*. Berkeley: University of California Press, 1986.

———. "An Exhibition 'Art from Zaire 100 masterworks from the National Collection at the African-American Institute (New York).'" *African Arts* 9, no. 2 (January 1976): 62–63.

———. *Lega Culture: Art, Initiation and Moral Philosophy among a Central African People*. Berkeley: University of California Press, 1973.

———. "A Survey of Zairian Art: The Bronson Collection by Joseph Cornet." *African Arts* 12, no. 2 (February 1979): 81–82.

Binkley, David A., and Patricia J. Darish. "'Enlightened But in Darkness': Interpretations of Kuba Art and Culture at the Turn of the Twentieth Century." In *The Scramble for Art in Central Africa*, edited by Enid Schildkrout and Curtis A. Keim, 37–62. Cambridge: Cambridge University Press, 1998.

———. *Kuba*. Visions of Africa Series. Milan: 5 Continents Editions, 2009.

Binkley, David A., Bryna Freyer, Christine Mullen Kreamer, Andrea Nicolls, and Allyson Purpura. "Building a National Collection of African Art: The Life History of a Museum." In *Representing Africa in American Art Collections: A Century of Collecting and Display*, edited by Kathleen Bickford Berzock and Christa Clarke, 265–88. Seattle: University of Washington Press, 2011.

Blier, Suzanne Preston. *The Royal Arts of Africa: The Majesty of Form*. New York: Harry N. Abrams, 1998.

Bogaerts, Els, and Remco Raben, eds. *Beyond Empire and Nation: Decolonizing Societies in Africa and Asia, 1930s–1960s*. Leiden: KITLV Press, 2007.

Boniface, Priscilla, and Peter J. Fowler. *Heritage and Tourism in the "Global Village."* London: Routledge, 1993.

Bonnell, Victoria E., and Lynn Hunt, eds. *Beyond the Cultural Turn: New Directions in the Study of Society and Culture*. Berkeley: University of California Press, 1999.

Boswell, David, and Jessica Evans, eds. *Representing the Nation: A Reader*. New York: Routledge 1999.

Botembele, Bokonga Ekanga. *La politique culturelle en République du Zaïre*. Paris: Unesco Press, 1975.

———. "Preface." In *Trésors de l'art traditionnel*. Kinshasa: IMNZ, 1973.

Bourdieu, Pierre. *The Field of Cultural Production: Essays on Art and Literature*. Edited by Randal Johnson. New York: Columbia University Press, 1993.

———. "The Historical Genesis of a Pure Aesthetic." *Journal of Aesthetics and Art Criticism* 46 (1987): 201–10.

———. "Structures, Habitus, Power: Basis for a Theory of Symbolic Power." In *Culture/Power/History: A Reader in Contemporary Social Theory*, edited by Nicholas B. Dirks, Geoff Eley, and Sherry B. Ortner, 155–99. Princeton, NJ: Princeton University Press, 1994.

Bouttiaux, Anne-Marie, ed. *Afrique: Musées et patrimoines pour quels publics?* Paris: Culture Lab Editions, Karthala, 2007.

———. "Des mises en scène de curiosités aux chefs-d'oeuvre mis en scène: Le Musée Royal de l'Afrique à Tervuren: Un siècle de collections." *Cahiers d'Études Africaines* 39, nos. 155/156 (1999): 595–616.

Bragard, Véronique, and Stéphanie Planche. "Indépendance! The Belgo-Congolese Dispute in the Tervuren Museum." *Human Architecture: Journal of the Sociology of Self-Knowledge* 9, no. 4 (2011): 93–103.

———. "Museum Practices and the Belgian Colonial Past: Questioning Memories of an Ambivalent Metropole." *African and Black Diaspora: An International Journal* 2, no. 2 (July 2009): 181–91.

Breckenridge, Carol A. "The Aesthetics and Politics of Colonial Collecting: India at World Fairs." *Comparative Studies in Society and History* 31, no. 2 (April 1989): 195–216.

Bridges, Nichole N. "Transatlantic Souvenirs: A Dialogue of Slavery and Memory in Kongo-Inspired Relief Sculpture." In Cooksey et al., *Kongo across the Waters*, 90–97.

Buelens, Frans. *Congo 1885–1960. Een financieel-economische geschiedenis.* Berchem, Belgium: EPO, 2007.

Bundjoko Banyata, Henri. "Le Musée de Lubumbashi comme lieu de sociabilité et d'élaboration culturelle." In *Tout passe: Instantanés populaires et traces du passé à Lubumbashi*, edited by Danielle de Lame and Donatien Dibwe dia Mwembu, 301–22. Cahiers Africains 71. Paris: L'Harmattan, 2005.

Bundwoong, Lobo. *Afrikanische Gesellschaft im Wandel: Soziale Mobilität und Landflucht in Zaire.* Frankfurt a. M.: Brandes & Apsel, 1991.

Burton, Antoinette, ed. *After the Imperial Turn: Thinking With and Through the Nation.* Durham, NC: Duke University Press, 2003.

Byala, Sara. *A Place That Matters Yet: John Gubbins's Museum Africa in the Postcolonial World.* Chicago: University of Chicago Press, 2013.

Cahen, Lucien. "La collaboration entre le Musée Royal de l'Afrique Centrale et les Musées Nationaux du Zaïre." *Africa-Tervuren* 19, no. 4 (1973): 111–14.

Callaghy, Thomas M. *The State-Society Struggle: Zaire in Comparative Perspective.* New York: Columbia University Press, 1984.

Cameron, Elizabeth L. *The Art of the Lega.* Los Angeles: UCLA Fowler Museum of Cultural History, 2001.

———. "Coming to Terms with Heritage: Kuba Ndop and the Art School of Nsheng." *African Arts* 45, no. 3 (Autumn 2012): 28–41.

Castryck, Geert. "Whose History Is History? Singularities and Dualities of the Public Debate on Belgian Colonialism." In *Europe and the World in European Historiography*, edited by Csaba Lévai, 71–88. Pisa: Edizioni Plus, Pisa University Press, 2006.

Celenko, Theodore. "In Memoriam: Peggy S. Gilfoy." *African Arts* 25, no. 3 (1992): 41.

Ceuppens, Bambi. *Congo Made in Flanders? Koloniale Vlaamse visies op "blank" en "zwart" in Belgisch Congo.* Ghent: Academia Press, 2003.

Ceyssens, Rik. *De Luulu à Tervuren: La Collection Michaux au Musée Royale de l'Afrique centrale.* Tervuren: MRAC, 2011.

Chabal, Patrick. *Power in Africa: An Essay in Political Interpretation.* New York: St. Martin's Press, 1992.

Chabal, Patrick, and Jean-Pascal Daloz. *Culture Troubles: Politics and the Interpretation of Meaning.* London: C. Hurst, 2006.

Chakrabarty, Dipesh. "The Legacies of Bandung: Decolonization and the Politics of Culture." In *Making a World after Empire: The Bandung*

Moment and Its Afterlives, edited by Christopher J. Lee, 45–68. Athens: Ohio University Press, 2010.

———. *Provincializing Europe: Postcolonial Thought and Historical Difference.* Princeton, NJ: Princeton University Press, 2000.

Chatterjee, Partha. *The Nation and Its Fragments: Colonial and Postcolonial Histories.* Princeton, NJ: Princeton University Press, 1993.

Choay, Françoise. *The Invention of the Historic Monument.* Cambridge: Cambridge University Press, 2001.

Cinnamon, John M. "Missionary Expertise, Social Science, and the Uses of Ethnographic Knowledge in Colonial Gabon." *History in Africa* 33 (2006): 413–32.

Claerhout, Adriaan. "De Antwerpse Kongo-Kunst Tentoonstelling." *Congo-Tervuren* 4, no. 4 (1958): 72–75.

———. "De Ivoorkust-expeditie der Rijksuniversiteit te Gent en van het Vleeschhuis-Museum te Antwerpen." *Congo-Tervuren* 4, no. 4 (1958): 72–75.

Clarke, Christa, ed. *A Personal Journey: Central African Art from the Lawrence Gussman Collection.* Purchase, NY: Neuberger Museum of Art, 2001.

Clarke, Christa, and Kathleen Bickford Berzock. "Representing African Art in American Art Museums: A Historical Introduction." In *Representing Africa in American Art Collections: A Century of Collecting and Display,* edited by Kathleen Bickford Berzock and Christa Clarke, 3–19. Seattle: University of Washington Press, 2011.

Clavin, Patricia. "Defining Transnationalism." *Contemporary European History* 14, no. 4 (2005): 421–39.

Cleys, Bram. "On a Missionary Politics of Culture: The Gandajika Art School, 1952–1956." Unpublished paper.

Clifford, James. "Objects and Selves—an Afterword." In *Objects and Others: Essays on Museums and Material Culture,* edited by George W. Stocking Jr., 236–46. Madison: University of Wisconsin Press, 1985.

———. "Of Other Peoples: Beyond the 'Salvage' Paradigm." In *Discussions in Contemporary Culture,* edited by Hal Foster, 121–30. New York: New Press, 1987.

———. "On Ethnographic Allegory." In *Writing Culture: Poetics and Politics of Ethnography,* edited by James Clifford and George E. Marcus, 98–121. Berkeley: University of California Press, 1986.

———. *The Predicament of Culture: Twentieth-Century Ethnography, Literature and Art.* Cambridge, MA: Harvard University Press, 1988.

———. *Routes: Travel and Translation in the Late Twentieth Century.* Cambridge, MA: Harvard University Press, 1997.

Close, William T., and Malonga Miatudila. *Beyond the Storm: Treating the Powerless and the Powerful in Mobutu's Congo/Zaire.* Marbelton, WY: Meadowlark Springs Productions, 2007.

Cohen, Deborah, and Maura O'Connor. "Comparative History, Cross-National History, Transnational History: Definitions." In *Comparison and History:*

Europe in Cross-National Perspective, edited by Deborah Cohen and Maura O'Connor, ix–xxiv. New York: Routledge, 2004.

Cohn, Bernard. Colonialism and Its Forms of Knowledge: The British and India. Princeton, NJ: Princeton University Press, 1996.

Comaroff, John L., and Jean Comaroff, eds. Civil Society and the Political Imagination in Africa: Critical Perspectives, Problems, Paradoxes. Chicago: University of Chicago Press, 1999.

———. Ethnicity, Inc. Chicago: University of Chicago Press, 2009.

———. Ethnography and the Historical Imagination. Boulder: Westview Press, 1992.

Connerton, Paul. How Modernity Forgets. Cambridge: Cambridge University Press, 2009.

———. How Societies Remember. Cambridge: Cambridge University Press, 1989.

Connelly, Frances. "Authentic Irony: Primitivism and Its Aftermath." Critical Interventions 4, no. 2 (Fall 2010): 16–27.

———. The Sleep of Reason: Primitivism in Modern European Art and Aesthetics, 1725–1907. University Park: Pennsylvania State University Press, 1995.

Conklin, Alice L. "Civil Society, Science, and Empire in Late Republican France: The Foundation of Paris's Museum of Man." Osiris, 2nd ser., 17 (2002): 255–90.

———. In the Museum of Man: Race, Anthropology, and Empire in France, 1850–1950. Ithaca, NY: Cornell University Press, 2013.

———. A Mission to Civilize: The Republican Idea of Empire in France and West Africa, 1895–1930. Stanford, CA: Stanford University Press, 1997.

Conn, Steven. Do Museums Still Need Objects? Philadelphia: University of Pennsylvania Press, 2010.

———. History's Shadow: Native Americans and Historical Consciousness in the Nineteenth Century. Chicago: University of Chicago Press, 2004.

Cooksey, Susan, Robin Poynor, and Hein Vanhee, eds. Kongo across the Waters. Gainesville: University of Florida Press, 2013.

Coomans de Brachène, Oscar, ed. Etat présent de la noblesse belge, annuaire de 1996. Brussels: Etat Présent, 1996.

Coombes, Annie E. History after Apartheid: Visual Culture and Public Memory in a Democratic South Africa. Durham, NC: Duke University Press, 2003.

———. "Inventing the 'Postcolonial': Hybridity and Constituency in Contemporary Curating." New Formations 18 (Winter 1992): 39–52.

———. "The Object of Translation: Notes on 'Art' and Autonomy in a Postcolonial Context." In The Empire of Things: Regimes of Value and Material Culture, edited by Fred R. Myers, 233–56. Santa Fe: School of American Research Press, 2001.

———. Reinventing Africa: Museums, Material Culture and Popular Imagination in Late Victorian and Edwardian England. New Haven, CT: Yale University Press, 1994.

Cooper, Frederick. *Colonialism in Question: Theory, Knowledge, History.* Berkeley: University of California Press, 2005.

———. "Conflict and Connection: Rethinking Colonial African History." *American Historical Review* 99, no. 5 (December 1994): 1516–45.

———. *Decolonization and African Society: The Labor Question in French and British Africa.* Cambridge: Cambridge University Press, 1996.

———. "Possibility and Constraint: African Independence in Historical Perspective." *Journal of African History* 49, no. 2 (2008): 167–96.

Cooper, Frederick, and Ann Laura Stoler. "Between Metropole and Colony: Rethinking a Research Agenda." In *Tensions of Empire: Colonial Cultures in a Bourgeois World,* edited by Frederick Cooper and Laura Ann Stoler, 1–58. Berkeley: University of California Press, 1997.

———, eds. *Tensions of Empire: Colonial Cultures in a Bourgeois World.* Berkeley: University of California Press, 1997.

Les Cooperatives Indigènes au Congo Belge. Kalima, Congo: AIMO, 1950.

Coquery-Vidrovitch, Catherine, and Bogumil Jewsiewicki. "Africanist Historiography in France and Belgium: Traditions and Trends." In *African Historiographies: What History for Which Africa?,* edited by Bogumil Jewsiewicki and David Newbury, 139–50. Beverly Hills, CA: Sage, 1986.

Corbey, Raymond. *Tribal Art Traffic: A Chronicle of Taste, Trade and Desire in Colonial and Post-colonial Times.* Amsterdam: Royal Tropical Institute, 2000.

Cornelis, Sabine. "Artistes belges dans les territoires d'outre-mer, 1884–1962." *Annales sciences historiques.* Vol. 13. Tervuren: Musée Royal de l'Afrique Centrale, 1989.

———. "Birth of Academicism." In *Anthology of African Art: The Twentieth Century,* edited by N'Goné Fall and Jean Loup Pivin, 164–67. New York: Distributed Art Publishers, 2002.

———. "Le Musée du Congo belge, vitrine de l'action coloniale (1910–1930)." In *Du musée colonial au musée des cultures du monde,* edited by Dominique Taffin, 71–86. Paris: Maisonneuve et Larose, 2000: 71–86.

Cornet, Joseph. "African Art and Authenticity." *African Arts* 9, no. 1 (October 1975): 52–55.

———. *Art from Zaïre: 100 Masterworks from the National Collection; An Exhibition of Traditional Art from the Institute of the National Museums of Zaïre (IMNZ).* New York: African-American Institute, 1975.

———. *Art of Africa: Treasures from the Congo.* New York: Praeger, 1971.

———. *Art Royal Kuba.* Milan: Edizioni Sipiel Milano, 1982.

———. "Critique d'authenticité et art nègre." *Cultures au Zaire et en Afrique* 4 (n.d.): 125–36.

———. "Histoire de la peinture zaïroise à Kinshasa." In *La naissance de la peinture contemporaine en Afrique Centrale, 1930–1970,* 19–24. Tervuren: RMCA, 1992.

———. *Kongo: Objets de bois, objets d'ivoir.* Paris: Galerie Leloup, 1998.

———. *Pierres sculptées du Bas-Zaïre.* Kinshasa: IMNZ, 1978.

———. *A Survey of Zairian Art: The Bronson Collection.* Raleigh: North Carolina Museum of Art, 1978.

———. "Une mission fructueuse, ou comment j'ai pu apprendre beaucoup chez les Bakuba." *Antiquités: Journal des Antiquaires* (2000): 22–23.

Cornet, Joseph, Remi De Cnodder, Ivan Diericks, and Wim Toebosch, eds. *60 ans de peinture au Zaïre.* Brussels: Les Editeurs d'Art Associés, 1989.

Coronil, Fernando. "Can Postcoloniality Be Decolonized? Imperial Banality and Postcolonial Power." *Public Culture* 5, no. 1 (Fall 1992): 89–108.

Corsane, Gerard. *Heritage, Museums and Galleries: An Introductory Reader.* New York: Routledge, 2005.

Couttenier, Maarten. *Als muren spreken: Het museum van Tervuren, 1910–2010.* Tervuren: KMMA, 2010.

———. "Between Regionalization and Centralization: The Creation of Musée Léopold II in Elisabethville (Musée National de Lubumbashi), Belgian Congo (1931–1961)." *History and Anthropology* 25, no. 1 (2014): 72–101.

———. *Congo tentoongesteld: Een geschiedenis van de Belgische antropologie en het museum van Tervuren (1882–1925).* Leuven: Acco, 2005.

———. "Fysieke antropologie in België en Congo, 1883–1964: Levende tentoonstellingsobjecten." In *De exotische mens: Andere culturen als amusement,* edited by Bert Sliggers and Patrick Allegaert, 96–113. Tielt: Lannoo, 2009.

Crowley, Daniel J. "Stylistic Analysis of African Art: A Reassessment of Olbrecht's 'Belgian Method.'" *African Arts* 9, no. 2 (1976): 43–49.

Cuno, James, ed. *Whose Culture? The Promise of Museums and the Debate over Antiques.* Princeton, NJ: Princeton University Press, 2012.

Dembour, Marie-Bénédicte. *Recalling the Belgian Congo: Conversations and Introspection.* New York: Berghahn, 2000.

De Boeck, Filip. "Beyond the Grave: History, Memory and Death in Postcolonial Congo/Zaïre." In *Memory and the Postcolony: African Anthropology and the Critique of Power,* edited by Richard Werbner, 21–58. London: Zed, 1998.

De Cauter, Lieven, Lode de Clercq, and Bruno de Meulder. "Van 'Exposition Coloniale' naar 'Cité Coloniale': Tervuren als koloniale site." In *Het museum van de natie: Van kolonialisme tot globalisering,* edited by Herman Asselberghs and Dieter Lesage, 45–71. Brussels: Gevaert, 1999.

de Heusch, Luc. *Du pouvoir: Anthropologie politique des sociétés d'Afrique centrale.* Nanterre: Presse de l'Université de Nanterre, 2002.

———. *Le roi de Kongo et les monstres sacrés. Mythes et rites bantous III.* Paris: Gallimard, 2000.

———. *Le roi ivre ou l'origine de l'État. Mythes et rites bantous I.* Paris: Gallimard, 1972.

———. *Rois nés d'un cœur de vache. Mythes et rites bantous II.* Paris: Gallimard, 1982.

De Jong, Ferdinand, and Michael Rowlands, eds. *Reclaiming Heritage: Alternative Imaginaries of Memory in West Africa.* Walnut Creek, CA: Left Coast Press, 2007.

De Lame, Danielle, and Donatien Dibwe dia Mwembu. *Tout passe: Instantanés populaires et traces du passé à Lubumbashi.* Cahiers Africaines 71. Paris: L'Harmattan, 2005.

Depaepe, Marc, and Lies Van Rompaey. *In het teken van de bevoogding: De educatieve actie in Belgisch-Kongo (1908–1960).* Leuven-Apeldoorn: Garant, 1995.

De Plaen, Guy. "Le Musée de Lubumbashi: Un musée zaïrois tout à fait particulier." *Museum International* 41, no. 2 (1989): 124–28.

de Strycker, Louis. "In Memoriam, Joseph-Aurélien Cornet." *African Arts* 37, no. 2 (2004): 10.

de Villers, Gauthier. *De Mobutu à Mobutu: Trente ans de relations Belgique-Zaïre.* Brussels: De Boeck, 1995.

Depelchin, Jacques. *From the Congo Free State to Zaire (1885–1974): Towards a Demystification of Economic and Political History.* Dakar: Codeseria, 1992.

Deprez, Kas, and Louis Vos, eds. *Nationalism in Belgium: Shifting Identities, 1780–1995.* New York: St. Martin's Press, 1998.

Devisch, Réne. "Colonial State Building in the Congo, and Its Dismantling." *Journal of Legal Pluralism* 30, no. 42 (1998): 221–44.

———. "The University of Kinshasa: From Lovanium to Unikin." In *Higher Education in Postcolonial Africa: Paradigms of Development, Decline and Dilemmas,* edited by Michael O. Afoláyan, 17–38. Trenton, NJ: Africa World Press. 2007.

Diaïte, Ibou. "La coopération Belgo-zaïroise: Le maquillage d'une domination." In *Conflit Belgo-Zaïrois,* edited by Ibrahima Baba Kaké, 135–64. Paris: Présence Africaine, 1990.

Dias, Nélia. *Le Musée d'Ethnographie du Trocadéro (1878–1908): Anthropologie et muséologie en France.* Paris: Editions CNRS, 1991.

Dickinson, Greg, Carole Blair, and Brian L Ott, eds. *Places of Public Memory: The Rhetoric of Museums and Memorials.* Tuscaloosa: University of Alabama Press, 2010.

Dirks, Nicholas B., ed. *Colonialism and Culture.* Comparative Studies in Society and History Book Series. Ann Arbor: University of Michigan Press, 1992.

Döring, Thomas, ed. *African Cultures, Visual Arts, and the Museum: Sights/ Sites of Creativity and Conflict.* Amsterdam: Editions Rodophi B.V., 1994.

Drewal, Henry John. "African Art Studies Today." In *African Art Studies, the State of the Discipline,* edited by Rowland Abiodun, 29–62. Washington, DC: National Museum of African Art, 1990.

Duncan, Carol. "Art Museums and the Ritual of Citizenship." In *Exhibiting Cultures: The Poetics and Politics of Museum Display,* edited by Ivan Karp and Steven Lavine, 88–103. Washington, DC: Smithsonian Institution Press, 1991.

———. *Civilizing Rituals: Inside Public Art Museums.* London: Routledge, 1995.

Dunn, Kevin C. *Imagining the Congo: The International Relations of Identity.* New York: Palgrave Macmillan, 2003.

Ebong, Ima. "Negritude: Between Mask and Flag: Senegalese Cultural Ideology and the 'École de Dakar.'" In *Africa Explores: 20th Century African Art,* edited by Susan Vogel and Ima Ebong, 198–209. New York: Center for African Art, 1991.

Effiboly, Patrick. "Les musées béninois d'hier à demain." In *Dieux, rois et peuples du Bénin: Arts anciens du littoral aux savanes,* edited by H. Joubert and C. Vital, 126–32. Paris, Somogy Editions d'Art, 2008.

Enwezor, Okwui, ed. *The Short Century: Independence and Liberation Movements in Africa, 1945–1994.* New York: Prestel, 2001.

Errington, Shelly. *The Death of Authentic Primitive Art and Other Tales of Progress.* Berkeley: University of California Press, 1998.

Etambala, Zana Aziza. *Congo 55–65: Van Koning Boudewijn tot President Mobutu.* Tielt, Belgium: Lannoo, 1999.

——. *De teloorgang van een modelkolonie: Belgisch Congo, 1958–1960.* Leuven, Belgium: Acco, 2008.

Fabian, Johannes. "Curios and Curiosities." In *The Scramble for Art in Africa,* edited by Enid Schildkrout and Curtis A. Keim, 109–32. Cambridge: Cambridge University Press, 1998.

——. *Language and Colonial Power: The Appropriation of Swahili in the Former Belgian Congo.* Cambridge: Cambridge University Press, 1986.

——. *Out of Our Minds: Reason and Madness in the Exploration of Central Africa.* Berkeley: University of California Press, 2000.

——. "Popular Culture in Africa: Findings and Conjectures." In *Readings in African Popular Culture,* edited by Karin Barber, 315–34. Bloomington: Indiana University Press, 1997.

——. *Power and Performance: Ethnographic Explorations through Proverbial Wisdom and Theatre in Shaba, Zaire.* Madison: University of Wisconsin Press, 1990.

——. *Remembering the Present: Painting and Popular History in Zaire.* Berkeley: University of California Press, 1996.

——. *Time and the Other: How Anthropology Makes Its Object.* New York: Columbia University Press, 1983.

Fabian, Johannes, and Ilona Szombati-Fabian. "Art, History and Society: Popular Painting in Shaba, Zaire." *Studies in the Anthropology of Visual Communication* 3, no. 1 (1976): 1–21.

Fall, N'Goné, and Jean Loup Pivin, eds. *An Anthology of African Art: The Twentieth Century.* New York: Distributed Art Publishers, 2002.

Ferguson, James. *The Anti-Politics Machine: Development, Depoliticization and Bureaucratic Power in Lesotho.* Cambridge: Cambridge University Press, 1990.

——. *Global Shadows: Africa in the Neoliberal World Order.* Durham, NC: Duke University Press, 2006.

Fogelman, Arianna. "Colonial Legacy in African Museology: The Case of the Ghana National Museum." *Museum Anthropology* 31, no. 1 (2008): 19–27.

Ford, Caroline. "Museums after Empire in Metropolitan and Overseas France." *Journal of Modern History* 83, no.3 (September 2010): 625–61.

Foucault, Michel. "Two Lectures." In *Culture/Power/History: A Reader in Contemporary Social Theory*, edited by Nicholas B. Dirks, Geoff Eley, and Sherry B. Ortner, 200–221. Princeton, NJ: Princeton University Press, 1994.

Foutry, Vita, and Jan Neckers. *Als een wereld zo groot waar uw vlag staat geplant: Kongo 1885–1960*. Leuven: Instructieve Omroep-BRT, Nauwelearts, 1986.

Frank, Max, ed. *Histoire des finances publiques en Belgique. Tome IV–2: La période 1950–1980*. Brussels: Publications de l'Institut Belge de Finances Publiques, 1988.

Friedman, Martin. "African Art and the Western View." In *Art of the Congo*, 7–9. Minneapolis: Walker Art Center: 1967.

Fromont, Cécile. *The Art of Conversion. Christian Visual Culture in the Kingdom of Kongo*. Chapel Hill: University of North Carolina Press, 2014.

———. "By the Sword and the Cross: Power and Faith in the Arts of the Christian Kongo." In *Kongo across the Waters*, edited by Susan Cooksey, Robin Poynor, and Hein Vanhee, 28–33. Gainesville: University of Florida Press, 2013.

———. "Dance, Image, Myth and Conversion in the Kingdom of Kongo, 1500–1800." *African Arts* 44, no. 4 (Winter 2011): 54–65.

———. "Under the Sign of the Cross in the Kingdom of Kongo: Religious Conversion and Visual Correlation in Early Modern Central Africa." *RES: Anthropology and Aesthetics* 59–60 (Autumn 2011): 109–23.

Gaultier-Kurhan, Caroline, ed. *Le patrimoine culturel africain*. Paris: Maisonneuve & Larose, 2001.

Geertz, Clifford. *The Interpretation of Cultures*. New York: Basic Books, 1973.

Gellner, Ernst. *On Nations and Nationalism*. Ithaca, NY: Cornell University Press, 1983.

Genova, James E. *Colonial Ambivalence, Cultural Authenticity, and the Limitations of Mimicry in French-Ruled West Africa, 1914–1956*. New York: Peter Lang, 2004.

Gerard, Emmanuel, and Bruce Kuklick. *Death in the Congo: Murdering Patrice Lumumba*. Cambridge: Harvard University Press, 2015.

Gibbs, David N. *The Political Economy of Third World Intervention: Mines, Money and U.S. Policy in the Congo Crisis*. Chicago: University of Chicago Press, 1991.

Gifford, Prosser, and Wm. Roger Louis, eds. *Decolonization and African Independence: The Transfers of Power, 1960–1980*. New Haven, CT: Yale University Press, 1988.

Goddeeris, Idesbald, and Sindani E. Kiangu. "Congomania in Academia: Recent Historical Research on the Belgian Colonial Past." *BMGN Low Countries Historical Review* 126, no. 4 (2011): 54–74.

Gondola, Didier. "Ata Ndele . . . et l'indépendence vint: Musique, jeunes et contestation politique dans les capitales congolaises." In *Les jeunes en

Afrique, edited by Hélène d'Almeida-Topor, Catherine Coquery-Vidrovitch, Odile Georges, and Françoise Guitart, 463–87. Paris: L'Harmattan, 1992.

———. "Popular Music, Urban Society and Changing Gender Relations in Kinshasa, Zaire (1950–1990)." In *Gendered Encounters*, edited by Maria Grosz-Ngaté and Omari H. Kokele, 65–84. London: Routledge, 1996.

———. "Tropical Cowboys: Westerns, Violence and Masculinity Among the Young Bills of Kinshasa." *Afrique & Histoire* 7 (May 2009): 75–98.

Graburn, Nelson H. H., ed. *Ethnic and Tourist Arts: Cultural Expressions from the Fourth World*. Berkeley: University of California Press, 1976.

Gran, Guy, ed. *Zaire: The Political Economy of Underdevelopment*. New York: Praeger, 1979.

Greenfield, Jeanette. *The Return of Cultural Treasures*. Cambridge: Cambridge University Press, 1989.

Grootaers, Jan-Lodewijk, and Ineke Eisenburger. *Forms of Wonderment: The History and Collections of the Afrika Museum, Berg en Dal*. 2 vols. Berg en Dal, NL: Afrika Museum, 2002.

Guibernau, Montserrat, and John Hutchinson, eds. *Understanding Nationalism*. Cambridge: Polity Press, 2001.

Guisset, Jacqueline, ed. *Le Congo et l'art belge, 1880–1960*. Tournai: La Renaissance du Livre, 2003.

Gwete, Lema. "Acquisition et choix des objets africains traditionnels: Expérience de l'Institut des Musées Nationaux du Zaïre." In *Arte in Africa 2*, edited by Enzio Bassani and Gaetano Speranza, 78–86. Florence: Centro di Studi di Storia delle Arti Africane, 1991.

Halen, Pierre. "Les douze travaux du Congophile: Gaston-Denys Périer et la promotion de l'africanisme en Belgique." *Textyles: Revue des lettres belge de langue française* 17–18 (2000): 141–42.

———. "Une revue coloniale de culture congolaise: *Brousse* (1935–1939–1959)." In *Actes de la première journée d'études consacrée aux littératures "européennes" à propos ou issues de l'Afrique centrale*. Etudes Francophones de Bayreuth 3:68–91. Bayreuth: Universität Bayreuth, 1994.

Hall, Stuart. "Whose Heritage? Un-Settling 'The Heritage,' Re-Imagining the Post-Nation." In *The Third Text Reader on Art, Culture and Theory*, edited by Rasheed Araeen, Sean Cubitt, and Sardar Ziauddin, 72–84. London: Continuum, 2002.

Handler, Richard. "On Having Culture: Nationalism and the Preservation of Quebec's Patrimoine." In *Objects and Others: Essays on Museums and Material Culture*, edited by George W. Stocking Jr., 192–217. Madison: University of Wisconsin Press, 1985.

Haraway, Donna. *Primate Visions: Race, Gender and Nature in the World of Modern Science*. New York: Routledge, 1989.

Hargreaves, John D. *Prelude to the Partition of West Africa*. London: Macmillan, 1963.

Harney, Elizabeth. *In Senghor's Shadow: Art, Politics, and the Avant-Garde in Senegal, 1960–1995*. Durham, NC: Duke University Press, 2004.

Harries, Patrick. *Butterflies and Barbarians: Swiss Missionaries and Systems of Knowledge in South-East Africa*. Athens: Ohio University Press, 2007.

Harvey, Penelope. *Hybrids of Modernity: Anthropology, the Nation State and the Universal Exhibition*. New York: Routledge, 1996.

Helmreich, Jonathan E. *United States Relations with Belgium and the Congo, 1940–1960*. Newark, NJ: University of Delaware Press, 1998.

Hersey, Irwin. "Introduction." In *Art from Zaire*. New York: African-American Institute, 1976.

———. "The National Collection of Zaïre." *African Arts* 9, no. 2 (January 1976): 78–79.

Herskovits, Melville. "Frans Olbrechts in America." *Congo-Tervuren* 4, no. 4 (1958): 45–54.

Hiller, Susan, ed. *The Myth of Primitivism: Perspectives on Art*. New York: Routledge, 1991.

Hilton, Matthew, and Rana Mitter. "Introduction," in Supplement 8, *Past and Present* 218 (2013): 7–28.

Hobsbawm, Eric, and Terence Ranger, eds. *The Invention of Tradition*. Cambridge: Cambridge University Press, 1983.

Hochschild, Adam. *King Leopold's Ghost. A Story of Greed, Terror and Heroism in Colonial Africa*. Boston: Houghton Mifflin, 1998.

Hoffman, Barbara T., ed. *Art and Cultural Heritage: Law, Policy, and Practice*. Cambridge: Cambridge University Press, 2009.

Holsbeke, Mireille. " 'In de Grote Wazige Bergen bij een Indianenstam': De jonge Olbrechts in Amerika." In *Frans M. Olbrechts, 1899–1958: Op zoek naar kunst in Afrika*, edited by Constantine Petridis, 63–65. Antwerp: Etnografisch Museum van Antwerpen, 2001.

Hunt, Nancy Rose. *A Colonial Lexicon of Birth Ritual, Medicalization, and Mobility in the Congo*. Durham, NC: Duke University Press, 1999.

———. "Rewriting the Soul in Colonial Congo." *Past and Present* 198, no. 1 (February 2008): 185–215.

———. "Tintin and the Interruptions of Congolese Comics." In *Images and Empires: Visuality in Colonial and Postcolonial Africa*, edited by Paul S. Landau and Deborah Kaspin, 90–123. Berkeley: University of California Press, 2002.

ICOM. *What Museums for Africa? Heritage in the Future: Benin, Ghana, Togo, November 18–23, 1991. Proceedings of the Encounters*. Paris: International Council of Museums, 1992.

Institut des Musées Nationaux du Zaïre. *Sura Dji: visages et racines du Zaïre*. Paris: Musée des Arts Décoratifs, 1982.

———. *Trésors de l'art traditionnel*. Kinshasa: IMNZ, 1973.

Jameson, Fredric, and Masao Miyoshi, eds. *The Cultures of Globalization*. Durham, NC: Duke University Press, 1998.

Janzen, John M. "Laman's Congo Ethnography: Observations on Sources, Methodology, and Theory." *Africa* 42, no. 4 (1972): 316–28.

———. *The Quest for Therapy in Lower Zaire*. Berkeley: University of California Press, 1982.

———. "The Tradition of Renewal in Kongo Religion." In *African Religions: A Symposium*, edited by Newell Booth, 69–114. New York: Nok Publications, 1977.

Jewsiewicki, Bogumil. "African Peasants in the Totalitarian Colonial Society of the Belgian Congo." In *Peasants in Africa: Historical and Contemporary Perspectives*, edited by Martin A. Klein, 45–76. Beverly Hills: Sage, 1980.

———. "A la lecture d'une mémoire collective." *Canadian Journal of African Studies* 181, no. 1 (1984): 138–50.

———, ed. *Art pictural zaïrois*. Sillery, Québec: Editions du Septentrion, 1992.

———. *Chéri Samba: The Hybridity of Art*. Westmount, Québec: Gallerie Amrad African Art Publications, 1995.

———. "De la nation indigène à l'authenticité: La notion d'ordre public au Congo, 1908–1990." *Civilizations* 40, no. 2 (1992): 102–27.

———. "De l'art africain et de l'esthétique: Valeur d'usage, valeur d'échange." *Cahiers d'Études Africaines* 36, nos. 141–42 (1996): 257–69.

———. "Héritages et réparations en quête d'une justice pour le passé ou le présent." *Cahiers d'Études Africaines* 44, nos. 173–74 (2004): 7–24.

———. "Historical Memory and Representation of New Nations in Africa." In *Historical Memory in Africa: Dealing with the Past, Reaching for the Future in an Intercultural Context*, edited by Mamdou Diawara, Bernard Lategan, and Jörn Rüsen, 53–66. New York: Berghahn Books, 2010.

———. "Painting in Zaire: From the Invention of the West to the Representation of the Social Self." In *Africa Explores: 20th Century African Art*, edited by Susan Vogel and Ima Ebong, 41–62. New York: Center for African Art, 1991.

———. "Le primitivisme, le postcolonialisme, les antiquités 'nègres' et la question nationale." *Cahiers d'Études Africaines* 31, nos. 1 and 2 (1991): 191–213.

———. "Rural Society and the Belgian Colonial Economy." In *History of Central Africa*, edited by David Birmingham and Phyllis M. Martin, 2:95–125. London: Longman, 1983.

Jewsiewicki, Bogumil, and V. Y. Mudimbe. "Africans' Memories and Contemporary History of Africa." In *History Making in Africa: History and Theory: Studies in the Philosophy of History* 32 (1993): 1–11.

———. "Meeting the Challenge of Legitimacy: Post-independence Black Africa and Post-Soviet European States." *Daedalus* 124, no. 3 (1995): 191–207.

Jewsiewicki, Bogumil, and David Newbury, eds. *African Historiographies: What History for Which Africa?* Newbury Park, CA: Sage, 1986.

Jewsiewicki, Bogumil, and Barbara Plankensteiner, eds. *An/Sichten: Malerei aus dem Kongo, 1990–2000*. New York: Springer-Verlag, 2001.

Jewsiewicki, Bogumil, Yvette Brett, and Andrew Roberts. "Belgian Africa." In *The Cambridge History of Africa*. Vol. 7, *From 1905 to 1940*, edited by A. D. Roberts, 460–93. Cambridge: Cambridge University Press, 1986.

Jewsiewicki, Bogumil, Elikia M'Bokolo, Ndaywel è Nziem, and Sabakinu Kivulu. *Moi, l'Autre, Nous Autres: Vies zaïroises ordinaires, 1930–1980: Dix Récits*. Paris: École des Hautes Études en Sciences Sociales, 1990.

Jonaitis, Aldona, ed. *Wealth of Thought: Franz Boas on Native American Art.* Seattle: Washington University Press, 1995.

Jules-Rosette, Benetta. *The Messages of Tourist Art: An African Semiotic System in Comparative Perspective.* New York: Plenum, 1984.

Kabongo, Ilunga. "The Catastrophe of Belgian Decolonization." In *Decolonization and African Independence: The Transfers of Power, 1960–1980,* edited by Prosser Gifford and Wm. Roger Louis, 381–400. New Haven, CT: Yale University Press, 1988.

Kalb, Madeleine. *The Congo Cables: The Cold War in Africa—from Eisenhower to Kennedy.* New York: Macmillan, 1982.

Kamer, Henri. *The Authenticity of African Sculptures.* 1974. http://www.randafricanart.com/Authenticity_of_African_Sculptures_Henri_Kamer.html, accessed 4 July 2013.

Kangafu, Kutumbagana. *Discours sur l'authenticité.* Kinshasa: Les Presses Africaines, 1973.

Kaplan, Flora Edouwaye S., ed. *Museums and the Making of "Ourselves": The Role of Objects in National Identity.* London: Leicester University Press, 1994.

———. "Nigerian Museums: Envisaging Culture as National Identity." In *Museums and the Making of "Ourselves": The Role of Objects in National Identity,* edited by Flora Edouwaye S. Kaplan, 45–78. London: Leicester University Press, 1994.

Kapur, Geeta. "Contemporary Cultural Practice. Some Polemical Categories." In *The Third Text Reader on Art, Culture and Theory,* edited by Rasheed Araeen, Sean Cubitt, and Sardar Ziauddin, 15–23. London: Continuum, 2002.

Karp, Ivan, and Steven D. Lavine, eds. *Exhibiting Cultures: The Poetics and Politics of Museum Display.* Washington, DC: Smithsonian Institution Press, 1991.

Karp, Ivan, Christine Mullen Kreamer, and Steven D. Lavine, eds. *Museums and Communities. The Politics of Public Culture.* Washington, DC: Smithsonian Institution Press, 1992.

Karp, Ivan, Corinne A. Kratz, Lynn Szwaja, and Tomás Ybarra-Frausto, eds. *Museum Frictions: Public Cultures/Global Transformations.* Durham, NC: Duke University Press, 2007.

Kasfir, Sidney Littlefield. *African Art and the Colonial Encounter: Inventing a Global Commodity.* Bloomington: Indiana University Press, 2007.

———. "African Art and Authenticity: A Text with a Shadow." *African Arts* 25, no. 2 (July 1992): 41–53.

———. "One Tribe, One Style? Paradigms in the Historiography of African Art." *History in Africa* 11 (1984): 163–93.

Keim, Curtis A. "Artes Africanae: The Western Discovery of 'Art' in Northeastern Congo." In *The Scramble for Art in Africa,* edited by Enid Schildkrout and Curtis A. Keim, 109–32. Cambridge: Cambridge University Press, 1998.

Kelly, Sean. *America's Tyrant: The CIA and Mobutu of Zaire.* Washington: American University Press, 1993.

Kinnane, Dirk. "Committee Urges Co-operation in Returning Art Works." *Unesco Features* 755 (1980): 1–13.

Kirshenblatt-Gimblett, Barbara. *Destination Culture: Tourism, Museums, and Heritage*. Berkeley: University of California Press, 1998.

———. "World Heritage and Cultural Economics." In *Museum Frictions: Public Cultures/Global Transformations*, edited by Ivan Karp, Corinne A. Kratz, Lynn Szwaja, and Tomás Ybarra-Frausto, 161–202. Durham, NC: Duke University Press, 2007.

Kisangani, Emizet François, and F. Scott Bobb. *Historical Dictionary of the Democratic Republic of the Congo*. Historical Dictionaries of Africa, no. 112. 3rd ed. Lanham, MD: Scarecrow, 2010.

Klieman, Kairn A. "Oil, Politics, and Development in the Formation of a State: The Congolese Petroleum Wars, 1963–1968." *International Journal of African Historical Studies* 41, no. 2 (2006): 169–202.

Kochnitzky, Leon. *Negro Art in Belgian Congo*. New York: Belgian Government Information Center, 1958.

———. *Shrines of Wonders: A Survey of Ethnological and Folk Art Museums in Central Africa*. New York: Clark & Fritts, 1952.

Kramer, Paul. "Power and Connection: Imperial Histories of the United States in the World." *American Historical Review* 116, no. 5 (December 2011): 1348–92.

Kufimba, Bamba Ndombasi. *Initiation à l'art plastique zaïrois d'aujourd'hui*. Kinshasa: Editions Lokele, 1973.

Kuklick, Henrika. *The Savage Within: The Social History of British Anthropology, 1885–1945*. Cambridge: Cambridge University Press, 1991.

———, ed. *A New History of Anthropology*. Oxford: Blackwell, 2007.

Lagae, Johan. "Colonial Encounters and Conflicting Memories: Shared Colonial Heritage in the Belgian Congo." *Journal of Architecture* 9, no. 2 (Summer 2004): 173–97.

———. " 'Het echte belang van de kolonisatie valt samen met dat van de wetenschap': Over kennisproductie en de rol van wetenschap in de Belgische koloniale context." In *Het geheugen van Congo: De koloniale tijd*, edited by Jean-Luc Vellut, 131–38. Tervuren: Snoeck-KMMA, 2005.

———. "From 'Patrimoine Partagé' to 'Whose Heritage'? Critical Reflections on Colonial Built Heritage in the City of Lubumbashi, Democratic Republic of the Congo." *Afrika Focus* 21, no. 2 (2008): 21–30.

———. "Léopoldville—Bruxelles, villes miroirs? L'architecture et l'urbanisme d'une capitale coloniale." In *Villes d'Afrique: Explorations en histoire urbaine*, edited by Jean-Luc Vellut, 67–99. Cahiers Africains 73. Tervuren: Royal Museum of Central Africa, 2007.

Lagae, Johann, Beeckmans Luce, and Boonen Sofie. "Decolonizing Spaces: A (Visual) Essay on Strategies of Appropriation, Transformation and Negotiation of the Colonial Built Environment in Postcolonial Congo." *Hagar Studies in Culture, Polity and Identities* 9, no. 2 (2010): 49–88.

Landau, Paul S., and Deborah D. Kaspin, eds. *Images and Empires: Visuality in Colonial and Postcolonial Africa.* Berkeley: University of California Press, 2002.

Latour, Bruno. *Reassembling the Social: An Introduction to Actor-Network Theory.* Oxford: Oxford University Press, 2005.

——. *Science in Action.* Cambridge, MA: Harvard University Press, 1987.

Lears, T. J. Jackson. *No Place of Grace: Antimodernism and the Transformation of American Culture 1880–1920.* New York: Pantheon, 1981.

Lebovics, Herman. *Bringing the Empire Back Home: France in the Global Age.* Durham, NC: Duke University Press, 2004.

——. *Imperialism and the Corruption of Democracies.* Durham, NC: Duke University Press, 2006.

——. *True France: The Wars over Cultural Identity, 1900–1945.* Ithaca, NY: Cornell University Press, 1992.

Legassick, Martin, and Ciraj Rassool. *Skeletons in the Cupboard: South African Museums and the Trade in Human Remains, 1907–1917.* Cape Town: South African Museum, 2000.

Legros, Hugues. *Chasseurs d'ivoire: Une histoire du royaume yeke du Shaba (Zaïre).* Brussels: Editions de l'Université de Bruxelles, 1996.

Lemarchand, René. *Political Awakening in the Congo.* Berkeley: University of California Press, 1964.

Leurquin, Anne. *Utotombo: Kunst uit zwart Afrika in privé-bezit.* Brussels: Vereniging voor Tentoonstellingen van het Paleis der Schone Kunsten, 1988.

Leyten, Harrie, ed. *Illicit Traffic in Cultural Property.* Amsterdam: Royal Tropical Institute, 1995.

Likaka, Osumaka. *Naming Colonialism: History and Collective Memory in the Congo, 1870–1960.* Madison: University of Wisconsin Press, 2009.

——. *Rural Society and Cotton in Colonial Zaire.* Madison: University of Wisconsin Press, 1997.

Loomba, Ania, Suvir Paul, Matti Bunzl, Antoinette Burton, and Jed Etsy, eds. *Postcolonial Studies and Beyond.* Durham, NC: Duke University Press, 2005.

Lowenthal, David. *The Heritage Crusade and the Spoils of History.* Cambridge: Cambridge University Press, 1998.

Lumenganeso Kiobe, Antoine. *Congo: Guide des Archives Nationales.* Kinshasa: CEDI, 2001.

Lumley, Robert, ed. *The Museum Time Machine: Putting Cultures on Display.* London: Routledge, 1988.

Luwel, Marcel. "Histoire du Musée Royal du Congo Belge à Tervuren." *Belgique d'Outremer* 14, no. 289 (April 1959): 209–12.

——. "Histoire du Musée Royal du Congo Belge à Tervuren." *Congo-Tervuren* 6, no. 2 (1960): 30–49.

——. "Van onafhankelijk Congo tot Belgisch Congo." *Congo-Tervuren* 5, no. 1 (1959): 6–13.

Macdonald, Sharon, ed. *The Politics of Display: Museums, Science, Culture.* New York: Routledge, 1998.

Macdonald, Sharon, and Gordon Fyfe, eds. *Theorizing Museums: Representing Identity and Diversity in a Changing World.* Cambridge: Blackwell, 1996.

MacGaffey, Janet, ed. *The Real Economy of Zaire: The Contribution of Smuggling and Other Unofficial Activities to National Wealth.* Philadelphia: University of Pennsylvania Press, 1991.

———. "State Deterioration and Capitalist Development: The Case of Zaire." In *African Capitalists in African Development,* edited by Bruce J. Berman and Colin Leys, 189–204. London: Lynne Rienner, 1994.

MacGaffey, Wyatt. "Changing Representations in Central African History." *Journal of African History* 46 (2005): 189–207.

———. "Complexity, Astonishment and Power: The Visual Vocabulary of Kongo Minkisi." *Journal of Southern African Studies* 14, no. 2 (1988): 188–203.

———. *Kongo Political Culture: The Conceptual Challenge of the Particular.* Bloomington: Indiana University Press, 2000.

MacGaffey, Wyatt, and Michael Harris, eds. *Astonishment and Power.* Washington DC: Smithsonian Institution Press, 1993.

Mack, John. *Emil Torday and the Art of the Congo, 1900–1909.* London: British Museum Publications, 1991.

Maesen, Albert. "Congo Art and Society." In *Art of the Congo,* 5–16. Minneapolis: Walker Art Center: 1967.

Magee, Carol. *Africa in the American Imagination: Popular Culture, Racialized Identities and African Visual Culture.* Jackson: University of Mississippi Press, 2012.

Makengo Nkutu, Alphonse. *Les institutions politiques de la RDC. De l'État independent du Congo à la République du Zaïre (1885–1990).* Paris: L'Harmattan, 2010.

Mamdani, Mahmood. *Citizen and Subject: Contemporary Africa and the Legacy of Late Colonialism.* Princeton, NJ: Princeton University Press, 1996.

Mantels, Ruben. "De klacht van Nkunda: Over universiteiten, kolonisatie en dekoloniatie in Belgisch-Congo." *Studium* 3, no. 2 (2010): 61–73.

Marcus, George E., and Fred R. Myers, eds. *The Traffic in Culture: Refiguring Art and Anthropology.* Berkeley: University of California Press, 1995.

Mathur, Saloni. *India by Design: Colonial History and Cultural Display.* Berkeley: University of California Press, 2007.

Maxwell, David. "Photography and the Religious Encounter: Ambiguity and Aesthetics in Missionary Representations of the Luba of South East Belgian Congo." *Comparative Studies in Society and History* 53, no. 1 (2011): 38–74.

———. "The Soul of the Luba: W.F.P. Burton, Missionary Ethnography and Belgian Colonial Science." *History and Anthropology* 19, no. 4 (2008): 325–51.

Mbambu Makuka, Ferdinand. "La problématique du musée en République Démocratique du Congo, vue par un muséologue." Unpublished manuscript, Kinshasa, 2006.

Mbembe, Achille. *On the Postcolony*. Berkeley: University of California Press, 2001.

Mbembe, Achille, and Janet Roitman. "Figures of the Subject in Times of Crisis." *Public Culture* 7, no. 2 (1995): 323–52.

McClintock, Anne. *Imperial Leather: Race, Gender and Sexuality in the Colonial Contest*. New York: Routledge, 1995.

Merryman, John, ed. *Imperialism, Art and Restitution*. Cambridge: Cambridge University Press, 2010.

———. "Two Ways of Thinking about Cultural Property." *American Journal of International Law* 80, no. 4 (1996): 831–53.

Miller, Joseph C. "Central Africa during the Era of the Slave Trade, c. 1490s–1850s." In *Central Africans and Cultural Transformations in the American Diaspora*, edited by Linda Heywood, 21–69. Cambridge: Cambridge University Press, 2002.

———. *Way of Death: Merchant Capitalism and the Angolan Slave Trade, 1730–1830*. Madison: University of Wisconsin Press, 1988.

Mitchell, Timothy. *Colonizing Egypt*. Berkeley: University of California Press, 1988.

———. "Orientalism and the Exhibitionary Order." In *The Art of Art History*, edited by Donald Preziosi, 409–23. Oxford: Oxford University Press, 2005.

Mobutu Sese Seko. "Foreword." In *Art from Zaire*. New York: African-American Institute, 1976.

———. *Le Général Mobutu Sese Seko parle . . . du nationalisme zaïrois authentique*. Kinshasa: Manwana Mungongo, n.d.

Monroe, John Warne. "Surface Tensions: Empire, Parisian Modernism and 'Authenticity' in African Sculpture, 1917–1939." *American Historical Review* 117, no. 2 (April 2012): 445–75.

Mooney, James, and Frans M. Olbrechts. *The Swimmer Manuscript: Cherokee Sacred Formulas and Medicinal Prescriptions*. Washington, DC: Smithsonian Institution, Government Printing Office, 1932.

Moore, Sally Falk. *Anthropology and Africa: Changing Perspectives on a Changing Scene*. Charlottesville: University Press of Virginia, 1994.

———. "Changing Perspectives on a Changing Africa: The Work of Anthropology." In *Africa and the Disciplines: The Contributions of Research in Africa to the Social Sciences and Humanities*, edited by Robert H. Bates, V. Y. Mudimbe, and Jean O'Barr, 3–57. Chicago: University of Chicago Press, 1993.

Morimont, Françoise. "L'Africanisation de l'art Chrétien du Congo Belge, 1919–1950." *Enquêtes et Documents d'histoire africaine* 12, (1995): 63–110.

Morton, Patricia. *Hybrid Modernities: Architecture and Representation at the 1931 Colonial Exposition*. Paris. Cambridge, MA: MIT Press, 2000.

Mount, Marshall Ward. *African Art: The Years Since 1920*. Bloomington: Indiana University Press, 1973.

Mpwate-Ndaume, Georges. *La coopération entre le Congo et les pays capitalistes: Un dilemme pour les presidents congolais 1908–2008*. Paris: L'Harmattan RDC, 2010.

Mudimbe, V. Y. "Et si nous renvoyions à l'analyse le concept d'art populaire," In *Art pictural zaïrois*, edited by Bogumil Jewsiewicki, 25–28. Sillery, Quebec: Editions du Septentrion, 1992.

———. "From 'Primitive Art' to 'Memoriae Loci.'" *Human Studies* 16, nos. 1–2 (1993): 101–110.

———. *The Idea of Africa*. Bloomington: Indiana University Press, 1994.

———. *The Invention of Africa: Gnosis, Philosophy and the Order of Knowledge*. Bloomington: Indiana University Press, 1988.

Mukulumanya, W. N. Z. "Authenticité: Mythe ou identité?" In *Authenticité et développement*, 65–96. Paris: Éditions Présence Africaine, 1982.

Murphy, Maureen. *De l'imaginaire au musée: Les arts d'Afrique à Paris et à New York (1931–2006)*. Dijon: Les presses du réel, 2009.

Museum of Primitive Art. *The Clark and Frances Stillman Collection of Congolese Sculpture*. New York: Museum of Primitive Art, 1966.

Muya wa Bitanko, "Le musée de Lubumbashi: Bref historique." Unpublished manuscript, Lubumbashi, 1999.

Mwana, George Kwete. *Souvenirs d'un prince Kuba du Congo (1913–1970)*. Paris: L'Harmattan, 2010.

Myers, Fred R., ed. *The Empire of Things: Regimes of Value and Material Culture*. Santa Fe: School of American Research Press, 2002.

Myles, Kwasi. "Museum development in African countries." *Museum International* 28, no. 4 (1976): 196–202.

La naissance de la peinture contemporaine en Afrique centrale, 1930–1970. Tervuren: RMCA, 1992.

Ndaywel è Nziem, Isidore. *Histoire générale du Congo: De l'héritage ancien à la République Démocratique*. Louvain-La-Neuve: Ducelot, 1998.,

———. *Nouvelle histoire du Congo: Des origines à la République Démocratique*. Kinshasa: Afrique Éditions; Brussels: Le Cri, 2008.

———, ed. *Quelle politique culturelle pour la Troisième République au Zaïre? Conference Nationale Souveraine et Culture*. Kinshasa: Bibliothèque Nationale du Zaïre, 1992.

Nelson, Steven. "Collection and Context in a Cameroonian Village." *Museum International* 59, no. 3 (2007): 22–30.

Nettleton, Anitra. *The Collection of W.F.P. Burton*. Johannesburg: University of Witwatersrand Art Galleries, 1992.

Newbury, David. "The Continuing Process of Decolonization in the Congo: Fifty Years Later." *African Studies Review* 55, no. 1 (2012): 131–41.

Newbury, M. Catharine. "Dead and Buried or Just Underground? The Privatization of the State in Zaire." *Canadian Journal of African Studies* 18, no. 1 (1984): 112–14.

Neyt, François, and Louis de Strycker. *Approche des arts Hemba*. Villiers-le-Bel, France: Arts d'Afrique Noire, 1975.

Ngũgĩ wa Thiong'o. *Decolonizing the Mind: The Politics of Language in African Literature*. Oxford: James Currey, EAEP, Heinemann, 1981.

Nooter, Mary H. "Fragments of Forsaken Glory: Luba Royal Culture Invented and Represented (1883–1992) (Zaire)." In *Kings of Africa: Art and Authority in Central Africa*, edited by Erna Beumers and Hans-Joachim Koloss, 79–89. Maastricht: Foundation Kings of Africa, 1992.

———. *Secrecy: African Art That Conceals and Reveals*. New York: Museum for African Art, 1993.

Nzongola-Ntalaja, Georges. *The Congo from Leopold to Kabila: A People's History*. London: Zed, 2002.

———, ed. *The Crisis in Zaire: Myths and Realities*. Trenton, NJ: Africa World Press, 1986.

Ogbechie, Sylvester Okwunodu. *Ben Enwonwu: The Making of an African Modernist*. Rochester, NY: University of Rochester Press, 2008.

———. *Making History: African Collectors and the Canon of African Art*. Femi Akinsanya African Art Collection. Milan: 5 Continents Edition, 2011.

Oguibe, Olu, and Okwui Enwezor, eds. *Reading the Contemporary: African Art from Theory to the Marketplace*. Boston: MIT Press, 1999.

Olbrechts, Frans M. *Congolese Sculpture*. New Haven, CT: Human Relations Area Files, Inc., 1982.

———. "De 'Kabila' beelden van Dr. J. Maes." *Kongo-overzee: Tijdschrift voor en over Belgisch Kongo Rwanda-Burundi en aanpalende gewesten* 6 (1940): 38–48.

———. *Het roode land der zwarte kariatieden*. Leuven: Davidsfonds, 1935.

———. *Maskers en dansers in de Ivoorkust*. Leuven: Davidsfonds, 1940.

———. *Plastiek van Kongo*. Antwerp: Uitgeverij Standaard, 1946.

———. *Quelques chefs-d'oeuvre de l'art africain des collections du Musée Royal du Congo Belge, Tervuren*. Tervuren: Museum van Belgisch Kongo, 1952.

———. "Westerse invloed op de inheemse kunst in Afrika?" In *Voordrachten Koninklijke Musea voor Schone Kunsten van België, 1940–1941*, 4–24. Brussels: KMSK, 1942.

Ortner, Sherry B. "Theory in Anthropology since the Sixties." In *Culture/Power/History: A Reader in Contemporary Social Theory*, edited by Nicholas B. Dirks, Geoff Eley, and Sherry B. Ortner, 372–411. Princeton, NJ: Princeton University Press, 1994.

Östberg, Wilhelm, ed. *Whose Objects? Art Treasures from the Kingdom of Benin in the Collection of the Museum of Ethnography, Stockholm*. Stockholm: Etnografiska Museet, 2010.

Paulme, Denise. "Les Collections d'Afrique Noire depuis 1945." *Objets et Mondes: Revue du Musée de l'Homme* 1, no. 1 (1961): 41–42.

Pearce, Susan M., ed. *Interpreting Objects and Collections*. London: Routledge, 1995.

Peemans, J.-P. "Imperial Hangovers: Belgium—The Economics of Decolonization." *Journal of Contemporary History* 15, no. 2 (1980): 257–86.

Penny, H. Glenn. *Objects of Culture: Ethnology and Ethnographic Museums in Imperial Germany*. Chapel Hill: University of North Carolina Press, 2002.

Penny, H. Glenn, and Matti Bunzl, eds. *Worldly Provincialism: German Anthropology in the Age of Empire*. Ann Arbor: University of Michigan Press, 2003.

Périer, Gaston-Denys. "A la commission pour la protection des arts et métiers indigènes: Rapport du Secrétaire sur sa visite à Elisabethville." *Revue Congolaise* 9, no. 10 (December 1950): 3–15.

——. "L'art vivant des nègres: Un imagier Congolais." *Cahiers de Belgique* 2, no. 7 (July 1929): 256–59.

——. *Les arts populaires du Congo Belge*. Brussels: Office de Publicité, Collection Nationale. 8th ser.

——. *La colonisation pittoresque*. Brussels: L'Edition, 1930.

——. *Les flèches du Congophile: Mémoires d'un employé au Ministère (des colonies)*. Brussels: Editions L'Afrique et le Monde, 1957.

Petridis, Constantine, ed. *Frans M. Olbrechts, 1899–1958: Op zoek naar kunst in Afrika*. Antwerp: Etnografisch Museum van Antwerpen, 2001.

——. "Kongo-Kunst in Antwerpen." In *Frans M. Olbrechts, 1899–1958: Op zoek naar kunst in Afrika*, edited by Constantine Petridis. Antwerp: Etnografisch Museum van Antwerpen, 2001.

Phillips, Ruth B. "Exhibiting Africa after Modernism: Globalization, Pluralism, and the Persistent Paradigms of Art and Artifact." In *Museums after Modernism: Strategies of Engagement*, edited by Griselda Pollock and Joyce Zemans, 80–103. Oxford: Blackwell, 2007.

——. "Fielding Culture: Dialogues between Art History and Anthropology." *Museum Anthropology* 18, no. 1 (1994): 39–46.

Phillips, Ruth B., and Christopher B. Steiner, eds. *Unpacking Culture: Art and Commodity in Colonial and Postcolonial Worlds*. Berkeley: University of California Press, 1999.

Pieprzak, Katarzyna. *Imagined Museums: Art and Modernity in Postcolonial Morocco*. Minneapolis: University of Minnesota Press, 2010.

Pierce, Steven. "Looking Like a State: Colonialism and the Discourse of Corruption in Northern Nigeria." *Comparative Studies in Society and History* 48, no. 4 (2006): 887–912.

Pinney, Christopher, and Nicholas Thomas, eds. *Beyond Aesthetics: Arts and the Technologies of Enchantment*. New York: Berg, 2001.

Poncelet, Marc. *L'invention des sciences coloniales belges*. Paris: Karthala, 2008.

Povey, John. "A Survey of Zairian Art: the Bronson Collection." *African Arts* 12, no. 3 (May 1979): 88–89.

Prakash, Gyan, ed. *After Colonialism: Imperial Histories and Postcolonial Displacements*. Princeton, NJ: Princeton University Press, 1995.

Price, Sally. *Paris Primitive: Jacques Chirac's Museum on the Quai Branly*. Chicago: University of Chicago Press, 2007.

——. *Primitive Art in Civilized Places*. Chicago: University of Chicago Press, 1989.

Probst, Peter. *Osogbo and the Art of Heritage: Monuments, Deities and Money*. Bloomington: Indiana University Press, 2011.

Rahier, Jean Muteba. "The Ghost of Leopold II: The Belgian Royal Museum of Central Africa and Its Dusty Colonialist Exhibition." *Research in African Literatures* 34, no. 1 (Spring 2003): 58–84.

Ranger, Terence, and Olufemi Vaughan, eds. *Legitimacy and the State in Twentieth-Century Africa*. London: Macmillan, 1993.

Rassool, Ciraj. "Community Museums, Memory Politics, and Social Transformations in South Africa: Histories, Possibilities, and Limit." In *Museum Frictions: Public Cultures/Global Transformations*, edited by Ivan Karp, Corinne A. Kratz, Lynn Szwaja, and Tomás Ybarra-Frausto, 286–321. Raleigh, NC: Duke University Press, 2007

——. *Recalling Community in Cape Town: Creating and Curating the District Six Museum*. Cape Town: District Six Museum, 2001.

——. "The Rise of Heritage and the Reconstitution of History in South Africa." *Kronos* 26 (August 2000): 1–21.

Raymaekers, Jan. "Het Museum voor Kunst en Folklore van Luluaburg." *Bulletin des Séances: Académie Royale des Sciences d'Outre-Mer/Mededelingen Zittingen Koninklijke Academie voor Overzeese Wetenschappen* 59, nos. 2–4 (2013): 243–82.

Reefe, Thomas Q. *The Rainbow and the Kings: A History of the Luba Empire until 1891*. Berkeley: University of California Press: 1981.

Robbins, Warren M., and Mary Ingram Nooter. *African Art in American Collections*. Washington, DC: Smithsonian Institution Press, 1989.

Roberts, Allen F. *A Dance of Assassins: Performing Early Colonial Hegemony in the Congo*. Bloomington: Indiana University Press, 2013.

Roberts, Mary Nooter, and Allen F. Roberts. *Luba*. Milan: 5 Continents Editions, 2007.

——, eds. *Memory: Luba Art and the Making of History*. New York: Museum for African Art, 1996.

Roes, Aldwin. "Towards a History of Mass Violence in the Etat Indépendant du Congo, 1885–1908." *South African Historical Journal* 62, no. 4 (2010): 634–70.

Rosaldo, Renato. *Culture and Truth: The Remaking of Social Analysis*. Boston: Beacon, 1993.

Rubbers, Benjamin. "The Story of a Tragedy: How People in Haut-Katanga Interpret the Post-colonial History of Congo." *Journal of Modern African Studies* 47, no. 2 (2009): 267–89.

Rubin, William, ed. *"Primitivism" in 20th Century Art: Affinity of the Tribal and the Modern*. 2 vols. New York: Museum of Modern Art, 1984.

Sabakinu, Kivulu. "La spécificité de la colonisation et de la décolonisation du Zaïre." In *Belgique/Zaïre: Une histoire en quête d'avenir: Actes des rencontres de Bruxelles, ULB, 7–8–9 octobre 1993*, edited by Gauthier de Villers, 27–39. Brussels: Institut Africain-CEDAF; Paris: L'Harmattan, 1994.

Salmon, Pierre. "Réflexion à propos du goût des arts zaïrois en Belgique durant la periode coloniale (1885–1960)." In *Papier blanc, encre noire: Cent ans de culture francophone en Afrique centrale: Zaïre, Rwanda et Burundi*, edited by Emile Van Balberghe, 179–201. Brussels: Editions Labor, 1992.

Sang'Amin, Kapalanga Gazungil. *Les spectacles d'animation politique en République du Zaïre*. Louvain-la-Neuve, Belgium: Cahiers Théâtre Louvain, 1989.

Sanjek, Roger. "Anthropology's Hidden Colonialism: Assistants and their Ethnographers." *Anthropology Today* 9, no. 2 (1993): 13–18.

Saunders, Barbara. "Congo-Vision." In *Science, Magic and Religion: The Ritual Process of Museum Magic*, edited by Mary Bouquet and Nuno Porto, 75–94. New York: Berghahn, 2004.

Schädler, Karl-Ferdinand. "L'héritage culturel autochtone en pays étranger. À propos de la restitution des oeuvres d'art." In *De l'art Nègre à l'art africain*, edited by Raoul Lehuard, 130–36. Paris: Musée National des Arts Africains et Océaniens, 1990.

Schatzberg, Michael G. *The Dialectics of Oppression in Zaire*. Bloomington: Indiana University Press, 1988.

——. *Mobutu or Chaos? The United States and Zaire, 1960–1990*. Lanham, MD: University Press of America, 1991.

——. *Political Legitimacy in Middle Africa: Father, Family, Food*. Bloomington: Indiana University Press, 2001.

——. *Politics and Class in Zaire: Bureaucracy, Business and Beer in Lisala*. New York: Africana, 1980.

Schildkrout, Enid. "Museums and Nationalism in Namibia." *Museum Anthropology* 19, no. 2 (1995): 65–77.

——. "Personal Styles and Disciplinary Paradigms: Frederick Starr and Herbert Lang." In *The Scramble for Art in Central Africa*, edited by Enid Schildkrout and Curtis A. Keim, 169–92. Cambridge: Cambridge University Press, 1998.

Schildkrout, Enid, and Curtis A. Keim, eds. *African Reflections: Art from Northeastern Zaire*. New York: American Museum of Natural History, 1990.

——. "Objects and Agendas: Re-collecting the Congo." In *The Scramble for Art in Central Africa*, edited by Enid Schildkrout and Curtis A. Keim, 1–36. Cambridge: Cambridge University Press, 1998.

——, eds. *The Scramble for Art in Central Africa*. Cambridge: Cambridge University Press, 1998.

Schmeisser, Iris. *Transatlantic Crossing between Paris and New York: Pan-Africanism, Cultural Difference and the Arts in the Interwar Years*. Heidelberg: Universitätsverlag Winter, 2006.

Schmidt, Peter, and Roderick MacInctosh, eds. *Plundering Africa's Past*. Bloomington: Indiana University Press, 1996.

Schouteden, H. *Geïllustreerde gids van het museum van Belgisch Congo*. 2nd ed. Tervuren: Museum van Belgisch Congo, 1936, 1946.

Schumaker, Lyn. *Africanizing Anthropology: Fieldwork, Networks, and the Making of Cultural Knowledge in Central Africa.* Durham, NC: Duke University Press, 2001.

Scott, James C. *Seeing Like a State: How Certain Schemes to Improve the Human Condition Have Failed.* New Haven, CT: Yale University Press, 1988.

Sewell, William H., Jr. "The Concept(s) of Culture." In *Beyond the Cultural Turn: New Directions in the Study of Society and Culture,* edited by Victoria E. Bonnell, Lynn Avery Hunt, and Richard Biernacki, 35–61. Berkeley: University of California Press, 1999.

Shelton, Marie-Denise. "Fakes, Fakers, and Fakery: Authenticity in African Art." *African Arts* 9, no. 3 (1976): 21–48.

Sheppard, Todd. *The Invention of Decolonization: The Algerian War and the Remaking of France.* Ithaca, NY: Cornell University Press, 2006.

Sheriff, Abdul. *Slaves, Spices and Ivory in Zanzibar: Integration of an East African Commercial Empire into the World Economy, 1770–1873.* Athens: Ohio University Press, 1987.

Sherman, Daniel J. *French Primitivism and the Ends of Empire, 1945–1975.* Chicago: University of Chicago Press, 2011.

———, ed. *Museums and Difference.* Bloomington: Indiana University Press, 2008.

———. *Worthy Monuments: Art Museums and the Politics of Culture in Nineteenth-Century France.* Cambridge, MA: Harvard University Press, 1989.

Sidibé, Samuel et al., eds. *Le Musée du Mali: Catalogue de l'exposition permanente.* Ghent: Snoeck, 2006.

Siegmann, William. "A Collection Grows in Brooklyn." In *Representing Africa in American Art Collections: A Century of Collecting and Display,* edited by Kathleen Bickford Berzock and Christa Clarke, 19–22. Seattle: University of Washington Press, 2011.

Simpson, Moira G. *Making Representations: Museums in the Post-colonial Era.* London: Routledge, 1996.

Slatyer, Ralph. "The Origin and Development of the World Heritage Convention." *Monumentum* 3, no. 16 (1984): 1–8.

Stanard, Matthew G. *Selling the Congo: A History of European Pro-Empire Propaganda and the Making of Belgian Imperialism.* Lincoln: University of Nebraska Press, 2012.

Steiner, Christopher. *African Art in Transit.* Cambridge: Cambridge University Press, 1994.

Steiner, Christopher B., and Ruth B. Phillips. "Art, Authenticity and the Baggage of Cultural Encounter." In *Unpacking Culture: Art and Commodity in Colonial and Postcolonial Worlds,* edited by Ruth B. Phillips and Christopher B. Steiner, 3–19. Berkeley: University of California Press, 1999.

Stengers, Jean. "La Belgique et le Congo: Politique coloniale et décolonisation." In *Histoire de la Belgique contemporaine, 1914–1970,* edited by J. Bartier, F. Baudhuin, H. Haag, J. H. Pirenne, J. Stengers, E. Wanty, and J. Willequet, 391–440. Brussels: La Renaissance du Livre, 1975.

——. *Congo: Mythes et réalités*. Brussels: Éditions Racine, 1989.

——. "King Leopold's Imperialism." In *Studies in the Theory of Imperialism*, edited by R. Owen and B. Sutcliffe, 248–76. London: Longman, 1972.

Stengers, Jean, and Jan Vansina. "King Leopold's Congo, 1886–1908." In *The Cambridge History of Africa*, edited by Roland Oliver and G. N. Sanderson. Vol. 6, *From 1870 to 1905*, 337–58. Cambridge: Cambridge University Press, 1985.

Steward, Gary. *Rumba on the River: A History of the Popular Music of the Two Congos*. New York: Verso, 2000.

Stewart, Susan. "Death and Life, in That Order, in the Works of Charles Willson Peale." In *Cultures of Collecting*, edited by John Elsner and Roger Cardinal, 204–23. London: Reaktion, 1994.

Stillman, Clark. "Congolese Art in Europe and America." In *Art of the Congo*, 11–12. Minneapolis: Walker Art Center: 1967.

Stocking, George W., Jr., ed. *After Tylor: British Social Anthropology, 1881–1947*. London: Athlone, 1995.

——, ed. *Colonial Situations: Essays on the Contextualization of Ethnographic Knowledge*. Madison: University of Wisconsin Press, 1991.

——, ed. *Objects and Others: Essays on Museums and Material Culture*. Madison: University of Wisconsin Press, 1985.

——. *Victorian Anthropology*. New York: Free Press, 1987.

Stocking, George W., Jr., et al. *Essays on Museums and Material Culture*. Madison: University of Wisconsin Press, 1988.

Stoler, Ann Laura. "Colonial Archives and the Arts of Governance." *Archival Science* 2, nos. 1–2 (2002): 87.

Strother, Zoe. "Iconoclash: From 'Tradition' to 'Heritage' in Global Africa." *African Arts* 45, no. 3 (2012): 1–6.

——. *Inventing Masks: Agency and History in the Art of the Central Pende*. Chicago: University of Chicago Press, 1998.

——. *Pende*. Milan: Five Continents Editions, 2008.

Sweet, James H. *Recreating Africa: Culture, Kinship and Religion in the African-Portuguese World, 1441–1770*. Chapel Hill: University of North Carolina Press, 2006.

Taffin, Dominique, ed. *Du musée colonial au musée des cultures du monde*. Paris: Maisonneuve et Larose, 2000.

Tagg, John. *Grounds of Dispute: Art History, Cultural Politics and the Discursive Field*. Minneapolis: University of Minnesota Press, 1992.

ter Keurs, Pieter, ed. *Colonial Collections Revisited*. Leiden: CNWS Publications, 2007.

Teslow, Tracy Lang. "Representing Race: Artistic and Scientific Realism." *Science as Culture* 5, no. 1 (1995): 12–38.

Thelen, David. "The Nation and Beyond: Transnational Perspectives on United States History." *Journal of American History* 86, no. 3 (December 1999): 965–75.

Thomas, Nicholas. "Collectivity and Nationality in the Anthropology of Art." In *Rethinking Visual Anthropology*, edited by Marcus Banks and Howard Murphy, 256–75. New Haven, CT: Yale University Press, 1999.

——. *Entangled Objects: Exchange, Material Culture, and Colonialism in the Pacific.* Cambridge, MA: Harvard University Press, 1991.

Thomas, Nicholas, and Fiana Losche, eds. *Double Vision: Art Histories and Colonial Histories in the Pacific.* Cambridge: Cambridge University Press, 1999.

Thompson, Robert Farris. *The Flash of the Spirit: African and Afro-American Art and Philosophy.* New York: Vintage, 1984.

Thompson, Robert Farris, and Joseph Cornet. *Four Moments of the Sun: Kongo Art in Two Worlds.* Washington, DC: National Gallery of Art, 1981.

Thornton, John K. *Africa and Africans in the Formation of the Atlantic World, 1400–1680.* Cambridge: Cambridge University Press, 1992.

——. *A Cultural History of the Atlantic World, 1250–1820.* Cambridge: Cambridge University Press, 2012.

——. *The Kongolese Saint Anthony: Dona Beatriz Kimpa Vita and the Antonian Movement 1684–1706.* Cambridge: Cambridge University Press, 1998.

Thornton, John K., and Linda Heywood. *Central Africans, Atlantic Creoles, and the Foundation of the Americas.* Cambridge: Cambridge University Press, 2007.

Timmermans, Paul. "Le Musée d'Art et de Folklore à Luluabourg, Congo." *Museum* 13, no. 2 (January–December 1960): 92–97.

Toebosch, Wim. "L'école d'Elisabethville." In *Naissance de la peinture*, 13–18. Tervuren: RMCA, 1992.

——. "Pierre Romain-Defossés." In *60 ans de peinture au Zaïre*, edited by Joseh-Aurélien Cornet, Remi De Cnodder, Ivan Diericks, and Wim Toebosch, 59–71. Brussels: Les Editeurs d'Art Associés, 1989.

Tilley, Helen. *Africa as a Living Laboratory: Empire, Development, and the Problem of Scientific Knowledge, 1870–1950.* Chicago: University of Chicago Press, 2011.

——, ed. *Ordering Africa: Anthropology, European Imperialism and the Politics of Knowledge.* Manchester: Manchester University Press, 2007.

Tyrrell, Ian. "Reflections on the Transnational Turn in United States History: Theory and Practice." *Journal of Global History* 4, no. 3 (2009): 453–74.

Vail, Leroy, ed. *The Creation of Tribalism in Southern Africa.* Berkeley: University of California Press, 1991.

Van Avermaete, Tom, and Johan Lagae. "L'Afrique C'est Chic: Architecture and Urban Planning in Africa 1950–1970 — Architectuur en stadsplanning in Afrika 1950–1970." *Architectural Journal* 82 (2010): 1–4.

Van Beurden, Sarah. "The Art of (Re)Possession: Heritage and the Cultural Politics of Congo's Decolonization." *Journal of African History* 56, no.1 (March 2015): 143–64.

——. "Forty Years of IMNC: 11 March 1970–11 March 2010." *African Arts* 45, no. 4 (Winter 2012): 90–93.

——. "The Value of Culture: Congolese Art and the Promotion of Belgian Colonialism (1945–1959)." *History and Anthropology* 24, no. 4 (December 2013): 472–92.

Van Damme–Linseele, Annemieke. "Homage to Dr. Alphonse Lema Gwete." *African Arts* 38, no. 1 (Spring 2005): 10.

———. "From Mission 'Africa Rooms': Frans M. Olbrechts's Rediscovered African Collection." *African Arts* 41–42 (Summer 2008): 38–49.

Van Den Audenaerde, Dirk Thys, ed. *Africa Museum Tervuren*. Tervuren: KMMA, 1998.

Vanden Bossche, Jean. "Le Musée de la Vie Indigène, Léopoldville, Congo Belge." *Museum* 8, no. 2 (1955): 82–84.

Van der Grijp, Paul. *Art and Exoticism: An Anthropology of the Yearning for Authenticity*. Berlin: Lit Verlag, 2009.

Van der Kerken, Georges. *Les sociétés bantoues du Congo Belge et les problèmes de la politique indigène*. Brussels: Bruylant, 1920.

———. *L'ethie Mongo*. 2 vols. Brussels: IRCB, 1944.

Vandeweyer, Luc. "Missionary-Ethnographer." In *Mayombe: Ritual Sculptures from the Congo*, edited by Jo Tollebeek. Tielt, Belgium: Lannoo, 2010.

Van Geluwe, Huguette. "Belgium's Contribution to the Zairian Cultural Heritage." *Museum* 31, no. 1 (1979): 32–37.

Vangroenweghe, Daniel. *Rood Rubber: Leopold II en Zijn Kongo*. Brussels: Elsevier, 1985.

Vanhee, Hein. "Agents of Order and Disorder: Kongo Minkisi." In *Re-Visions: New Perspectives on the African Collections of the Horniman Museum*, edited by Karel Arnaut, 89–106. London: Horniman Museum & Garden, 2001.

———. "Niet-Europese collecties." In *Over collecties 2*, edited by Annick Hus, An Seurich, and Alexander Vander Stichele, 142–49. Brussels: Agentschap Kunsten en Erfgoed, 2012.

Van Hooland, Seth, and Hein Vanhee. "Van steekkaart tot webinterface: De evolutie van metadatabeheer binnen de erfgoedsector." In *Erfgoed 2.0 Nieuwe Perspectieven*, edited by Bart de Hil and Jeroen Walterus, 87–105. Brussels: Pharo, 2009.

Vanhove, Julien. *Histoire du ministère des colonies*. Brussels: Koninklijke Academie voor Overzeese Wetenschappen, 1968.

Van Schuylenbergh, Patricia. "Découverte et vie des arts plastiques du Congo dans la Belgique des années 1920–1930." In *Rencontres artistiques Belgique-Congo, 1920–1950*. Enquêtes et documents d'histoire africaine 12, edited by Patricia Van Schuylenbergh and Françoise Morimont, 1–64. Louvain-la-Neuve, Belgium: Centre d'Histoire de L'Afrique, 1995.

Van Schuylenbergh, Patricia, and Françoise Morimont. *Rencontres artistiques Belgique-Congo, 1920–1950*. Louvain-la-Neuve, Belgium: Centre d'Histoire de L'Afrique, 1995.

Vansina, Jan. *Being Colonized: The Kuba Experience in Rural Congo, 1880–1960*. Madison: University of Wisconsin Press, 2010.

———. *The Children of Woot: A History of the Kuba Peoples*. Madison: University of Wisconsin Press, 1978.

———. "The Four Moments of the Sun: Kongo Art in Two Worlds by Roberts Farris Thompson; Joseph Cornet." *African Arts* 16, no. 1 (November 1982): 23–96.

———. *Kingdoms of the Savanna: A History of Central African States until European Occupation.* Madison: University of Wisconsin Press, 1966.

———. "La survie du royaume Kuba à l'époque coloniale et les arts." *Annales Aequatoria* 28 (2007): 5–29.

———. *Living with Africa.* Madison: University of Wisconsin Press, 1994.

———. "Ndop: Royal Statues among the Kuba." In *African Art and Leadership,* edited by Douglas Fraser and Herbert M. Cole, 41–55. Madison: University of Wisconsin Press, 1972.

———. *Paths in the Rainforests: Toward a History of Political Tradition in Equatorial Africa.* Madison: University of Wisconsin Press, 1990.

Vantemsche, Guy. *Congo: De impact van de kolonie op België.* Tielt, Belgium: Lannoo, 2008.

Van Wyk, Gary, ed. *Shangaa: Art of Tanzania.* New York: QCC Art Gallery, City University of New York, 2013.

Vellut, Jean-Luc. "Aperçu des relations Belgique-Congo (1885–1960)." In *Le Congo et l'art belge, 1880–1960,* edited by Jacqueline Guisset, 21–35. Tournai: La Renaissance du Livre, 2003.

———. "Colonial Kitsch." In *Anthology of African Art: The Twentieth Century,* edited by N'Goné Fall and Jean Loup Pivin, 160–63. New York: Distributed Art Publishers, 2002.

———. "De dekolonisatie van Kongo 1945–1965." In *Algemeene geschiedenis van de Nederlanden,* edited by A. F. Manning, H. Balthazar, and J. De Vries, Part 15, *De nieuwste tijd,* 401–20. Haarlem: Fibula-Van Dishoeck, 1982.

———. "Hégémonies en construction: Articulations entre Etat et Entreprises dans le bloc colonial Belge (1908–1960)." *Canadian Journal of African Studies* 16, no. 2 (1982): 313–30.

———, ed. *Het geheugen van Congo: De koloniale tijd.* Tervuren: Snoeck-KMMA, 2005.

———. "La violence armée dans l'Etat Indépendant du Congo." *Cultures et Développement* 16, nos. 3 and 4 (1984): 671–707.

Verbeek, Léon, ed. *Les arts plastiques de l'Afrique contemporaine: 60 ans d'histoire à Lubumbashi.* Paris: L'Harmattan, 2008.

Verhulpen, Edmond. *Baluba et les Balubaïsés du Katanga.* Antwerp: L'Avenir Belge, 1936.

Verswijver, Gustaaf, Els De Palmenaer, Viviane Baeke, and Anne-Marie Bouttiaux-Ndiaye, eds. *Schatten uit het Afrika-Museum, Tervuren.* Tervuren: KMMA, 1995.

Viaene, Vincent. "Reprise-Remise: De Congolese identiteitscrisis van België rond 1908." In *Congo in Belgiê: Koloniale cultuur in de metropool,* edited by Vincent Viaene, David Van Reybrouck, and Bambi Ceuppens, 43–62. Leuven: Universitaire Pers Leuven, 2009.

Visonà, Monica Blackmun, Robin Poynor, Berbert M. Cole, and Michael D. Harris, eds. *A History of Art in Africa.* Upper Saddle River, NJ: Prentice Hall, 2003.

Vogel, Susan, ed. *Art/Artifact: African Art in Anthropology Collections.* New York: Center for African Art, 1988.

———, ed. *The Art of Collecting African Art.* New York: Center for African Art, 1988.

———. "The Buli Master, and Other Hands." In *Arts of Africa, Oceania, and the Americas,* edited by Janet Catherine Berlo and Lee Anne Wilson, 68–75. Upper Saddle River, NJ: Prentice Hall, 1992.

———. "International Art: The Official Story." In *Africa Explores: 20th Century African Art,* edited by Susan Vogel and Ima Ebong, 182–85. New York: Center for African Art, 1991.

———. "Zairian Authenticity." *Art Forum* 14, no. 10 (Summer 1976): 38–42.

Vogel, Susan, and Ima Ebong, eds. *Africa Explores: 20th Century African Art.* New York: Center for African Art, 1991.

Vogel, Susan, and Mary Nooter Roberts, eds. *Exhibition-ism: Museums and African Art.* New York: Museum of African Art, 1994.

Volper, Julien. *La part indomptée: Les masques d'homme-fauve des Luba.* Liège: Antroposys, 2009.

Von Eschen, Penny. "Rethinking Politics and Culture in a Dynamic Decade." *OAH Magazine of History* 26, no. 4 (2012): 9–12.

Vrdoljak, Ana Filipa. *International Law, Museums and the Return of Cultural Objects.* Cambridge: Cambridge University Press, 2008.

Walker, Roselyn Adele. *The Arts of Africa at the Dallas Museum of Art.* New Haven, CT: Yale University Press, 2010.

Walker Art Center. *Art from the Congo.* Minneapolis: Walker Art Center, 1967.

Wastiau, Boris. *Chokwe.* Milan: Five Continents Editions, 2008.

———. *Congo-Tervuren, Aller-Retour.* Tervuren: RMCA, 2001.

———. *Exit Congo Museum.* Tervuren: RMCA, 2000.

Weiss, Herbert F. *Political Protest in the Congo: The Parti Solidaire Africain during the Independence Struggle.* Princeton, NJ: Princeton University Press, 1967.

Weiss, Herbert F., and Terence Ranger, eds. *Postcolonial Identities in Africa.* London: Zed, 1996.

Werbner, Richard. "Beyond Oblivion: Confronting Memory Crisis." In *Memory and the Postcolony: African Anthropology and the Critique of Power,* edited by Richard Werbner, 1–17. London: Zed, 1998.

———, ed. *Memory and the Postcolony: African Anthropology and the Critique of Power.* London: Zed, 1998.

White, Bob W. "L'incroyable machine d'authenticité: L'animation politique et l'usage public de la culture dans le Zaïre de Mobutu." *Anthropologie et Sociétés* 30, no. 2 (2006): 43–64.

———. "The Political Undead: Is It Possible to Mourn for Mobutu's Zaire?" *African Studies Review* 48, no. 2 (September 2005): 65–85.

———. *Rumba Rules: The Politics of Dance Music in Mobutu's Zaire*. Durham, NC: Duke University Press, 2008.

Wilder, Gary. *The French Imperial Nation-State: Negritude and Colonial Humanism between the Two World Wars*. Chicago: University of Chicago Press, 2005.

Willame, Jean-Claude. *L'automne d'un despotism: Pouvoir, argent, et obéissance dans le Zaïre des années quatre-vingt*. Paris: Karthala, 1992.

———. "Les 'conseillers' belges d'hier et aujourd'hui: Actiers ou figurants des crisis zaïroises?" In *Belgique/Zaïre: Une histoire en quête d'avenir: Actes des rencontres de Bruxelles, ULB, 7–8–9 octobre 1993*, edited by Gauthier de Villers, 42–52. Brussels: Institut Africain, CEDAF; Paris: L'Harmattan, 1994.

———. "La politique africaine de la Belgique à l'épreuve: Les rélations belgo-zaïroises (1978–1984)." *Cahiers CEDAF/ASDOC Studies* 5 (1985): 1–112.

Witz, Leslie. *Apartheid's Festival: Contesting South Africa's National Pasts*. Bloomington: Indiana University Press, 2003.

Wynants, Maurits. *Van hertogen en Kongolezen: Tervuren en de koloniale tentoonstelling 1897*. Tervuren: KMMA, 1997.

Yoshida, Kenji, and John Mack, eds. *Preserving the Cultural Heritage of Africa: Crisis or Renaissance?* Suffolk, UK: James Currey Press, 2008.

Young, Crawford. *The African Colonial State in Comparative Perspective*. New Haven, CT: Yale University Press, 1994.

———. "Nationalism, Ethnicity and Class in Africa: A Retrospective." *Cahiers d'Études Africaines* 26, no. 3 (1986): 421–95.

———. *Politics in the Congo: Decolonization and Independence*. Princeton, NJ: Princeton University Press, 1965.

———. "United States Policy toward Africa: Silver Anniversary Reflections." *African Studies Review* 27, no. 3 (September 1984): 1–17.

———. "Zaïre: The Shattered Illusion of the Integral State." In *The Decolonization Reader*, edited by James D. Le Sueur, 414–27. London: Routledge, 2003.

Young, Crawford, and Thomas Turner. *The Rise and Decline of the Zairian State*. Madison: University of Wisconsin Press, 1985.

Zeleza, Paul Tiyambe. "The Troubled Encounter Between Postcolonialism and African History." *Journal of the Canadian Historical Association* 17, no. 2 (2006): 89–129.

Zimmer, Marcel. "Les finances coloniales jusqu'en 1960 et leurs conséquences." In *Histoire des finances publiques en Belgique*. Vol. IV–2, edited by Max Frank, 968–71. Brussels: Publications de l'Institut Belge de Finances Publiques, 1988.

Zimmerman, Andrew. *Anthropology and Antihumanism in Imperial Germany*. Chicago: University of Chicago Press, 2001.

Index

Page references in italics denote illustrations: figures (*fig.*) and color plates (*pl.*). Notes are indicated by *n* (or *nn*) and the note number(s) following the page number.

Darish, Patricia, 211
Dartevelle, Pierre, 140
Dayton Art Institute, 323n34
decolonization, 2, 16–19, 98, 100–126, 128, 130,
 157, 159, 209, 261–62, 273n63, 273–74n65,
 274n66
de Jonghe, Eduard, 35
De Maret, Pierre, 156
de Menil collection, 322n6
Department of Culture and Arts, 115, 134, 139,
 164, 204
De Plaen, Guy, 133, 142, 156, 165
de Poerck, Roger, 129, 133
De Rudder, Isidore, 54
Detroit Institute of Arts, 213, 239
D'Haenens, Antonin. See Father Antonin
 D'Haenens
diffusionism, 41, 42
Dillens, Julien, 54, 55 (fig. 1.9)
Diop, Cheikh Anta, 109
Du Bois, W.E.B., 109
Duponcheel, Christian, 139

East African slave trade, 5, 7
École de Dakar, 192
Egypt: influence on Congolese art, 42, 282n67
Elements d'art Bakuba, 200
Elima, 234
Elisabethville, 65, 66, 70, 80, 81, 82, 86, 87,
 88, 93, 129, 132, 134, 304n5
ethnography: as a discipline, 9, 40–42, 45; and
 the IMNZ, 151; and missionaries, 36; at the
 Museum of the Belgian Congo/RMCA,
 26, 29, 30, 32, 39, 53, 54 (fig. 1.8), 55–56,
 59, 85 ; and museums in the colony, 61,
 84, 86, 295n106
évolués, 28, 60, 89, 277n19
evolutionism, 41, 45, 56
explorers, 6, 10, 14, 25, 31, 32, 34, 36, 39, 57,
 147, 149, 152, 169, 171, 268n24

Fabian, Johannes, 7, 193, 197, 255, 317–18n52
Fanon, Frantz, 125
Father Antonin D'Haenens, 78
Father Cyprianus, 78
Felix, Marc Leo, 136
FIKIN fairs, 186–88 (FIGS. 5.8–10), 198
First Congo Crisis, 17, 100, 209, 297n14
Flemish: folklore, 44; heritage, 213;
 missionaries, 79, 296n119; sources, 22; staff
 at IMNZ and RMCA, 130, 157, 311n113
Fonds du Bien-être Indigène, 288n25
Force Publique, 27, 297–98n17
Four Moments of the Sun, The (Thompson
 and Cornet), 209, 238–43 (figs. 6.16–19),
 251–52 (pls. 9–12)
France, 28, 53, 90, 234, 295n108, 306–7n32
French West Africa, 8, 307n42, 309n75
Friedman, Martin, 212, 322n11

Gandajika, 78
Gansemans, Jos, 145, 155
geology, 42, 53, 80, 86, 297n9
Ghent University, 84, 292–93n81
Gilfoy, Peggy S., 226, 227
Girauld, Charles, 26

Hague 1954, The. See Convention for the
 Protection of Cultural Property in the
 Event of Armed Conflict
"Hangar, Le" (The Warehouse), 70
Harney, Elizabeth, 192
Hemba, 135, 147, 178, 188, 283n81
Hénault, Charlie, 130, 131, 134 (Fig. 4.2), 146,
 148, 149, 151, 155, 157, 161
heritage: African American, 208–9, 212;
 American, 209, 238–43; Belgian heritage/
 patrimony, 34, 98, 103, 213, 259; colonial
 protection of, 17, 64, 73, 79, 105;
 Congolese cultural, 59, 61–66, 69, 79, 87,
 89, 90, 95–96, 98–99, 135, 143, 208, 259;
 cultural, and identity, 3, 16–19, 100, 112,
 125, 152, 153, 158, 168–69, 180, 210, 221, 261;
 and decolonization, 100–126; definition,
 274n73, 310n96; and the international
 conservation regime, 115–18; Kuba, 199–
 205; modern art as, 188–99; postcolonial
 protection of, 20, 134, 141, 147, 302n76; in
 South Africa, 9; world/universal, 2, 19, 100,
 116, 201, 205, 232, 259; Zairian national,
 1, 2, 124, 134, 183, 185, 206, 209, 220–34,
 244, 259
Hersey, Irwin, 221, 223, 324n38
Herskovits, Melville, 45, 211, 282n73
High Museum of Art in Atlanta, 230, 323n34
history: African Diaspora, 242, 243; colonial,
 20, 22, 57, 158, 171, 215, 216, 218, 258;
 colonial, at Museum of the Belgian
 Congo/RMCA, 57; of decolonization,
 16, 21, 101, 254; and the IMNZ, 133,
 160, 162, 173, 177; of the Kuba, 222;
 and the Mobutu regime, 109, 111, 126,
 186; and modern Congolese art, 193,
 197; precolonial African, 7, 13, 39, 125,
 268–69n28; at the RMCA, 27, 32, 42,
 53, 56–59; transnational, 3. See also art
 history
Hochschild, Adam, 258
Hulsaert, Gustaaf, 296n119

Idea of Africa, The (Mudimbe), 20
Independence, Congo, 16–17, 98, 100, 101–4,
 106, 114, 123–24, 129, 134, 153, 191, 212–13,
 277n19, 305n10
Indianapolis Museum of Art, 226, 228 (fig.
 6.11), 229 (figs. 6.12–13), 230, 248 (pls. 5–6),
 323n34
Indiana University, 227, 235
Indian Ocean slave trade, 3, 5

economic, 102, 120, 165; Kuba controversy, 200, 202, 203

retour à l'authenticité. See authenticité

retrocession: economic policy of, 153, 165

Robbins, Warren, 212, 232, 234

Roberts, Allen, 32, 142, 211

Roberts, Mary Nooter, 5, 211

Romain-Desfossés, Pierre, 70, 198, 290n40

Rosaldo, Renato, 67

Royal Museum for Central Africa (RMCA): *Art of the Congo*, 212–20; collection, 29–40, 278nn27–28, 279nn29–30; displays, 40–60 *(figs. 1.5–11)*; and the IMNZ, 117, 154–58, 254, 257–58; name, 2, 265; and restitution, 101–7, 119–26. *See also* Museum of the Belgian Congo

Ruanda-Urundi, 82

Ryckmans, Pierre, 65, 80

Sakombi Inongo, 109, 110

Salongo, 234

Samba, Chéri, 193

Samuel, Charles, 54

Schatzberg, Michael G., 113, 163

Scheut missionaries, 34, 140, 141

Schildkrout, Enid, 11

Schillings, Charles, 89

Schumaker, Lyn, 128, 312n122

Seeuws, Nestor, 121 *(fig. 3.1)*, 130–33, 140–41, 144, 146–52, 155–57, 165, 178, 198, 305n14

Senghor, Léopold, 104, 109, 110, 111, 191, 192, 193, 194

Shaba, 149, 176, 231. *See also* Katanga

Sham Kwete, 200 *(fig. 5.14)*

Sheppard, William Henry, 160

Sieber, Roy, 211, 227

Société anversoise, 25

Songye: as an artistic style, 283n79; and the IMNZ, 141, 150; and the Museum of Art and Folklore in Luluabourg, 91; objects, 149 *(fig. 4.6)*, 224 *(fig. 6.7)*, 247 *(pl. 4)*, 320n81

Soviet Union. *See* USSR

Stanley, Henry Morton, 25, 57, 169, 171

Stanleyville, 80, 82, 291n65, 295n106

Steiner, Christopher, 15, 168, 309n75

Stillman, Clark, 212, 213, 214, 322n13

Stoler, Ann Laura, 208

Storms, Émile, 31, 32, 33 *(fig. 1.1)*, 34, 38

Strother, Zoe, 18, 211

Suka, 181, 325n67

Sura Dji. See under IMNZ

Survey of Zairian Art: The Bronson Collection, A (Cornet), 209, 234–38

Szombati, Ilona, 193, 317–18n52

Tabwa, 32, 135, 231

Tempels, Placide, 110; *Bantou Philosophy*, 110

Tempelsman, Maurice, 221

temporal diremption, 29

Tervuren museum. *See* Royal Museum for Central Africa

Thompson, Robert Farris, 211, 227, 239; *The Four Moments of the Sun*, 209, 238–43

Tilley, Helen, 128

Timmermans, Paul, 91, 92, 96

Tippu Tip, 6

Torday, Emil, 36, 79, 120, 160, 268n24, 292n68

tourist art, 272–73n60

transnationalism, 3, 265–66n7

Treasures of Traditional Art. See Trésors de l'art traditionnel

Treasures from the Africa Museum Tervuren, 30

Trésors de l'art traditionnel, 174, 176, 182

Tshibumba Kanda-Matulu, 193

Tshikapa, 76–77, 77 *(fig. 2.1)*, 88–92, 96, 137, 291n63

Tshiluila, Shaje'a, 114, 131, 156, 157, 159, 161, 162

Turner, Thomas, 112

UN (United Nations): and Congolese independence, 305n10

UNESCO (United Nations Educational, Scientific and Cultural Organization), 8, 18, 118, 120, 124, 205, 302n71, 314n12; UNESCO Convention on the Means of Prohibiting and Preventing the Illicit Import, Export and Transfer of Ownership of Cultural Property (1970), 19, 115, 116, 117

Union Minière de Haut-Katanga, 86–87, 102, 104–05, 111, 153, 275n4, 297n115

United States of America: and African art scholarship, 211, 244; exhibitions, 203, 208–44; and heritage politics, 117, 205; and the international politics of Zaire, 22, 120, 220–34, 238–44, 254; market for African art, 14, 74, 141, 208–12, 234, 236–38

USSR, 211

Vanden Bossche, Adrien, 65, 68, 69, 82

Vanden Bossche, Jean, 61, 69, 84–88, 92–96, 122, 129, 189, 292–93n79

Van Elslande, Renaat, 117, 120, 166, 204

Van Geluwe, Huguette, 124, 140, 157, 160, 215

Van Moorsel, Hendrik, 293n85

Van Noten, Francis, 156

Vansina, Jan, 37, 79, 110, 200, 201, 203, 211, 222, 241

Vellut, Jean-Luc, 69

Verly, Robert, 71, 76–78, 77 *(fig. 2.1)*, 88–91, 96, 97 *(fig. 2.10)*, 291n63, 294n94

Voix du Congolais, La, 98

Waldecker, Burghart, 87, 293n87

Walker Art Center, 105, 208, 212, 216, 217 *(figs. 6.1–3)*, 218 *(fig. 6.4)*, 220, 224 *(fig. 6.7)*, 247 *(pl. 4)*, 322n11
Wallenda, Marc, 70, 198, 289n38
Walschot, Jeanne, 38 *(fig. 1.3)*, 39
Wastiau, Boris, 34
welfare colonialism. *See* Belgian colonialism
West African Museums Programme (WAMP), 8
White, Bob, 111, 255, 298–99n31, 299n32
Wissaert, Paul, 55 *(fig. 1.9)*
World Heritage Convention (1972), 116
World War II, 8, 15, 18, 28, 66, 80, 115, 221, 297n15

Yaka: and the IMNZ, 150, 178, 181 *(fig. 5.6)*, 185, 225, 325n67; king, 58 *(fig. 1.11)*
Young, Crawford, 163

Zaire River, 146, 169
Zairian second republic, 101
Zairization: of economy, 111, 128, 139 ,162, 165, 300n46, 311n98; of the IMNZ, 114–15, 129, 153–58, 160, 166, 231; of knowledge production, 159, 225; of names, 19
Zande, 147, 148, 150, 152, 178, 215, 225
Zola Kwandi Mpungu Mayala, 121 *(fig. 3.1)*, 132, 140, 141, 148